How to Read a Photograph

Lessons from Master Photographers

How to Read a Photograph
Ian Jeffrey

Lessons from Master Photographers

Foreword by Max Kozloff

Abrams, New York

Picture research
Isabelle Pateer

Design
Dooreman, with Anagram, Ghent

Cover design
Darilyn Lowe Carnes

Copyediting
Paul van Calster

Typesetting
Anagram, Ghent

Duotones and colour separations
Die Keure, Bruges

Cataloging-in-Publication Data has been applied for and may be obtained from the Library of Congress. ISBN: 978-0-8109-7297-1

Printed and bound in China
10 9 8 7 6 5 4 3 2

Abrams books are available at special discounts when purchased in quantity for premiums and promotions as well as fundraising or educational use. Special editions can also be created to specification. For details, contact specialmarkets@abramsbooks.com or the address below.

THE ART OF BOOKS SINCE 1949
115 West 18th Street
New York, NY 10011
www.abramsbooks.com

CONTENTS

TECHNICAL NOTE:
THE QUESTION OF DIMENSIONS

Certain of the pictures in this anthology, specifically those from the world wars, come with measurements added. This is in part because they are previously unpublished and do not yet belong to any historical consensus. As few have seen the pictures, measurements act as a guarantee that they really exist. But there is another reason which has to do with the sort of photographs that they are: personal images, like entries in a diary. Almost all of the pictures which make up photography history were meant for public disclosure, as book illustrations and as entries in magazine articles. It was understood in this context that the original was no more than a starting point to be enhanced by improved printing techniques. In the alternative tradition, represented by the war pictures on show here, publication was never intended. Instead the image was meant as a primary source to be passed from hand to hand or loosely mounted in an album. Photographs, under these terms, were tangible items. Sometimes they are difficult to read because original audiences only needed to be reminded and were quite happy with the sort of contact prints which seem to have satisfied Wilhelm von Thoma in 1914–18. That is to say, there is an important distinction to be made between the private and the public domains in photography, even though there is a certain amount of intermingling. Because the war pictures were meant to be handled, their dimensions matter, even if only as a way of indicating that these were always actual items.

THE AUTHORS

In 1981 Thames & Hudson published **Ian Jeffrey**'s *Photography: A Concise History*, a classic study of the medium. In 1997 he surveyed the medium at large in *The Photography Book*, prepared for Phaidon Press. In 1998 Amphoto published a series of his thematic studies, *Timeframes*, and in 1999 he wrote 'an alternative history of photography', entitled *Revisions*, for Britain's National Museum of Photography, Film & Television. In 2000 he surveyed photography from its origins onwards for *The Oxford History of Western Art*, edited by Martin Kemp. In the 1970s and '80s Ian Jeffrey wrote art criticism for Alan Ross's *London Magazine*. He has taught principally in the University of London Goldsmiths College and in the Central European University in Prague.

Max Kozloff's most recent books are *New York: Capital of Photography*, published by Yale University Press in 2002, and *The Theatre of the Face: Portrait Photography since 1900*, Phaidon Press, 2007.

FOREWORD

The history of photography is a marvellous subject and a tricky field. We 'breathe' in a dimension fabricated by pictures, which visibly comprise a great deal of our environment. Not only do they illustrate a society's appetites, distractions and dreads, but they afford us the wonder of regarding similar dimensions fixed by earlier photographs. All those precious murmurs of appearance from the past would have been lost but for the attention given them by the camera, even in nonchalant hands. From this illimitable legacy, photographic images enter into history, once they are published. Yet the lens of history wavers as it tries to focus upon them.

Historians in general tend to look at photographs as secondary documents when compared with primary sources such as written testimonies and archives. As against this, historians of photography consider the images as primary objects, sometimes illuminated by records. A photograph may be used to extract evidence of vanished material conditions, ideals, cultures and epochs. Additionally, photographic content may be treated as an evocation of feelings, suggested by a mind at work upon its objects in space. Clearly, two complementary historical approaches are implied in this distinction of preferences between the discursive and the figurative. The tricky part for the scholar of photography is how to progress from a description of what is made present in a picture to an account of what makes sense, based on a projection of causes and effects. To use a photograph as a machine for dispensing information is legitimate and necessary. However, it also offers a softer imaginative experience – something to behold – that invites a viewer's involvement. By themselves, the visual facts convey a material reality of their time; as they're composed and framed, they reflect a narrative desire of their time.

Ian Jeffrey singles out both such phenomena as he puts together his own stories, given in capsule remarks. They're gathered in exposition of pictures, centred always by a consideration of the one who made them. The method is biographical, uncoiled by a succinct relay of personal details and professional circumstance. From these intimate matters he nevertheless develops a larger panorama of observers, idiosyncratically engaged with their world, as chance, enterprise and purpose would allow. Connecting through the pages of this book, these figures have or had in common their practice of a medium whose destiny, as he says (in a passage on Roger Fenton), was to be 'scanned and seen through – leaving the nuances as a reserve – too elusive for public speech'.

Histories of photography are often structured as sequences of technological, media, genre, aesthetic, commercial and political dynamics, pressuring each other. In these pages, such events ripple through individual life stories, with writing that keeps in mind the vital association between the word 'sense' and the word 'sensibility', no matter what the level of expressive intent.

The agent of meaning, in this case, is activity, much of it work. What people do and how they – including the photographer – do it is of major concern. Such an emphasis sets the commentary in motion, whether it reckons with the impetus or only the pretence of work. About a bolt tightener in a photograph by François Kollar, Jeffrey says 'It is likely that the man is just posing and that the bolts [of an electric motor] were all in order, but it makes an impressive picture. Kollar was attracted to subjects where the man/machine ratio was out of kilter – as in a tall tale.' To appreciate the fact that the prosaic nuts and bolts of ordinary life can be fashioned into a 'tall tale', or even myth, is to get close to the nature of photography.

Here is a mode of depiction equipped with a transcriptional bias that allows for guile. Taking that in, the historian deals not only with the spontaneity of behaviour but the way it is socialized for the camera. Far from producing a mere inventory of things and gestures, Ian Jeffrey discusses psychological relations implied in the frame, just then visualized by a micro-second's opening of a shutter. A view of these relations is inevitably speculative and allows for alternative readings. But it does permit the extension of 'public speech', an act that this inquisitive book performs from its very beginning.

Max Kozloff

WILLIAM HENRY FOX TALBOT

1800–1877

Fox Talbot made the first photographic negative in 1835, of a lattice window in his house at Lacock in Wiltshire. The idea of photography, of imprinting an image on paper through the action of light, came to him in 1833, whilst making drawings at Lake Como in Italy. He sensitized paper with salt and silver nitrate, and called it 'photogenic drawing paper'. He announced the process in London in 1839, and in 1841 introduced development, which brought out the latent image in the paper. In 1843 he patented the calotype process – Greek for a beautiful print. Patenting inhibited the development of photography in Britain, and gave the French a clear run. In 1843 he set up his own printing works, and published *The Pencil of Nature*, in parts between 1844 and '46. A mathematician, scientist and etymologist, he published *English Etymologies* in 1847.

THE HAYSTACK. April 1844

Plate X in *The Pencil of Nature*. Hay was cut, dried and stacked in early summer for use as winter food for cattle. Stacks were thatched with straw to keep the rain out, and they were cut up with the heart-shaped blades of hay-knives. Ladders gave access to those workers who carried the hay.

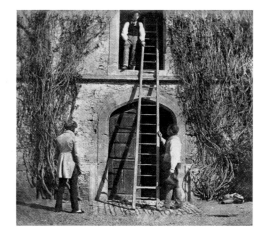

The Ladder. Pre-1845

Plate XIV in *The Pencil of Nature*. This ladder is from the same family of ladders as that used in *The Haystack*. The man above can't see the whole arrangement; nor can the man below. The third man, Nicolaas Henneman – who was Talbot's assistant – has a view of the whole operation. He is an overseer, just like the photographer who is further back and out of sight.

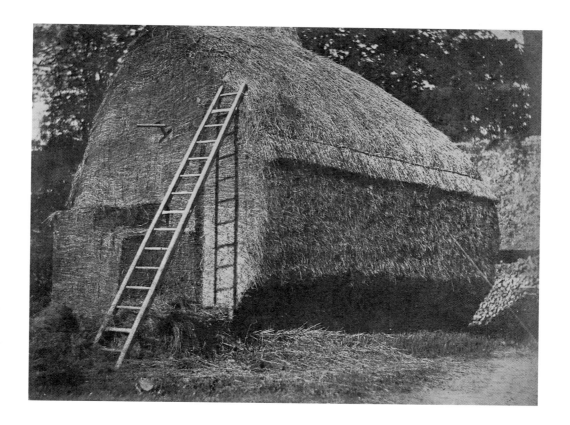

What was Talbot doing early in the 1840s? Looking for and at things which might be photographed. A haystack would have been such a thing: a large item – the largest around – occupying space. The ladder introduces an idea of measurement and of the human scale. It also serves as an attribute, making practical sense of the haystack. If the haystack is a thing, the scene shown in the picture of the ladder is an event. What exactly is going on, having to do with the safe placing of the ladder, can easily be worked out with reference to the three participants. The trick was to know just where to stop, for if more figures were added to either picture you would end up with genre scenes concerning country life. The problem with sparse compositions like these, however, is that they become suggestive. A ladder on a busy site is no more than a means of access but in isolation it becomes something to be wondered at. This would mean speaking its name and remembering other ladders: that one, for instance, which used to reach from earth to heaven, with angels ascending and descending – when God spoke to Jacob dreaming at a place called Bethel. Photographers never tired of this conceptual game in which one step forward delivers things and words and one back discloses the scene itself in all its natural complexity.

WILLIAM HENRY FOX TALBOT

Fox Talbot was learned and cultured. His first six published papers in the 1820s were on mathematics. In 1827, when he moved to Lacock Abbey, he remodelled the South Gallery to house his picture collection. In 1830 he published *Legendary Tales in Verse and Prose*, including a poem called 'The Magic Mirror', featuring a wizard, a daughter and a magical mirror, not meant to be looked into. The daughter, on inheriting the mirror, removes the veil to see 'a crystal Lake' and 'a lovely Isle', followed inevitably by 'the Storm of Death'. During the 1830s he kept notebooks on all sorts of natural phenomena: comets burning up in the atmosphere, the blueness of the sky, the motions of thunderclouds and the effects of the sun and moon on the weight of bodies.

WIFE AND CHILDREN. April 19, 1842
They lived at Lacock Abbey, which Talbot didn't like, saying that it was 'low and damp'. His wife, Constance, liked the place, and had three daughters in quick succession: Ela, Rosamond and Matilda. Here, near to the garden door, Constance sits on a rustic bench, with the youngest child on her knee. She looks towards Rosamond, who looks towards the door. All three children wear bonnets which restrict their vision, which means that they are under the supervision of their mother. The door might be a sign of the future, although on April 19, 1842, when the picture was taken, it was closed. The heavily pruned wood around the doorway has not yet begun to sprout and looks like a labyrinth, which might also have a bearing on the future. Constance had been very ill after the birth of Ela, the first child.

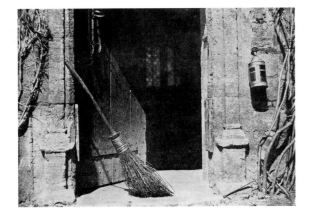

The Open Door. April 1844
Plate VI in *The Pencil of Nature*. There are several versions of this image, with rearrangements. At Lacock there was a statue of Diogenes the Cynic who once took a lantern at midday to look for an honest man, and who once asked Alexander the Great to step out of his light – when asked if there was anything he wanted. Christ, in the Sermon on the Mount, was 'the light of the world'. The piece of harness, a halter, might signify self-control. Jonathan Swift, in his pamphlet of 1710 called *A Meditation upon a Broomstick*, imagined a broomstick as a figure for a man turned upside-down and worn out by long use, ready to be thrown away or used for lighting a fire. Lady Elizabeth, Talbot's mother, knew this picture as 'The Soliloquy of the Broom'. Introducing the image in 1844 Talbot wrote: 'A casual gleam of sunshine, or a shadow thrown across the path, a time-withered oak, or a moss-covered stone may awaken a train of thoughts and feelings, and picturesque imaginings.'

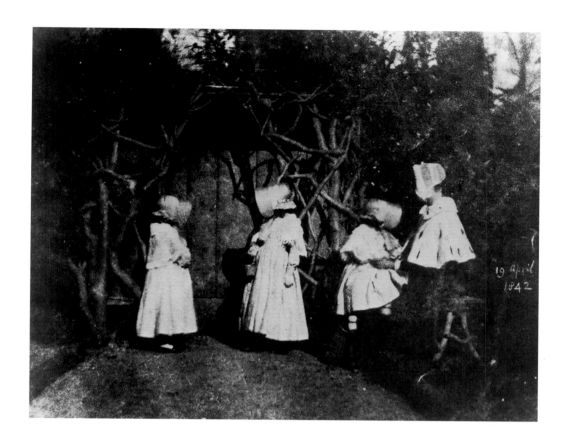

In photography Talbot discovered a medium which was hospitable to an inconclusive iconography. Meanings might be construed, but with no certainty. Photography, with its 'picturesque imaginings', took its place in a list of media: poetry (out-and-out fantasy), letter writing (observation and self-expression), scientific papers (objective accuracy), essay writing (explanation and argument).

As practised by Talbot, it was a medium which was naturally not too fussy about interpretation. *The Open Door*, with its iconographic selection, doesn't look very coherent, and in a painting that might be a fault but here it is intriguing. In the family group the girls might have been asked to stand like that just to keep the light from their eyes, and their faces under those cowls wouldn't have been visible anyway. The result, touching on destiny and its intricacies, might have been no more than a by-product but all the same one which it was impossible to overlook. Photography uncovers meanings even where none might be intended.

DAVID OCTAVIUS HILL & ROBERT ADAMSON

1802–1870 | 1821–1848

Hill and Adamson worked in partnership from 1843 to 1847. Adamson already had a calotype studio in Edinburgh. Fox Talbot's new process was not under patent control in Scotland. Hill, who was a landscape painter and secretary to the Royal Scottish Academy, was about to begin a massive undertaking in history painting. Around 450 clergymen had withdrawn from the Church of Scotland to set up a Free Church and it was Hill's idea to make a painting to show the act of secession. It seemed to be a good idea to speed things up by photographing the participants, for the event had only just taken place in 1843. The picture was meant to be finished in 1846 but took twenty-one years to complete. Hill found himself fascinated by photography and during their years together he and Adamson made many portraits of Edinburgh's notables, of distinguished visitors, and of fisherfolk who lived nearby on the coast at Newhaven. Photography was decidedly new in 1843 and looked as if it had a future in book illustration. Pictures were sold loose and in albums, but money was lost rather than made. Adamson was the technical expert and on his early death the business ended. More than anyone they established photography as a medium fit for art.

**THE REVEREND FYVIE,
MR CADELL, MR SPIERS**. c.1843
This is one of 258 prints assembled by Hill in 1848 and given to the Royal Academy in London. Robert Cadell was the publisher of Walter Scott's 'Waverley Novels'. Robert Spiers was Sheriff of Edinburghshire. The three may have been got together to re-enact scenes from the lively debates of 1843.

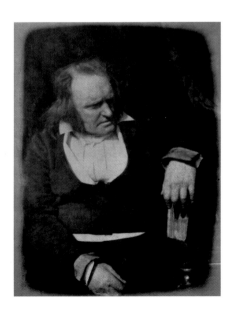

John Wilson, Professor of Moral Philosophy. Edinburgh, November 1843
Wilson, under the name 'Christopher North', had written a commentary for a book of 1840 on the Scottish poet Robert Burns, illustrated by D. O. Hill, *The Land of Burns*. Wilson was one of Edinburgh's notables.

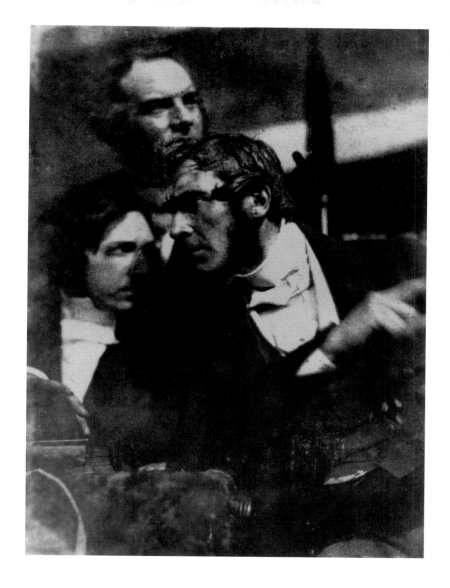

The portraits of Hill and Adamson were often compared to those of Rembrandt, for long exposures intensified shadows and highlights and dramatized their subjects. There were Scottish antecedents, too, especially the painted portraiture of Sir Henry Raeburn (1756–1823), but the men and women of the 1840s look rough and ready by comparison. It should be remembered that Hill and Adamson meant originally to take portraits of men involved in a rebellion, and that the style of rebels is unkempt and expressive. They persevered with this robust manner, and it was this which attracted attention when their pictures were rediscovered in the 1890s. Their negatives had been kept and new prints were made and shown in London in 1898 and in Hamburg in 1899. Stieglitz printed their pictures in *Camera Work* ('Christopher North' in July 1905) and cited them as worthy forerunners. They were admired for their honest approach, especially by Paul Strand writing in the 1920s. He meant that they didn't tinker with their negatives and prints. Their portraits also embodied energy and force of character, and that, too, was appreciated in an era when the big battalions seemed to be gaining the upper hand.

GUSTAVE LE GRAY

1820–1884

His is a romantic story: celebrity and the trappings of wealth followed by bankruptcy and exile. In the late 1850s his studio at 35 boulevard des Capucines was a meeting place for Parisian high society. In 1840 he had started as a clerk to a notary. In 1842 he took up painting but wasn't successful and in 1847–8 he turned to photography. He made daguerreotypes, on silver-plated copper grounds, before beginning to work with waxed paper negatives and paper prints. An expert technician and talented teacher, he was asked in 1851 by the Historic Monuments Commission in France to participate in the 'Mission héliographique', intended to survey those buildings in France due for renovation on grounds of historic importance. For the Mission he photographed in south-west France in the summer of 1851. When travelling he used a dry paper negative process, to save on preparation time. The popularity of photography encouraged him to undertake printing on a commercial scale, but he was no businessman and this venture proved his undoing. In 1856, however, he was 'photographer to the Emperor', Napoleon III, and in 1857, on the Emperor's behalf, he took pictures at a large military training camp at Châlons-sur-Marne between August and October.

STUDY OF TREE TRUNKS, FONTAINEBLEAU. c. 1855–7

From 1849 he began to take pictures in the Forest of Fontainebleau to the south-east of Paris. It was approached via Chailly-en-Bière, and Le Gray took pictures alongside the Chailly road. Barbizon, beloved of painters at this time, lies not far off to the west. Le Gray was interested in this group of trees, which appears in other photographs. Not far from the edge of the road, they are oak trees which have grown tall and straight but which have spread to allow space between the crowns.

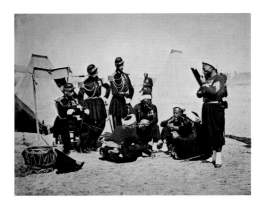

Zouaves gambling (Le Jeu de la drogue), Châlons-sur-Marne. 1857

Zouaves were French soldiers from North Africa. These have medals and may have been active in the recently completed Crimean War. The four card players are watched by a sergeant and three French native officers. There is a drum nearby and a bugle, which might suggest readiness for action.

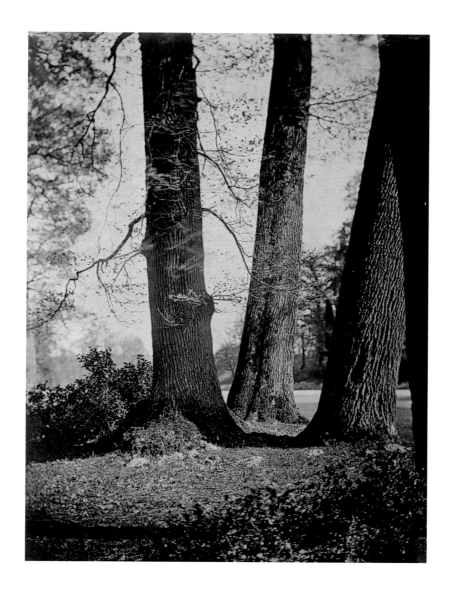

Le Gray may have had the field to himself in the 1850s, but he also had an aesthetic. The three trees, for instance, may have grown like this for the sake of air and light. Le Gray was always interested in how space is filled and in how it might be mapped. The zouaves, who look at first sight like an exotic part of the French military scene, scrutinize the pieces in the game, and they in their turn are looked at by the adjacent officers. The drum and bugle reach further afield to the camp at large. Thus local spaces and the wider theatre of the camp are surveyed and controlled. Many of his pictures are taken from elevated positions and show items scattered on level ground, calibrating space.

GUSTAVE LE GRAY

When Le Gray moved to his new studio in the boulevard des Capucines in the centre of the city he kept his old establishment near to the place de Clichy – not far north of the new place. He used the old premises as a laboratory, and employed around twenty assistants. An aristocratic backer paid for the new studio and Le Gray paid for the furnishings. Money was to be made through portraiture, although Le Gray had other ideas – seascapes especially. Even though he described himself as 'photographer to the Emperor', commissions didn't follow as a matter of course, and when the Court toured Brittany and Normandy in the summer of 1858, Edouard Baldus was given the job of covering the tour. His career in Paris came to an end in 1858 when his financial backers called time on him. The coming of the popular carte-de-visite format undermined the trade in expensive portraiture. In 1859 Le Gray met Alexandre Dumas who was planning a journey to Italy, Sicily, Greece and the Near East. Dumas would write the text and Le Gray would take the pictures. The expedition started in April 1860, but soon Dumas was sidetracked by the idea of helping Garibaldi liberate Sicily. The expedition broke up in disorder in Malta, and Le Gray was left to fend for himself. He pressed on to Syria and to Alexandria, and eventually settled in Cairo, where he remained.

THE BROKEN WAVE, SÈTE. 1857

In the summer of 1856 he took remarkable pictures of coastal shipping and scenery in Normandy. The pictures are expansive enough to give some idea of what it might be like to navigate on the ocean with its range of winds and tides. In the spring of 1857 he went to Sète on the Mediterranean coast, on the golfe de Lion, to mark the opening of a new railway line linking Sète with Toulouse to the west. Use of the sensitive wet collodion process allowed him to capture waves in action on the shore. The two single-masted fishing boats, sloops with lugsails, are tacking into the harbour in windy weather.

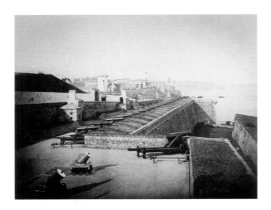

Battery of cannon at Brest. August 1858
Brest, a major naval base on Finistère (far to the west), would have been on the imperial itinerary. Le Gray took pictures of the British and French fleets moored at Cherbourg in Lower Normandy. This picture gives a good idea of lines of fire in and around the fort. The mortars would have been trained on landing beaches, and the walls would have been defended by the cannon. Practice firings have scorched the turf on the rampart.

Le Gray envisaged landscape as a field of operations traversed by a variety of forces. At the military camp cavalry manoeuvred in wide spaces, guns were fired and orders shouted. At sea ships were towed, navigating carefully in shallow and dangerous waters. At Sète those two fishing boats proceed with difficulty on rough waters. The fort with its surrounding space has also been surveyed. Le Gray imagined landscape as empty space which had somehow to be indicated by sails and guns. His immediate successors, recognizing the difficulties involved, treated it instead as a space to be filled.

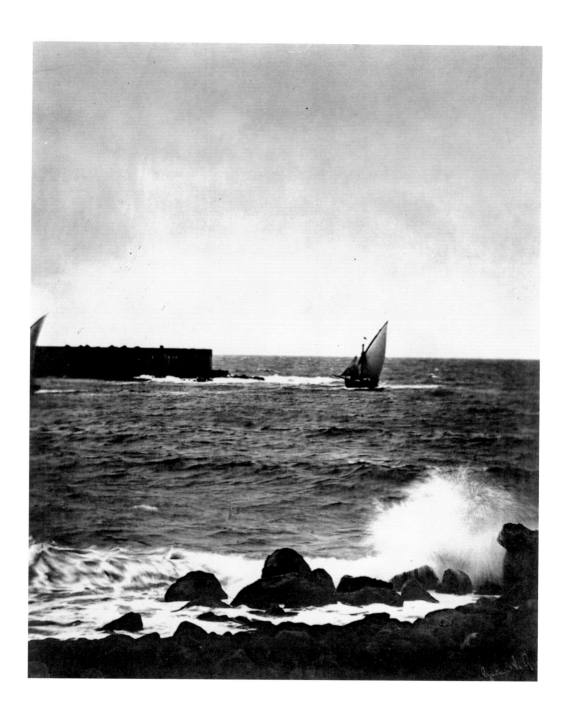

ROGER FENTON

1819–1869 He came from a well-to-do family in Lancashire (banking and textile mills). His father was a Member of Parliament, and Fenton himself trained in law. In the 1840s he took up painting and seems to have studied in Paris. By 1851 he had turned to photography, which was making progress in France. Fenton, who was energetic and business-like, tried to advance British interests and in 1852 he began to plan the formation of a Photographic Society in Great Britain, which was founded in January 1853. In Paris he had learned to use a dry waxed-paper negative process in 1851–2, taught by Gustave Le Gray. In September 1852 he went to Kiev to take pictures of the building of a bridge across the Dnieper. In 1853 he became secretary to the newly established Photographic Society and in 1854 gave advice to the British Museum on the use of photography. In March 1854 France and Britain declared war on Russia, which the French said had usurped its position as protector of the Holy Places in the Middle East. The British army, inactive since 1815, was out of condition and things went from bad to worse, resulting in the resignation of the government in February 1855. In that month Fenton set sail for the Crimea to make a photographic report, commissioned by Thomas Agnew & Sons, Manchester print dealers.

THE ORDNANCE WHARF, BALACLAVA. 1855
Cannonballs had to be unloaded and stacked, a difficult job given their shape and weight. Hence the baulks of timber here and what look like tree roots. The picture offers a cross-section: transport ships, stevedores, cargo and port installations. Fenton was a systematic operator.

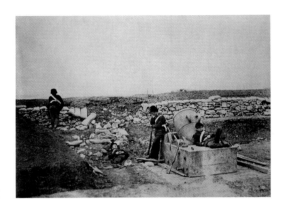

A quiet day on the mortar battery. 1855
The apparatus was mounted on wooden blocks. The emplacement has come under fire, which has broken through the protective wall. Not much seems to be happening: one of the squad sleeps on a cloak, and another drowses on the gun carriage; a sentry stands lost in thought, leaving lookout duties to a fourth member of the team who scans the horizon. They represent states of consciousness: sleep, torpor, day-dreaming and alertness. Studying in Paris in the late 1840s he would have seen pictures by Delacroix who always remarked on states of being: death and collapse on the one hand and animation on the other. Delacroix's usual sign of vivacity was a head above the horizon, like that of the dutiful sentry keeping watch here.

Fenton took over 300 pictures in the Crimea. They were exhibited in September 1855 – and very widely reviewed. Critics liked the pictures of the allied generals especially: speaking likenesses of the *dramatis personae*. They recounted personal and place names, but none of them seemed to have looked closely at the pictures. They saw them simply as transcripts of the setting and its characters. It was photography's destiny to be scanned and seen through in this way, leaving the nuances as a reserve – too elusive for public speech.

In the Crimea Fenton used a horse-drawn photographic van as a travelling darkroom. The van, which had to remain stationary for long periods, made an attractive target and had its roof shot off at one point. By 1854 he was using the wet collodion process which required large glass plates to be prepared on the spot and in darkness. Eventually in the Crimea he contracted cholera. Lord Raglan, head of the British forces, died of it. Fenton had taken landscape pictures before going to the Crimea and he did so afterwards. He wanted to make money from photography, and although the Crimean pictures were celebrated, they didn't sell in sufficient quantities. In 1856 he and several others tried to set up a Photographic Association to sell prints, and as a result the Photographic Society asked him to resign from its council. His work at the British Museum also led to difficulties, for it cost more than the Museum expected, and this led to an official inquiry. In 1859 Fenton experimented with the newly introduced stereoscopic process, which would become big business later in the century. In 1861 he retired from photography, selling his negatives and equipment. The family cotton business was hard hit by the American Civil War in the 1860s, which resulted in a cotton famine. He returned to the Law, his original profession, and died of 'nervous exhaustion' and heart failure in 1869.

THE KEEPERS REST, RIBBLESIDE. 1858–9
The river Ribble rises in the Pennines in Yorkshire and flows west through Lancashire. The Fenton family had estates and mills near to the river. Fenton took other pictures of the river flowing gracefully through a wooded landscape. Here, though, the bank has been strewn with fine driftwood, probably from spring floods. Above and beyond is a track and then a bank with bushes and a fence. Five men and a dog make up a group on the edge of the track. One is a fisherman, and there are two gamekeepers with guns. The two men in dark coats and white trousers may be Fenton's coachmen. It looks like a genre scene, but the figures all have specific jobs within that rural economy.

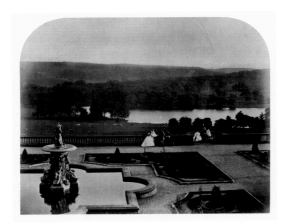

Terrace and park at Harewood. 1860
This late picture is of Harewood House in the West Riding of Yorkshire, and in 1860 it had not been long redesigned. By the distant balustrade there are two family groups: that to the left concentrates on a child seated on the parapet and the others look towards the camera. Beyond them a wooded world stretches to infinity, in contrast to the carefully arranged elements of the parterre in the foreground. Posing for the camera, both groups by implication look towards the future. In April 1860 Fenton's only son died, aged two, and family trajectories could have been on his mind during this visit to a dynastic property.

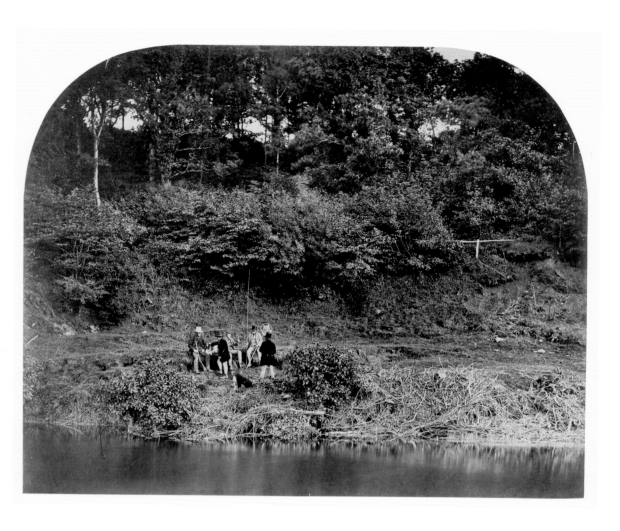

Fenton's pictures, with their discrete elements, give an impression of planning and programme. It is as if they have been encrypted. Fox Talbot hinted at such secrets when he wrote of 'picturesque imaginings'. It would, though, be another eighty years before Alfred Stieglitz would care to tell all about the meanings secreted in his photographs.

JULIA MARGARET CAMERON

1815–1879

Cameron began to take photographs in 1863 and had established herself by 1864, when she arranged for a London dealer, Colnaghi, to sell her prints. She intended to revive her family fortunes, which were at a low ebb. She took pictures for the next ten years – one of photography's most tantalizing collections. The pictures are portraits drawn from the Bible and from the writings of Milton and Alfred Lord Tennyson, who was also known to her as a neighbour on the Isle of Wight. Her husband, Charles Cameron, had worked in India, where she was born. They kept distinguished company in the arts and sciences, and both of them were well read, to say the least. She was a member of the Arundel Society, which had been set up in the 1850s to promote knowledge of art by means of high-quality reproductions, such as chromolithographs. Participation in the work of the society may have given her the idea of making and distributing her own art.

The Mountain Nymph Sweet Liberty. June 1866
The title refers to John Milton's *L'Allegro* of 1632 in which the poet represents himself as having escaped from 'loathed Melancholy' with the aid of one of the Graces, accompanied by a mountain nymph. Milton writes of mirth and of pleasures, but the nymph looks most unhappy as if she too has knowledge of the 'blackest midnight' mentioned by Milton at the beginning of his poem.

THE ANGEL AT THE TOMB / FRESHWATER. 1869

Freshwater is on the Isle of Wight. The tomb was Christ's, and the angel came down from heaven like an earthquake to roll away the stone which sealed the entrance. Christ, however, had already gone, to the added amazement of Mary Magdalene. According to Matthew the angel was male. What Cameron seems to have done is to present the angel as Mary Magdalene, out of whom Christ had expelled 'seven devils'. The event took place at first light.

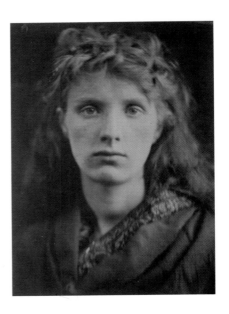

Cameron's tactics, so engrained as to amount to second nature, were to take account of the original scene as broadly as possible. Participants in the Resurrection, for instance, were the missing Christ, an angel whose 'countenance was like lightning' and the baffled Magdalene. The Magdalene's story as told by Matthew, Mark and Luke is, whatever else, a love story in which she had meant to anoint Christ's body with spices and ointments. It may be an undoing of those early carnal moments when Adam and Eve brought about their expulsion from Paradise. Cameron always negotiated this difference between doctrine and psychology, between the story grown commonplace by repetition and its more human aspects. It is also likely that as Mrs Cameron remembered *L'Allegro* she thought, too, of *Il Penseroso*, a companion piece on the rewards of melancholy which Milton began with a remark on 'vain deluding joyes'. A lot more is meant, in her pictures, than meets the eye.

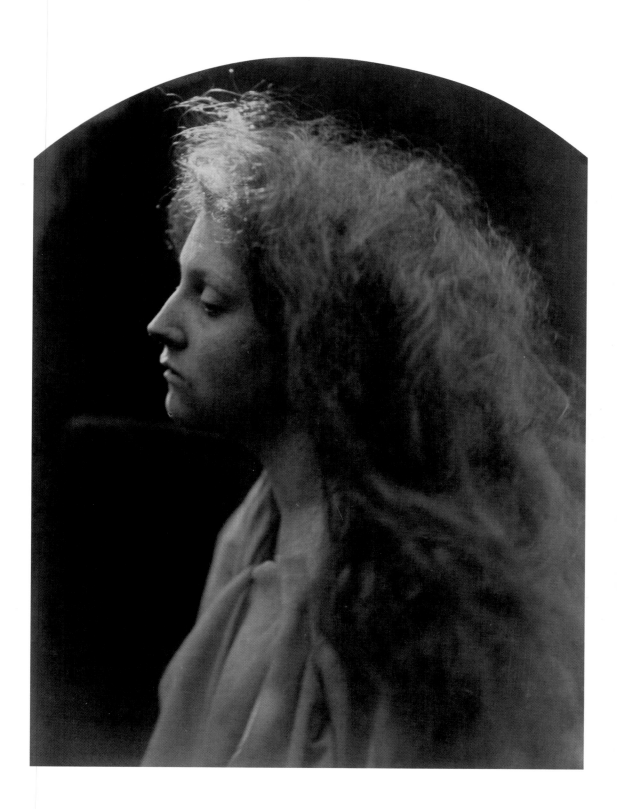

In 1874 she wrote a short memoir, 'Annals of My Glass House', in which she recalled early struggles but gave little away about her creative processes – which are of the greatest interest. In 1859 Tennyson published four *Idylls of the King*, long poems on topics around King Arthur, a legendary king of the Britons. Cameron knew and admired Tennyson, and from the late 1860s made pictures with Tennysonian subjects. Tennyson is a key to her art. He was at his best with flawed heroes whose exemplary lives have been touched by impropriety: Sir Lancelot and Queen Guinevere, for example. Cameron, too, liked such composite characters in whom, for instance, sensualism warred with asceticism – the Magdalene was one such. King Arthur was also a type: a national saviour whose like might come again. The high and religious culture in which Mrs Cameron acted knew of typology from Scripture: Joseph, for example, cast into a pit by his jealous brothers and raised from it by passing Midianites rehearsed the Resurrection in the New Testament. Those who posed for her were friends, relatives and servants and her tendency was to show them in and out of character: natural Madonnas asked to take the part of the Magdalene and vice versa. She was an active photographer for around ten years. In 1875 the Camerons returned to Ceylon (Sri Lanka) where they owned a plantation, and it was there that she died.

IAGO. STUDY FROM AN ITALIAN. 1867
Iago betrayed Othello who trusted him. It would be convenient to leave it at that, but it is worth wondering why she didn't make more of such a fine image – there seems to be only one copy, from an album given to Sir John Herschel. The model had posed for the painter George Frederick Watts as the Prodigal Son – a type both of King David and of Christ. Here he looks like Christ as the Man of Sorrows, predicted in Isaiah. Mention of Iago in this context also brings Judas to mind – the betrayer racked by bad conscience. In an authoritative text of the era, *The History of Our Lord* (1864), Anna Jameson notes that just as Othello took Iago for an honest man, so the Roman soldiers at the Crucifixion took Christ for a criminal. Mike Weaver, in a compelling interpretation of Cameron, sees this as an image of Christ in disguise.

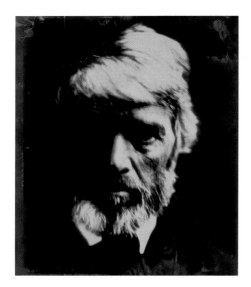

Carlyle like a rough block of Michelangelo's sculpture. 1867
Thomas Carlyle's *Heroes and Hero-Worship and the Heroic in History* was published in 1840. He noted that the poet 'could not sing the Heroic warrior, unless he himself were at least the heroic warrior too'. The poet, he thought, was also a prophet, which is how Cameron envisages him here.

William Blake, also a typologist, saw Christ as a process, as a remaking of God in human form. Typology has been important in photography, to which it is well suited. Photographs of working and moving individuals ask to be re-enacted and they give rise to fellow-feeling. Sweeping a street (Vert) or planting rice (Tomatsu) are examples of commonplace acts of which photographs remind us. Cameron's types, on the other hand, belong to more elevated walks of life.

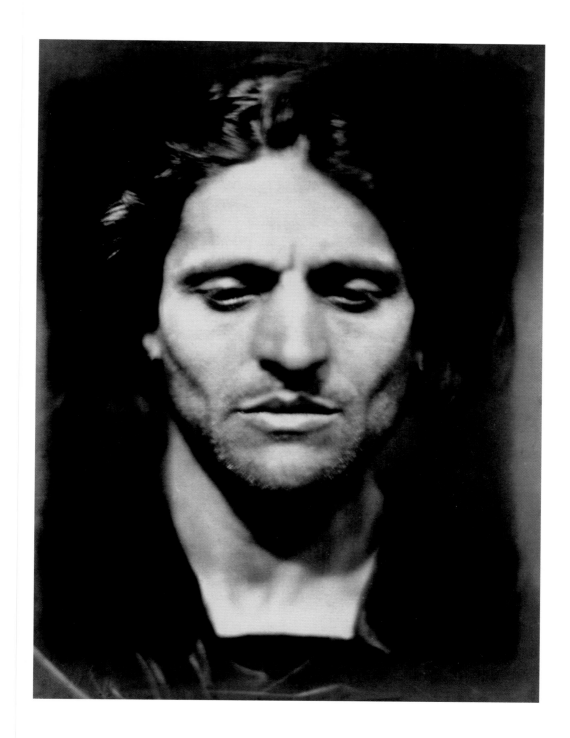

PETER HENRY EMERSON

1856–1936

Emerson decided that photography was an unsuitable medium for art. To begin with he was influenced by naturalist painters, mainly French, and took pictures of the countryside in sharp focus. His idea was to record country life, and his first book was *Life and Landscape on the Norfolk Broads*, 1886. The problem with sharp focus was that it didn't discriminate, showing all objects equally. Emerson then opted for soft focus, as being truer to how things appear to us. That didn't satisfy him either, for it still remained difficult to make inflections of the sort you would expect of an artist. If you

tampered with the negative and brought alien substances into the printing, the picture ceased to be a photograph. There seemed to be no way out of the impasse, and Emerson withdrew from photography in the mid-1890s. In the end, in his books *On English Lagoons* (1893) and *Marsh Leaves* (1895), he used photo-etchings made by himself – he learnt the gravure process after bad experiences with commercial printers. Emerson was a gifted writer and publicist, with a taste for controversy. Born in Cuba, of an American father and English mother, he moved to England on the death of his father in 1869.

AT THE FERRY – A MISTY MORNING, NORFOLK. 1893
At Buckenham on the river Yare the ferryboat was summoned by a bell, hanging in that frame to the left. The cart's iron wheels would have jarred on the stony road, and the milk churns would have jangled.

Marsh weeds. 1895
This appeared as plate VI in *Marsh Leaves*. It shows a line of weeds succumbing to the cold, backed by a snowfield, a stretch of fencing and scattered trees along the horizon.

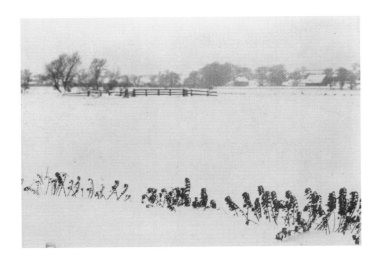

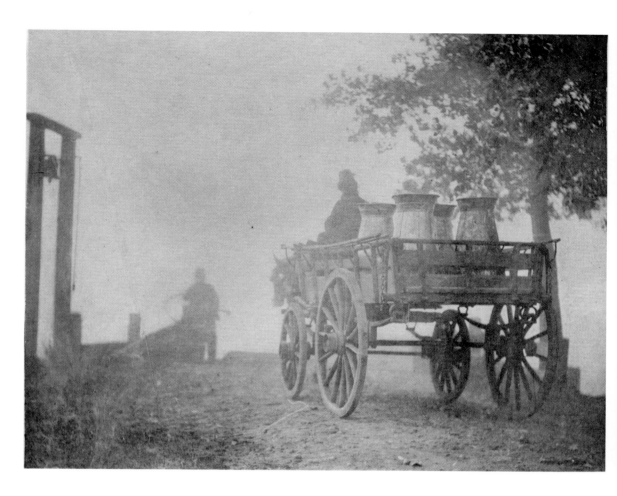

Emerson's idea was to do justice to the beauty and magnificence of the world, as revealed in landscape. He had started out as a documentarist with an interest in rural life – in East Anglia. Naturalistic pictures, of the sort he took in the late 1880s, only answered to practical interests. Initially he used writing to express his admiration for the paradise in which he had chosen to work. Even writing let him down, for he found it difficult to escape from second-hand phrasing. Gradually he discovered how to circumvent the problem. In his writing he became interested in eventualities: scraps of speech overheard, exclamations, rustic clichés, greetings, bird-song or just cries in the dark. Noises could never express everything he felt, but somehow they stood in for it, no matter how inadequately. His photography began to go in the same direction. The ferry bell and the clanking winch at Buckenham make their commonplace noises in the mist and darkness. Those weeds and bushes in the snowscape suggest musical notations in an otherwise featureless space. Emerson was on the alert for what he called 'the great mystery', which it was art's business to apprehend. All he could get were intimations: bits of sound which kept him on the alert, and sparse notations from the original score. It was an aesthetic of renunciation, quite explicable but with few parallels in the history of the medium.

FREDERICK H. EVANS

1853–1944

A bookseller and print collector in London, where he was born, Evans took up photography in the early 1880s. At first he made pictures through a microscope of the spine of a sea urchin, for example. By 1890 he had begun to take pictures of cathedrals, and his fame was as an architectural photographer. In 1898 he devoted himself to photography, and in 1900 was elected to the Linked Ring Brotherhood, a vanguard society of artist photographers who had seceded from the Royal Photographic Society in 1892. Evans was a polemicist, writing in *Amateur Photographer* after 1900. He was a purist at a time when many liked to modify negatives as well as prints with gums and oils. He favoured platinum printing, a contact process introduced in 1893, which gave a detailed, sensitive finish. When platinum paper became unavailable after the Great War, Evans gave up photography. From 1903 his pictures were featured in *Camera Work*, Alfred Stieglitz's magazine. His art was appreciated during the 1960s when he was seen as one of the originators of straight photography.

**LINCOLN CATHEDRAL:
STAIRS IN THE S.W. TURRET**. 1895
Evans wrote about the purist approach to photography and didn't analyse his own pictures. This image, however, appeared in a book of 1914, *The Curves of Life* by Theodore Andrea Cook, where it was used to illustrate a chapter on the spiral staircase. Cook, a follower of Swedenborg, thought of the spiral as an embodiment of a vital force in nature. Emanuel Swedenborg held to a theory of correspondences: anything visible below, in our earthly domain, was reflected above in the spiritual realm. Thus it was important to attend to evidence of the senses for the sake of insight into the world of the spirit. In this image a series of heavy stone steps rhyme with an unfolding spiral above, implying the earthly realm below and the heavenly above. The steep steps below begin in shadow and come to a lighted turning point or parting of the ways. The traveller can make a choice. There is also a massive block overhead, insecurely supported on corbels – and another sign of the dangers ahead.

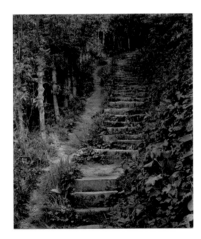

Winchelsea: Stairs to St Catherine's Well. c. 1905
On this wavering rather than spiral staircase there is also a choice of ways, and a divergence towards the top of the hill. The alternatives are flanked by a dark wood, making for another allegory on human progress through life.

Evans's generation, through Stieglitz to Paul Strand and Edward Weston, took note of energies running through life: streams of force independent of individuals. Evans himself also seems to have been an allegorist, conscious that the way was marked by pitfalls and strewn with obstacles. He would have been aware of Dutch landscape painting from the seventeenth century, where turbulent rivers, rocks, broken trees and threatened bridges point to perilous encounters in daily life. Sublimated subject-matter has been a characteristic of photography from the outset – a medium especially sympathetic to the unconscious and quite untroubled by anachronism.

EUGÈNE ATGET

1857–1927

Atget was a big influence, even if not in his lifetime. Brought up in Bordeaux, he went to sea in his late teens. In 1878 he went to Paris, meaning to become an actor. His studies at the National Conservatory of Music and Drama were cut short when he was drafted into the army in November 1878. The Conservatory refused to have him back on demobilization. For most of the 1880s he worked as an actor in the suburbs and in the provinces, before taking up photography in 1888. He thought of becoming a painter but decided instead to make photographs which might be of use to painters – 'Documents pour Artistes', he called them. By the late 1890s he had begun to specialize in pictures of Old Paris and in the *petits métiers* [small trades] which were characteristic of its streets: knife grinders, singers, delivery men, sales people of all sorts.

SELLER OF CAFÉ AU LAIT, RUE MOUFFETARD. c.1898–9

Baedeker (1910) puts the rue Mouffetard, on the Left Bank, in a squalid quarter rich in 'curious ancient signs'. Sellers of *café au lait* made arrangements with concierges to set up stalls in entrances. They sold coffee (*le petit noir*) and bread and milk to early morning clients, and at lunchtime they sold soup. The tradeswoman is seated near to a metal stove – to keep the coffee and soup warm. Near to hand, tucked in behind the screen, is what looks like a copy of *Le Petit Parisien*, whose illustrations featured just such scenes as this. The lamp to the left must have provided light on dark mornings. The lids to the milk cans are secured by chains.

Marchande de frites, rue Mouffetard. 1898

The seller of fried things is busy in her alcove, whilst the woman from next door keeps an eye on Atget, who seems to have been interested in the apparatus. In 1898 Atget began to sell pictures of street traders to the musée Carnavalet which specialized in Parisian life. In 1904 twenty-four images from his *petits métiers* series were published as postcards – a new practice, only just begun in 1898.

What were Atget's merits? His pictures have been dwelt on more than most, even if they do show no more than tins, baskets and jugs. His procedure was simple enough: a picture taken, at an angle, of the topic in view. More than likely his good fortune, and photography's, was that he coincided with a set of conditions which suited his eye and his equipment. What he found was a city with an extensive intermediate zone in which interiors merged with the street. These two women on the rue Mouffetard practise their trade somewhere between the porch and the pavement, making their arrangements in public view. Vehicles would eventually make the streets uninhabitable, but in Atget's window of opportunity just before the Great War the pavements were places of public display where you could see your fellow citizens at work. Atget's was a natural curiosity about this world of small-scale adjustments – easily taken for granted, but a milieu which would never recur.

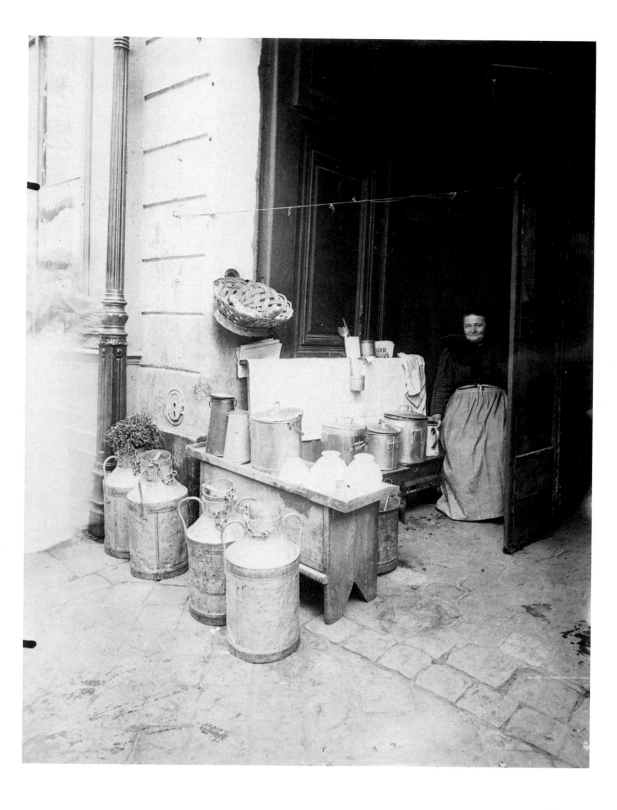

EUGÈNE ATGET

He began by making 'documents for artists' during the 1890s. In 1898, however, he turned his attention to Old Paris, partly in response to an increasing public interest in historic parts of the city. In 1897 a Municipal Commission on Old Paris had been set up to take care of conservation. Atget developed a catalogue: Landscape Documents, Picturesque Paris, Art in Old Paris, Art in the Environs. These categories were introduced, expanded, subdivided and sometimes incorporated into others. He took pictures of any objects that an artist might like to include in a picture: trees, boats, flowers, farmyards. As painters often worked in the countryside, Atget began by travelling there, too, but by 1900 he was largely a Parisian photographer. He was assisted in his studio and with the organization of the collection by Valentine Delafosse Compagnon, an actress, who was his partner from 1886 until her death in 1926.

VERSAILLES, VASE (DETAIL). 1906

Versailles, to the west of the city, attracted his attention from 1901 onwards. His main job at the time was to record Art in Old Paris, and this soon expanded to take account of art in the environs: the 'Petits Environs' close to the city, and the 'Grands Environs', as far afield as Beauvais and Compiègne. By the end of 1902 he had visited the park at Versailles sixteen times and had exposed around 150 negatives. He continued his visits until 1906, and returned in the 1920s. These vases had been copied around 1700 from Italian originals, when the park was established. The scenes in relief show Bacchanals, with music-making and dancing, supplemented by graffiti: signatures and dates mainly, with some of the dates recent.

Versailles, vase (detail). 1906
The performers caper in a narrow space, impeded by masks and beasts. Pressed into their stone base they have difficulty in manoeuvring and in keeping in touch. Atget appears to have sympathized with the parkland statuary, subject, as it was, to bad weather and maltreatment.

Atget's many pictorial categories were quite sensible, for he had to sell his pictures to painters, illustrators, architects and conservators. They were, though, headings of first resort, or the public face of a venture with private aspects. He was, for example, always conscious of the passage of time, understood as a process in which formats are used up. The vases at Versailles were copies and were being put to new uses before his very eyes. In Paris he saw much more of the same in the trappings of façades adapted and abraded. Second-hand shops and sites often caught his eye. At Versailles, too, the statues leaping on their precarious ledges allowed him to indulge himself as an artist or at least to bring these stony scenes to life. He was an empathizer with a strong feeling for all those expressive creatures transfixed by sculpture and forced to spend the rest of their days exposed to all and sundry in unsupervised parkland.

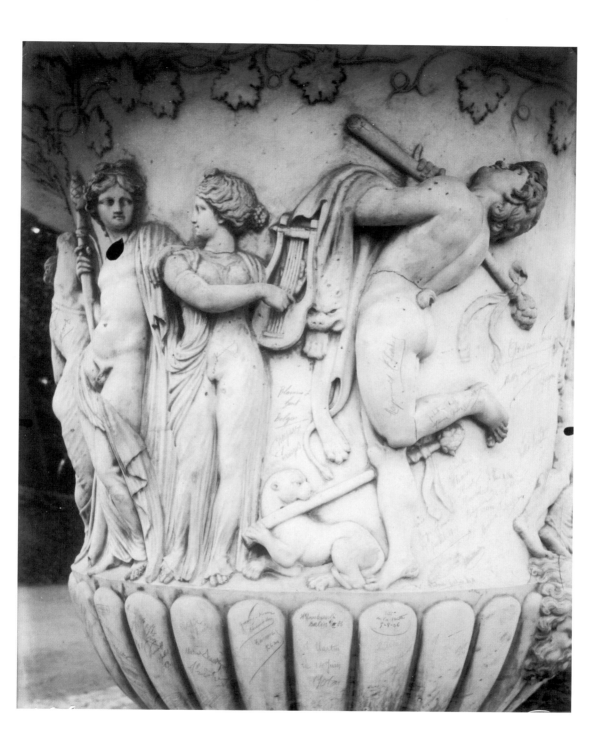

In 1909 Atget began to think of publications and to that end assembled sixty pictures under the heading *L'Art dans le Vieux Paris*. A few specimen books were put together, but there seems to have been no interest in the venture. In 1910 he made an album of sixty pictures called *Intérieurs Parisiens* for the Bibliothèque Nationale: inhabited rooms in Paris including kitchens, bedrooms and salons, ranging far and wide in the social order, from the home of a well-known actress in the Champs Elysées via financiers and businessmen to shop assistants and manual workers. He had previously taken pictures of interiors to sell to illustrators. In 1910 he took pictures for a third album, on vehicles in Paris: handcarts to hearses, along with steamrollers, tumbrils and tramcars. In 1912 he devised *Métiers, boutiques et étalages*, on trades, shops and window displays, a sort of shopping trip which also took in cabarets and brasseries. Three more of these albums followed: one on signs and old shops in the city (1913), another on the *Zoniers* (mainly ragpickers), who lived and worked on the outskirts of the city and a third on the fortifications of Paris (1915).

Boutique d'articles pour hommes, 16 rue Dupetit-Thouars (Temple). 1911

This picture appeared in the posthumous *Atget, photographe de Paris* in 1931, p. 21. In 1912 it was placed in his book on shops between a shoeshop and a greengrocer. It is of a shop specializing in travel goods – to judge from those suitcases, trunks, bags and blankets on show under the awning. The tailors' dummies who flank the door are dressed as coachmen, and the horns also point in that direction.

INTÉRIEUR D'UN OUVRIER, RUE DE ROMAINVILLE. 1910

This workman's home is modestly furnished. The drawer on the washstand has lost a handle. The bowl would have been used for washing hands and face and for cleaning teeth. The carpet is rucked, perhaps from dampness as the workman moved his hands from bowl to towel. There is a lot to examine in what was, in fact, Atget's own apartment at no. 17 rue Campagne-Première. The rue de Romainville, the supposed site, is far away to the north-east of the city, just off the rue de Belleville.

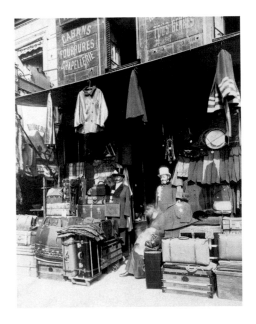

We can examine the evidence at leisure and wonder about the drowsy woman in the entrance to the boutique. Atget's intentions date back decades – to Degas, say, taking us behind the scenes. Atget also has a very distinctive outlook on time as anticipation. The shops that he liked to photograph are proposals regarding the shape of the immediate future with its needs for food and clothing – and journeying. It is a future which stretches some way ahead: weeks and, in the case of the workman's house, days. Much of his Parisian material deals with the limited future: food shops where meals will be planned and brasseries where they might be eaten, plus cabarets where time of a different sort will be spent. Hence his interest in ragpicking and junk shops where, in terms of the major metaphor, it will all come to an end in mere material.

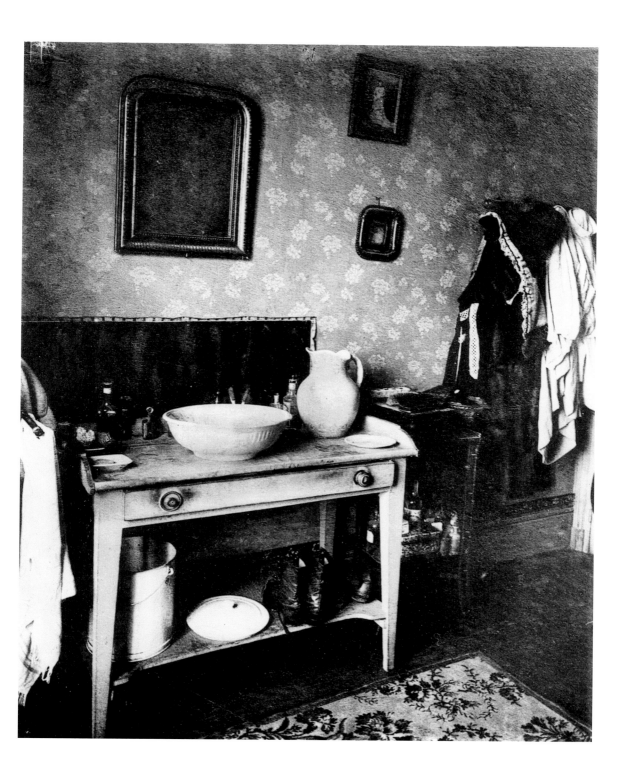

Until 1907 Atget was an independent photographer. Then the Bibliothèque Historique de la Ville de Paris asked him to make a survey of several sections of the centre of Paris. The library also asked him to survey the Tuileries Gardens with its statuary. These gardens didn't inspire him and there was a dispute with the authorities in June 1912. In 1910, whilst employed by the library, he had begun to take pictures of life in the *zones*, which were areas in and round the fortifications put up around Paris in the 1870s. Ownership of this land wasn't clearly established and some of it had been settled by *chiffonniers* [ragpickers] who were an important factor in the economy of the city. The land was about to be redeveloped and the *chiffonniers'* way of life disrupted. The Great War intervened and Atget's work dried up. In the 1920s Atget resumed, often working in small towns and villages south of the city: Bièvres, Igny and Sceaux in particular. This was an area easily accessible from the nearby Gare du Luxembourg, whence trains ran to the Sceaux-Robinson station. The town was 'pleasantly situated upon a hill amid charming scenery' (Baedeker, 1910).

Sceaux, coin pittoresque. 1922
There are some pelargoniums in pots on a wooden base propped up on bricks and on bits of sawn timber – to keep the structure level on a sloping pavement. The small table near to the doorway has been steadied on pieces of tile. One of the birdcages impedes access to the house and the other is in full sun. Birdcages, too, had to be managed and adjusted.

CHIFFONNIERS, CITÉ TRÉBERT, PORTE D'ASNIÈRES, PARIS. 1913
The site is to the north-west of the city, near to Clichy and adjacent to a main railway line. Ragpickers collected rubbish from bins put out in the morning and this was sorted into categories (cloth, paper and metal) in a process known as *le tri*. The results were sold on to *maître-chiffonniers* who directed it to the appropriate factories. This picture is of a sorting centre guarded by a sleeping black dog.

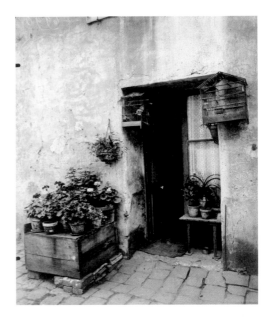

Atget was respectable and not badly off, but all the same he was interested in the doomed ragpickers of Paris. They were unbiddable outsiders with a well worked-out way of life and Atget would have seen them as co-workers, sorting out materials from the city. They, too, were specialists in process, for the material had to be gathered, transported, scrutinized and sorted before being fed back into the system. Their trade took time and was subdivided into a multitude of small acts of attention which in the long run kept things going. The modernist frame of mind liked to see what was happening in detail, to see the apparatus in operation. Atget was no exception, but the times were changing and by the time he resumed work in the 1920s the developing 'new vision' preferred to keep the machinery out of sight. That little arrangement at Sceaux, which shows exactly what the occupants had in mind, belongs to the old transparent order: adjustments made for the sake of short-term convenience.

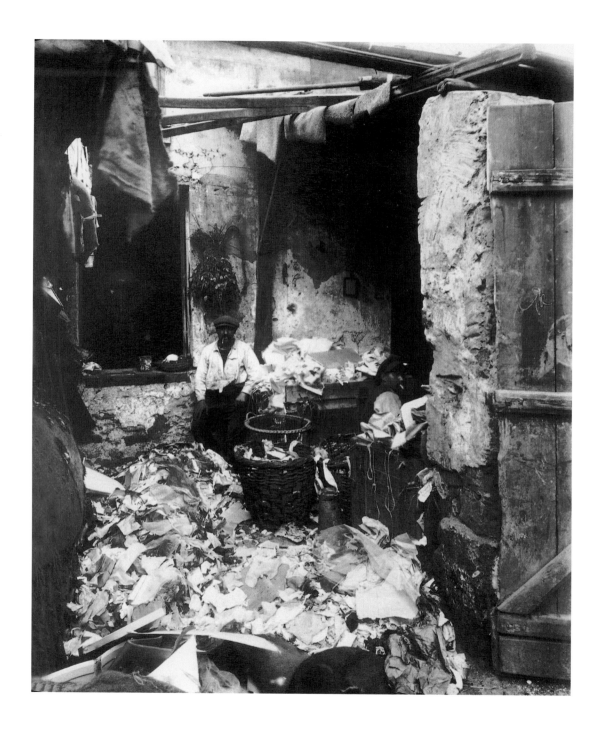

LOUIS VERT

1865–1924

Vert was a printer by trade. He entered the family business in Paris and worked there until it was sold in 1906. An amateur, he took up photography in the 1880s, and in 1904 became a member of the Société d'Excursions des Amateurs de Photographie which made group excursions to museums and to beauty spots. He used a 9 x 12 cm Sigriste camera, introduced in 1899, which allowed him to take pictures at a distance without disturbing his subjects. He took pictures of horse and motor racing for *L'Illustration*, the major illustrated magazine of the period, but hesitated to become a professional. From 1900 onwards he classed his pictures under the headings 'Petits Métiers' and 'Bords de la Seine'. Many small trades, such as dog clipping, were practised on the banks of the Seine. The pictures were converted into transparencies and projected at the meetings of the Société d'Excursions. In 1912 a friend, who was also an amateur photographer, gave eighty-eight of his pictures to the Musée Carnavalet in Paris, which is how his work has continued to be known. Three of his photographs were published in Raymond Lécuyer's *Histoire de la Photographie* (1945), and Vert does prefigure the humanitarian outlook of the post-war years.

PETIT PÂTISSIER AU JARDIN DU LUXEMBOURG, PARIS. c.1900
This junior pastrycook in the Luxembourg gardens is making a delivery, but his eye has been caught by whatever it is that is happening on the pond. The children on the water's edge, not much older than he is, are dressed up in sailor suits, in contrast to his working outfit. He leans to one side to get a better view.

Balayeuse, place de l'Hôtel-de-Ville, Paris. c.1900
She is a road-sweeper, in fact, using a long-handled birch broom, which she uses in a quite particular way – settled on her right shoulder. Vert has taken her in action, for her right foot is raised from the ground as she moves forward.

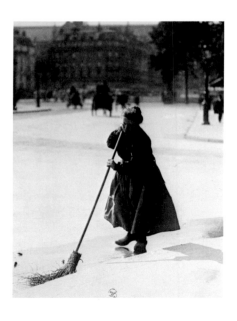

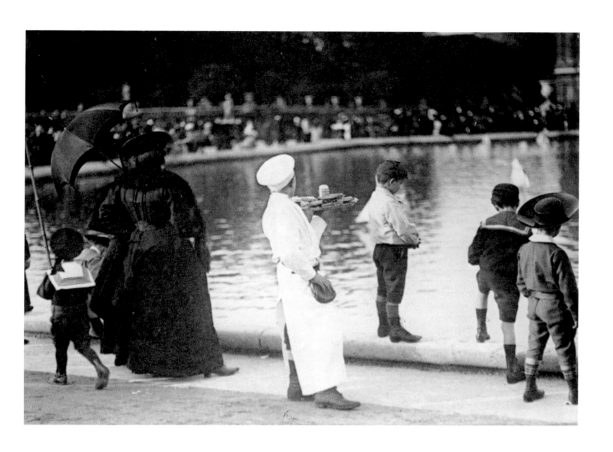

Vert discovered empathy, that fellow-feeling which was so much admired in the 1940s and after. What would it feel like to be the person in question? To most photographers of Vert's generation it would have been enough to represent the subject statically and with enough attributes to invite identification: a pastrycook's hat or a street-sweeper's brush. Static portrayals invited naming, which was almost enough. The pastrycook, however, watching those sailing boats on the pond, turns to look, taking care to keep that tray in balance. It is a gesture and a movement which can be imitated, for it can be remembered. For security's sake, he keeps his hand on his purse. Then the street-sweeper turns as she works and her skirt flares. Light catches her leading hand and the side of her face as she moves on the sunlit square. Vert's is a vicarious kind of portrayal, asking us to put ourselves in the subject's position, very often emphasizing a figure in a crowd or in a space. Sometimes his protagonists are elderly, keeping going beyond their natural span. Affecting or not, his seems to have been an art without consequence, decades ahead of the moment in which his talents would have been appreciated.

PAUL GÉNIAUX

1873–?

Although younger than Eugène Atget, Géniaux entered photography at around the same time, when it looked as if it had a future. Atget is a major artist in the medium, but it is Géniaux who anticipates and even develops the styles of the 1930s and '40s. He moved to Paris in 1898 and with his brother had a photographic business at no. 32 rue Louis-le-Grand, not far from the Opéra. They remained there until 1909 and sold pictures to *L'Illustration* and to the new illustrated periodicals of the period. Around 1900 Paul Géniaux also traded from an address in the rue du Cherche-Midi, taking Parisian scenes for postcards: *La Foire aux Jambons* [Ham Fair] and *La Foire à la Ferraille* [Ironwork Fair], for example, both of which took place in the boulevard Richard-Lenoir.

LE MARCHÉ AUX OISEAUX, PARIS. c. 1900

The bird market took place on Sundays at the quai aux Fleurs. Sold birds were placed in cardboard boxes and in small cages of the kind held by the girl in the foreground. The sellers have a nice range of clients waiting to be persuaded.

Clochards on the terrace of a café, place Maubert, Paris. c. 1900

The nearby wine drinkers are deep in conversation. The beer drinkers on the further table are more studious and one of them may be a bootblack.

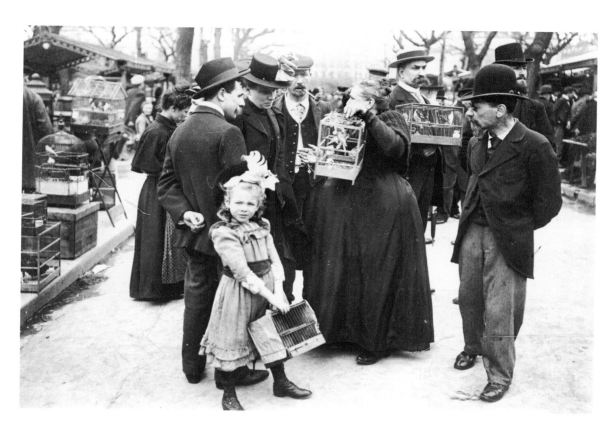

Photography has been subject to uneven development. In the 1890s postcards led to a demand for street scenes from the major cities. Atget, Géniaux and their contemporaries took pictures of *petits métiers* [small trades] and of representative street people. There were no rules against taking groups of people involved in a transaction, as you see in the bird market, but the results could be excessive – a captivating surplus of character. Each of the seven persons in Géniaux's tableau is a study. Such pictures would have to wait until the 1940s and '50s for a means of publication which would do them justice – specifically the gravure printing in Cartier-Bresson's *The Decisive Moment* (1952). The attraction of market scenes was that participants were intent enough on the matter in hand to forget about the photographer.

Those people on the place Maubert also excel themselves. They were probably just meant to provide local colour in a notorious area on the Left Bank, but the narrator acts his part to perfection as do his listeners. Sociability had been a topic in French painting since the 1860s at least (Degas and Renoir especially) and it became a possibility for photographers just as painting was beginning its drift into abstraction. The painters, though, had found sociability largely within their own culture, and they also associated it with bourgeois leisure. Géniaux and his successors (Brassaï, for instance, in the 1930s) found evidence elsewhere, and often of different kinds of sociability: where leisure verged on passing time or simply waiting, with reference to Beckett.

JACQUES-HENRI LARTIGUE

1894–1986 Instructed by his father, a wealthy industrialist, Lartigue began to take pictures as a child. In January 1912 he sold his first picture, of an aircraft, to *La Vie au grand air* [Life in the great outdoors], a weekly magazine devoted to sport. It was the first great age of photographically illustrated magazines and Lartigue might have established himself as a professional photographer but for the outbreak of war, which put a halt to the culture of leisure and sport. He wanted to work as an aerial cameraman during the war, but – to his parents' relief – he was exempted on health grounds and spent the war years as a chauffeur in Paris. He worked as an illustrator and cartoonist under the name of 'Pic', and in February 1915 began to attend painting classes at the Académie Julian in Paris. It was as a painter that he was subsequently known. It was only in 1963 that his photography was discovered for the wider art world by John Szarkowski, curator of photography at the Museum of Modern Art in New York.

GUITTY (MARGUÉRITE BOURCART) AT LA BARRE DE L'ADOUR, BIARRITZ. 1905
Guitty, playing on the tideline, might just have been caught by the incoming water. She was trying to estimate the turning point or *point mort*, when the water came to a stop and began to recede. Guitty was a cousin of the Lartigue family secretary, a M. Folletête who accompanied the young Jacques to race meetings and motoring Grands Prix. The picture, from a glass negative measuring 4.5 x 6 cm, was taken on a Block-Notes Gaumont, a lightweight camera with a speed of 1/300 of a second.

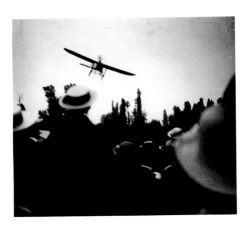

Audemars in a Blériot, Vichy.
15th September 1912
Audemars trained with René Simon, Roland Garros and Barrier, and they had learned many of their manoeuvres in the USA. By 1912 Lartigue had a 6 x 13 cm Klapp-Nettel stereo camera with a shutter speed of 1/1200. He received his first press pass to visit airfields in 1906. The first great *meeting d'aviation* took place at Rheims in August 1909.

Audemars, flying low, will have passed the trees and the straw hats in an instant or so. The crowd will turn to look at the plane directly overhead and then watch it into the distance. The noise of the Blériot will intensify and diminish. The picture gives some impression of the onward rush of Audemars.

Lartigue was a connoisseur of the excitements of time: the split second, the turning point. He believed that you could catch the moment itself, and he had the latest equipment to hand. The instant was attractive on technical grounds as a challenge, but more than that it represented life as a kind of sporting event. Quick time photography was a novelty during Lartigue's formative years. It didn't survive the shock of the Great War.

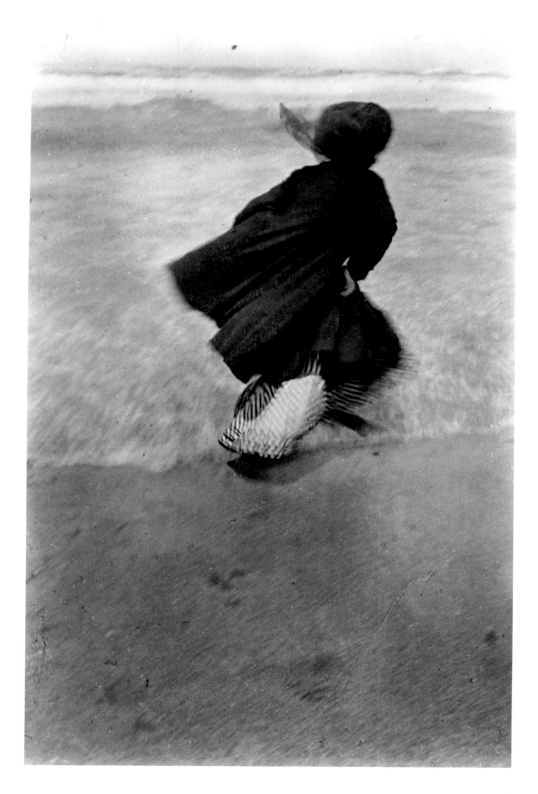

THE GREAT WAR

1914–18

The Great War opened as burlesque. It would be like other wars with quick campaigns, triumph and defeat – along with acts of heroism. There would be treaties and a return to normal. There was no inkling of total war. The period of naïveté lasted for maybe a year or so, during which time photographers subscribed to the idea of culture as usual. It was an image of war as an all-male excursion to foreign resorts. The British weren't great photographers, nor were the French – but the Germans were adepts. The German camera trade was well developed, with major companies like Goerz, and the German officer caste seems to have been more enterprising than its counterparts. The war developed a momentum of its own. The pictorial styles and formats of 1913 and beyond were soon outmoded. It was a terrible event, of course, but at the same time it was filled with wonders. There were the dead men in their hundreds of thousands and captives in droves. Family men from small towns were introduced to a place called Armageddon. There were craters to see, which looked as if they had been made by the fall of comets. There were alien captives, mostly from the wilds of Russia, and tribespeople from the east – gypsies mainly, who were as astonished by the Germans as the Germans were by them. Wooded landscapes with farms and fields were transformed into primal sites by shelling. Death proliferated: men suspended like failed acrobats in wire or absorbed into the earth. Aviators died spectacularly in twisted wreckage – and broken planes were often photographed, with crowds of onlookers at first. Awe-inspiring artillery pieces were captured and photographed. Giant bombs and shells were often paraded for the camera. New kinds of men emerged with a new look never before captured in photography. These were the aviators, who were the cult heroes of the war. And everywhere, in the visual records, there is an iconography of waste: acres of broken material, churned fields and roads, ruined dwellings. Pressure of circumstances,

and the sheer novelty of this new culture, brought into being a kind of photography particular to 1914–18. The war was hideous, but at the same time it was a great adventure. A lot of it was also carried out in the earth, in saps, shellholes, trenches and bunkers. The Germans were good hands at this kind of underground building, particularly on the eastern

front where timber was plentiful. The modernists of the 1920s would recall this kind of grounding and make every effort to transcend it. Hence the culture of youth and stylishness associated with the Weimar Republic in Germany. The National Socialism of the 1930s was to some degree a veterans' movement nostalgic for the epic landscape of 1914–18.

Kriegsmarine (German sailors). 1913–14 (180 x 270 mm)

Two German cadets. 1914 (180 x 135 mm)
The picture seems to have been taken in the springtime of 1914 and just precedes the outbreak of the Great War. At the moment they know nothing about what will happen in the years ahead. They are to all intents and purposes still living in the world of the Belle Epoque. They smile spontaneously and their placing against the boarded background recalls the proportional systems of 1900. Their expressions and postures should be compared to those of the aviators of 1916 and after. The cadets belong to a world of light opera, and this kind of exuberance and innocence wouldn't re-emerge. The war became an increasingly serious business incompatible with mere youthfulness, and the war's influence lasted for decades.

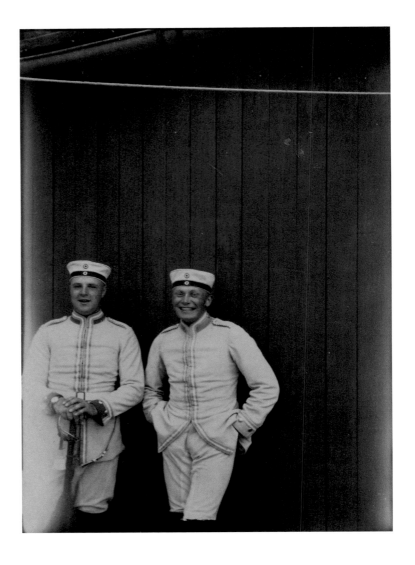

WILHELM VON THOMA

1891–1948

Wilhelm Ritter von Thoma was in the 3rd Bavarian Infantry Regiment, the 'Prinz Carl von Bayern'. He served throughout the war, in France especially, but also in Russia, Serbia and Romania. He was captured by Americans in the summer of 1918 before returning to the German army in 1920. He served until 1942 when he was captured by the British at El Alamein. At that time he was General in charge of the Afrika Korps. Although one of Germany's most distinguished soldiers he was also, as a young man, an especially gifted photographer of the war. Not only did he take pictures from 1914 to 1918, but he kept records and collected other photographs, some of them taken by his brother, Otto. He had a vest-pocket camera which he used informally as his successors would use Leicas. Unusually daring, he took pictures on the front line and had a real interest in his colleagues who appear as characters in his narrative of the war.

Bavarians in France. 1914 (90 x 140 mm)
Initially the war was envisaged as an adventure supplemented by carousing and good comradeship. The soldiers here are probably at Vigneulles, just to the south of Nancy in eastern France. They are in good spirits, in an ancient building, and still have something of the Belle Epoque about them – that whiskery pipe-smoking quality, which had disappeared by 1915. The picture, only partly exposed, has been used as a postcard, with a long message in pencil from von Thoma. It may have been taken by a technician attached to the unit. Such smiling group portraits as these must have maintained morale on the home front.

Germans in Belgium. 1914 (90 x 140 mm)
This front-line postcard from early in the war mentions 'Basdamhoch' (?) and Leuven. Creature comforts were uppermost in the mind of the invading army: pipes, cigars and cigarettes and those boots drying on the upper ledge of the stove. Many pictures of this type were taken, some of them showing Christmas feasting with decorations. Portrait groups were often on this scale, which allowed senders and recipients to identify individuals, for army units were drawn from localities and men and their families were known to each other. Casualty rates and the pressures of war soon put an end to this genre.

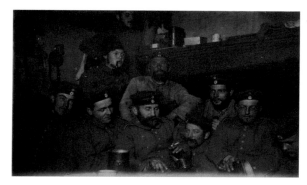

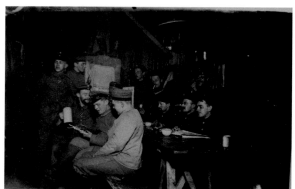

**A minecrater at the Sharp Corner,
Dompierre**. 1914–15 (66 x 60 mm)
That is a Lieutenant Kasdal (?) seated to give a
sense of scale. There are many Dompierres in France,
some of them near to the Somme, where von Thoma
was slightly wounded in September 1914 – and
again in October of that year. In between bouts
of fighting von Thoma was billeted on farms near
to Péronne: at Assevillers, for example, at Brussus
and at Fay. He himself took pictures of his hosts and
of their garden. This picture might have been part
of a set taken by the Bavarians as a record of life
at the front-line during the stalemate of 1914.
Such craters as these were greatly wondered
at during the early stages of the war, and
helped to give shape and punctuation to
events. By 1915–16 events had begun to merge
to form a continuum in which there were few
highlights. Craters belonged to the old order
which believed in decisive moments.

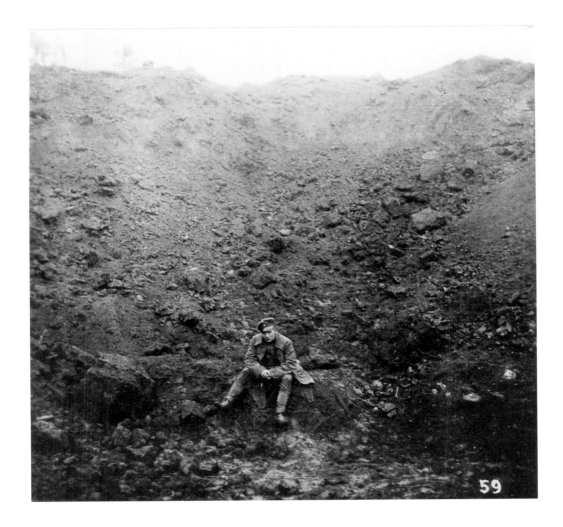

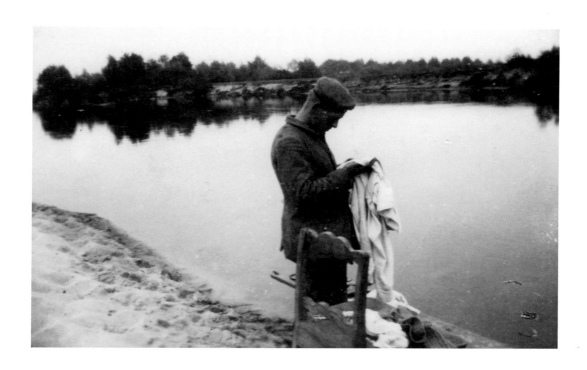

Russian idyll on the Bug. 1915 (48 x 70 mm)
The river Bug flows from the Carpathians to Brest-
Litovsk and thence to Warsaw, and in 1915 was
in Russian territory. Von Thoma's regiment was
sent to the eastern front early in 1915. In the east
there was less stability and less chance of settling
down to reflect on progress. The documentary
picture-taking which had characterized France
in the early months of the war was no longer
possible, and von Thoma was thrown back on his
own resources; hence this photograph of a German
soldier inspecting the hem of a shirt for lice.
If you were on the move you took pictures when
opportunities presented themselves, and as
movement was the norm they were pictures of
small events seen in passing. Campaigning in
the east broke the mould and turned von Thoma
into the sort of observant passer-by who would
be recruited into photography in the 1930s.

Man pumping water, Galicia. 1914–15 (130 x 185 mm)
Galicia, which lies south of Warsaw and north of the
High Tatra mountains, was part of Austria-Hungary.
In the first year of the war it was contested by
seven Russian armies and by six from Germany
and Austria-Hungary. Fighting centred on Łódź,
which was captured by the Germans late in 1914.
This particular picture, of a soldier pumping water
into a can, could have been taken anywhere in the
region. The building in the background has suffered
damage but the foreground seems intact and might
be in a village or on the outskirts of a town. That
might be the soldier's transport wagon to the right,
and that is a village cart to the left. It has been
raining and the ground is muddy. The soldier has
had to reach from the lever to the pipe. The sluice
in the foreground would have kept water from the
immediate surrounds of the pump, which otherwise
would have been impassable. The Great War provided
a lot of first-hand experience of earth and weather,
and creature comforts soon became a theme:
foraging, eating, drinking, keeping warm. The war
returned its participants to first principles and led
to a new evaluation of the most prosaic experience.

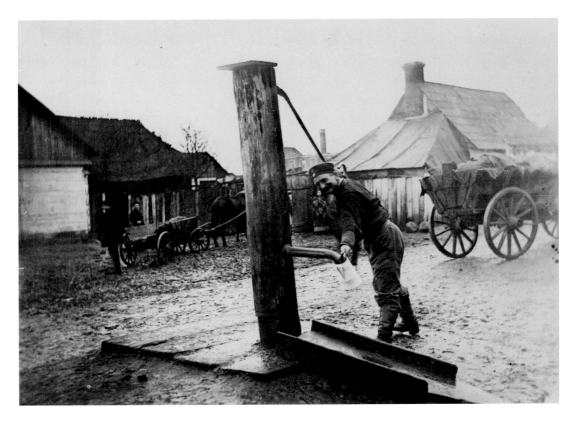

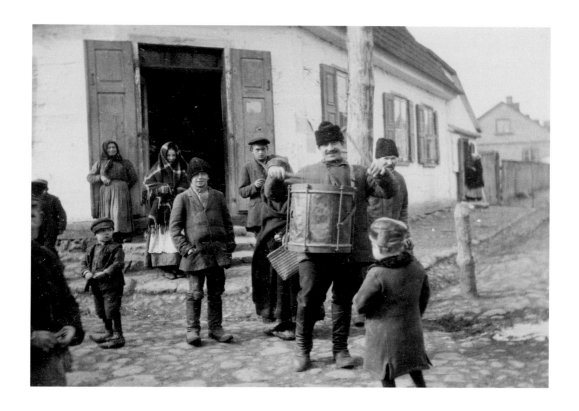

A Drummer. 1915 (130 x 185 mm)
The event takes place somewhere in Galicia,
in the Łódź area, early in 1915. He is playing for
the camera, and the older members of the audience
look to the camera, too. The smaller children
find the drummer more remarkable. The scene
is a village street with cobblestones, in front of
the doorway to a shop. The war on the eastern
front took a time to stabilize, which meant that
soldiers for a while mingled with the people; out
of this involvement came a nascent documentary
movement. German soldiers – probably just a few
of them – photographed street life in Łódź and in
the surrounding countryside: citizens collecting
firewood, market trading, stalls selling warm drinks
and bread, and – in this case – a drummer who
looks like an incidental player from a novel by
Günter Grass. On the western front, by contrast,
the war was a self-contained process fought within
its own zones. The documentary moment in the
east, which had appetites and physical pleasures
as its subject, survived into the summer of 1915,
when the armies began to move once more.

The crossing of the Danube. October 8, 1915
(40 x 68 mm)
Having acted against the Russians during the
bulk of 1915 von Thoma and his Bavarians were
sent to subdue the Serbs. He was wounded
on October 12. The crossing of the Danube
took place in what look like pontoon boats
and seems to have been considered a major
event, for von Thoma took a lot of pictures.
Others had cameras too (see no. 6 in von
Thoma's original numbering). The principal
figure in these three pictures is Oberleutnant
von Stengel, the elderly man with wire-rimmed
spectacles and a walking stick. He reappears
in von Thoma's oeuvre and figures here as
a principal character. The younger man in
the spiked helmet is Stabs-arzt Dr Hermann
(chief medical officer) near to the Regimental
Commander deep in thought in a peaked hat.
What did von Thoma have in mind on the
Danube? Perhaps he was thinking in terms
of a national epic, for the oarsmen at least
look somewhat heroic. But von Stengel, for
all his aplomb, looks like a reservist called
out of retirement; and the commander isn't
enjoying himself one bit. For all his excellence
as a soldier and his bravery – he eventually
got Bavaria's highest possible award for
courage under fire – von Thoma's was a
picaresque vision of war as a madcap test in
which character might show itself. His tactic
was to reflect on events via portraiture, for
in that way he might recall what it felt like to
be there. The equivalent in writing was to tell
the same story from different points of view.

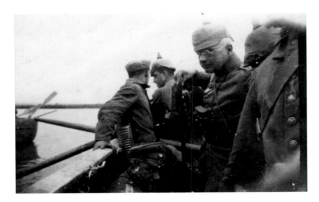

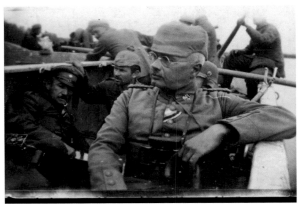

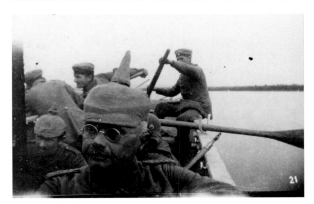

Near Jagodina, Serbia. 1915
(40 x 68 mm)
On October 12 von Thoma was wounded badly enough to spend five days in hospital, after which he rejoined his unit and caught up with his colleague Oberleutnant von Stengel savouring grapes outside the town of Jagodina in southern Serbia. Von Stengel without his spectacles frowns over his work and then holds forth. In the second picture in the set he has leaned backwards and made himself more comfortable. It was increasingly von Thoma's habit to work in series. The pictures make up an unfolding which allows for comparison and insight.

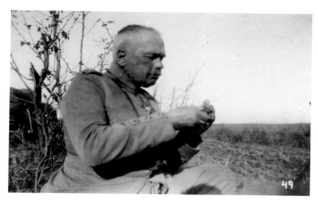

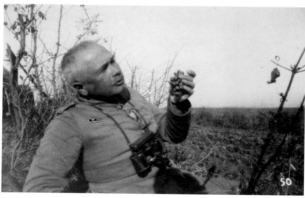

What can be learned from such pictures about the conduct of the war is very little indeed but, as von Thoma was coming to realize, photography was acutely sensitive to gesture: the intentness of the first picture and the expansiveness of the second, for example. Gestures such as these are recognizable the world over but in 1915 they were a private matter in photography. They became part of photography's public currency only in the 1930s when liberal values were under threat – which meant that personal space came to matter as never before.

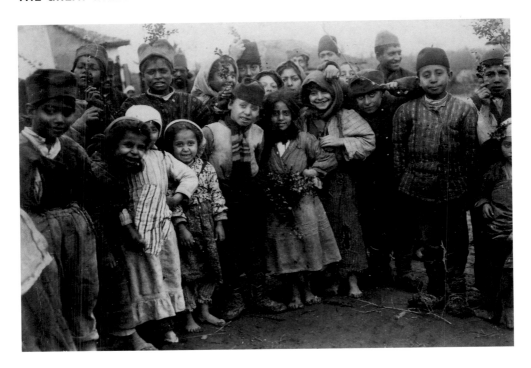

Gypsy children, Leskovac, Serbia. 1915
(60 x 85 mm)
This picture may have been taken by a regimental
expert and acquired by von Thoma on the Serbian
campaign. They are holding twigs, especially the
young man to the left who holds two, with one in
his hat. The girls go barefoot. German soldiers were
attracted by anthropological topics – in both wars.
In the Great War gypsy children always posed
enthusiastically, as if they had been waiting
all along for news of the modern world.
Undoubtedly they were part of the show and
may have been shepherded into position by the
adults barely visible in the background. All the
same, they were probably the only predictably
cheerful people in Europe at that time.

Wounded English pilot. March 9, 1916 (90 x 140 mm)
There is snow on the ground, and the event may have
been taken by a cameraman who was on the spot
and who quickly converted the scene into a postcard.
The wounded flyer is far from happy and may have
been taunted by one of the crowd. By February
1916 von Thoma was back in France where his
regiment was involved in the attack on Verdun.

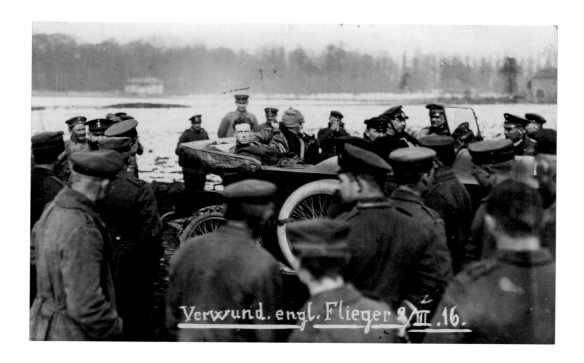

Verwund. engl. Flieger 9/III .16.

The Great War was an extended photo-opportunity, which began in 1914 with scenes from life in camp
– from carousing to de-lousing. By 1916 aviation was beginning to play a considerable
part – crashed planes in particular. Postcard photography was always more eloquent
than anything taken for publication. It featured local incidents taken on the wing, and it
set standards to which the photographers of the 1920s and '30s aspired. The Great War
was a training ground for all those reporters who worked for the illustrated magazines
of the 1920s.

Registering horses at a market-place. 1915

(Stemplowanie Koni na Rynku Targowym 3.II.1915)
(90 x 140 mm)

This picture was taken by Michal Daszewski, who was active in the area in 1914–15. The war, which opened so incoherently in 1914, changed everything because whatever now took place did so under the sign of history. Nothing was irrelevant, and some events and procedures were of particular importance. The campaigns of 1914–15 failed because of poor logistics: lack of ammunition, transport and fodder. Soldiers and their associates reflected on the infrastructure on which they depended, and there are many pictures throughout the war on organizational topics: depots, stores and marshalling yards. In this instance the carters and hauliers of Łódź have been asked to turn up with their horses at an office – probably the tall building to the right – to notify the new authorities. It may be that the horses were branded or marked somehow, for they would have been of great use to the authorities. Motor transport hadn't yet developed and the railways could easily be put out of action. Daszewski was a systematic recorder of the war effort. Subjects of documentary relevance could now be found anywhere.

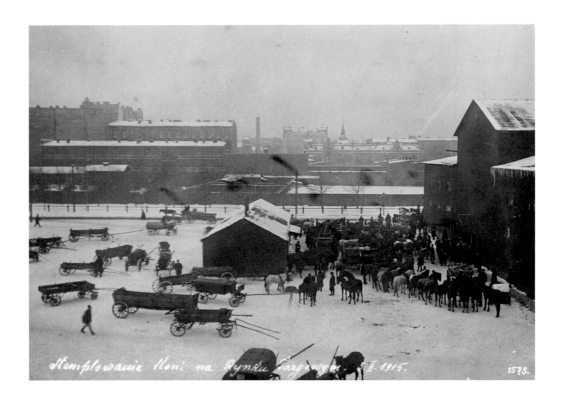

WILHELM VON THOMA

In transit. February 1916 (40 x 68 mm)
He was transferred from Serbia to France early
in 1916 to fight in the Argonne and at Verdun.
He travelled by train and took pictures from the
windows of transient landscape, some of it in
mountainous areas in Austria – in the Steiermark,
for example. Many of the pictures are bleak and
remote, of residual scenes of the kind he would
become familiar with in the Argonne around
Montfaucon and the Bois d'Avocourt. Some of them
look like Peter Henry Emerson's wintry landscapes of
the 1890s when Emerson was troubled by his inability
to express the immanent harmonies of the earth.

Passing through Berlin von Thoma took an especially
poignant picture of women and youngsters waving
to the troops as they passed by on the bridge.
Troop trains would have been a common enough
occurrence and any number of soldiers in transit
must have seen just such scenes on the street
below. What von Thoma saw was an arrangement
which spelled out normality: people, many of them
schoolchildren, going about their business and
come to a standstill just where they were – a cross-
section of the kind which would preoccupy the
aesthetic imagination of André Kertész, for example,
a fellow combatant in the Austro-Hungarian army.

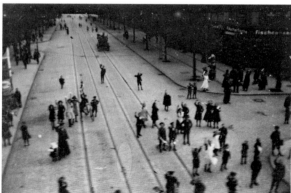

Von Thoma was in the Verdun area from February 28 until May 17, 1916, after which he was once again sent to the east to help with the conquest of Romania, which had ill-advisedly joined the war early in the year. The three pictures here are representative of his photography in the Verdun area.

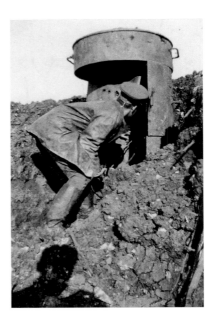

A casualty, Verdun. 1916 (68 x 40 mm)
On the back of the picture, in pencil, von Thoma has written that it is 'Befehlsempfänger Reiss gefallen durch Granatschuss' (subordinate Reiss, killed by shell-fire) – a portrait in death of someone known to von Thoma. His interest in other people was unremitting, and here, amongst the strands of barbed wire in the foreground, lies the missing lens of his colleague's spectacles.

A French observation post on the front line, Verdun. 1916 (68 x 40 mm)
The observer can't have survived – on the evidence of explosions and bullet holes. That is von Thoma's shadow in the foreground. Other pictures in the series show the desolate post as they approach it.

Boots, Verdun. 1916 (48 x 68 mm)
On the parapet of the trench, discarded boots are
stuck in the mud, according to von Thoma's caption.
He doesn't say whose trench it was, nor where
exactly. Boots were usually removed from dead
men, and may have been useful in building work.

Von Thoma was an anachronism, decades before his time. Eventually – in the 1940s and
'50s – photographers would feel free to present their own experience, adrift in
the USA, for example; but in 1914–18 no one, apart from von Thoma, envisaged
the war in such personal terms.

French captives on their way to make a road, Argonne. May 1916 (46 x 68 mm)
These French infantrymen have been sent out on a road-building task. They are watched by German guards and by medics with Red Cross armbands. Some of the soldiers have pinned back the fronts of their coats in the French style to guard against mud. By May 1916 von Thoma was coming to the end of his period at Verdun. He had taken other pictures of captured soldiers, who were of unceasing interest to all sides. Captives were one of the war's photographic themes. The English (tommies) often remained cheerful and insolent in captivity. Germans and French were more morose, and Russians impassive. Captives fascinated not just because they were alien but because they had been released from certain imperatives: military discipline and constant alertness. They were often photographed *en masse* in holding areas, and von Thoma's close-ups are a rarity.

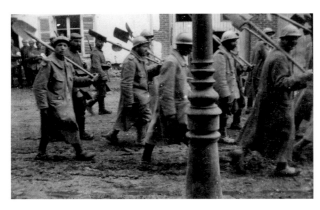

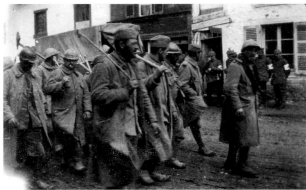

He realized early in his photographic practice that gestures are eloquent and engrossing just for their own sake. These images record an encounter between the work party and the watching soldiery on the pavement. The French, under some duress, look thoughtful. Gesture could only be captured in close-up and in action. Von Thoma, with his small glass-plate negatives, took exactly the kind of pictures you would expect from Robert Frank and his contemporaries in the 1940s and '50s.

German pilots. 1916 (130 x 210 mm)
Pilots constituted a new aristocracy. They were
technical adepts who had to have a feeling for their
machines. These look like ex-cavalrymen. It is a
portrait of equals, in contrast to army group portraits
which feature hierarchies. These men stand as they
please, and most of them seem to have dressed that
way, too, for they may have been brought together
from different units. There had been aviators
before the Great War, and they had charisma but
certainly not to this degree. They set a standard for
stylishness which would last through the 1920s, and
their example as well as their looks would shape
the idea of the 'star' as it developed in film between
the wars. German aviators usually had a dog or two
in attendance at photo-shoots, and the walking sticks
might be a pointer to gentlemanly backgrounds.

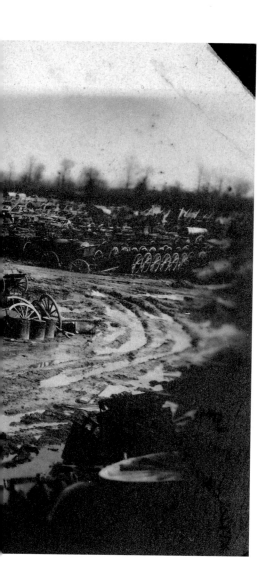

A Depot in France. 1918 (90 x 140 mm)

This is one of many pictures taken by an American serving behind the lines in France towards the end of the Great War – in April 1918. The vehicles in store are horse-drawn carts and artillery limbers: wheeled boxes attached to field guns and used for carrying ammunition. By 1918 much of the equipment in use in 1914 was outmoded. Motor transport was becoming the norm and infantry attacks were supplemented by tanks. The Germans wore a new kind of steel helmet which gave them a generic look; the British adopted a helmet with a brim – as protection against air-bursts. The war in the west was organized as never before and made no allowances for the regional styles of 1914–15. After four years of accelerated development participants began to imagine a new kind of automated warfare conducted with precision and at long range. The war ended just as these possibilities started to become apparent. Veterans remembered and put them into effect in 1939–45.

ALFRED STIEGLITZ

1864–1946 Stieglitz photographed for the
best part of fifty years, starting in the mid-1880s.
In September 1890 he returned to the USA after
nine years in Germany, and went into the photo-
engraving business. After five years the business
failed. In 1891 he joined the Society of Amateur
Photographers of New York, and in 1892 began to
use a hand camera. These small cameras, principally
the Kodak introduced in 1888, were frowned on by
serious photographers, but they allowed Stieglitz to
take pictures of street scenes and incidents. He did
editorial work for the magazine *American Amateur
Photographer* and in 1897 founded *Camera Notes*
for the Camera Club of New York. In the 1890s
interest in photography was waning in New York
and there was talk of transforming the Society of
Amateur Photographers into a bicycle club. Stieglitz
resigned from *Camera Notes* in 1903 to establish
the illustrated periodical *Camera Work*, which he
ran until 1917 – fifty issues altogether. The pictures
in *Camera Work* were gravures made from original
negatives and printed on Japan tissue. They were
tipped in by assistants. By 1900 Stieglitz was an
established photographer, prizewinner and exhibition
organizer throughout Europe and the USA.

THE TERMINAL, NEW YORK. 1892
Stieglitz sometimes called it 'Car-Horses'. He took
it at the Terminal-Astor House, and saw it as a
milestone in his career. He recalled being depressed
to be back in New York after so long away, but having
his spirits restored on seeing the driver tend to his
horses: 'America was saved for me; I was no longer
alone.' His autobiography was constituted of such
turning points. In 1934 the writer Paul Rosenfeld told
of Stieglitz as a boy identifying with an organ grinder
who played outside the house on a winter's night.

Going to the post, Morris Park, New York. 1904
The scene, neatly bisected by that upright,
contains two arcs. It is composed in the geometric
pictorial style popular in the 1890s. The horses
canter towards the starting line and the crowd
ready themselves for the event. Stieglitz was
interested in horses and in horse-racing and
recalled playing a game in July 1873 with 'tiny
leaded horses' which were taken to a tintypist
to be photographed – at Lake George in upstate
New York, where the family had a summer home.

Stieglitz told and retold his life story, using his pictures as motifs. He presented a lot of his pictures in *Camera Work* and they often show actions winding up or winding down – not the event itself. He saw his own life as a heroic struggle against widespread complacency. He was in poor health, due to kidney stones and a bad heart, and poor, in part because his father lost money in a financial panic of 1907. New York's was a culture of financiers, unprecedentedly wealthy. For his part he had self-belief. Edward Dahlberg, a writer who knew him in the 1930s, described him as 'a seer ... a doting-mad camera man ... a chameleon in his affections ... the greatest art peacock in America'.

Stieglitz organized exhibitions. In 1902 he put on a show of what he called 'The Photo-Secession' at the National Arts Club in New York City. Then in 1905, along with the photographer Edward Steichen, he set up 'The Little Galleries of the Photo-Secession', at 291 Fifth Avenue. This gallery, known as '291', continued at that address and then at no. 293 until 1917. In 1907 he began to exhibit paintings and drawings as well, beginning with Pamela Colman Smith, followed in 1908 by Auguste Rodin and then by Henri Matisse. In 1915 he helped to publish the Dadaist magazine *291*. In 1917 he photographed Marcel Duchamp's *Fountain* (the famous urinal signed by R. Mutt) for *The Blind Man*, a short-lived Dadaist magazine. Stieglitz's exhibitions at '291' were described by H. J. Seligmann, author of a book on D. H. Lawrence, as 'bright, pulsating events in the dead sea of New York commercialism'. The events included exhibitions by Cézanne, Picasso, Picabia and Brancusi.

THE STEERAGE. 1907
This notable picture was taken on board the passenger liner *Kaiser Wilhelm II* on the way to Europe in 1907. Poorer passengers travelled steerage, which simply meant that they were kept apart from the more expensive classes. Stieglitz saw this scene in the bows of the ship and liked the look of it. It reminded him of Rembrandt and he wondered just how he would have responded. Stieglitz himself saw the scene as an arrangement of shapes related to each other, and he also warmed to the common people from whom he was cut off. He didn't like the atmosphere of the first-class quarters in which he was travelling. Anyway, he raced back to his cabin, took his Graflex and returned to find that the scene was unaltered. He had one unexposed plate left, and as luck would have it the picture was a success.

Nearing land. 1904
In 1904 he also went to Europe, and these, too, look like steerage passengers acting in an earlier version of the picture of 1907. The solitary figure up above attending to the ropes must have caught his eye as an active individual in relation to a passive mass. In *The Steerage* the situation is re-staged more discreetly.

In *The Steerage* the passengers look, paradoxically, like immigrants, but going back to Europe. Stieglitz made huge claims for the picture as 'another milestone in photography'. It was based, he thought, on 'related shapes and on the deepest human feeling'. Abstract shapes, according to ideas in currency, resonated in the imagination, and if they added up the picture was a success. Rembrandt also excelled at crowd scenes of the kind seen in the lower part of *The Steerage*. Stieglitz, in his early years, was assembling pictures with symbolic potential – notes towards a life story. The strength of these early pictures, published in sets in *Camera Work*, is that they both suggest and withhold sense at the same time. They invoke tradition (Rembrandt's '100 Guilder Print' in the case of *The Steerage*) and Stieglitz's own more or less private visions – just on the edge of comprehension.

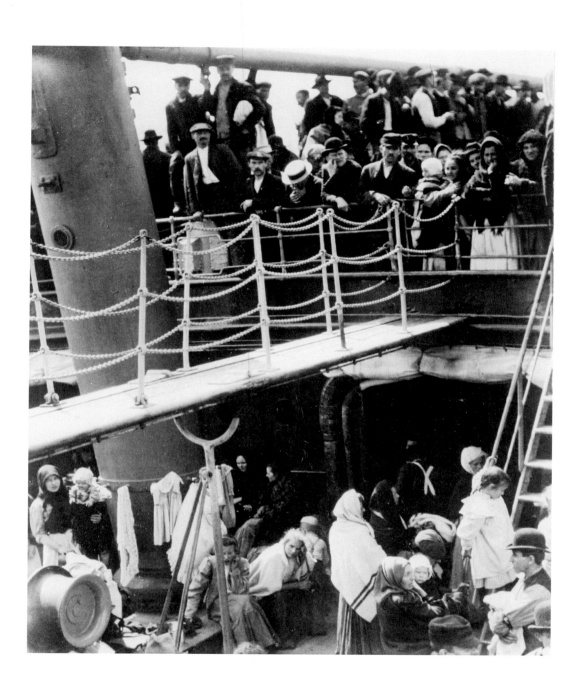

ALFRED STIEGLITZ

The gallery at 291 closed down in 1917. America's entry into the war against Germany was a blow, for Stieglitz was as much German as American. Between 1925 and 1929 he was at the Intimate Gallery, and from 1930 at An American Place, where he spoke at length to a new generation of followers. Herbert Seligmann recalled that 'he would talk for hours, for entire days, and his talk would be directed in various planes of exposition to two or ten or twenty people, draped on the couch, occupying what chairs there were, sitting in ranks on the floor. People came, departed, stayed till the early morning hours.' The great event, however, in his later life was his meeting with Georgia O'Keeffe. Stieglitz exhibited her art at 291 for the first time in May 1916 and then in April 1917 – the last of the exhibitions at 291. They shared a studio and lived together at East 65th Street, in his brother's house. They spent the summer months at Lake George in upstate New York, north of Albany and to the east of the Adirondack mountains. Marsden Hartley, a major American painter of the era and a protégé of Stieglitz, said that O'Keeffe's paintings were 'permeated with an almost violent purity of spirit'.

A PORTRAIT (8).* 1920

In this image with a thimble, O'Keeffe is pinning back her hair. She is working in the dark or from memory, and you see what she senses and touches. He might have asked her to place her fingers just so in order to occupy that limited space. Modernist photography, as it developed during the 1920s, concerned itself increasingly with such nuances, finely judged. Edward Dahlberg, a writer, recalled that once when he 'was raving wildly about O'Keeffe's paintings, he showed me his photographs of her hands – large hands, with fierce knuckles and punishing fingers which somehow resembled the face of Savonarola, and I told him so. He nodded with rare enthusiasm and took out more camerawork he had done on her hands.'

A Portrait (13). 1922

O'Keeffe and Stieglitz married in December 1924, when she was 37 and he was 60. Since 1918 he had made hundreds of studies of her. In September 1920 he wrote to Paul Strand that 'it is most difficult to *add* to what I have of her'. Until 1924 he did add, until he turned his attention to cloud photography. The O'Keeffe portraits vary, sometimes showing her as an exotic dancer, sometimes as a pioneer. It is worth remembering that when Stieglitz was a student in Berlin he had been to the operas *Tristan* and *Carmen* over a hundred times each. In New York he was bowled over by the performances of the dancer Eleonora Duse. O'Keeffe shown here has a shapely face, well defined, but it is also a portrait which singles out her lips, along with an eye, an ear and a nostril. She appears as a figure for the senses, spelled out one by one. The senses, though, are nothing without the will, and it is this which emerges from the set of the face shaped by shadow and by the pale light reflected in her eye.

* The title numbers refer to a donation made by Stieglitz to the Museum of Fine Arts in Boston.

LEWIS HINE

1874–1940

Hine established criteria which remain to this day. He was born in Wisconsin, left school at sixteen and undertook unskilled work to help his newly widowed mother. Eventually he studied to become a teacher and was lucky enough to meet Frank Manny, a reformer who helped him on his way – initially to the University of Chicago. In 1901 Manny became head of the Ethical Culture School in New York City and he appointed Hine as a science teacher. The school stressed learning by involvement, and in 1904 Manny asked Hine to serve as a photographer, documenting the school's work. Together they went to Ellis Island to take pictures of newly arrived immigrants – and Hine began the work for which he became famous. He followed the immigrants to their places of settlement and noted what became of them. Often they ended up as cheap labour, exploited by unscrupulous employers. By 1906 he was an active reformer, photographer and publicist for the National Consumers' League and the National Child Labor Committee.

ITALIAN FAMILY LOOKING FOR LOST BAGGAGE ON ELLIS ISLAND, NEW YORK. 1905

The older woman looks wary, for she has just arrived in an alien country. The boy, carefully dressed with his coat buttoned, looks after his sister. The smaller children are also tidily presented, for the family wants to make a good impression. It is a moving account of family solidarity, and Hine's idea was to show that these new immigrants from southern and eastern Europe were worthy of respect. At the same time the idea of looking through a plethora of newly landed baggage is the stuff of nightmares.

Steelworkers at a Russian boarding house, Homestead, Pennsylvania. 1907–8

In 1907 he undertook work for the Pittsburgh Survey, a sociological study of that city. Homestead is a district in Pittsburgh. Slavs had settled there and they had a good reputation in family matters. They looked after their children well, although the surveyors worried about the impact of single male lodgers in the crowded tenements. These look like fine upstanding men, however, and would have been quite at home in Soviet tableaux during the 1930s. Hine's purpose in these early pictures was to demonstrate the worth of these new citizens. They show solidarity, too: those hands discreetly placed on shoulders.

Public portraiture is a contentious matter. It is often intended to correct perceptions and to right wrongs, and Hine's virtue was to hit upon the right format almost from the outset. Full-length portraits, as in the Italian family group, carry with them an aura of over-exposure and of awkwardness – just right for those first uncertain steps in the New World. Head and torso portraits, on the other hand, suggest stability and a right ratio between spirit and body. The photographers of the Farm Security Administration in the USA during the 1930s were well aware of these distinctions, as was Hine himself as he continued on his reformist course.

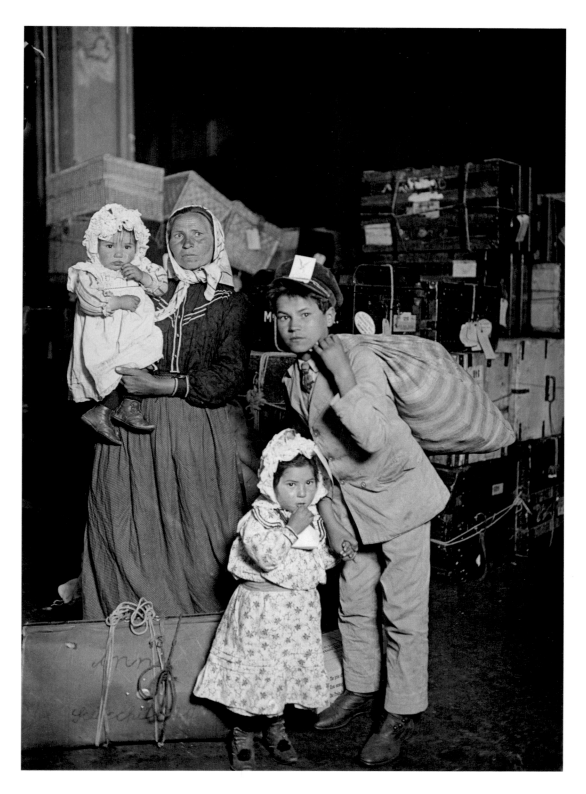

LEWIS HINE

He was active in what historians call the Progressive Era – in which there was a lot to be progressive about: bad working conditions in particular. Hine and his colleagues were dismayed by the wastage involved, for uneducated and brutalized children didn't grow into good citizens. The system was inefficient as well because it produced people who had not developed their creative side. A lot of the child labour he came across was simply cruel, and Hine made extensive notes which served as a basis for captions. He produced montage posters, one called 'Making Human Junk' showing vibrant children spent before they had reached adulthood. He worked for the National Child Labor Committee until 1918, took pictures briefly for the Red Cross in Europe, and in 1919 returned to New York to take 'work pictures', many of which reflect on the interaction of man and machine. In 1930–31 he documented the construction of the Empire State Building, and in 1932 published *Men at Work*, a picture book meant for children – his only book published in his lifetime. In the 1930s he took pictures for the National Research Project, often showing older people gainfully employed.

YOUNG GIRLS KNITTING STOCKINGS IN A HOSIERY MILL, LONDON, TENNESSEE. 1910

This girl was so small that she had to stand on a box in order to reach the machine. Cotton mills were much worse in Hine's opinion. He noted that even the smallest children had been taught to tell him that they were fourteen years old, which was the minimum legal age for work. It was never his intention to show children at a low ebb – rather to show that they didn't belong in the kind of workplaces to which they were recruited.

An expert linotyper. 1920
On his return from Europe he took pictures for the Interchurch World Movement, documenting 'the life and achievements of the Negro, North & South'. This was skilled work and noisy, on the evidence of all those moving parts. She is also wearing a protective vest. It looks like a staged picture, and probably had to be if it was to show her in the clearest context possible.

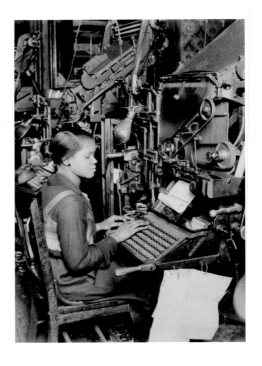

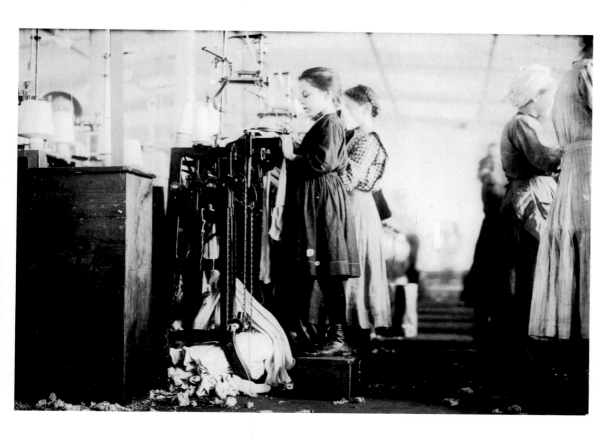

Hine knew that work could be fulfilling. In 1910, however, it was anything but. By the 1920s conditions had changed due to the mechanization of many processes. Workers were subject to time-and-motion studies and sometimes seen as little more than automated machine parts. Even so, he was in two minds about the new mechanical culture, for some of its operatives, like the woman at the keyboard, learned to cope. His virtue throughout was to show people in quite elaborate settings, as if to note that there was always a lot to contend with: complex apparatus, a multitude of things, crowds to negotiate and choices to be made. This world in which there is a lot to be done is easily recognizable to anyone at all. His point was that its ill-effects could be mitigated. At the same time it remains an indissoluble part of the human condition.

AUGUST SANDER

1876–1964
Sander was born in the small town of Herdorf on the river Sieg in the Siegerland, just to the north of the Westerwald area where he would photograph extensively in the years before the Great War. His father was a carpenter in the iron mine at Herdorf. In 1892 the young Sander became interested in photography. By 1898 he was a commercial photographer specializing in architecture and industry. He went to work at Linz, on the Danube in Austria, and bought a studio there. In 1911 he moved to Cologne. As a portraitist he had to master various art-printing procedures, to make pigment and gum prints. Early in the 1920s he rejected these procedures in favour of a plain, objective style which helped to align him with New Objectivity, the emerging aesthetic of the era. In effect he began to print portraits in the manner previously reserved for architecture – where clarity was at a premium. Around 1910, it seems, he began to think of an extended photographic project called 'People of the Twentieth Century', made up of representative portraits of German people. After the Great War, when he served as a soldier, he returned to the survey idea, and a preview, *Antlitz der Zeit* [Face of our time], was published in 1929 by Transmare Verlag/Kurt Wolff Verlag. The book contained sixty portraits from all walks of life, taken between 1910 and 1928, and it established his reputation.

HERDSMAN. Westerwald, 1913
He wears a smock and crumpled hat and belongs to the Westerwald, where Sander began his great scheme. In a radio talk of 1932 Sander recalled a herdsman from his childhood who took the village cattle, two hundred of them, into the forest in springtime to graze. This happened on a daily basis. Children took food to him at midday and he told them stories and spoke about the forest and its plants. He had a reputation as a wizard. This man probably reminded Sander of that herdsman of his childhood. He appears on the second plate in *Antlitz der Zeit* and represents 'the earthbound man'.

Farmer from the Westerwald. c.1911
He looks fixedly into Sander's lens and holds a book and a pair of spectacles. He is dressed in his best. It may have been Sunday, for Sander cycled from Cologne on the weekends to take these pictures. He had a portrait business in Cologne. The farmer, still a working man to judge from his hands, provides the opening picture in Sander's series and might be intended as a man of the book, in contrast to the herdsman who is more naturally learned.

The herdsman and the farmer shouldn't be taken for granted. They look into the lens, and would have expected to do so. They were used to the idea that photographs were taken to be sent to loved ones, almost as stand-ins. Sander had taken pictures in the Westerwald amongst communities where there was a lot of emigration to the United States. Then he had taken pictures on military service and during the Great War for people who wanted to be remembered by their families. A photographic portrait was the next best thing to being together. It was a token of intimacy and candour.

AUGUST SANDER

Sander persisted in the face of all sorts of difficulties, and is rightly regarded as a hero of photography. *Antlitz der Zeit*, which might best be translated into formal English as 'Countenance of the time', was suppressed by the National Socialist authorities in Germany in 1934; books were seized and the printing plates destroyed by the Ministry of Culture. Sander had meant it as no more than an introduction to a much bigger work of 540 pictures. His eldest son, Erich, who had contracted polio as a boy, had, like many of his contemporaries, joined the Communist Party of Germany. In 1934 Sander had helped him to prepare anti-Nazi pamphlets. Erich was arrested and given a ten-year sentence – and was to die in prison in 1944. Quite why the new government banned Sander's book is not absolutely clear. It might simply have been because it contained pictures of figures from the Left, including one of Paul Frölich, co-founder of the Socialist Workers Party. It is just as likely that National Socialist assessors didn't like the look and tone of the book.

WORKING-CLASS MOTHER. 1929 or before
She was introduced in 1929 as a proletarian mother, from the Latin word for one who served the state with offspring rather than with money. She looks cheerful, as does the proletarian infant whom she holds upright for the camera. The view amongst ordinary people was that you presented yourself as directly as possible to the camera, as a matter of etiquette. This approach said something about you and your outlook. Walter Benjamin, very astute about photographic ways of seeing, said that Sander's book was a training manual in a culture where appearances were being analysed more and more.

Unemployed sailor. Hamburg, 1929
The sailor is in a good humour, and may have had too much to drink by the look of him. He is standing on a curving balcony and behind him the girders of the bridge give a destabilizing effect which rhymes with his stance. He is, though, trying to oblige, and it is possible to sympathize with him. Sander had a comic sense, with which he is not often credited.

By 1934 Sander's book must have looked like a national satire to Nazi officials. By then the USSR had advertised itself as the land without unemployment. It, too, had proletarian mothers, but they looked to the future and not to the camera. Drunken sailors were out of the question in the USSR. In the new Germany, it would have looked as though Sander was deliberately letting the side down. Nor was he as typological as he intended to be. He was just too full of empathy for that. The mother, for example, may at some level represent the working class, but principally she is a genial woman holding and displaying a child to good advantage. And the drunken sailor, who is doing the very best he can under the circumstances, is a credit to mankind – even if not to the German state. Sander specialized in the kind of one-to-one relationships which just could not be tolerated by totalitarians, for if you sympathize with individuals, how on earth can you ever reform them?

Sander's vision for the finished work was complicated. It would start from the earthbound man and woman (peasant farmers from the Westerwald), and then proceed by degrees to 'the highest peak of civilization' and then 'downward according to the most subtle classifications to the idiot'. After 1929 he continued to add to his collection of portraits, although he began to devote a lot of his time to landscape photography and regional studies. In the early 1930s he published books under the heading *German Land, German People*. This turn to landscape was intensified after the arrest of his son Erich in 1934 and the seizure of *Antlitz der Zeit*. During the war and with the onset of bombing raids on Cologne, the site of his studio, he returned to a village in the nearby Westerwald. His studio was eventually destroyed by bombing and many of his negatives lost in a subsequent fire – this was the fate of a lot of German photography from the 1920s and '30s, especially in Berlin.

Painter [Anton Räderscheidt]. Cologne, 1927
Räderscheidt (1892–1970) was a painter in Cologne and he belonged to the 'Progressive Artists Group'. In his paintings he himself often appears like this, clad in a black suit against the standardized building of a modern city. Räderscheidt had begun to make these remarkably impassive pictures around 1920, and may very well have influenced Sander during the mid-1920s. He was classed by the Nazis as one of the most 'degenerate' of German painters, and in 1934 the resemblance might have counted against Sander.

THE COMPOSER [PAUL HINDEMITH].
Cologne, 1926
Hindemith (1895–1963) was thirty-one when this picture was taken and already well known as a violinist and composer in the modernist style. In 1925 Sander had taken a group picture of musicians at a festival in Duisburg where Hindemith appears as a small man in a crumpled suit. That wouldn't have mattered, though, in the Weimar Republic (1918–33), where talent was honoured. By the time this picture was taken, Hindemith would have known how to present himself to the camera: with a level stare and as expressionlessly as possible.

German portrait photography was at its zenith during the Weimar years. Artists, musicians, writers, scientists and politicians expected to be taken, and knew how to appear. Under Weimar's terms of reference – which were those of the New Objectivity, given its name in 1923 by the art historian G. P. Hartlaub – the torso of the sitter was no more than a plinth or pedestal on which the head was held in balance. The head in its turn was understood as a frame for the eyes which expressed the spirit of the subject. Impassivity mattered because a smile, for example, would imply distraction and a loss of self-possession. Sander's variation, prompted maybe by Räderscheidt, was to add these imposing Weimar heads to full-length figures: made up of suits, shoes and cigarettes. No matter how imposing one's mentality, hands and feet can still be a problem, and Sander's portrayals often have an unusual poignancy in their details.

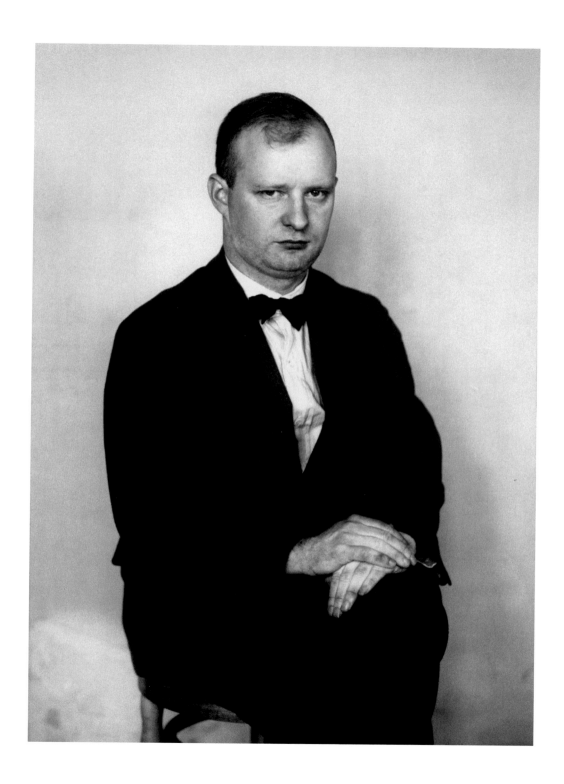

AUGUST SANDER

The Sander family had a hard time of it. When Erich died in prison in 1944 his younger brother Günther was fighting on the Russian front, where he was captured – and eventually released. Sander's photographic archive was badly damaged. In the 1940s and '50s he was on the way to being forgotten, except that he had been reviewed in the early 1930s along with Eugène Atget and he was irrevocably in the history of the medium. Edward Steichen included some of his pictures in 'The Family of Man' in 1955 and then in 1959 the Swiss editor Manuel Gasser presented his work in *Du*. Gasser shaped taste in the 1960s and *Du* was expertly printed. Sander was, in effect, rediscovered and his pictures have haunted the imagination of photography ever since.

PROTESTANT MISSIONARIES. Cologne, 1931
They seem to be arranged on portable staging with a bed or couch in the background. It doesn't seem like the inside of a Protestant church, nor like a photographic studio. Sander may have been attracted by the horizontal stripes on the wall, which look as if they belong to a gauging system of the kind once used by ethnographers in faraway places. The men look somewhat dumbfounded. What had Sander been telling them? He probably told the standing man second from right to keep his hands out of sight, for hands could be disturbing in full-length portraits. Did he tell the two lower figures to clutch their stomachs – for the sake of the composition?

Max Beckmann
Self-Portrait in Tuxedo. 1927

Oil on canvas. Harvard Art Museum,
Busch-Reisinger Museum, Association Fund, BR41.37

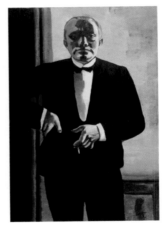

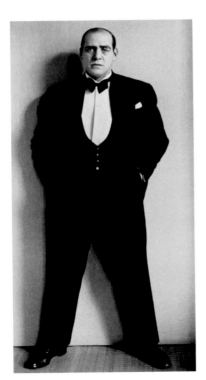

Maître d'. Cologne, 1930
He has kept his hands in his pockets for the sake of a more unified picture. He is well turned out, although his monocle makes him seem to have a black eye, as if he has been coping with rowdyism. He is wearing a tuxedo or dinner-jacket, and is very reminiscent of Max Beckmann's *Self-Portrait in Tuxedo* of 1927, which is now in the Busch-Reisinger Museum in Harvard University but which had been purchased in 1928 by the Nationalgalerie in Berlin – and put on show.

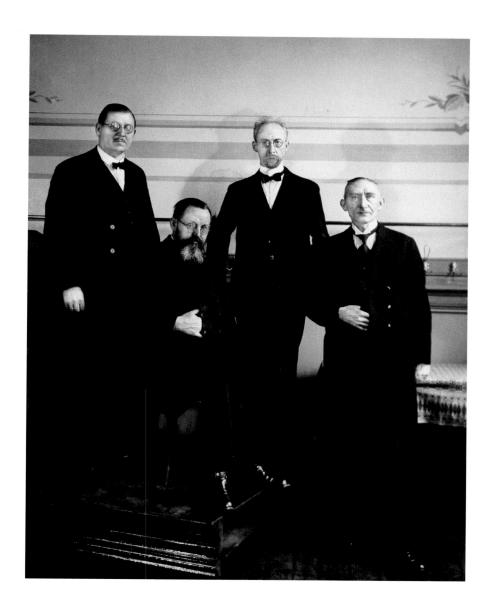

It is true that the new German government in 1933 didn't like *Antlitz der Zeit* and put a stop to the publication of Sander's portrait project. It is also possible that Sander was disconcerted by the direction his portraits were taking. In the mid-1920s he sometimes used plain backgrounds, but in 1928 he began to present standing figures hard up against white screens, even if they were dressed for the streets. If the portraits of 1925–6 were taken in available light and in natural habitats those of 1930–31 were sometimes taken in laboratory conditions. Brought in from the street to face the lights, anyone might feel as nonplussed as the Protestant missionaries of 1931. He may have begun to sense that change was in the air, a new order less sensitive to the rights of the subject. In his studio and in controlled settings he was able to reflect on these changes in the national mood.

DORIS ULMANN

1882–1934

Born in New York City, where her father owned a textile business, Doris Ulmann studied teacher training at the Ethical Culture School – an important progressive institution. She read law and psychology at Columbia University, and then studied photography at Clarence White's school. In 1918 she became a studio portraitist, and during the early 1920s became interested in American folklore. She took pictures of Shaker and Mennonite communities and around 1925 worked on a scheme to photograph people in the Southern Highlands – in Kentucky, Tennessee, the Virginias and the Carolinas. She enlisted the help of John Jacob Niles, whom she saw acting in burlesque theatre – New York's Grand Street Follies. From 1927 onwards they made at least seven road trips to the South. Niles collected music and ballads, carried her equipment and acted as a go-between, for he was from the area, from Louisville, Kentucky. Niles's memoirs appear in *The Appalachian Photographs of Doris Ulmann*, Penland, North Carolina: The Jargon Society, 1971.

JAMES DUFF, FIDDLER, AND JOHN JACOB NILES, HAZARD, KENTUCKY. 1933
James Duff leans against a wall. J. J. Niles notes details of their conversation in a notebook. Duff, a middle-aged to elderly man, may have dressed for the event, with a jacket, necktie and a pair of decent trousers. The picture is a record of an event: an encounter during which Duff played snatches of tunes and Niles relighted his pipe.

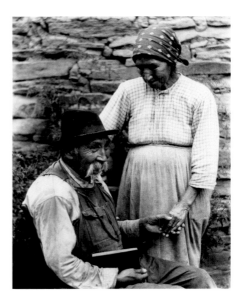

Unidentified couple. c. 1930
They hold hands, and he holds a book – a Bible probably. Ulmann has asked them to pose, for they both look amused.

Ulmann's gift was to get people to act themselves, to be aspiring young people or esteemed elders. Her subjects become accomplices and participants in a drama – the Ages of Man. Even if only implicitly, she invited people to act for her, to play in a game partly of her and partly of their devising. They are amusing themselves rather than representing an area or a class down on its luck or hoping to put its imprint on the world at large. Elderly people such as these also suggest long settlement and accumulated memory. As the 1930s progressed it was the future which occupied more and more of the mental space of the era.

John Jacob Niles (1892–1980) was thirty-three when Ulmann took him on as her assistant. He came from a musical family and after Ulmann's death he made great headway as a performer and writer. He is known for his folk songs: 'Black is the Colour of My True Love's Hair' and 'I Wonder as I Wander'. He played a dulcimer. Ulmann was in poor health almost all her life, and lame too – Niles carried her at times. He was in love with her, and they seem to have been lovers. Seventy-two of her pictures appear in *Roll, Jordan, Roll*, on the black Gullah culture in South Carolina (New York: Ballou, 1933). Another fifty-eight illustrate *Handicrafts of the Southern Highlands* (New York: Russell Sage Foundation, 1937).

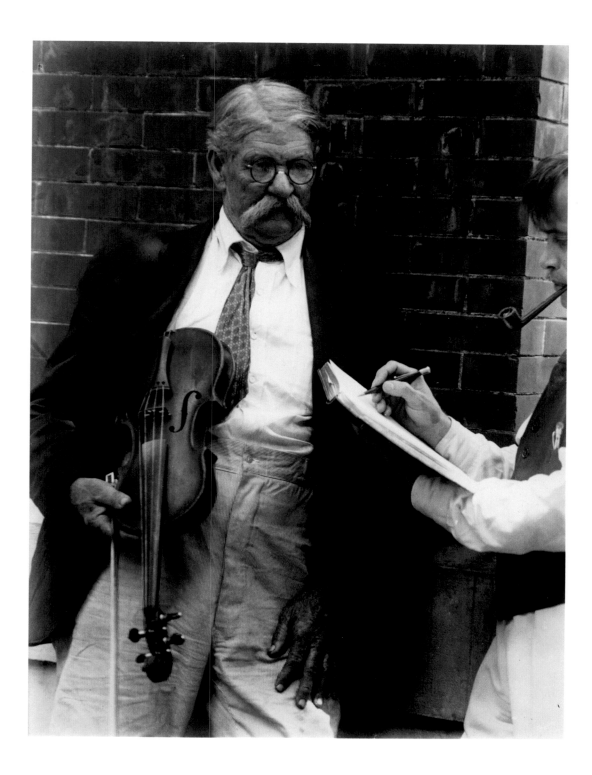

ALEKSANDR RODCHENKO

1891–1956

Rodchenko took up photography in 1924 at the age of thirty-three. He already had a lifetime of experience in art, most of it in Moscow's avant-garde. In 1924 he was head of the metal- and wood-working unit in VKhUTEMAS [Higher State Artistic and Technical Workshops] which had been set up in 1920 to train artists to work for the benefit of the national economy. VKhUTEMAS didn't prosper, because most of the students wanted to do easel painting. Rodchenko, who taught Construction, was an inspiring teacher, and even looked inspiring in appearance 'like a combination of pilot and motorist'. The same student remembered him as 'a new type of man, a special one'. He dressed the part, and probably had to for he was a close associate of the poet Vladimir Maiakovskii, an extra-special one known for his flamboyance. Together, and assisted by students from VKhUTEMAS, they worked on adverts and posters for the streets of Moscow: for example, 'All smokers everywhere always prefer "Red Star"'. As a book illustrator, Rodchenko also experimented with photomontage and it was this practice which led him to photography.

PORTRAIT OF MOTHER. 1924

She was a laundress and had learned to read only in her fifties. In one version of this she is leaning over a table to read a newspaper, and Rodchenko may have meant the picture to reflect on the achievements of the Revolution, which had put a premium on literacy. In this later variant from the same negative he only includes the head and hand, so that the image is about seeing in general. The headscarf with its pattern of dots losing themselves by degrees in the darkness itself looks like a sight test, and that possibility may have caught his eye. She is also holding the wire-rimmed glasses oddly for someone reading a newspaper, and it may be that the small growth on the side of her nose was rubbed by the frame. So it may have been taken as no more than a sympathetic family portrait.

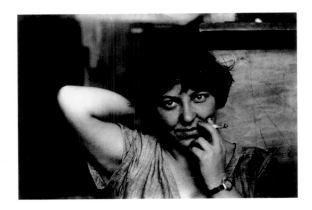

Stepanova with a cigarette. 1924

Rodchenko and Varvara Stepanova met when they were students at the Kazan School of Art, 1911–14. They stayed together through what must have been difficult times. She taught textile design in Moscow, and in the 1930s they worked together as designers. This might be no more than an intimate portrait, but it might also be planned. Her right arm is highlighted and it looks like a nude study. In her other hand she holds an extinct cigarette, and with her fingers she touches the side of her face. She looks thoughtfully into the lens, almost smiling.

Rodchenko was a Constructivist, which is a broad enough term, but it meant that he thought of himself as someone who assembled pictures. These assemblages were meant to engage audiences, to make them think, and they were made up of disparate items – especially the photomontages. Hence, perhaps, the distinct elements in this portrait: the face, the hand touching and holding, and the erotic elbow off to one side. At the time he was experimenting with photography to see if it could be adapted to modern ways.

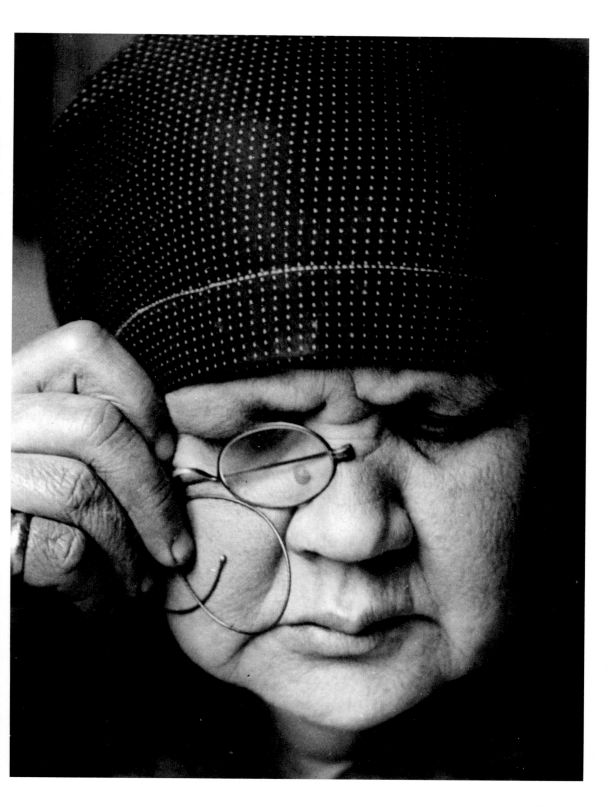

ALEKSANDR RODCHENKO

Rodchenko was a polemicist in the early 1920s. There was a lot at issue in the USSR. The times were changing more rapidly than ever before and you could make extravagant statements, and believe in them. Rodchenko foresaw the end of painting and the opening of a new world in which art was everywhere. Hence his interest in advertising, which gave him a chance to demonstrate his ideas about what would later be called basic design. Art had to involve itself with the people and Rodchenko thought that they could be stimulated by simplified arrangements which would break with the routines of everyday life. Exposed to his challenging and playful Constructivism, people would come to their wits and emerge from their centuries of serfdom. In Lenin's era, which came to an end in 1924, this sort of utopian thinking was still possible – but it became more questionable as the decade unfolded.

POET VLADIMIR MAIAKOVSKII. 1924
Rodchenko designed poetry books for Maiakovskii and he needed portraits for use on covers and in photomontages. The poet, two years younger than Rodchenko, had been a celebrity since 1913. He saw himself as the 'drummer' of the Russian Revolution and wrote a vernacular poetry meant for declamation. Most at home in the heroic era up to 1924, he cultivated the menacing look of a gangster. In this picture, which does justice to the poet's boots, suit, hat and hands, Rodchenko is applying the Constructivist method: a selection of motifs and forms impassively displayed – evidence inviting consideration.

Poet Sergei Tretyakov. 1920
In 1928 Tretyakov criticized Rodchenko for his excessive interest in aesthetics: impressive pictures, that is, which had little social content. He can't have approved of this portrait of himself, which is a very aesthetic arrangement of stretched skin and spectacles. Reading glasses were a sign, in the early USSR, of the intelligentsia (a Russian coinage from an Italian source). In 1928, when Russian farms were being collectivized, Tretyakov went to the 'Communist Lighthouse' collective to work as an 'operative' writer, helping with publicity and literacy projects. He wrote an influential book on collective farms: *Field Commanders*. Even so, he was arrested in 1937, charged with espionage and executed.

Rodchenko was always a believer in talent. Optimistically, he imagined that the public could be brightened up by exposure to what he called Constructivism. Even when he saw the tide running against his way of thinking in the late 1920s, he continued to make stylish pictures – unable to help himself. Having committed himself to a certain way of thinking during the heroic era, 1917–24, and having stated his position again and again, he must have found change difficult. Eventually he went down-market but his touch never deserted him. No other photographer, before or since, has been so close to the centre of events as Rodchenko was for the best part of a decade.

ALEKSANDR RODCHENKO

Photographers in the USSR during the 1920s might have imagined themselves to be in touch with history, yet they lived somewhat within their own world. They were necessary to the government, for they could present the new nation abroad. In 1925, for example, Rodchenko produced a 'Workers' Club' for the International Decorative Arts Exhibition in Paris. Maiakovskii was on the organizing committee. Foreign illustrated weeklies, German in particular, also needed articles on life in the USSR. In literary and critical magazines, such as *LEF* and *Novyi LEF*, edited by Maiakovskii and Osip Brik – another of Rodchenko's friends, photography was debated, and criticism levelled and disregarded. The choice was mainly between old-fashioned reportage, taken 'from the navel', and pictures taken from strange angles, meant to show the everyday in a new light. Photographers also collected pictures for use in photomontages, which became popular in the illustrated press from around 1924. By 1928, though, Rodchenko was beginning to speak up for a photography of 'socialist facts' gathered from workplaces.

THE WORKERS' FACULTY STUDENT. 1924
In 1931 he appeared in E. Glaeser and F. C. Weiskopf's anthology of the USSR, *The Land without Unemployment*, as 'A woodcutter from the Urals'. That book, prepared in Germany, presented a smiling and constructive USSR to the world. The woodcutter-student represents youth and wears his cap raffishly, with the peak detached from the crown. (Rodchenko appreciated heads for themselves, as objects revealed by light.) Smiling, he reveals his teeth which calibrate the lower part of his face. The cap, a polyhedron topped by a curve, frames the face; and in the background a division between light and shade gives the ingredients of the picture as a diagram.

Pioneer Girl. 1930
A breeze ruffles her hair. She looks in the direction of the sun, to judge from those shadows. The picture was shown in public for the first time in May 1931 at an exhibition staged by the October Association, founded in 1928. By then the division between formalism and naturalistic reportage was becoming marked. This picture was criticized because the girl seemed to be looking upward rather than forward: thinking of utopia, that is to say, rather than of the foreseeable future. In actuality, Rodchenko may have been reflecting on Europe's developing taste for neoclassicism, exemplified by the Italians. She is exactly the sort of beautifully symmetrical figure who often appears in the patriotic statuary of the 1930s, and visible from the same angle too.

To his Russian contemporaries Rodchenko's pictures must have looked monumental, heroic and utopian – even bombastic. Handsome youngsters were all very well but average citizens had work to do, and they weren't necessarily contented. If they could be given a place in the unfolding national story, so much the better. Nor did Rodchenko's idealizing style allow for differences within the proletariat: miners, teachers, metalworkers and harvesters, and all the others who made up society as it stood then and there.

ALEKSANDR RODCHENKO

In December 1927 the Fifteenth Convention of the All-Union Communist Party opened a new era in the USSR. Opponents of the Central Committee, especially Trotsky, were exiled and a five-year plan was decided on. Previously there had been hopes of a Communist triumph worldwide, but in 1927 it was decided to concentrate on internal revolution. This meant top-down industrialization. Plans were made for new factories and quotas were set. An agrarian economy was to be industrialized – and it was. Farms were collectivized, often quite violently, and agricultural production plummeted. Photographers in their parallel community had to keep track of these catastrophic events. From 1928 onwards many of them belonged to the newly founded October Association. They were up against a new threat, the Association of Artists of the Revolution, which specialized in naturalistic paintings made on site – and rather to the taste of the Politburo. In an October manifesto of 1931, probably written by Rodchenko, the naturalistic painters were denounced as well as the taste for 'flagwaving patriotism in the form of spewing smoke-stacks and identical workers with hammers and sickles'.

STEERING WHEELS AND CLUTCHES. 1929
These pictures were taken at the AMO automobile plant, where the first AMO truck was built – based on the Fiat F-15. They were published in the new picture magazine *Dajosh* [Let's give], no. 14, 1929. Patterned fragments like these were placed side by side in sets of six to a page – in *Dajosh* and in *30 Dnei* [Thirty days]. The idea was to bring audiences into as close contact as possible with work as undertaken in the new factories. Such pictures were also, in Rodchenko's terms, 'photo-stills', looking like extracts from a cinema film and thus rich in implications of movement and of a wider setting.

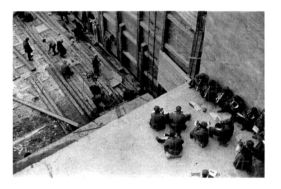

Working with an orchestra. White Sea Canal, 1933. They are constructing a lock in a canal which was one of the great works of the five-year plan. The canal ran from the White Sea in the north to the Baltic, via several lakes. The workers included many anti-social and criminal elements brought for retraining. Some of these were *kulaks*, the peasant landowners who had resisted collectivization. Rodchenko wrote enthusiastically of his visit to the canal site, and took 3000 pictures in all. Issue no. 12 of *SSSR na stroike* [USSR in construction] is given over completely to the canal project. The venture was initiated by Stalin.

Soviet photography in the 1920s, in which Rodchenko played a leading role, was exceptional in that it was explained and contested every step of the way. In conventional market economies photography responded to public opinion as it shifted. Operatives didn't need to explain themselves and to challenge troublesome rivals. In the USSR, though, you spoke up or you went under. Fear of the authorities played a part, but in the 1920s it was also a culture devoted to explanation and to agendas.

ARKADY SHAIKHET

1898–1959
Born in Nikolayev in the southern Ukraine, Shaikhet came up the hard way. He left school early to train as a metalworker. In 1918 he moved to Moscow and from 1922 worked as a retoucher in a portrait studio. In 1924 he began to take pictures for the *Rabochaya Gazeta* [The workers' gazette]. In 1924 he went to work for the weekly illustrated *Ogonjok* [gleam]. Eventually he crossed paths and swords with Rodchenko and the formalists. Experience as a reporter told him that readers warmed to pictures they could sympathize with. In 1929 in *Sovetskoe Foto* [Soviet Photo] he wrote about competing tendencies in photojournalism: angled close-ups of machines on the one hand and events clearly stated on the other. He had Rodchenko in mind – and the abstract tradition represented by Moholy-Nagy. In 1931 he helped to set up ROPF, the Russian Society of Proletarian Photographers. In 1931 along with two colleagues, Max Alpert and S. Tules, he prepared an influential article on 'A Day in the Life of the Filippov Family'. Fifty-two pictures from the Filippov series were published in the German *Arbeiter Illustrierte Zeitung*, and the Russian authorities liked its straightforward style, seeing it as a model for 'proletarianization' in photography.

PETITIONERS AT KALININ'S OFFICE. 1924
Peasants benefited from the Revolution in Russia. They seized the land of their former landlords and became independent farmers. They didn't always co-operate with the state which responded by classifying villagers as *kulaki* [rich peasants], *seredniaki* [middle peasants] and *bedniaki* [poor peasants]. The poor were put in charge of local committees. Michael Kalinin was a middle peasant who had done well enough to become chairman of the All-Russian Central Executive Committee. The peasant problem took a long time to resolve, and in the end the kulaks were liquidated (as a class, the banners read). In 1924 bearded peasants represented traditional Russia but by 1930 they were seen as criminal anomalies standing in the way of progress, epitomized by a clean-shaven industrial operative – of the kind taken for granted by Rodchenko, for example.

Ploughing. c. 1930
Collective farms were meant to be scientifically managed. Tractors would take over the work of horses and oxen, but at first tractors were in short supply – and difficult to keep in working order. These are International machines, imported from the USA. These ones are stationary, with their drivers looking towards the camera, although they are meant to express a forward surge. Diagonals in Soviet photography meant dynamism, even for a relatively conservative reporter like Shaikhet.

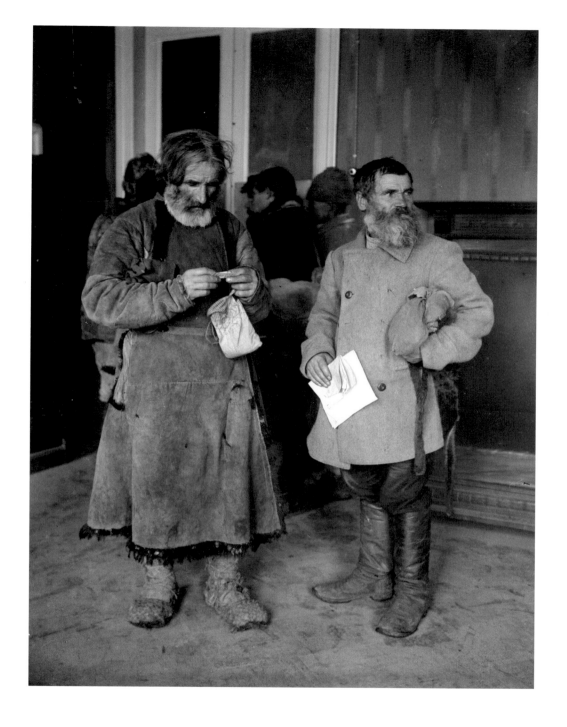

Accelerated development in the USSR meant that cultural elements signified as never before – nor since. Spectacles meant literacy, and beards archaism. Tractors were harbingers of an organized future, but American tractors were stop-gaps. Threshing machines, combine harvesters and Bessemer furnaces were all significant novelties for a year or two. It was an evolving iconography which could be charted with accuracy.

BORIS IGNATOVICH

1899–1976

Ignatovich might be a special case in Soviet photography, which increasingly felt that it had to toe the party line. He was in the Rodchenko camp and had been trained by him. He took over when Rodchenko was expelled from the October Association in 1931 and Rodchenko blamed him for the breakdown of the group. Born in Lutzk in the Ukraine, he began as a journalist and editor, and when he became interested in photography around 1923 he was chief editor of a humorous magazine in Leningrad. He went to Moscow in 1926 and emerged as a photographer in 1928–9, in the new magazine *Dajosh* [Let's give], where his reportage pictures on industrial themes appear packed together ('packing') and closely cropped to show close-ups and patterned fragments ('de-framing'). Even though innovative he survived as a photographer, documentary film-maker and editor.

LUNCH IN THE COMMUNE. c.1928
He took pictures of village subjects, especially at the Ramenskoye settlement near Moscow. They are eating from bowls and, it appears, listening to a broadcast from the radio speaker in the foreground. Radio was new in the 1920s and in the USSR it was used for public instruction. It might have been understood at the time as no more than a photo-document but Ignatovich took other pictures in which the arrangements suggest oppression – as they do here. In the 1950s, in a photograph by Robert Frank, a picture with these proportions would remind us of just how overbearing the media might be.

The Conductor Dmitry Shostakovich. 1930
Shostakovich (1906–1975) was a young man, with the opera *Lady MacBeth of the Mtsensk District* (1930–32) still ahead of him. Like the photographers he, too, would be accused of 'formalism' later in the 1930s. In this dynamic arrangement the conductor seems to address the heavens, whilst the band plays on regardless in the foreground. There is a very definite discrepancy here between the ruler and the ruled – at least after a moment's reflection there is. Perhaps Shostakovich and his musicians knew what they were doing, but all the same the picture with its anomalies and asymmetries is suggestive. Robert Frank, again, in the 1940s and '50s took pictures of browbeaten common men in the presence of official and patriotic music.

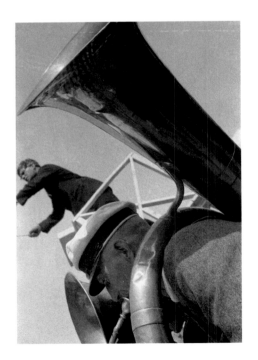

Ignatovich stands out in the Soviet era. He was a romantic, unable to subdue his temperament. He claimed political correctness, which may have been enough to delude the authorities, who had very little aesthetic awareness anyway. His bias, which was certainly in tune with the industrializing tendency in the USSR, was towards the sublime: an iconography of labyrinths and pits which he found on officially sanctioned sites, such as timber yards and cotton mills. Hidden agendas and nightmarish subtexts, of the kind projected by Ignatovich, might seem unlikely in photographic culture in the USSR, but by 1928 he would have been well aware of the turn towards coercion and of the need for concealment and metaphor.

FRANÇOIS KOLLAR

1904–1979 During the 1930s Kollar was Europe's most prolific documentarist, even though his reputation didn't survive. He was born and brought up in Slovakia, not far to the north of Bratislava – also called Presbourg, and Pozsony by Hungarians. After the Great War the area passed from the Hungarian to the Czech sphere of influence. The young Kollar took a job on the railways but in 1924 decamped to Paris where at first he worked in the Renault factory at Boulogne-Billancourt. He wanted to become a photographer, and as a boy had used an Ernemann 10 x 15 – which was an important new camera good for available-light pictures. He found work in 1927 taking pictures of fine art before moving to Draeger Frères, where he began to make publicity and advertising photos. This was a new field and Kollar flourished. In 1931 he was asked by the publishing house Horizons de France to undertake a photographic survey on the theme of work in France. Kollar, energetic and ambitious – and with work experience on the railways and at the Renault factory, was an apt choice. The project began early in 1931 and kept Kollar busy for three years.

ELECTRIC MOTOR. 1931–2

A technician using a giant wrench tightens bolts on the cylinder of an electric motor at an industrial company in Alsace. It is likely that the man is just posing and that the bolts were all in order, but it made an impressive picture. Kollar was attracted to subjects where the man/machine ratio was out of kilter – as in a tall tale. He was, after all, dealing with the topic of heavy industry.

The control room at Vitry. 1931–2

Kollar emphasized handwork, even in the domain of electric motors. His working French people may act in a modernizing economy, but almost all of them use their hands: pulling levers, turning wheels, painting, polishing, weaving – for Kollar ranged very widely across the work spectrum. Workers use their hands, of course, but Kollar might have had quite good reason to reflect on manual labour. He was working in an age of transition – as all ages are – which was increasingly dependent on electricity. In the old steam-driven order of things it was evident from the action of pistons, cogs and belts just how energy was transmitted. Electricity, though, was more mysterious and less dependent on manual interventions. It hinted at a new world order in which management was increasingly important. Key workers in the new scheme of things read dials and gauges. They made adjustments and spoke on the telephone.

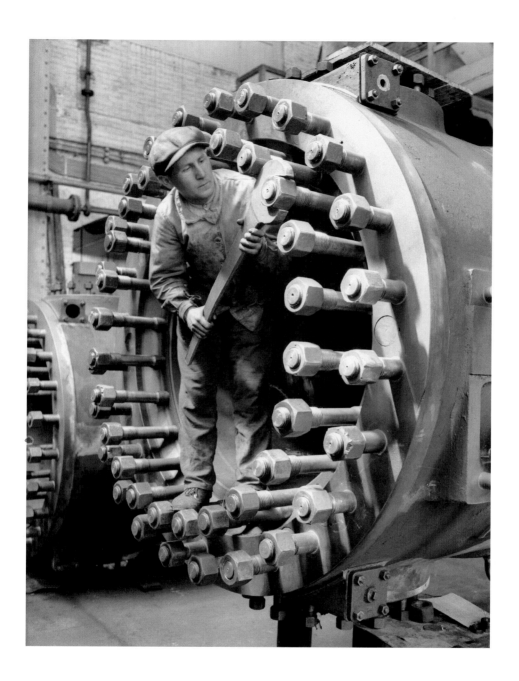

Kollar was directly implicated in the new commercial and industrial order. He had been a car worker and
railwayman, but he had also been an advertising photographer stimulating demand for car tyres
and gramophone records: 'Pneus Goodrich' and 'Magic Phono' – both 1929. He was also the
beneficiary of new printing processes. *La France Travaille* would be printed on the heliogravure
presses which had been introduced to France in the late 1920s and which gave to photographic
printing a new range and dimension.

Horizons de France had published a partwork, in eighteen sections, called *Le Visage de la France* (1925–7) on landscape and on places of historic and artistic interest. They followed it up with another series on the regions of France. At the same time it must have been evident to publishers that the USSR especially was presenting itself as a dynamic working environment, with a lot of heavy industry and electrification. New weekly magazines were also beginning to report on daily life in France – most notably *VU*, set up by Lucien Vogel in March 1928. Conditions were favourable for *La France Travaille* which came out in fifteen sections between 1932 and 1934. Kollar took over 3000 photographs of which around 1400 were used in the series. He ranged far and wide, from fishing to factory work, by way of printing and mining. He touched too on viticulture, ceramics, fashion and the book trade; so it wasn't by any means a Soviet vision of the French at work. He preferred to use a heavy wooden camera taking 13 x 18 cm Agfa glass plates. It was a slow and cumbersome process which he carried out by himself, travelling everywhere by rail. Long exposures meant that his workers had to hold still for longer than was usual. In some circumstances Kollar used a 6 x 6 cm Rolleiflex, first marketed in France in 1929. He carried out his own printing in his studio in Paris.

MINERS REHEARSING. 1932

A brass band practises in a community hall in the garden city of 'la Clochette' (the little bell) at Waziers (North). They belong to the band of the company of the mines of Aniche. Waziers and Aniche lie to the north and east of Douai, close to the Belgian frontier, in a traditional coal-mining area. Miners seem to have liked to wear their hats indoors, even when not on mining duties; this may have been a habit they got into underground. Kollar tried to evoke the scents and sounds of the places in which he took pictures. This is as much a study of hands in action as it is a portrait of a group of miners. He also chose to go behind the scenes and to show workers eating and relaxing after work.

A weaver's home, Bohain. 1932

At Bohain, in Picardy in northern France, he took this picture of a weaver's premises – both a house and a workshop – showing the weaver's wife serving a bean stew. There is a checked tablecloth, a bottle of wine, a bunch of flowers and a two-kilo loaf. Kollar remarked on details of this kind because they constituted the fabric of France – as he found it.

Like everyone else at the time, Kollar would have seen reportage from the USSR, in particular *La Russie au travail*, published in English in 1931 as *The Land without Unemployment*, an impressive survey of three years of the five-year plan. Kollar's is a much more intimate account of workaday France, one in which labour often enjoys a smoke and a nap. His workers have homes to go to, as well as bars and bistros. Kollar used them to formulate a practice of liberal documentary that continued to be influential in the West into the 1960s and beyond.

MARGARET BOURKE-WHITE

1904–1971

Between 1930 and 1950 Bourke-White was one of the world's most successful photographers. Her autobiography, *Portrait of Myself* (1963), shows that she was well organized and resourceful – and reliable. Just before the Depression of 1929 she began to take pictures of new architecture and industrial structures, and these set her on her way. She made impressive pictures of installations at the Utis Steel Company in Cleveland, which attracted the attention of Henry Luce, who was planning a new magazine called *Fortune*, specializing in business and industry. Luce, who also published *Time* magazine, appointed her principal photographer to *Fortune* and even carried equipment for her. *Fortune*, printed to very high standards, survived the Depression. On behalf of *Fortune* Bourke-White set off for the USSR in the early summer of 1930. The industrialization of the USSR, undertaken in 1928, was carried out with American technical assistance, some of it from Cleveland – where she had learned her trade.

WATCHING ORE THREADS FOR BREAKS. 1930

The bobbins rise up towards the right upper edge of the picture. The threads pass through the riders to the warper. These are the photographer's own specialist words in her book of 1931, *Eyes on Russia*. The textile mill was on the outskirts of Moscow and Bourke-White went there by *droshky*, a horse-drawn carriage. One of the operatives, an elderly woman like this one, wept at the thought of being photographed, for that was normally restricted to the younger and prettier workers. The picture itself is composed according to pictorial principles: an arrangement, that is to say, in which objects are related to intervals, and all of it rhythmically put together – as if on a harmonic substructure.

A Soviet Official (David Petrovitch Serebriakoff, Vice Commissar of Railways). 1930

Serebriakoff had been Secretary-General of the Communist Party in the USSR but had stepped down to run the railways. He had a long history as a Bolshevik, including seven years in Siberia chained to a wheelbarrow. Since 1926, he had been to the USA three times. He presents himself informally, as if listening, and the light reveals his face sympathetically. He could be a kindly businessman from the USA posing for *Fortune*. Bourke-White has used artificial light, marking the bright cuff with its shadow, but it is softly applied – to look like available light. So, he exists reflectively in his own ambience, not facing up boldly to any imagined audience.

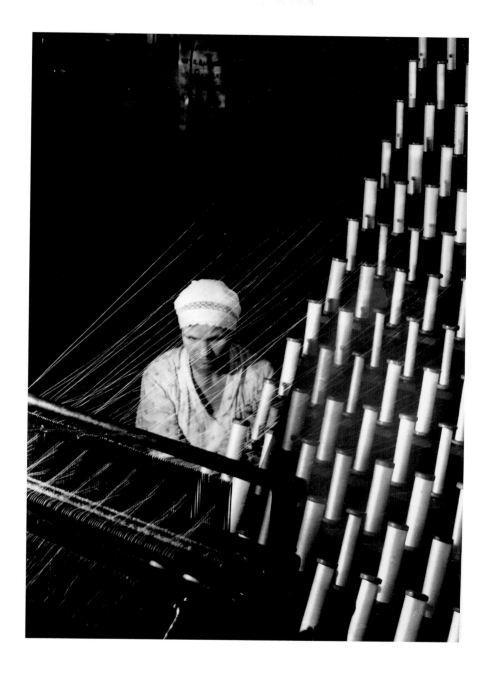

In 1930 the USSR might have seemed to Bourke-White like a branch of the USA, but she was seeing it with American eyes. Her training meant that in 1930 she was a pictorialist who thought of pictures as harmonious arrangements: parallel smokestacks and criss-cross girders outlined against the sky. To Rodchenko and Ignatovich, working for the new illustrated magazines in the USSR, pictorialism was tainted by its associations with old-fashioned painting. Nor would they have appreciated her compassionate regard for individuals.

Bourke-White took up photography in order to make money when she was a university student at Cornell. Previously she had taken a short course at the Clarence White School in New York, which had whetted her appetite. She made friends and was helped by people in the trade, as she points out in her autobiography.

The technical side of photography always interested her, and in her books there are many passages on cameras and lighting equipment. Architectural and industrial subjects put an onus on lighting. Cables and lamps had to be carried everywhere and set up. During the 1930s she relied on these procedures even when taking portraits in the field, and there is a staged look to many of her documentary studies. Working for *Fortune* magazine and then for *Life* from its foundation in 1936, she had deadlines to meet and had no time to waste. Her expertise and success set her apart from many of her contemporaries who were amateurs by contrast – Ben Shahn, for instance, and others on the FSA payroll. James Agee, author of *Let Us Now Praise Famous Men*, wrote sarcastically about her, although she may not have noticed. The provocation was *You Have Seen Their Faces* of 1937, in which her pictures accompanied a text by Erskine Caldwell, the author of *Tobacco Road.*

AUGUSTA, GEORGIA. 1936

The caption, written by Erskine Caldwell for *You Have Seen Their Faces*, runs as follows: 'Everybody likes to fish, but nobody likes to rustle up bait, so I expect that's why I make a sizable living.' To judge by his coat he was out in all weathers. Handwritten adverts feature in American documentary of the 1930s. This one with its list of species of bait was meant for specialists.

Augusta, Georgia. 1936

Caldwell's caption runs thus: 'She's caught so many crickets she's got so now she sets like one.' The various kinds of live bait listed on the board must have been kept in the row of containers watched over by the girl whilst her father was out hunting.

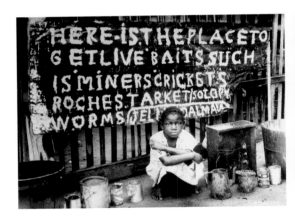

In 1934 Bourke-White was sent on assignment by *Fortune* to the American Dust Bowl stretching from the Dakotas in the north to the Texas Panhandle. Shocked by what she saw, she determined to do what she could and to give up her advertising work, at which she made a lot of money. She agreed with Erskine Caldwell to begin a book on the Deep South starting on June 11, 1936. Caldwell was a quiet man, a good listener and a deft writer. As a Georgian he also knew the language of the area. The book with its seventy-five pictures and Caldwell's texts is both entertaining and poignant. A reviewer referred to 'the magic bitterness' of the text. Such eloquent 'speaking likenesses' are unequalled in photography, even if Caldwell did most of the speaking. The era of eloquence didn't last long. It was implicit in Bourke-White's book on Russia (1931) where her text had the familiarity and flow of speech. Caldwell completed the process to perfection. Thereafter photographers looked for other kinds of more visual closure. Making a match between speech and image was too difficult, for it needed not just local knowledge but a local audience, too, which might understand the language.

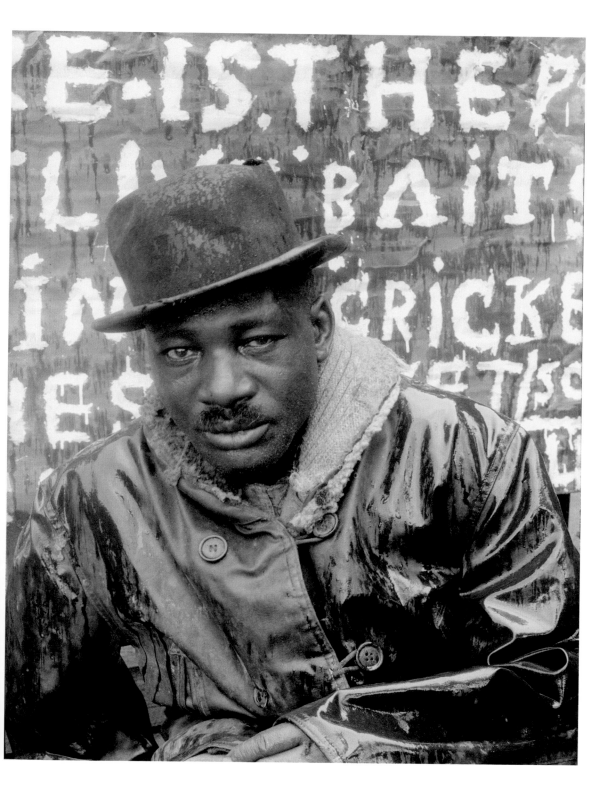

EDWARD WESTON

1886–1958 Weston's is a foundation story –
and as compelling as any ever was. He redeemed
the medium – for a while, anyway. Like Stieglitz,
the great precursor, he feared mediocrity and
was driven by that fear. He had more first-hand
experience than Stieglitz and thus more to fear.
He trained as a commercial photographer in Chicago
and in 1911 opened his own portrait studio in Tropico,
later part of Glendale in the Los Angeles area.
His sister lived nearby and it was there that he met
his first wife, Flora Chandler. By 1919 they had four
children. Weston was ambitious but discontented,
conscious of his own unfulfilled potential in a
medium which had been undervalued. He was
a successful pictorialist, making nicely designed
pictures in soft focus – up to 1923. Pictorialism,
though, was on the way out; and the portraiture
through which he earned a living was irksome.
He had noteworthy friends: the mysterious dancer
Ramiel McGehee and the photographer Margrethe
Mather, whom he met in 1913 and who became
an important influence. Excited by an account
of Mexico City as an 'artists' paradise', he decided
to try his luck in 1923. He would set up shop
there assisted by the trainee photographer Tina
Modotti. It was her husband, the painter Roubain
de l'Abrie Richey, who had recommended Mexico
City, just before succumbing to cholera in 1922.

NUDE. 1923
The body is that of Margrethe Mather, on Redondo
Beach in California. The sun, somewhere to the upper
left, makes some unreliable disclosures. Her right
breast, for instance, is adjusted by the shadow of
the parasol. Her left breast, in its turn, emerges
from a range of half lights and shadows. The parasol,
it seems, has been placed laterally to the sun
– to judge from the shadows cast on her thigh and
on the sand. That segment of the sunshade, with its
spokes, looks like an emblem of the sun with its rays.
Weston's pictures from the 1920s are characterized
by spatial puzzles of the sort suggested here.

Tina on the Azotea. 1924
The *azotea* was the flat roof of their house
in Mexico City. She appears to be stretching
and awakening, and has her origin in some
of Michelangelo's encumbered figures – his *Dying
Slave*, for instance, in the Louvre. She was taken
thus, in all likelihood, for the sake of Diego Rivera
who in 1924 undertook the decoration of an
agricultural institute at Chapingo in Mexico. Rivera
asked her to model for him – for subjects such as
'Germination' – but Weston thought it best to send
photographs. Weston and Modotti were lovers, and
even in love, but one was as faithless as the other.

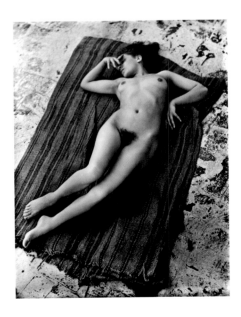

Weston was inspired by the idea that there was a centre to art's events and that it was elsewhere. In the 1920s this centre was often identified with Paris, but Mexico City made strong claims too – and for Weston it was a lot closer. Mexico in the early 1920s had just emerged from a revolution and years of civil war. It was 'beginning again' (Octavio Paz), which meant rediscovering its indigenous traditions. Weston imagined that the Mexican renaissance would give him more strength than he could ever find in bourgeois California.

EDWARD WESTON

In the summer of 1923, aged thirty-seven, Weston sailed for Mexico, accompanied by Tina Modotti, who was to be his apprentice, assistant and translator, and Chandler, his thirteen-year-old son. It was an odd way to make a break with the past. He lived there for eighteen months. He returned to Mexico in the summer of 1925 and stayed there until late in 1926. On his second visit he was paid to make pictures for Anita Brenner's book on Mexican folklore, *Idols and Altars*. An exhibition at the Aztec Land Gallery in Mexico City in 1923 made a reputation for him and introduced him to the muralist Diego Rivera. Even though fêted, Weston was up against it in Mexico: there was political trouble, and he was mostly impoverished. None the less, Mexico made a difference, for it brought him finally to 'the thing itself'. Stieglitz had spoken to him of this 'thing' in New York in 1922. It was in Mexico, however, that he finally found it.

WASHBOWL. 1925
The bathroom had wheel motifs in mosaic on the floor. The two pipes to either side may be made of polished copper and lead to the taps above. The drain pipe from the sink is partly concealed. The metal bowl under the sink is propped on its edge and held on a pad. It touches the pipes and is held upright by the U-bend of the outlet pipe. With some effort you can work out the space indicated by these elements, moving by stages from observation towards a provisional sense of just how things are placed.

Casa de Vecindad. 1926
It is a courtyard in a laundry and there is a figure working at one of the tanks in the background. Some shadows disclose the angle of the sun and, with a little attention, some of the washing can be identified. What seem like shadows in the middle distance turn out to be black gauze sheets. A documentarist proper would want to give information on the laundry trade but this picture was made for the pleasure of investigation: checking, discerning and noting changes in scale.

Photographers had taken complex spaces almost from the beginning, sometimes presenting them as labyrinths. Weston's generation, born in the 1880s, made pictures of gantries, cranes and girders, and these can be hard to decipher. There is, though, nothing sublime about Weston's handbasin and even if the laundry is intricate it is not intimidating. Weston's procedure was to start with a given, some kind of figured ground such as a courtyard, and to build on that. Discerning how things stand in relation to that base means that they are taken into account and scrutinized. Under the sink, for instance, the pipes shine as they ascend and the bowl gleams modestly. To be 'a thing itself' the thing had to qualify, to be remarkable even if taken for granted. The photographer's job was to stage these discreet items so that via a process they came to attention. Weston decried art and lauded photography – and this was what he meant by photography.

EDWARD WESTON

Weston returned from Mexico in 1927 to his old work as a portraitist. Prompted by a local painter, Henrietta Shaw, he began to make expressive still-life studies – of nautilus shells to begin with, followed by bananas and gourds. He tried to establish himself as a portraitist in San Francisco, for his studio in Glendale, Los Angeles, had been overtaken by development. In January 1929 he moved to Carmel, on the coast to the south of San Francisco, and he remained there until 1934. At Carmel, well away from the city, he continued to make vegetable still lifes and he began to take pictures at the nearby Point Lobos – Point of the Sea Wolves (sea-lions). Monterey cypresses grew on the point, which was bought by the State of California as a reserve in 1933. Thirty pictures of the coastline, of eroded rocks and vegetation were published in 1950 in *My Camera on Point Lobos*. Even though impoverished, his reputation grew. In 1932 he was a founding member of the f/64 group, set up by Californian photographers, and fifty of his pictures were published in *The Art of Edward Weston*.

PEPPER. 1930
Peppers attracted him 'because of their extraordinary surface texture, because of the power, the force suggested in their amazing convolutions' – from his daybook, which is a primary source for much of his life and work. These supple folds might be seen, say, as bronze musculature from Rodin's sculptures for the *Gates of Hell*: shoulders and limbs in a kind of elegant torment. No one, though, could say for sure what the image might mean beyond its being forceful.

Cypress Root. 1929
The Monterey cypresses on Point Lobos could look more dead than alive, although their desiccated roots could be taken for running water too. Abraded over the years such roots reveal unexpected formations: patterns and features reminiscent of eyes and fingers – depending on your state of mind.

Ansel Adams, Weston's younger colleague in f/64, took pictures in similar areas but liked to compose with distinct elements: a rock and a tree rather than just one or the other. Weston's pictures don't have such differences. They are suggestive – not conclusive. For Weston photography was a process of psychological scanning. He found areas, such as Point Lobos, which looked promising and he investigated and took pictures of materials which looked right. Point Lobos was especially valuable to him because it was subject to seasonal change and to the weather, which made it reliably unpredictable. The sun at different times of day would bring out different features in rocks and roots. He could identify imagery which was imbued with force, because he had the right instinct and intuitions. This idea of the instinctive took hold in photography, in part because Weston embodied it to such a high degree, but it was most exploited in urban settings where it was harder to apply for any length of time.

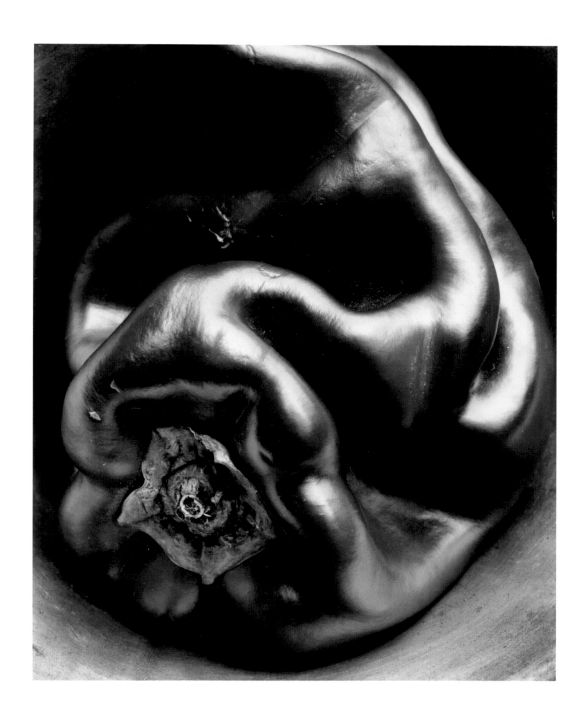

EDWARD WESTON

Weston's love life was prolific. His first marriage yielded four sons, who remained close to him. Nos. 2 and 4, Brett and Cole, became photographers, and Brett was a member of f/64. Tina Modotti was his first long-term mistress in the early 1920s. He lived with the photographer Sonya Noskowiak between 1929 and 1931 and finally married Charis Wilson in 1939. He was charismatic, to say the least, and on his return from Mexico had numerous affairs (between twenty and thirty), sometimes simultaneously. His daybooks and letters have been preserved, and seem to tell all. He was seen, by himself and by others, as a force of nature. Relationships broke up when they had reached their natural term and he often stayed in touch. The affairs and the photography seem to have been part of the same creative endeavour. His pictures, mostly taken with an 8 x 10 inch view camera, gave him a closeness to nature which he craved. To be so closely implicated in the earth's fabric might have reconciled him to mortality.

DUNES, OCEANO. 1936

In 1935 Weston moved to Santa Monica, on the seaward side of Los Angeles, and set up a portrait studio with his son Brett. He took many pictures in the dunes at Oceano north of Los Angeles on the way to Carmel, showing them rippled and patterned by the wind. They have been shaped by nature, registered as an external force similar to the one which abraded the roots of the cypress trees at Point Lobos. The dunes, though, are intricate and often ambiguous in their spaces, looking like labyrinths. This one has been investigated by a creature whose footprints can be seen.

Nude. 1936

In 1934 he met Charis Wilson, who posed for him on the sands at Oceano. Here she seems to be falling down a precipitous slope as if rehearsing a part in a Last Judgement. Or she may be in ecstasy, just like Danaë who was ravished by Jupiter disguised as a shower of golden coins – see Titian, and then Rembrandt. More than likely Wilson and Weston had their own ideas, but that of the loves of the gods must sometimes have occurred to them.

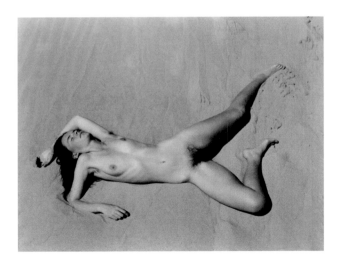

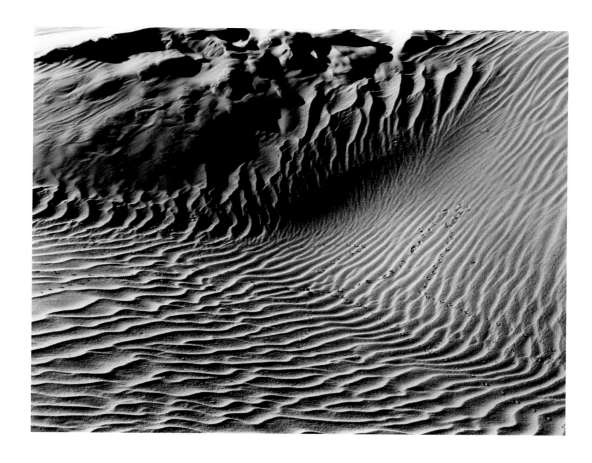

The dunes at Oceano may have been labyrinthine, and the bird, whose tracks are just visible, may not
have been able to make up its mind; and the ensemble may reflect on Weston's psyche
in 1936. But because the pictures only suggest meaning, they remain as possibilities;
and as such they can be looked at for long enough. Perhaps Weston understood them
as relevant enigmas. It should be remembered, too, that the prints were only part of the
process which began with the finding of the image and its assessment on the glass screen
of the viewfinder. This was the intuitive moment followed, often much later, by development
and printing, when further judgements took place. The active life of the picture began and
ended with the photographer in two frames of mind. In phase one, the moment of exposure,
the proposal was made, and in phase two it was wondered at.

EDWARD WESTON

In March 1937 Weston secured a Guggenheim Award of 2000 dollars so that he could 'continue an epic series of photographs of the West, begun about 1929'. It was the first such award to have been given to a photographer, and it was geared to the more sedentary life of poets. Weston had been encouraged to apply by Charis Wilson, and she organized the venture. The low level of the award meant that they lived and slept out of doors and didn't get much further than California, which was big enough anyway. They travelled in a car sponsored by the southern California Auto Club magazine *Westways* and planned their journeys to avoid extremes of weather. All told Weston took around 1500 negatives or a quarter of his life's work in that period – which was extended by a year to permit printing. An account of their explorations was published in *California and the West*, with an interesting text by Charis Wilson (1940). In 1941 Weston undertook another journey in the USA to illustrate Walt Whitman's *Leaves of Grass* (1855). In 1946 the Museum of Modern Art in New York honoured him with a retrospective of 250 prints. By then he was showing signs of Parkinson's disease which would blight the rest of his life.

TOMALES BAY. 1937
These are oyster beds on the coast forty miles north of San Francisco. Weston told the Guggenheim committee about an 'epic series' of pictures which he meant to continue, but he can't have known how his survey would turn out for he had little experience of being on the road. At Tomales Bay, from the tribal word for a bay, he found this and other landscapes, which suggest remnants at the end of Time. Humanity, on the evidence of many of the Guggenheim pictures, has been and recently gone, leaving no more than a few bones, shards and scraps of splintered wood.

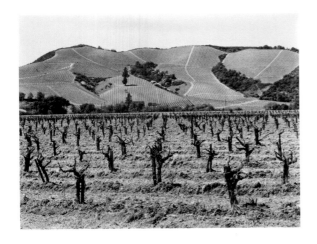

Vineyard, Clear Lake, California. 1939?
Charis Wilson says that he looked for two years for a satisfactory picture of grape stumps, which would locate this in 1939. Clear Lake lies to the north of San Francisco. The gesturing grape stumps stand in echelon tied to their stakes. Beyond that they cover the wilder hills, rising almost to the ridge, like colonists, or alien settlers, or a conformist army.

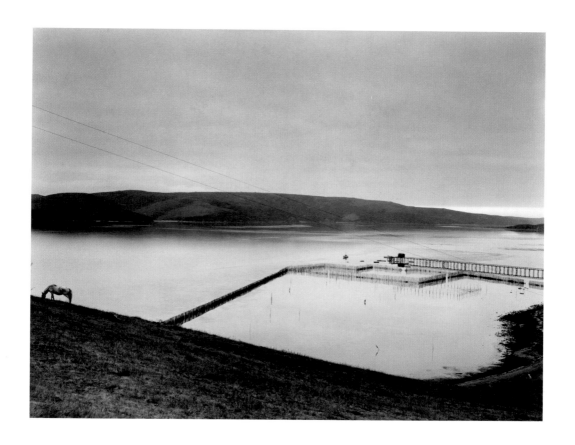

In 1937 Weston set out with an intention, which was to take pictures in California and some adjoining
states, but he had no programme. The state of the nation wasn't his responsibility, even
if he disliked aspects of the new world order represented by suburbia and the clients
in his portrait studio. He took things as they cropped up, taking it for granted that his
choices would resonate elsewhere. Contemporaries such as Dorothea Lange and the FSA
photographers wanted to benefit mankind. Weston wasn't exactly sceptical about the wider
world but realized that his own responses were the only ones he could know with any
confidence. In this respect he was a prototype for his successors in the 1950s and '60s.

PAUL STRAND

1890–1976

Paul Stransky was born in New York City. His father was from Bohemia. Studying at New York's Ethical Culture School, he met Lewis Hine, then an assistant biology teacher. Hine set up a photography class and the young Strand enrolled. Hine took his students to see Alfred Stieglitz's gallery at 291 Fifth Avenue, and when Strand left school in 1909 he joined the New York Camera Club, and in 1912 set up as a portrait photographer. Strand, one of the most single-minded of photographers, continued to visit the Stieglitz gallery, often to see the new European painting which it exhibited. In 1914–15, under the influence of the new painting, he turned from soft-focus pictorialism towards abstraction. In October 1916 Stieglitz published six of Strand's pictures in *Camera Work* and another eleven in the magazine's final issue in 1917. The pictures of 1917, described by Stieglitz as 'brutally direct', made Strand's reputation.

WALL STREET, NEW YORK. 1915
This picture was published by Stieglitz in 1916. The early pictures show that Strand was experimenting with modular formats complemented by such irregular items as these passers-by. In three of the six pictures of 1916 humanity strides out, each figure a study in itself. He may not even have intended to show Wall Street in a bad light, even if later on he spoke of its 'sinister windows – blind shapes'.

Blind Woman, New York. 1916
She appeared in *Camera Work* in 1917, and she, too, occupies a place in the hall of fame. Blind she may be, but she still keeps an eye open. The number says that she is a licensed beggar. Strand took the picture with the aid of a right-angle viewfinder. Many years later (1971) he said that he took this picture to see if he could take a picture in the street without people being aware of it. In 1912 in *Camera Work* comparable pictures of street people had appeared, taken by Adolf de Meyer in London, but they do look like portraits of character actors.

Strand, in his early years, liked procedures. He was an experimental artist curious to see what would emerge from the kind of two-part scheme which resulted in *Wall Street*. In 1915–16 he may have learned from both Lewis Hine and Alfred Stieglitz, but even so had no project of his own – that would come later. In the absence of any aesthetic which he could call his own, there was no option but to investigate and to base these investigations on what had gone before. With the study accomplished he moved on. He may not even have intended to continue as a photographer because by 1916 he had met Charles Sheeler, a painter and photographer from Philadelphia. On moving to New York in 1919 Sheeler bought a motion picture camera (a French Debrie L'Interview Type 'e') and in company with Strand produced *Manhatta* (1921), a seven-minute portrait of New York City. In 1922 Strand purchased his own movie camera, an Akeley, which he used during the 1920s for news and sports reportage.

After a brisk beginning Strand took some time to get his bearings. In 1918, for example, he was inducted into the army where he served as an X-ray technician. With Charles Sheeler he took up cinematography, and he continued to know Alfred Stieglitz, who continued to be a great influence on him – for better or worse. Strand's output in the 1920s was desultory, and it may be that Stieglitz's credos were inhibiting. Strand, writing in 1922 and 1923, uses phrases like 'a new and living act of vision' and 'a profound feeling and experience of life'. Photographs, under these terms of reference, had to be intuited, and you could fail to get a good result or to 'create a living organism' without quite knowing why – except that you weren't equal to the task. Strand continued to take pictures during free time and on visits to Georgetown Island, Maine – at the home of the sculptor Gaston Lachaise. In 1929 he helped Stieglitz establish his gallery An American Place.

TOADSTOOL AND GRASSES, GEORGETOWN, MAINE. 1928

In this cruel scene sharp grasses touch and cut into the tender gills of a fungus. Writing earlier in the 1920s, Strand mentions 'differentiated time' and the possibility that a photograph can put together many moments in one. These grasses touching and cutting the rim of the toadstool indicate such a series of moments. Elsewhere he writes of pictures by Stieglitz where 'every object, every blade of grass, is felt and accounted for'.

White shed, Fox River, Gaspé, Canada. 1929

The Gaspé Peninsula projects into the Gulf of St. Lawrence. Strand took pictures there in September using a medium-format Graflex camera. Here the sun shines and throws some shadows. The dilapidated fence runs at an angle down the slope, counterpointing the four barrels and the dark door. Baulks of timber lean against walls, and that pole on the rooftop bends in the wind. The scene invites careful inspection and seems to fit together. Strand liked the idea that the photographer was a craftsman who took 'camera materials' (which might be anything at all) and put them into form 'as vision, as song, as some kind of clear saying ...'. As a prerequisite the photographer had to have experience and to have lived 'deeply and beautifully' (from a letter of September 11, 1931).

In this Gaspé picture, as in others from the same journey, elements just touch or sometimes overlap to make an image which is really a still life, a disinterested study. It might even be a piece of machinery which works elegantly to no purpose other than that of aesthetic satisfaction. Critics wondered what had become of the fishing community which was such a feature of the peninsula, and Strand took those criticisms to heart, but at the time he was thinking about integrated imagery – somewhat in the manner of Cézanne, where the planes of figure and ground are given equal attention.

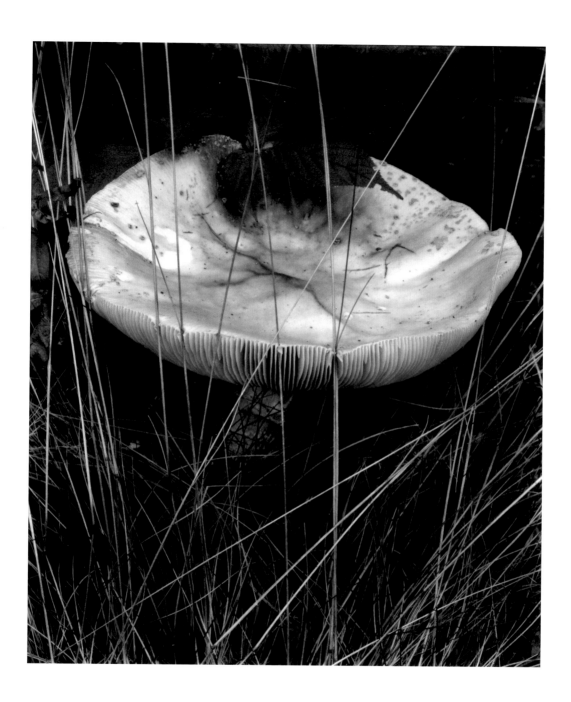

Strand had high hopes, both for himself as an artist and for society at large. During the 1920s he wrote of energies leading to 'a living future'. Photography would contribute to 'universal expression'. Photographers, like everyone else, were caught up in nature's drive towards perfection, but they were even better placed than all the others because their medium, with its objective qualities, had access to the truth. Hence his hostility to artistic photography where handwork obscured the purity of the negative. His beliefs, like those of Stieglitz, were fervently held and gave to photography a standing which it never quite lost afterwards. He subscribed, in fact, to *life philosophy*, a tendency of the period. But if he was to make a difference he had to work with others, and towards the end of the 1920s he moved Left. In 1932 he advised the Group Theater in New York – a collective enterprise directed by Harold Clurman. He was attracted to Mexico, which at the time looked like a socialist society in the making. In October 1933 he became chief of the department of photography and cinematography in the Mexican Secretariat of Public Education, where he remained until December 1934.

RANCHOS DE TAOS CHURCH, NEW MEXICO. 1931

This church of San Francisco de Assisi was completed in 1755. Strand, who was in northern Mexico in 1926, 1930, 1931 and 1932, took many pictures of this building. In 1931 he wrote to Alfred Stieglitz: 'It is a strange and miraculous country, every day brilliant sun and this black violence usually somewhere on the horizon – appearing as though by magic – disappearing as quickly –.' In 1946, with respect to the church, he spoke of trying 'to see whether you couldn't get a very big feeling into a small thing'. Apart from what look like beam ends at the top of the apse wall there are few points of reference and comparison.

Man, Tenancingo, Mexico. 1933

Tenancingo lies to the south-west of Mexico City. The man appears in *Photographs of Mexico* (1940), a portfolio of photogravures, next to a picture of a vernacular sculpture of Christ Crowned with Thorns. Strand's implication is that this, too, is a Man of Sorrows, as well as a representative of indigenous people cruelly treated by invaders.

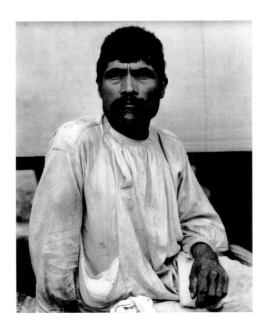

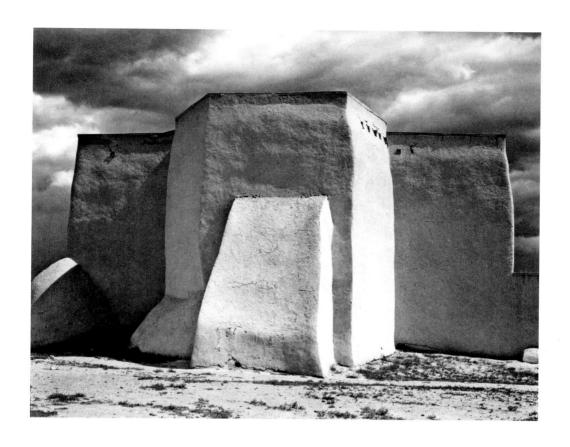

Although on the Left, Strand often referred to Christian imagery: the Lamentation, the Man of Sorrows and the Virgin of Solitude. The idea was to use motifs which were familiar to the people. Apart from that he liked 'the Christs and Madonnas, carved out of wood by the Indians'. This man, who looks so gravely into the distance, is typical of many of Strand's subjects. There was something very serious in Strand's character and demeanour which transmitted itself to the portraits. Nor, despite his Marxist tendencies, was he ever very interested in the urban working classes, preferring to take pictures amongst the peasantry.

PAUL STRAND

In 1935 he went to Moscow, hoping to work as an assistant to the film-maker Eisenstein. Unable to get a work permit, he returned to New York and joined Nykino (new cinema) and then the Photo League in 1938. He became active in third-party political movements in the USA, including the American Labor Party. Nykino became Frontier Films, with Strand as president. He photographed and directed *Native Land*, on oppression and exploitation in the USA during the 1930s. He worked for government agencies, making films in Hollywood, and around 1943 took up still photography again, making pictures which would appear in *Time in New England* in 1950, by which time he had quit the USA to live in France. His connection with Frontier Films meant that he was under suspicion of un-American activities and might well have been black-listed had he remained. His French pictures came out in *La France de Profil* in 1952, a book on folk and folklife, followed in 1955 by *Un Paese*, on life in the Italian village of Luzzara. *Tir a'Mhurain* (1962) featured life and landscape in South Uist in the Hebrides, and *Living Egypt* (1969) was selected from pictures taken on a long visit to Egypt in 1959. In 1963 he took pictures in Ghana, published in *Ghana: An African Portrait* (1976).

TAILOR'S APPRENTICE, LUZZARA, ITALY. 1953

Novella Pedrolina lived at Luzzara in the Po Valley in northern Italy, which was the setting for *Un Paese*, written by Cesare Zavattini, whose birthplace it was. She represents youth, for that is a sapling to the right. The people of the village, who were poor, braided straw for use in hats such as the one she holds. Perhaps she borrowed the hat from an elder, and it may be there to give shape to the scene.

Lusetti Family, Luzzara, Italy. 1953

The doorway, with its step, makes up a stage on which the family members present themselves. A few objects arranged on the lintel above make a rhyme with the figures below.

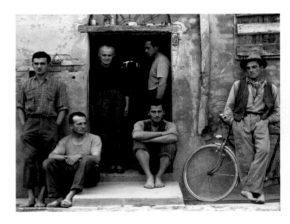

In a letter of April 28, 1953 Strand wrote about portraiture as a lost art – since Cézanne and Van Gogh. Strand's intention was to photograph people 'to make others care about them by revealing the core of their humanness'. It wasn't necessary 'to be acquainted with the subject in order to have from the portrait complete aesthetic and human satisfaction'. What did he mean by 'complete human and aesthetic satisfaction'? These two portraits are discreetly artful. The range of objects placed along the lintel above the door reflect on and even mimic the diversity of the Lusetti menfolk. Novella Pedrolina, a very composed young person, has her dignity enhanced by that set of four black buttons each of which catches the light a little differently. They give a sense of orderliness and decorum, as does the woven hat. Strand was attentive to the suggestions made by such motifs – see, for example, those fastidious buttons glinting on the shirt of the Lusetti man standing to the left.

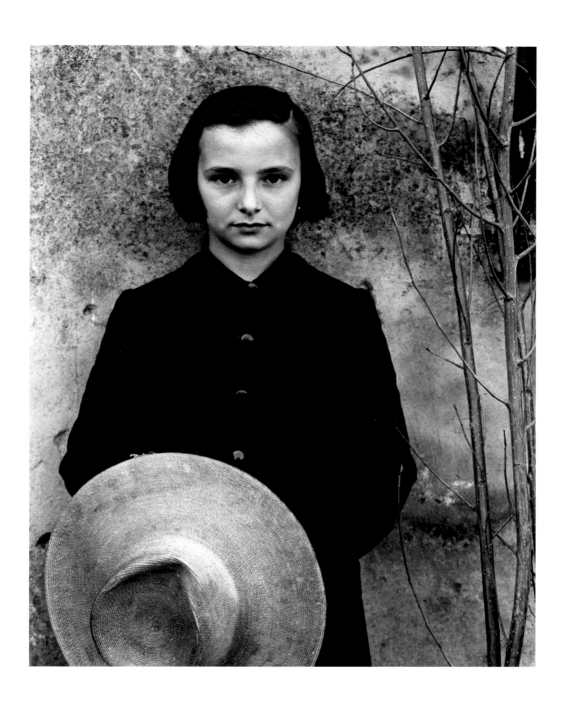

ALBERT RENGER-PATZSCH

1897–1966

Renger-Patzsch was born in Würzburg and brought up mainly in Dresden. His father, who ran an art and music shop, was also an amateur art photographer of some standing. Albert studied chemistry and in the early 1920s went to work as a photographer at the Folkwang publishing house in Hagen, just south of Dortmund. He was in photography almost all his life, sometimes working for publishers and museums and sometimes as a freelancer. He took pictures of plants and flowers, architecture and landscape. In Germany during the 1920s there was an interest in survey photography of regions and cities, flora and fauna. It was educational publishing which took stock of the nation's resources. Renger-Patzsch was an expert technician with medium- and large-format cameras, and a purist, too. He didn't like artistic tricks, as practised by his father's generation before the war; nor did he like the output of the new miniature cameras of the 1920s – good, in his eyes, only for holiday pictures. His purist style was admired and copied. In 1928 his pictures were collected in what would become one of photography's best-known books, *Die Welt ist schön* [The world is beautiful]: nature pictures often in close-up, technical and industrial scenes and fragmented landscapes and buildings. Walter Benjamin, the critic, claimed that his objective manner obscured the contexts in which items functioned, their human connections in particular. Benjamin may not have examined the images closely enough.

SHOEMAKING IRONS, FAGUS WORKS, ALFELD. 1936

In 1926 Renger-Patzsch was a freelancer living at Bad Harzburg in the Harz mountains. The Fagus factory was not far away at Alfeld, to the north-west. He must have been asked to make some publicity pictures of new equipment, and the image eventually found its way into *Die Welt ist schön*, where the irons in echelon look as if they might stand for contemporary regimentation. They are, however, electric irons and were probably heated up prior to use at special sockets. Light glints on their curved surfaces, suggestive of heat. Plugged in they would become alive.

Adder's Head. 1925

Although a pioneer of objective photography, Renger-Patzsch was always aware of the life force within. The charged irons would be hot to the touch. In 1925 he took a picture of an adder's head in close-up, so that you can examine the configuration of the scales and how they lie. You feel that you could lift them with your fingernail where they overlap – but better not to, for the snake is alert and poised, ready, perhaps, to strike. The many plants he photographed in the early 1920s also signal caution, for they are guarded by spikes and serrated edges – and some are fly-traps.

In German Expressionism (c. 1910–14) energy infuses and shapes the image. Renger-Patzsch, in the 1920s, is just as interested in force, but he associates it with stillness: heightened alertness, gathering, the moment before the strike.

He wrote little about his aesthetics. He was a working photographer and undertook architectural and industrial commissions. There is even something a little perverse about his choice of topics. His first landscape book, for example, was on *Die Halligen* (1927), a group of islands off the Friesian coast, not far from the Danish frontier. In 1936 he devised a book on *Sylt*, an island very close to Denmark. In 1927 he began to photograph in the Ruhr area, Germany's industrial heartland named after the river Ruhr – which joins the Rhine at Duisburg. The Ruhr, although important, is hardly picturesque and Renger-Patzsch never suggests otherwise. Many of his landscapes of the 1920s are in a sparse style which gives notice of much German landscape photography of the 1990s. There is, however, a world of difference, for Renger-Patzsch in the Ruhr was always attentive to something that might be called immanence, made up of the pressures of history, trade and mere traffic.

COUNTRY ROAD NEAR ESSEN. 1929

It looks like a picture which might have been taken by road engineers for future reference. That is a bridge in the distance and the river seems to wind around to the left. The road itself is on an elevated causeway, probably to guard against flooding. The cement posts have been painted white for the sake of visibility at night, and they look strong enough to keep vehicles from plunging over the embankment. The crisp kerbstones in the foreground would keep traffic from the footpath at the corner. The road, the river and even the slag heaps in the distance all point to elsewhere: headwaters, underground, other towns and cities. The whited posts bring day and night to mind. The picture is a cross-section, readable in terms of geography and geology, expressed by the river and the slag heaps, and in terms of human intentions, signalled by the road with its features.

Slag Heaps. 1929

Here Renger-Patzsch works with a similar range of features. The railway line, road and path lead elsewhere, to the larger world beyond. The spoil heaps, which are notoriously unstable structures, have been eroded by downpours. There are other signs of erosion: an erratic gutter across the foreground and a path worn bare by feet. A taut wire sustains a pole off-stage, and the fence is propped up by a metal bar.

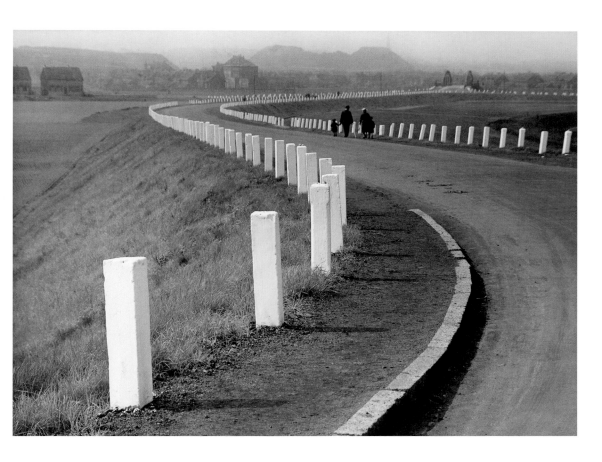

His landscape pictures are of sites acted on by weather and by passing traffic. He invokes history, but
so discreetly that it might almost be nature itself. The landscapes, with their finely judged
range of details, bring together nature's elements – raining and blowing, warming and
cooling – and humanity's expedients. The Ruhr, with its rather pared-down scenery, provided
him with what amount to diagrams through which he could express what was in effect
a pioneering example of ecological awareness.

LÁSZLÓ MOHOLY-NAGY

1895–1946

A visionary, and one of the most influential of all modernists, Moholy-Nagy began to make photograms in 1922, and he continued to do so when he went to work for Walter Gropius at the Bauhaus in 1923. Born at Bácsborsòd in Hungary, he studied law for a while before serving in the Great War in the Austro-Hungarian army. He was wounded in 1917 and after time in Budapest moved to Berlin in 1920. He lived in a cultural climate where great things were expected of art as a redemptive force. Artists formed collectives, spoke at conferences and often disagreed as to the way ahead. Although accused sometimes of subjectivism, Moholy-Nagy believed in collective work intended for the common good – and this is reflected in his Bauhaus teaching schemes. By 1925 he was a major force in the Bauhaus and spoke of the victory of photography over traditional painting. In 1928 he resigned from the Bauhaus after a dispute over the need for vocational training. He believed in the enhancement of self-awareness, and expressed himself clearly in *the new vision*, his last Bauhaus book, published in 1929.

DOLLS, ASCONA. 1926

The photographer said that the segments and shadows provided an eerie setting for the dolls – or moved them 'into the realm of the fantastic'. László and his wife Lucia were on holiday in Ascona, Switzerland, with Oscar Schlemmer and his family. Schlemmer taught figure drawing in the Bauhaus. His contoured images precisely placed in segmented settings might have prompted this photograph. The dolls look as if they are sliding downhill in a catastrophe. The lattice work with its reflections suggests constraint, and it should be remembered that Moholy-Nagy's view of mankind was pessimistic: creatures in thrall to bad habits.

Belle-Île-en-Mer. 1925

The man at the table is Siegfried Giedion, author in 1941 of *Space, Time and Architecture* and in 1948 of *Mechanization Takes Command*. Like Moholy-Nagy, he was interested in the gap between thought and feeling and in the causes of contemporary alienation. In 1925 they were on holiday at this site off the coast of Brittany. Giedion described the picture as a new beginning, made up of the simplest elements seen on the same plane and in relation to each other. The new photo vision of about 1930 was often attributed to Moholy-Nagy, and it was on such ordinary sites as this that it was discovered.

Moholy's vision was worthy of the name. Many of his contemporaries took only the form without any of the substance: sharp and surprising angles taken simply for effect. Moholy-Nagy, on the other hand, had both a diagnosis and a remedy. In his opinion many of his contemporaries were no more than specialists, unable to imagine alternative and better worlds. To achieve full human potential mankind had to think in terms of a world without boundaries. Giedion's space, for example, is accessed by a choice of staircases and serves as a vantage point.

LÁSZLÓ MOHOLY-NAGY

After leaving the Bauhaus in 1928 his career fragmented. He participated in the 'Film und Foto' exhibition in Stuttgart in 1929 – one of the great events in modernist photography. He worked as a stage designer in Berlin, and started to make international contacts, in France, Britain and the USA. He left Europe in 1937 and set to work to establish a New Bauhaus in Chicago. This became the Institute of Design in 1944. In a revised and expanded edition of *the new vision*, no.1 in the series of New Bauhaus Books, 1939, he set out his agenda. Architecture fascinated him, for he felt that if space could be mastered people would benefit. They would heighten and harmonize their powers. This meant escaping from fixed enclosures into a realm in which there were only relationships between bodies. There was an evolutionary aspect to his thinking: the era of relativity had arrived, and it had to be recognized. His photographs, mostly taken in the 1920s, are trial pieces through which he was able to reflect on his proposals for a new world.

PHOTOGRAM. c.1922
He first wrote about photograms in the magazine *Broom* in March 1923, saying that he had made 'a few primitive attempts'. These involved passing light through fluids like water, oil, acids, crystal, metal, glass, tissue, etc. onto a screen or straight onto a sensitive plate or paper. With his first wife, Lucia, he continued to make these experiments during his Bauhaus years. At first the papers used were daylight papers onto which objects were placed in the light. Later they used faster gaslight papers. In this case they have achieved what looks like a planetary arrangement of items circulating in deep space – in a space, that is to say, where there appear to be only interrelationships and no fixed base.

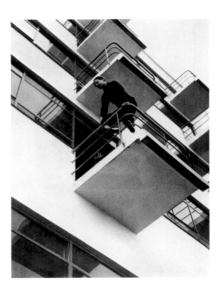

Bauhaus balconies at Dessau. 1926–28
This picture shows the segmented architecture of the Dessau building to perfection: balconies, balustrades and reflections. However, it also shows the student volunteer in a dangerous position, finely balanced on the corner.

What exactly were his pictures about? The gymnast on the balcony is running a risk. Moholy-Nagy had a taste for vertigo. He took pictures, for example, from the Eiffel Tower and within its complicated structure; and he also photographed from the top of the Transporter Bridge in Marseille harbour – in both cases dangerously unsupported. At sea and on quaysides passengers stand perilously close to hanks of rope; in the city builders balance on ladders. Humanity in many of his pictures is isolated and even threatened. Altogether there was something alarming about his credo with its stress on freedom. His vision is of an individual in a kinetic relation with the universe envisaged as a site traversed by fields of force and opening onto infinity. This taste for the sublime sets him apart from most modernists, who had little idea that their movement was anything other than a style.

ERICH SALOMON

1886–1944 He was a phenomenon, the pioneer
of 'candid photography'. His doctorate came from
legal studies completed in 1913. He had investigated
zoology and engineering before turning to law.
He came from an affluent German-Jewish background
in Berlin. His father was a banker and his mother's
family were publishers. Captured at the Marne early
in the Great War, he spent four years as a prisoner
which gave him an opportunity to become fluent
in French. The family fortune dissolved in the
1920s and he went into business unsuccessfully
in car and motorcycle rental. Then the publishers
Ullstein gave him a job in promotion, which somehow
involved him in legal actions regarding billboards.
To collect evidence he had to use a camera, and
his interest in photography was born. On family
outings at weekends he began to take pictures
for the Ullstein press. Exploiting new technology,
he began to take pictures in hitherto forbidden
zones: law courts, government offices and
international conferences. In effect, he discovered
reportage as it was practised thereafter.

**DR ERICH FREY CROSS-EXAMINING
A WITNESS**. 1928
In this, a very early courtroom picture, the lawyer
questions a witness, extreme left, during a trial
of a group of gangsters – 'Immertreu' [Ever-
loyal). Salomon took such pictures with a camera
concealed in a bowler hat. When discovered, as
he sometimes was, he handed packs of unexposed
film to the court ushers. To begin with he used
a small-scale Ermanox camera with a large lens
which made it possible to take pictures in low light.

Gustav Stresemann in a dining car. August 1928
Stresemann was travelling to Paris to sign the Briand-
Kellogg Pact with the French (the Pact of Paris).
Stresemann, German Foreign Minister for most of
the 1920s and founder of the German People's Party,
was admired throughout Europe as a statesman.
The pact of 1928 was seen as a final settlement
of the Great War, and there was widespread optimism
– soon invalidated by the American crash of 1929.
Stresemann's death in October 1929 was seen as
the beginning of the end, but in his lifetime he was
a guarantor of a negotiated future for Europe.
Salomon took a lot of pictures of Stresemann
and of his French counterpart, Aristide Briand.

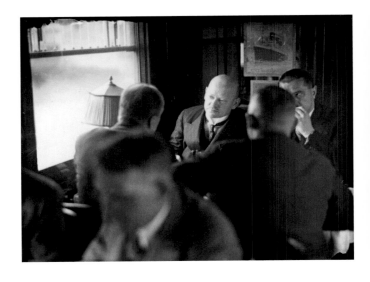

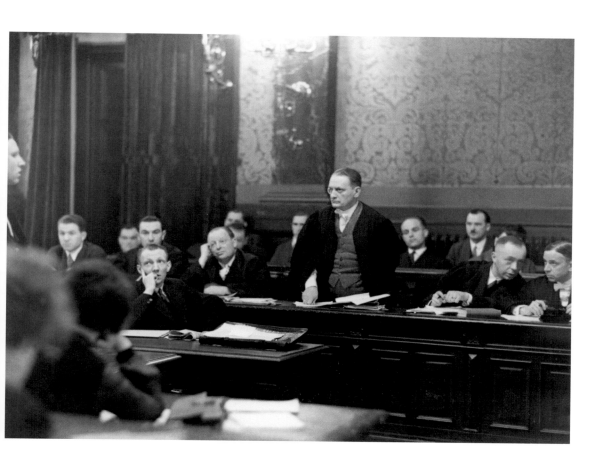

If Europe's hopes rested on the good judgement of statesmen such as Stresemann and Briand, there was every reason to find out about them. Before Salomon came on the scene, posed photographs of statesmen were available, but such pictures gave little away. Salomon's portraits, by contrast, show his subjects in action, speaking, listening and otherwise reacting. Stresemann always looks composed and intent, taking things in. Your confidence would be justified, for he must surely have weighed up the situation. This vision of politics as conversation wouldn't survive beyond 1933, but it is central to Salomon's art.

ERICH SALOMON

Salomon gained access to parliaments and conferences because he looked the part, spoke languages and knew when to make his moves. He sometimes carried his camera concealed in a briefcase but was eventually welcomed by conferring statesmen, who appreciated his pictures. In 1930 he left Ullstein and became an independent photographer. In 1931 his work to date was represented by 112 pictures of *Berühmte Zeitgenossen in unbewachten Augenblicken* [Famous contemporaries in unguarded moments]. The most famous of these were Gustav Stresemann, the German Foreign Minister, and Aristide Briand, the French Prime Minister, both of them conciliatory. A celebrity himself, Salomon travelled to Britain and to the USA. He took a lot of pictures at the League of Nations in Geneva. Shortly after the Nazis came to power in 1933, he left Berlin for The Hague, Netherlands. He was imprisoned in 1943, sent to Theresienstadt in Czechoslovakia, thence to Auschwitz, where he died in 1944.

NIGHT SITTING AT THE SECOND HAGUE CONFERENCE ON GERMAN/FRENCH WAR REPARATIONS, 11 P.M. 1930

Those involved, according to Salomon's notes, are (standing) Professor Hesnard, who was Briand's interpreter, and then (from left to right) Louis Loucheur, a French industrialist, deputy and frequent minister; André Tardieu, French Prime Minister; Julius Curtius, German Foreign Minister; and finally Henri Chéron, French Minister of Finance. With their backs to the camera: Moldenlauer and Dr Melchior, an expert. Salomon's conference pictures often require careful working out as to identity. He proposes a world of named individuals, which contrasts with that of the masses who were increasingly in evidence in the illustrated journals of the period.

NIGHT SITTING. PART 2, 1 A.M.

The French have fared badly, with Tardieu in a deep sleep, and Chéron struggling. Loucheur is feeling the pressure and Curtius remains wakeful. The two pictures appeared in *Berühmte Zeitgenossen* placed one over the other. Salomon was no satirist, but the pairing has an element of George Grosz about it. The milieu on which Salomon reported thought that business could be transacted by statesmen in armchairs. Dangerous populist forces were already waiting in the wings, stirred up by economic disintegration.

Salomon invented the inside story. He went behind the scenes. At The Hague in 1930, for example, he also photographed the cloakroom man who looked after the statesmen's hats. At the League of Nations his pictures include the translators and the recording equipment called for by the speeches. His courtrooms are staffed by clerks and subalterns. Afterwards documentarists applied the inside story across the board. Secondly, he envisaged events as extending through time, as having the kind of duration evident in the war reparations talks. Documentarists took this up in the 1930s and began to think in terms of a day in the life of almost anyone they came across: barmaids, waitresses, jockeys and workers everywhere.

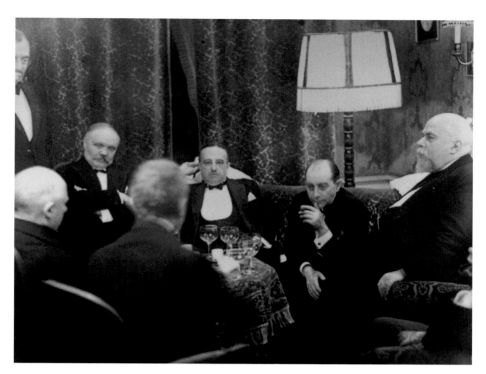

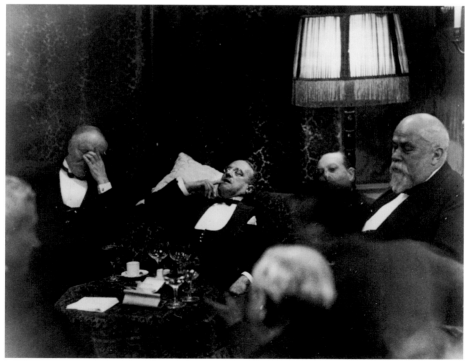

ANDRÉ KERTÉSZ

1894–1985 Born Kertész Andór in Budapest,
he went to an Academy of Commerce but didn't
excel. He tried his hand at gardening, and then
in 1912 became a bank clerk. He was interested
in visual art and his mother bought him a camera
which he shared with his brother. Conscription
in 1914 saved him from banking, but in January
1915 he contracted typhoid. In August he was
wounded. On recovery he seems to have served
as a military escort, which meant that he travelled
widely in the Austro-Hungarian empire: from Albania
to Romania, in today's terms. He took advantage
of his life in the army and photographed wherever
he went. He entered competitions and established
himself as a promising amateur photographer.
The end of the war saw him back in banking,
and in 1921 training as a beekeeper. Determined
to become a professional photographer, he moved
to Paris in October 1925 on a three-month visa.

**VILLAGE COUNCIL,
POMAZ, HUNGARY**. June 11, 1916
At the time, Kertész was recovering from his
wounds and a journey to Pomaz would not have
been out of the question for it lies just to the
north of Budapest. The picture was published on
March 25, 1917 in the picture magazine *Érdekes
Ujság* [Interesting news] as a competition winner.
It shows a group of local men talking amongst
themselves, with one of them seated on a stool.
They are looking towards some cattle at a watering
trough in the distance. Neither party seems
to be much interested in the other. Kertész liked
to show groups, and individuals too, at a good
distance one from the other – and increasingly
so during the 1920s. This is the point at which the
principle first becomes evident in his pictures.

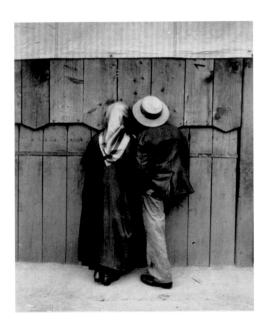

Circus. Budapest, May 19, 1920
They are peeping through boards at whatever
is going on in the circus. At least she is, to judge
from the gap. She may, in fact, be telling him what
she is seeing, for his board looks unpromising and
his head is also to one side, as if he were listening.
By the look of it he may also have only one leg,
and there would have been a lot of war-wounded
in Budapest at the time – as throughout Europe.
Kertész was interested in what it was to pay
attention: soldiers reading and writing letters home,
people lost in thought or engrossed in conversation.

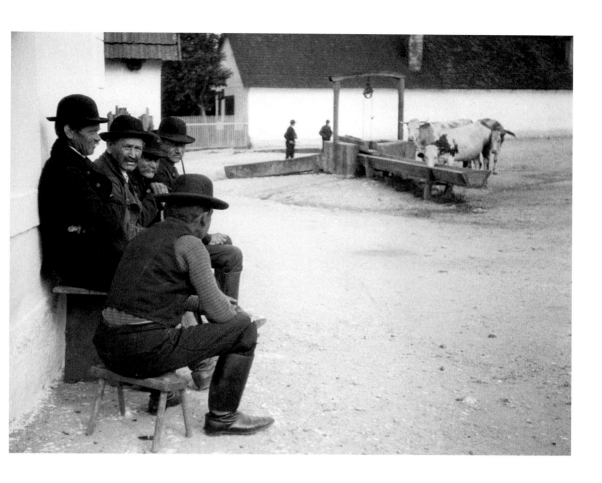

Kertész was apolitical, which means – in effect – that he was liberal. His early pictures, mostly on traditional Hungarian subjects, often feature individuals wrapped up in whatever it is that they are doing: feeding ducks, sweeping the street. In the army he must have remarked on people getting along together in the throng. Coexistence would become his topic: disparate groups and individuals sharing spaces without impinging. It may have been an instinct and a preference to begin with, but as the 1920s wore on, it would become a matter of urgency – an imperative, for Kertész and for all the other magazine photographers of the era.

ANDRÉ KERTÉSZ

In 1914 Kertész Andór went to war as an imperial subject. In 1918 he was demobilized as a Hungarian citizen. He returned to a constitutional monarchy, shortly to be replaced by a democracy. A revolution in 1919 established a communist regime, which was overthrown in its turn by the proto-fascist Admiral Horthy. Nationalism, although comforting, lives next door to parochialism. Global Paris looked attractive to many artists in the newly emerged states of eastern Europe. Kertész was no overnight success in Paris. He had trouble with the language, took low-level jobs and often changed his address. His supportive family supplied him with a new camera, a Goerz Ango Anschutz 10 x 12.5 cm, but in 1926 asked him to return home. He persisted, however, making portraits and taking pictures for and of painters and architects. In 1927 he exhibited forty-two photographs at a left-bank gallery, Au Sacre du Printemps. Following the theft of his Goerz in 1928, he eventually bought a Leica, the camera of choice for a new generation of photo-reporters.

MONDRIAN'S GLASSES AND PIPE. 1926

Michel Seuphor, a Belgian poet, introduced Kertész to Piet Mondrian in 1926. Kertész visited Mondrian six times, according to his diary, and may have been asked to take pictures of the painter's studio and work. If so, they were not published at the time. Mondrian, who was a formidable theorist, liked to make distinctions between essentials and inessentials. Thus the pipe, spectacles and sugarbowl ashtray might have been intended as attributes. The essential Mondrian might be conveyed by the geometrical background. In other words, Kertész might have been prompted by the idea of Mondrian to make this displaced or mediated portrait.

Fork. 1928

Fork, along with *Mondrian's glasses and pipe*, helped confirm Kertész's reputation in 1928. He made another picture around this time of a spoon in a bowl with three lumps of sugar and he may have intended a series on kitchen utensils. Or he may just have been interested in the arrangement of simple objects in shallow spaces.

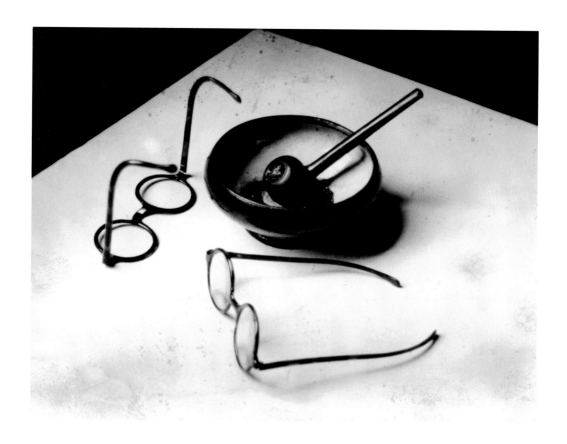

Photographers are no more prescient than other people, and it must have looked to Kertész as if photography would become a branch of print-making, like lithography or etching. An ideal photograph would be a scrupulously realized miniature fit for exhibition on the walls of a gallery. *Fork*, for instance, is all about nice judgement, about the fall of light on the tapering handle and about the relation of the handle to its shadow. This purist phase in the history of the medium began in the early 1920s and lasted until around 1928. Manuel Álvarez Bravo, the Mexican maestro, was a great exponent, as was Edward Weston in the USA. It came to an end, in Kertész's case, because in 1928 alternative opportunities opened up, principally the market for magazine articles in the German illustrated press and in *VU* in France. *VU*, set up by Lucien Vogel early in 1928, transformed photography in France, giving priority to documentary pictures.

ANDRÉ KERTÉSZ

André Kertész, as he became known in France, gained renown through his exhibitions. In 1928, for example, he showed fifteen pictures in Paris in what was described as the first independent salon of photography. Real fame, however, came through his association with Lucien Vogel's *VU* magazine. Vogel, a former art director at *Vogue*, launched the magazine on March 21, 1928. It was intended to 'translate the precipitous rhythm of modern life' and to document 'political events, scientific discoveries, cataclysms, explorations, sports events, theatre, cinema, art, fashion'. Kertész began to work for *VU* in April 1928 and continued to do so until he left for the USA in 1935. Visual culture of the late 1920s and early '30s, as exemplified in *VU*, was promiscuous and lively. The Russian model, with which it was competitive, was puritanical, as was the Nazi version as it materialized after 1933.

MEUDON. 1928
Meudon is on the left bank of the Seine, not far from Sèvres, and in 1928 easily accessible by rail and river. Rodin had had a studio there, and it was to Meudon that Rabelais had retired. In 1911 Lyonel Feininger made an etching based on this view and in 1928 Kertész set out to make his own version. He made some trial shots of the empty street and viaduct before accomplishing this picture, which was first published in the USA in *Day of Paris* in 1945. The viaduct at Meudon with the curving street and works site allowed Kertész to make a fine cross-section: the train going about its scheduled business, the building operations below and everyman in the foreground with his secret package – a wrapped artwork, perhaps.

Blois. 1930
One of Kertész's missions for *VU* might have taken him to Blois. The view down onto a crossroads reveals six citizens: two in conversation and the others passing by. Oblique views down onto streets made for diagrammatic pictures and provided a setting for everyman attending to his routines.

Vogel's proposals for *VU*, stretching from political events to fashion, proposes simultaneity: technocrats, film stars, sports stars and artists all within the same time frame and pressing on regardless. F.T. Marinetti, declaiming for Futurism in 1908, may have identified the format: stations, factories, steamers, locomotives and 'the slippery flight of airplanes'. In the early 1920s images of metropolis kept the idea of simultaneity in mind: skyscrapers above and workshops below, with a full cast of bankers and mendicants. Under totalitarian terms of reference, the nation worked as one and didn't care to admit to private lives and individual destinations. Kertész's vision of points of consciousness within the mass was probably shaped by his experiences of collective life during the Great War.

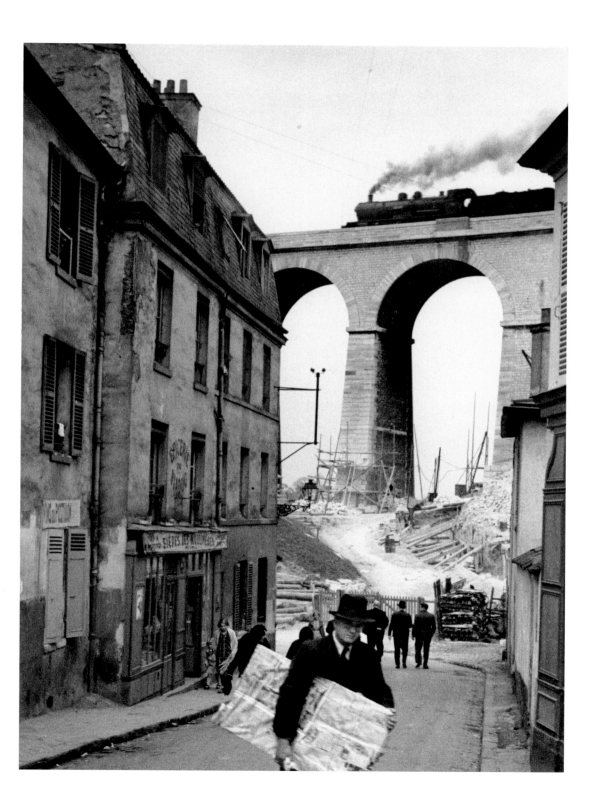

ANDRÉ KERTÉSZ

Kertész's major work during his Parisian years was *Paris vu par André Kertész*, published in 1934 by Librairie Plon. Pictures in the book date back to 1925, and the short texts by Pierre Mac Orlan, which go with every picture, are knowing and poetic. Mac Orlan liked Paris for its wealth of language – foreign tongues and the argot of the streets. In 1930 he had written the text for *Atget Photographe de Paris*. Kertész was quite late with his book on Paris. Even his one-time student Brassaï had published his celebrated *Paris de Nuit* in 1933. Germaine Krull, one of the most prolific of Parisian photographers, had taken the pictures for *100 x Paris*, published in 1929. Kertész, who had been a student of Paris since 1925, might have felt that he was being pushed aside by a new generation.

FÊTE FORAINE. Paris, 1931
Fairground entertainers feature in Parisian art and literature during the 1920s and 1950s. Here, in one of Kertész's most accomplished pictures, an acrobat balances on a column of chairs. A passer-by takes in the spectacle from above, mirroring the acrobat's posture. The column of chairs is paralleled by a leafless civic tree, and the public looks on, represented by a sampling of varied hats and coats – wintry weather, confirmed by a fractional snowscape to the right. It is another Kertészian cross-section, all done with simplifications: a man in black, a man in white and a set of headgear.

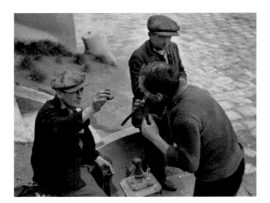

Shaving. Paris, 1930
Clochards, who slept rough in Paris, were supposed to have left their last lodgings at dead of night without paying, having muffled the doorbell for the sake of silence. All the same, shaving out of doors in cold water would have been no joke. That might be the top of a water pump in the foreground. The man to the right is using a cut-throat razor, which would have demanded care and attention, and there was not much mirror to rely on. The man with the mirror is doing good work needing a steady hand. A scene like this would have taken Kertész back to his army days in eastern Europe. *Clochards*, in the terms of the time, weren't just down-and-outs; they could also be construed as lovers of liberty, unwilling to be recruited into the rank and file of the employed.

Parisian photography in about 1930 worked hand-in-glove with popular culture. The streets of the city were alive with argot, which was much appreciated by the writers of the period. Any scene taken by Kertész or by Germaine Krull, his much more prolific contemporary, could be given a narrative context at the drop of a hat. Most of the writers were old hands, native born, whereas the photographers were often *émigrés* learning the language. Paris at the time was photography's creative zone, in contention with Berlin until the Nazi takeover in 1933. The torch passed to London in the late 1930s and then to New York. It was a torch usually carried by *émigrés* who knew that they had to get out whilst the going was good.

GERMAINE KRULL

1897–1985

When Lucien Vogel set up *VU* magazine in Paris in 1928, he asked Germaine Krull to take pictures of the Eiffel Tower. In 1924–5, when living in Amsterdam, she had made pictures of cranes and other structures in the port. In 1927–8 these were published in Paris under the title *Metal* – a book which made her reputation as a modernist. Born in Poznań (Poland) of Franco-German parents, she studied photography in Munich, lived in the USSR between 1919 and 1922, and moved to Paris in 1926 – at around the same time as André Kertész, who would be a colleague at *VU*. She knew the painters Robert and Sonia Delaunay, who helped her in Paris – although she was well able to look after herself. In Paris she set up as a fashion photographer, but found it thankless work – there was simply too much printing to do. At a party given by some wealthy and high-toned Romanians she had her first properly mixed Martini and, more importantly, met Eli Lotar, newly arrived from Bucharest. Lotar, who became a distinguished photographer in his own right, was an inspiration – and he was a very good darkroom worker too. With Lotar by her side, Krull set out to explore secret Paris: its subcultures and night workers of all sorts.

LA MARCHANDE DE FRITES. Paris, pre-1930
The noticeboard advertises mussels and fried potatoes. The bit of apparatus the woman is attending must be a deep-frier, for it has a protective screen. The chimneys, which look precarious, are held upright by wires. Atget, twenty years or so before, took comparable pictures, but the difference in 1930 is that it is the cooking that counts. There must have been quite a smell of hot oil, and you would have had to watch your step on that cluttered pavement. Krull and the observant Lotar frequented low dives; their café was 'Les Deux Magots' on the Left Bank – five tables outside and a narrow room inside.

Fête foraine. Paris, pre-1930
Street entertainers featured in the life of the city in the late 1920s. These appear to be about to walk on a nailed board. They are barefoot, and the man is making adjustments before the event. The blanket to the right may have been there for comfort, to ease the pain in their feet. The performers have also stacked their clothes neatly in the foreground. These entertainers and the lady restaurateur were photographed in the late 1920s when Krull was beginning her study of the vernacular side of Parisian life. They were published in 1930 in André Warnod's *Visages de Paris*, along with another forty of her pictures.

Krull was a materialist, attentive to what people did in Paris: eating and cooking potatoes and mussels, and walking on nails if need be for the entertainment of children. She took the practical view, remarking on apparatus and on the appetites. Her subject was not just the look but the feel of the city. Outright materialists are rare in photography, despite its naturalistic biases, but Arthur Rothstein, who would go to work for the Farm Security Administration in the USA in the mid-1930s, was another such.

GERMAINE KRULL

Krull lived Paris. In an account written in 1976 she remembered going at night to Les Halles, the major wholesale food markets which were situated in the centre of the city on the rue de Rambuteau. She recalled the porters carrying the carcasses of animals from one cold store to another. At the end of the night in their blood-stained aprons they went to drink white wine at nearby bistros – the 'Chien qui fume' [Smoking dog] or the 'Cochon de lait' [Suckling pig]. With Lotar she also went to the *bals-musettes* and bars in the rue de Lappe, a centre for the Parisian underworld or 'le milieu', just north of la Bastille. In the *bals-musettes* dancers paid 20 or 30 centimes to dance to the music of two accordions – the money collected for each dance by a barman. In the dance halls of the rue de Lappe she learned the java, a cross between a polka and a quick waltz which she very much enjoyed, 'in the arms of a handsome young man from the underworld'. Even if Lotar was late, she was left alone, for women were respected in 'le milieu'. An anthropologist by inclination, she often remarked on patterns of behaviour.

Aux Halles. Paris, pre-1930
Porters in Les Halles stacked incoming vegetables in remarkable cones and pyramids – these are cauliflowers. In the background, scarcely visible, porters unload a wagon.

LES PATRONS DE LA GRAPPE D'OR.
Paris, pre-1930
Photographing in low light, Krull has caught the patrons at a disadvantage, which gives them the look of drunkards. Warnod said that by 1930 'La Grappe d'Or' had been closed, although he might have made the whole thing up: a terrible place where itinerants could spend the night sleeping seated at the tables or downstairs on straw alive with vermin. Krull's first story for *VU* was on the *clochards* who lived on the banks of the Seine between Notre-Dame and the nearby Pont Neuf. They were a cut above the patrons shown here. The place Maubert, just south of Notre-Dame, was, she notes, a place where the destitute congregated in hostels.

Business at Les Halles was conducted in the faltering light of gas lamps, and Krull took mysterious pictures there. The night, with its varied cast of artists, porters, dancers, criminals and *clochards*, was part of the pictorial pattern, complementing the daytime world of traffic and passers-by. Krull also took pictures of *midinettes*, hopeful Cinderellas from the fashion world working as seamstresses and looking forward to a better outcome. They were the other side of the coin, sunlit and innocent. The night, never without its devotees, had gained in standing during the Great War when, in the metropolis at least, it was used as a cover for black-marketeering and a range of illicit pleasures. It also sheltered 'le milieu', the Parisian underworld which was a culture unto itself – a world apart. 'Le milieu', deviant though it was, represented community especially to photographers who were itinerants too.

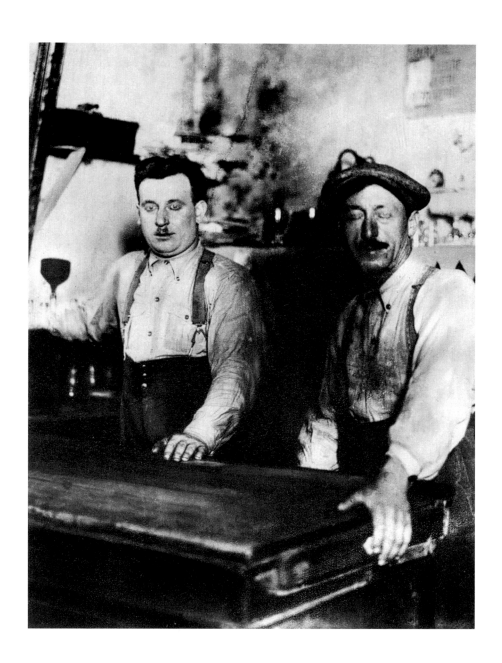

Krull's golden years lasted from 1928, from the foundation of *VU* magazine, until around 1935, when Librairie Plon published her picture book on *Marseille*. In the dance halls of Montmartre she and Eli Lotar were well known, although eventually they parted. She was successful and able to buy better cameras and to rent better darkrooms with more space and running water. In her memoir she notes these improvements in detail. Quite soon she was taking advertising pictures for the major car companies Peugeot and Citroën. In payment for one job she was given a car which allowed her to travel in France as never before. Advertising interfered with her work for *VU*, but she remained a valued contributor and she was invited to make portraits for the magazine of Colette, Cocteau, Malraux and other literary celebrities. Publishers commissioned her to illustrate novels, including Georges Simenon's

La Folle d'Itteville in 1933 – so badly printed as to be illegible. Her talents, which were quite specific, were frittered away. The times, too, were changing in Paris. A new generation, which went hatless and wore pullovers, was in a hurry – students in particular, she thought. Small bistros and corner dairies, which had characterized the old Paris, were replaced by 'Les Dumont' – a chain in traditional guise.

MOORED BOATS, MARSEILLE. Pre-1935
This quite descriptive picture shows how boats might be moored in a congested harbour. The dinghies would have had their uses, ferrying to and from moored ships, and the tugboats would have taken larger vessels to their berths.

Pont transbordeur, Marseille. Pre-1935
The transporter bridge across the harbour was mounted on four steel pylons carrying rails from which this platform was suspended. It was a notable piece of apparatus whose workings were clearly visible – and as such it would have been admired by modernists in the 1920s. In Krull's version the platform carries one man and a handcart, who seem to represent her interest in the material world. *Marseille* is a fine book with forty-eight pictures printed in heliogravure, completed on February 25, 1935. Krull was interested in the bridge but even more attracted by the daily work of the port, where a lot of coal was unloaded and sorted. In Marseille itself open sewers ran through the streets. Bilges were pumped in the harbour, and seafood sold. Old and destitute men idled in the city's squares – as in Paris by the river.

Krull was a photographer with an eye for the non-visible, for whatever might be smelled, tasted or handled. Hence this picture of the boats jammed together, moored and tied up. Hence, too, the man with the handcart. Even the heliogravure of the era had a sooty look, as if smoke and ash had settled on the page. Very few of Krull's pictures have come down to us, for she left them in Paris when she fled in 1940 and most didn't survive the war.

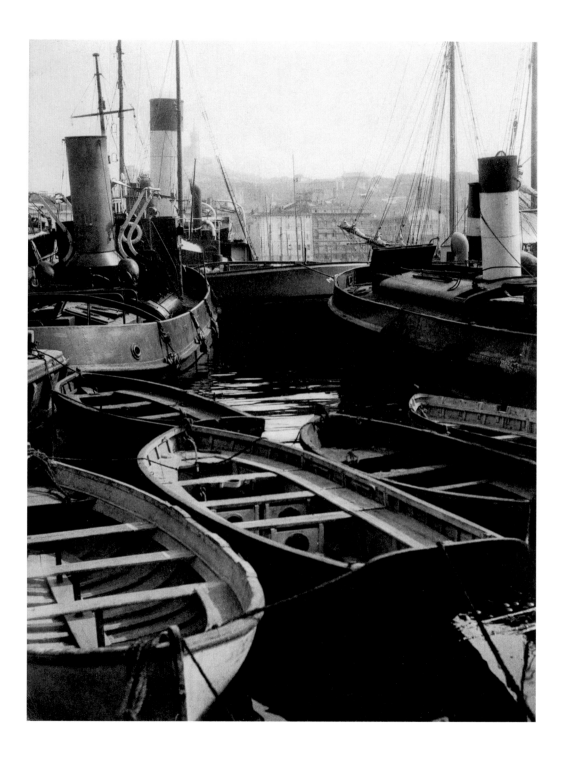

BRASSAÏ

1899–1984 Born in the city of Brassó
in Transylvania (now Braşov in Romania) and
educated in Budapest, Gyula Halász served in the
cavalry in the Austro-Hungarian army. After the
war he studied fine arts in Budapest and in Berlin,
before moving to Paris in 1924. He made a living by
working for the international magazine business,
which introduced him to writers and photographers,
including André Kertész, who was also a Hungarian
speaker. In 1929 he began to take photographs, and
in 1930–31 started to specialize in night studies.
In December 1932 his subsequently very famous
book *Paris de Nuit* was published by the periodical
Arts et Métiers Graphiques: sixty unpublished
pictures with an introduction by Paul Morand, a well-
known writer on Parisian subjects. In 1932 he also
became Brassaï, meaning simply that he came
from Brassó. Once he decided on photography
he lost no time in making his mark, although by
1932 he must have known the publishing business
inside out. *Paris de Nuit* made his name and it was
an inspiration – to Bill Brandt, for instance.

Policemen, Paris. 1931–2
They were known as 'hirondelles' (swallows),
these policemen who patrolled the city's
streets by night. They travelled swiftly with
their cloaks flying behind them, and from time
to time blew their whistles, which reminded
people of swallows. The sign on the wall forbids
fly-posting, according to the law of July 29, 1881.

PROSTITUTE, PARIS. 1931–2
She stands on the corner of the rue de la Reynie
and the rue Quincampoix between the 'Sébasto'
(boulevard de Sébastopol) and the Beaubourg area.
Brassaï's notes are quite specific, almost as if *Paris
de Nuit* was an alternative guidebook to the city.
Morand, in his introduction, remarks on prostitutes as
watchers with territorial interests and regular habits.

Night photography caught on in Paris and Berlin around 1930. Photographers who worked for the new
illustrated magazines of the late 1920s were liberal in their outlook, naturally drawn
to individuals, specialists and coteries. The people of the night made up one such coterie with
its own language and habits. Subcultures offered a refuge, in the imagination at least, from the
coercive power of the state and from the totalitarian threat which was beginning to emerge.
Photography c.1930 operated in the context of film, which, with the aid of sound and
commentary, promised disclosures. To remain competitive, publishers had to supplement mere
photographs which they did with texts such as that provided by Paul Morand for *Paris de Nuit*.
Morand, like many of his contemporaries, was an enthusiast for *argot*, the language of the
streets. The lure of argot was that it asked readers to speak it to themselves, to mull it over
and to wonder at it. In addition Morand went out of his way to evoke the sound of the streets:
factory sirens, car horns, metal on metal and on stone. Morand's text is a soundtrack to the city
evoked in Brassaï's shadowy images.

BRASSAÏ

Parisian photographers in the 1930s kept company with writers, and Brassaï was no exception. In 1925 he met the young Belgian poet Henri Michaux, later to become a painter of note. Michaux travelled widely and wrote about his experiences, and his influence can be felt in *Paris de Nuit*. Night photography told of subjective experience of the kind valued by the poet. Leon-Paul Fargue and Raymond Queneau were other writers with whom he investigated Paris by night. He lived in Montparnasse, in the south of Paris, in a hotel where Queneau also rented a room. By 1933 he seems to have known most of the writers and artists in Paris. In the shadow of Surrealism he developed an interest in marginal arts and *art brut*: found objects and the graffiti which abounded on Parisian walls. In 1935 he joined the Rapho Agency, established by his friend, the Hungarian Charles Rado, and became known worldwide for his Parisian pictures.

TRAMP IN MARSEILLE. 1937

The poor man, resting his head on that bundle, might be dreaming of the delights of Dulcine. The broken eggshells suggest that Dulcine is a kind of mayonnaise, which makes the contrast all the more unbearable.

Street fair. 1933

There were plenty of *fêtes foraines* in Paris where such a scene might be taken. The person in front of Brassaï seems to have ducked down to give him a better shot of the grim event.

Brassaï's was a harsher aesthetic than that of his Parisian contemporaries. The vagrant in Marseille is mocked by the delicious scene above. The poor girl so demeaningly put on display in what looks like a Wild West Show deserves our sympathy. Brassaï had spent time in Berlin during the early 1920s studying art at a time when George Grosz was at his most prolific: *Ecce Homo* and *Abrechnung Folgt* both came out in 1923. In Grosz's usual formats bloated capitalists consume heavily in the presence of the emaciated poor. His was a montage technique which allowed him to make just the sort of comparisons made by Brassaï in the 1930s. Paris in the 1930s, though, was more a way of life, interesting and attractive to its devotees. Berlin, by contrast, was a running sore and couldn't really be translated to Paris in 1932. *Paris de Nuit* is comparatively mild when seen in the context of Grosz in the 1920s.

Montages, at which Brassaï excelled, were tailor-made for photography but they didn't catch on. The problem was that they made points on their own and thus pre-empted the picture editor whose job it was to make telling arrangements. Montages, even if they were found in nature – as in Brassaï's case – were also associated with the extremist politics of the 1920s, when enemies could be identified and ridiculed. French politics in the 1930s were far less cut-and-dried, and photography – as represented by *VU*, for which Brassaï also worked – was on the side of empathy and fellow-feeling.

HENRI CARTIER-BRESSON

1908–2004
His name is synonymous with modernist photography. Interested in painting, Cartier-Bresson studied with André Lhote, 1927–8. At around the same time he began to take photographs. His first photographic excursion was to eastern Europe in 1931, and later in the same year he went to the Ivory Coast, returning to France in 1932. In Marseille he bought a Leica, which he used from then on. In 1933, with his childhood friend André Pieyre de Mandiargues, he travelled to Italy. He took pictures in Spain, some of which were published in *VU* magazine in Paris in November 1933 – on recent elections and on social disorder. His first exhibition was at Julien Levy's gallery in New York in October 1933. He had met Levy at a party in Paris in 1927 and had kept in touch with him.

ALLÉE DU PRADO, MARSEILLE. 1932
He was walking behind this man, who suddenly turned around. The picture appears in *Images à la Sauvette*, his famous book of 1952, as no. 27. The two rows of trees in winter make a jagged pattern, and in two parts like this they suggest that they are a diagram of the man's state of mind. Dressed in a cape and hat for a damp day, the man does give a sinister impression.

Mexico. 1934
This man may be asleep, or resting; and he may be intoxicated. In his right mind he must have been prudent, for he has both a sturdy belt and suspenders. He is being watched by a person in a nearby doorway. The pavement is rough, made up of shattered slabs of stone marked by a dividing line.

The Surrealists appreciated hysteria, ecstasy and dreams. In 1928 *La Révolution Surréaliste* marked the fiftieth anniversary of the announcement of hysteria with a special article. What Cartier-Bresson has done in both of these pictures is to show figures for mind. The man in Marseille stands in a space split up into sectors: some plain and some convoluted, like a diagram of the brain. The Mexican sleeper has his head between the rectangles of the wall and the shattered pavement: between turmoil and lucidity. States of mind were a challenge to photography, which was a naturalistic medium.

Modernist photographers in the late 1920s took schematic pictures of pieces of machinery, piano keyboards and city streets seen from above. They even took such perspectives as that on the Allée du Prado. Cartier-Bresson's innovation was to combine these settings with human figures – to suggest a meaningful connection. Such self-contained imagery wasn't of much use to editors who preferred transient and fragmentary scenes to illustrate their texts. Structured pictures, of the kind shown here, must have been taken as part of a personal project or for use in an imagined book. It is also likely that organized imagery was suspect in that it emphasized the photographer as an editor in his own right – someone who imposed rather than discovered meanings. Such pictures are a feature of Cartier-Bresson's early years.

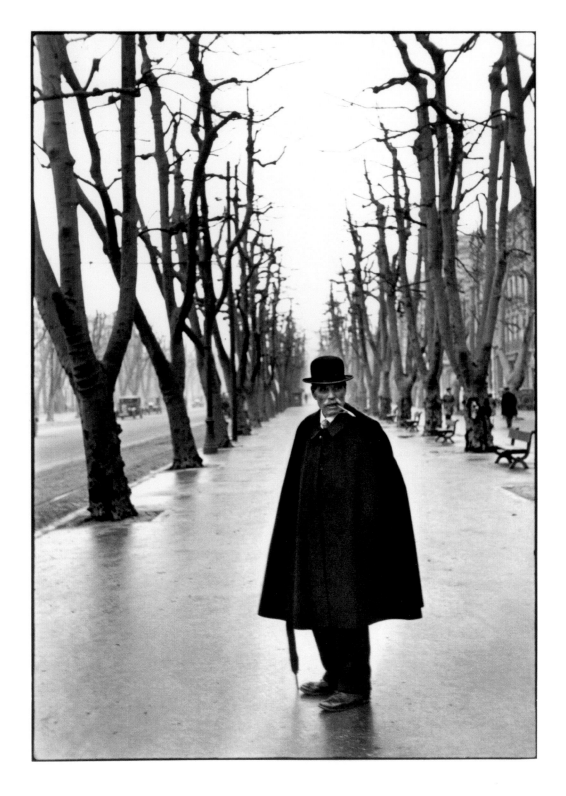

His travels between 1932 and 1934 took him to Italy, Spain and Morocco, with interludes in France. In 1934 he set sail for Mexico with a French geographic mission from the Trocadéro Museum. The mission foundered due to lack of cash but Cartier-Bresson stayed on and spent a year in Mexico City in the company of the Harlem poet, Langston Hughes, and Ignacio Aguirre, a Mexican painter. In the early 1930s photographers were expected to travel to report for the new illustrated magazines, but not to spend a year in one place. Mexico City, though, was an attractive venue, and in 1934 Paul Strand was there working for the government. Edward Weston had been there, leaving in 1927, and Manuel Álvarez Bravo lived in Mexico City. In March 1935 Cartier-Bresson and Álvarez Bravo exhibited together at the Palacio de Bellas Artes. In April, along with Walker Evans, they exhibited at Julien Levy's gallery in New York in a show of 'Documentary & Anti-Graphic Photographs'. Levy said that Cartier-Bresson's pictures were 'septic' and that his idea about photography was 'rude and crude'. Levy noted that he wouldn't be drawn on a theory for his art, and that he was 'sincere and modest'.

MURCIA, SPAIN. 1934
This picture was in Levy's exhibition of 'Documentary & Anti-Graphic Photographs' and shows a lottery announcement for June 11, 1934 along with a passer-by.

Hyères, France. 1932
Hyères lies just to the east of Marseille. This picture was also in the show at the Levy gallery in 1935. The intricate staircase seems to lead down to the road, on which a cyclist passes at speed.

Cartier-Bresson's early pictures stage dilemmas. The lottery, for example, is rich in options arranged in columns and series, and looks like a diagram on the working of providence. The set of steps at Hyères twists and turns its way down to the road where the passing cyclist follows that better-marked route. Both pictures can easily be read as allegories touching on the path of life, on which there are plenty of twists and turns and the promise of smooth going, represented by the cyclist. Even by 1932 Cartier-Bresson had experience of life's ups and downs, for he had been seriously ill in Africa. And photography itself depended on good fortune, being in the right place at the right time. But more importantly, art in the early 1930s took place in a philosophical environment. Cartier-Bresson would have been aware that the kind of photojournalism he made in Spain was debased: crowd scenes, typical citizens and snatches of landscape. The other pictures, for which he is now famous, were meant to compensate for such banalities. They constituted a kind of meta-narrative or a poetic art which reflected on actuality. Ozenfant, the most exuberant theorist of the era, whose *Art* came out in 1928, claimed, among much more besides, that 'the aim of both science and art is to create fantasies which solace us for reality'.

He lived for a year in Mexico City, supported by money from his father. He was joined by his sister, Jacqueline, and in 1935 they set off for New York by boat. His exhibition at the Julien Levy Gallery in New York was retrospectively a success, but Levy recalled that the pictures didn't sell and that 'photography was a dead end in those days'. He added: 'People just couldn't conceive of anyone being interested in an exhibition of photographs – not to mention buying one'. He stayed in New York for some time and met Helen Levitt, then at the outset of her career. She described him as a genius and ascribed her own journey to Mexico City in 1941 as due to his influence. He also met Paul Strand, who was then involved in film-making, which may have been responsible for stimulating Cartier-Bresson's own interest in films. He managed to get employment with Jean Renoir on his return to France and worked as an assistant on *La Vie est à nous*, *Une partie de campagne* and *La Règle du jeu*.

Mexico. 1934

They were playing on an earthen platform next to a white wall: three boys and a little girl. In most of his shots of the scene nothing much is going on, but here he managed to find a reversed Z and an equal configuration of light and dark. In addition the boy to the left stands in profile whilst the figure to the right is silhouetted. This system of differences is repeated in the sex of the two children lying in the foreground, to make a set of symmetries.

ALICANTE, SPAIN. 1933

He took several pictures in this brothel, of these three women and of another group featuring Sissie, a *matrone* and a *négresse*. Some of them were exhibited in 1935. This particular scene is intriguing, for it seems to have been arranged. The woman next to the wall holds an odd position and looks towards the photographer, perhaps to ask if this is the posture he wants.

Cartier-Bresson trained as a painter, and didn't break with that training. The picture in the brothel is a composition, intended to show the younger woman in an alignment with the tiled wall behind her. She has been asked to keep her limbs on a diagonal like that shown in the tiles, and has just about succeeded. She holds a cushion, which might have been meant as a reference point. The older women lying on the tiled floor may also have been placed like that for the sake of perspective. That raised leg makes a link with the performer in the background. The upper sector in the picture is marked by rectilinear patterns and the lower by curvilinear – Ozenfant in *Art* (1928) called these 'modalities' and illustrated them. The reclining women look like the stoutly built nudes who recline in some of Fernand Léger's major compositions of the 1920s. The silhouettes in the picture of children in Mexico also recall some of Léger's compositions of the late 1920s, in which a lot of profiles appear. Irrespective of location he continued to be subject to experience of art in Paris as he had first found it in the 1920s.

He had worked in the film business with Jean Renoir, but mainly on dialogue. In 1937, however, he directed the film *Victoire de la vie*, on Republican hospitals during the Spanish Civil War. In the same year Louis Aragon, the revolutionary Surrealist and writer, asked him to contribute photo-reports to *Regards* (formerly *Regards sur le monde du travail*, established in 1932) and to *Ce Soir*, a Parisian evening newspaper set up in March 1937. France had been in a disturbed frame of mind since 1934, when Cartier-Bresson was out of the country, and by the summer of 1936 was run by a government of the Popular Front under Léon Blum. Containing both Communist and Socialist elements, the Popular Front restricted itself to reform rather than to revolution. Its first reforms, in June 1936, offered collective contracts, paid holidays and a forty-hour week. Blum's government lasted for little more than a year, brought down by the flight of capital from France and a plague of strikes.

THE FIRST PAID HOLIDAYS, FRANCE. 1936
He took a number of pictures on this theme, showing the people at leisure in such improvised shelters as this. Prior to 1936 his reportages, from Spain for instance, were continuity pictures. In 1936 he set himself the task of making structured images on topical themes.

On the banks of the Marne, France. 1938
This still looks like a Popular Front picture, and it is one of photography's highlights. None of the picnickers has ever stinted, it would seem, and the man at the back of the group is a study in self-interest: the hat and braces, for instance, and the position which allows him to indulge unseen. The elegance of the skiff on the water contrasts nicely with their stolidity. It may be their boat, but it looks as if it might sink under their weight.

The picture of 1936 is a heart-warming event, for the awning looks improvised and the two fishermen beyond are minding their own business, as if there is space for everyone. The gourmandizing group on the edge of the Marne make up a fascinating conversation piece, but to a concerned citizen in 1938 they might have looked complacent. By the summer of 1938 the Popular Front had disintegrated and strikes continued, with the promise of more to come. None the less, Cartier-Bresson liked open-air eating because it gave great scope for character study, and it represented conviviality. Somewhere in the background there is a memory of Seurat, for it is a very orderly image – in the traditional French style, yet at the same time he registers gestures with such accuracy: the hand that pours the wine, and the hands of the two women as they eat. He developed a flair for the everyday remarked on in passing. He had always had a capacity for observation but in the earlier pictures it ranked below the concept. With the Popular Front it comes to the fore and characterizes the many European pictures which he took after the war – published in 1955 in *The Europeans*.

During the Second War he was enlisted and captured. In February 1943 he escaped and in August 1944 witnessed and photographed during the Liberation of Paris. He directed a documentary film, *Le Retour*, on the repatriation of captives and displaced persons. He belonged to Alliance Photo, an agency set up as a workers' co-operative – but it failed for administrative and commercial reasons. In the USA it was believed that he had perished in the war and a commemorative exhibition was mooted at the Museum of Modern Art in New York. Eventually he helped in the organization of the exhibition, which took place in 1947. In the same year, with Robert Capa, George Rodger and David Seymour, he set up the agency Magnum. From 1948 to 1950 he travelled in India, China and Indonesia. In 1952 a selection of his pictures, taken between 1932 and 1950, was published by Editions Verve in Paris. This very celebrated book was assembled by Tériade, a Greek publisher who had known Cartier-Bresson since the early 1930s, and had been art director of *Minotaure*, the Surrealist periodical. *Images à la Sauvette* was the French title, meaning that the pictures were taken on the run. To sell 'à la sauvette' is to sell on the street without a licence. The English title was *The Decisive Moment*. In 1954 Robert Delpire, the great photography editor of the era, brought out *D'une Chine à l'autre*, an eye-witness account of China's transition from Kuomintang to Communism. Cartier-Bresson described it as a diary of events in Beijing and then in Shanghai, from December of 1948 onward. In 1955 Tériade published *Les Européens*, a sequel to *The Decisive Moment*.

A BLIND BEGGAR, CHINA. 1948–9
There are leaves on the street. The original caption notes that the blind man and the child are connected by a leash, and that the cobbled pavements of imperial China have outlasted the cement sidewalks of the Kuomintang era. The guiding child puts together a handful of banknotes. The beggar himself, supporting an even smaller child, holds a basket propped up on a pole and suspended from a string – to make things easier for donors.

Transit camp for Western Europeans, freed by the Soviets in East Germany, Dessau. 1945
Their suitcases and bundles are tied with string, and they wear a variety of hats – quite stylishly. The procession is overseen by a red flag and an image of a relaxed-looking Josef Stalin, under whose aegis the event is taking place. Huge numbers of French people had been conscripted to work in Germany during the war.

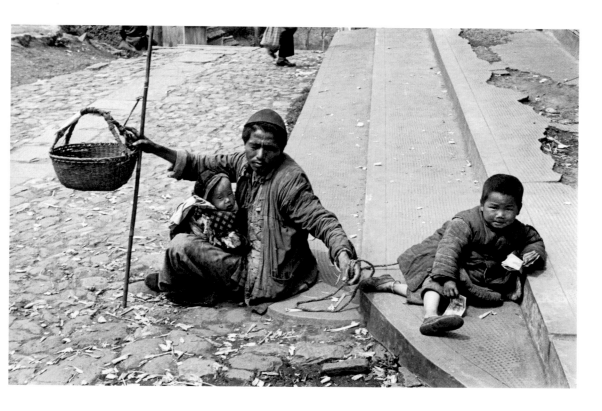

Transit imagery came into its own immediately after the war. In the 1930s transit pictures were taken by
travellers to give an impression of distance and remoteness. In 1945 and after they express
displacement and sometimes they are used to indicate history as process. Photographers,
under pressure of events, began to introduce themselves as mere witnesses to a historical
continuum which was almost beyond comprehension. They began to remark on incidents
which reflected both on their own helplessness and on that of the unwitting participants.
The blind man, for instance, may be living through one of history's major moments but
in the short term he simply senses that something is up. That something may only be
a photographer looking for material, but all the same he checks on the whereabouts of
the child in charge of the day's earnings. Cartier-Bresson's was a new idea of the witness
as outsider, and it was one which would develop from then on.

MANUEL ÁLVAREZ BRAVO

1902–2002 He was the most poetic of all
photographers. He was attentive to Mexican folklore
and to Surrealism, but always followed his own rather
metaphysical inclinations. A wise man, he quoted
the Talmud in later life: 'If you want to see the
invisible, carefully observe the visible.' He added:
'The invisible is always contained in the work of art
which re-creates it. If the invisible cannot be seen
in it, the work of art does not exist.' What exactly
he meant by 'the invisible' can only be guessed at:
grandiose thought sometimes, with reference to the
human condition, or just thoughts as they crop up
unbidden. Mostly, though, he acknowledges the
invisible as something to which we nod in passing or
formulate a phrase, knowing that we will never get
to the bottom of it. He began to take pictures in the
mid-1920s and continued intermittently all his life.

BARBER (PELUQUERO). 1920s
This is a documentary picture in that it shows
open-air barbering. It would fit into the French
small trades category of 1900 as you see
it in Eugène Atget. The French would have
been more forthright. Here you can see neither
of their faces and not much of what is going
on. In Mexico, however, it was usual for such
a haircutter to ask the client, 'Wall or landscape?'
More brazen personalities faced outwards, and
those who were shy faced the wall. We are dealing
here with someone who would prefer privacy.

Boy urinating (Niño orinando). 1927
In 1929, at the suggestion of his friend Tina Modotti,
he sent a package of prints to Edward Weston for
a judgement. Despite having to pay postage due,
Weston was impressed, and he liked this picture
in particular. He even thought that the pictures had
been taken by Modotti herself. The chipped enamel
pot rhymes with the rounded belly of the child, and
the stream of urine would have murmured in the
vessel. Uncircumcised urinators will recall the feeling
well enough. In later life Bravo said that the picture
reminded him of the statue of the *Manneken Pis*
in Brussels, which he had once seen in a postcard.

Photography can make you immortal, or at least keep you in being. Bravo, for instance, saw the barber and
his client and realized that the man had made a choice and even given himself away – both poor
and discreet. It is the perception which is on offer, and for a moment you are at one with Bravo
as the thought occurs to him. Likewise in front of the concave/convex rhyme in the other image
and that pleasing alignment of the liquid and the shadow. You see, as he did, that the scene
comes together for an instant, and you recognize it too. For a picture to work like this there
must be restraint if the idea is to emerge. Too many details and you are left with no more than
naturalism.

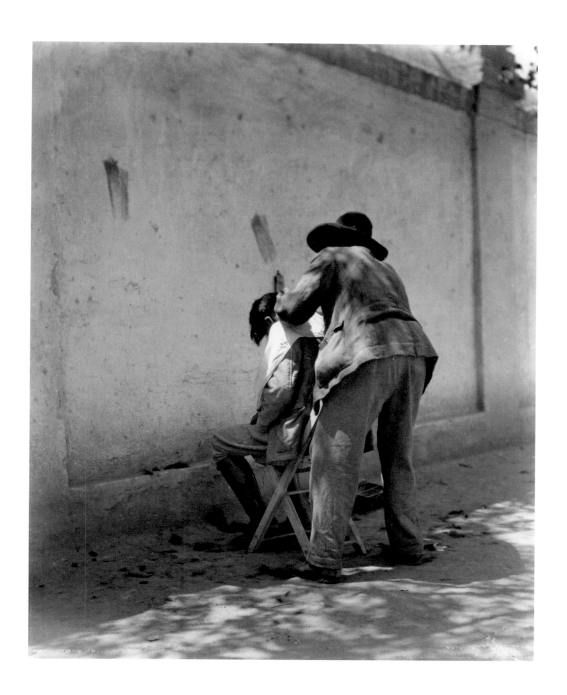

MANUEL ÁLVAREZ BRAVO

Born in Mexico City, Bravo was brought up
in a household which valued the arts: writing,
painting and photography included. His education
was interrupted by the Revolution of 1910. For
economic reasons he studied accountancy and
took up office work in the Treasury. His penchant
for the arts couldn't be suppressed and in 1924
he took to photography, having met the German
photographer Hugo Brehme whose *Mexico:
Baukunst–Landschaft–Volksleben* came out in 1925.
He went to live in Oaxaca and had seen Edward
Weston and Tina Modotti at a distance. He had seen
their work in magazines and wanted to meet them.
In 1929 Diego Rivera introduced him to Modotti,
and when she was expelled from Mexico in 1930 on
suspicion of being involved in a plot to assassinate
the president, he took her place as photographer for
Frances Toor's magazine, *Mexican Folkways*. He saw
her to the train and she gave him her 8 x 10 inch view
camera. In 1930–31 he was a cameraman on Sergei
Eisenstein's *Que Viva Mexico*. All this while he had
been somehow working for the Mexican Treasury, but
he left in 1932 to become a full-time photographer.

WOODEN HORSE
(CABALLO DE MADERA). 1928

The horse is half-hidden and it seems as though the
curtain has been drawn aside just enough to show
that it is there. Perhaps whoever was sitting on the
chair stood up and moved the curtain. It is a child's
horse and an adult's chair, and Bravo liked to make
allusions through attributes – the better to get the
idea of a child, say, and of an adult. Edward Weston,
who took close-ups of the furnishings of his bathroom
in Mexico, was intrigued by space and structure.
Here, by contrast, Bravo remarks on a revelation.

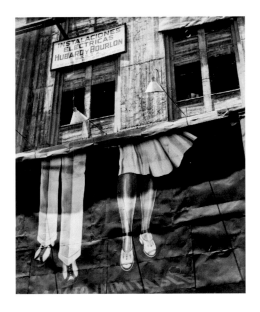

Two pairs of legs (Dos pares de piernas). 1928–9
ZAPATO INIMITABLE [Inimitable shoes], the
inscription reads. The advert has been hand-
painted and applied in rectangles to its backing.
The electric lights, by Hubard & Bourlon, project
beyond the hoarding and cast their own diagonal
shadows over the fluctuating paper. Although
it was a crafty idea to restrict the scene to two
pairs of legs, there is still a question of the missing
torsos. You can see the designer's predicament
in a scene where only the shoes really mattered.

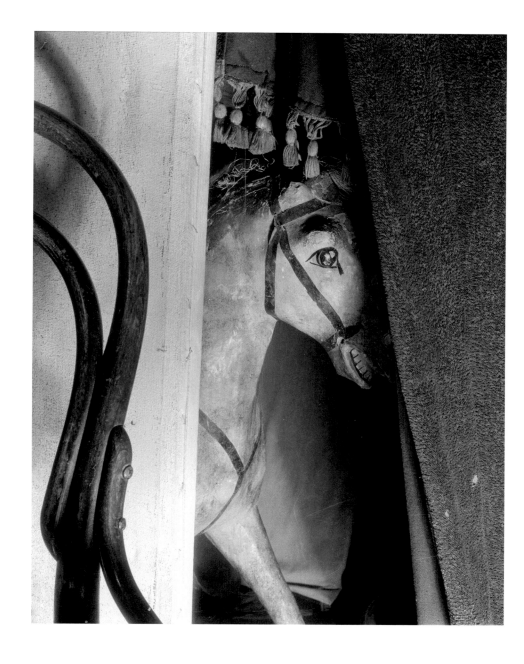

Photography for Bravo was akin to an art of installation taking place in improvised theatres. Onto the stage might walk a pair of disembodied legs, stone lions or a wooden horse. Carnivals, circuses, medicine shows and those *fêtes foraines*, appreciated by Bravo's French contemporaries, were an inspiration. The idea was that you too, if you were a photographer, could furnish your own circus with a varied display of events. The important thing about the circus as a model was that it didn't have to be comprehensive – just enough to put on a show. The documentary tendency, by contrast, as promoted by the new illustrated magazines of the 1920s and '30s spoke a language of archives, surveys and coverage. Bravo, who worked for *Mexican Folkways*, knew of this distinction.

In 1934 Bravo met Henri Cartier-Bresson in Mexico City, and in March 1935 the two of them exhibited together at the Palacio de Bellas Artes. In April 1935 they participated in Julien Levy's exhibition in New York, 'Documentary & Anti-Graphic'. The other participant in this subsequently famous show was Walker Evans. The 'anti-graphic' reference was meant to indicate that the photographers had moved on from the 'new vision' of the late 1920s. Levy thought that they represented a new tendency, more involved in real life and much less abstract than the 'new vision'. Bravo contributed thirty-two images to this exhibition and drew up a list with prices and titles.

THE DAYDREAM (EL ENSUEÑO). 1931

She is a young girl, and she may be daydreaming or just looking at something in the courtyard below. It can't have been very comfortable to lean like that on a narrow metal railing, and it isn't difficult to put oneself, in imagination at least, in her position. She has also placed her right knee through the railings and her foot in the adjacent interval. Originally the picture was simply called *El Corredor*, with reference to the balcony on which she stands. In 1935 this picture was valued at 50 dollars, with three others in the top bracket.

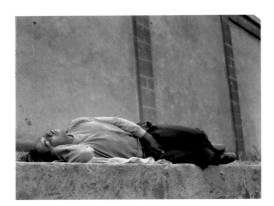

The Dreamer (El Soñador). 1931

It may be an erotic dream, for his left hand is on his genitals. The ribs on the wall suggest ascent. In 1935, in Bravo's list prepared for the exhibition at the Levy Gallery, he was no more than *El dormilón (The sleeper)* and valued at only 30 dollars on a list which went down to 25 dollars.

Bravo, usually called Don Manuel out of respect for his achievements, was interested in 'the invisible', which included states of mind. The girl, for instance, might be in love or just wondering about it. Her perplexity is reflected in the overlapping grids which edge the balcony, and this was just the kind of suggestive device used by Cartier-Bresson in some of his Spanish and Mexican pictures of 1933–4. Between 1928 and 1930 Bravo liked to take montage pictures featuring lettering and painted imagery come across in the street. In 1931 he began to relate these artificial materials to the human figure.

Bravo's picture titles changed from moment to moment. They tended to become more metaphysical, with a mere sleeper, for example, becoming a dreamer. It is likely that he saw his picture collection as material for thought and that images might change their meaning on reflection. He was working, that is to say, with a theory of the unconscious: an impulse not properly understood followed by a delightful uncertainty as to what was at stake. After decades of reflection a picture might accrue all sorts of possible readings and might reveal affinities with other pictures, especially when images had to be assembled in books and in exhibitions. This was a large part of photography's attraction in the age of psychology.

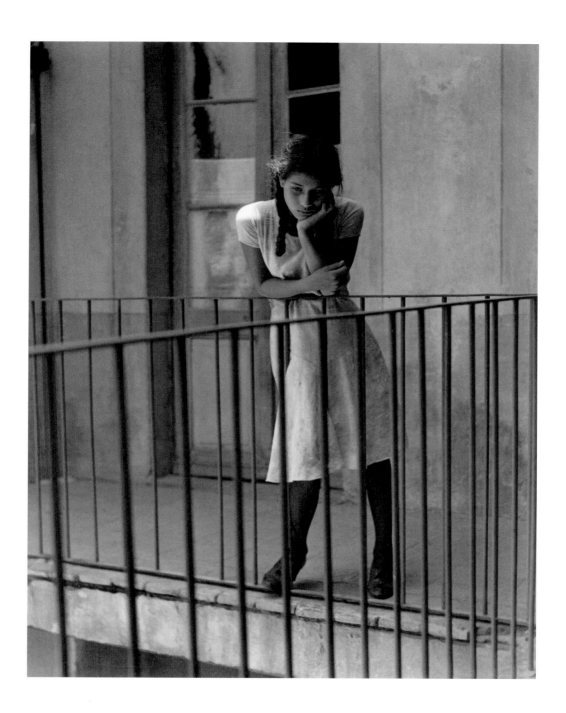

Bravo had difficulty making a living when he turned to photography in 1930. Mainly he made portraits and took pictures of paintings for artists. Like others at the time he tried his hand at film-making: *Tehuantepec* in 1934 – a tragedy based on a labour strike. In 1933 he met Paul Strand who was working on a film, *The Wave*, near to Vera Cruz – on the Gulf of Campeche in the south of the country. Nearby Bravo took his famous picture of the *Striking worker murdered*. In 1936 he taught in Chicago for a while and then at the Academia de San Carlos in Mexico City. In 1934 Mexico's turbulent politics began to settle down with the election of Lázaro Cárdenas, who introduced land reforms and encouraged union recognition.

PUBLIC THIRST (SED PÚBLICA). 1933
The boy is drinking from a tap which feeds a stone tank. The short hair on the crown of his head moves clockwise, and the flowing folds of his garment contrast with the darkness beyond. The fundamentals of eating and drinking interested Bravo during the early 1930s.

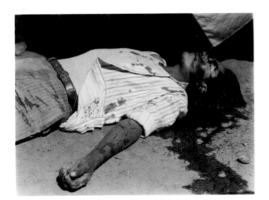

Striking worker murdered
(Obrero en huelga asesinado). 1934
Agitation up to and into the election campaign of 1934 resulted in bloodshed. His blood has flowed from his wounds and seeped into the earth. His outflung left hand lies unclasped by his side. A triangular piece of canvas hangs above his head, like a figure for a soul departing. It is a systematic depiction of death as the ebbing away of life, as a loss of force and form. Bravo liked to place this picture in books near to that of the boy drinking. He noted that the dead worker could be understood as a sacrifice, and even as part of a ritual – part Christian and part Aztec. In ancient Mexico human lives were sacrificed to Tlaloc, the god of rain. Sacrifice was a necessary transaction with the gods. The man was sacrificed so that the boy might live, in an allegory of social betterment perhaps.

In Mexico, during Bravo's period, theology was never far away. During the 1920s the Cristero Rebellion sought to oppose the liberal constitution of 1917 and the exclusion of church parties from politics. There were also many martyrs during the revolutionary period, including Francisco 'Pancho' Villa and the peasant leader, Emiliano Zapata. Bravo recalled seeing corpses on the streets during the Revolution of 1910 and hearing the sounds of gunfire.

Theology in Mexico wasn't straightforward. The old religions seemed to have been integrated into the new. Tlaloc's association with sacrificial victims does evoke the life of Christ. Yet no one looking at these pictures of the drinking boy and the murdered worker would think straight away of Mexico's traditional gods; they would think, rather, of the life of Christ. The worker even looks like Christ taken down from the cross, especially with the arm outflung and the fingers curled. The boy at the water tank is equally Christian, for Christ, too, was presented, by Paul, as a rock at which his followers drank – a spring in a rocky landscape.

MANUEL ÁLVAREZ BRAVO

Slowly Bravo earned a reputation. In 1938 he met André Breton, the French Surrealist, and Breton used some of his pictures in an article published in *Minotaure*, 'Souvenir du Mexique'. Pure photography paid badly, however, and for a while he had a commercial photographic shop. Then he went back to cinematography and to teaching and for around sixteen years (1943–59) did little personal work. American museums acquired and sometimes bought his pictures: Eastman House in Rochester, NY, acquired forty-five of them in 1957. John Szarkowski at New York's Museum of Modern Art published one in *The Photographer's Eye* in 1966. The Pasadena Art Museum, California, acquired sixty-three photographs in 1971, and exhibited them, which finally established him as a major artist in photography. Outsiders then began to research his pictures: notably Jane Livingston and Alex Castro for a Corcoran Gallery of Art, Washington, exhibition of 1978.

A FISH CALLED SIERRA
(UN PEZ QUE LLAMAN SIERRA). 1942

There is a sawfish, notable for a toothed snout which it uses as a weapon. Seen in profile it does look aggressive with its projecting jaw. That is probably the severed head of a marlin lying on the upturned boat, which has been used as a butcher's block. It looks like a dangerous head, but not so fearsome as that of the smaller sawfish. The third portrait is that of the handsome girl: a heroine almost, symmetrical and determined. Their faces are what they have in common, for the marlin has no body. Although it is unusual to compare faces in this way, the picture implies that it is a possibility, and each face does have a different character.

Huichol violin (Violin huichol). 1965

This still life features a violin and a bow supported on some rough fencing, along with a halter and a hank of rope. As a document the picture points out that in this region some cowboys play the fiddle. The instrument itself is made of wood, as is the fence. The bow is made of wood and fibre, which connects it with the ropes and straps hanging on the tree. The arrangement could be seen as an allegory: culture as a shaping of commonplace raw materials.

We know a lot. Most of it, though, we don't know very well. Some has been half-forgotten and some we didn't properly understand in the first place; or we didn't quite register a meaning. Photography, as practised by this artist, amounts to an investigation of this largely uncertain realm of consciousness. In phase one, or the first scan, we register the motifs. Then conjecture takes over and we begin to think of one thing in relation to another. Possibilities arise which might be entertained for a moment or two. Nothing in the picture of the violin, for example, can be quite conclusive but in the meantime we will have ranged far and wide within our own stock of stories and adages. These were always his tactics: a disarming invitation into a labyrinth of our own making.

JOSEF SUDEK

1896–1976 Sudek is an enthralling mystery, even though a lot is known about him. He overcame adversity. During the Great War, serving with the Austro-Hungarian army on the Italian front in 1916, he lost his right arm. He spent the next three years in various hospitals. He was born in Kolín, a town on the Labe (Elbe), 50 km to the east of Prague. When he was three his father, a house painter, died and he was brought up in nearby Kutná Hora by his mother. He was expected, as he recalled, to end up on the gallows or working as a shepherd but in 1911 he was apprenticed to a bookbinder. A cousin in Kolín was a professional photographer and it was with him that Sudek's sister, Božena Sudková, learned the trade. She helped her younger brother Josef throughout his career. As a crippled veteran in 1920 Sudek faced a future as a corner-shop tobacconist, but decided on photography and in 1922 entered the School of Graphic Arts in Prague, where he was introduced to the soft-focus pictorialism then in vogue. By 1924 that style was beginning to be challenged by the sharp-focus 'new vision', associated with American advertising.

VIADUCT IN THE ŽIŽKOV AREA OF PRAGUE. 1926

He has placed his camera on Husitská looking east towards Žižkov, a working-class area of the city. The legs of the railway viaduct rhyme with those of the horse beneath. The cart in the middle distance, heading in this direction, has been guided onto the tramline, which may have given the carter an easier ride on that rough surface. The carter entering from the left is on the lookout. Otherwise it is a harmonious arrangement: blocks of modulated tone articulated by elegant lines.

From the series 'The Invalids' Hospital', Prague. 1922–7

As one of 'the ruined generation' of veterans he would have known the hospital or taken a keen interest in it. His pictures show it as a place of quiet reflection in a smoky light. He was still a pictorialist responsive to the feeling of such places. All the same, he remarks ironically on a pair of boots in the foreground in the presence of a one-legged man sitting on a chair.

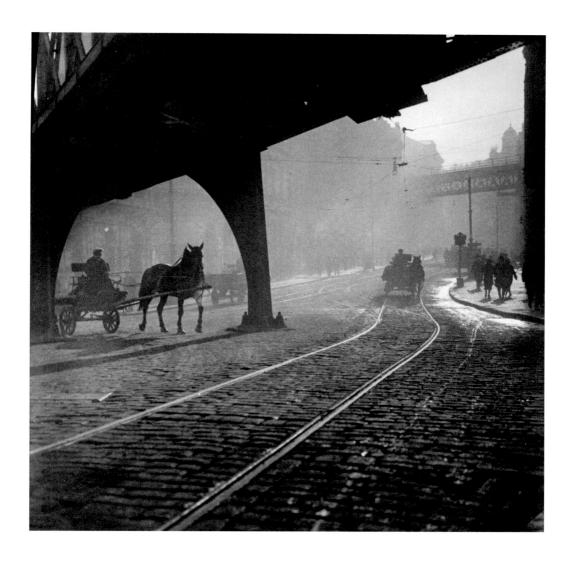

The temptation in Sudek's case is to say that he had the sort of preliminary career that you would expect of a Prague student who didn't know any better. He recalled that he was a rough diamond in his student days, with a lot of bad language which he had learned in the army. Yet it is likely that he always had something in mind, and that he never took the kind of formulaic pictures you would expect of a student. The viaduct picture, for instance, may be a misty street scene but it is also about traffic management – seen from a carter's point of view. The invalid picture remarks, quite openly, on what it must be like to have to manage with one leg. The invalids read, play chess and drink, and they concentrate on what is on the table in front of them. The early pictures are structured and invite decipherment. The later pictures are laconic and altogether harder to get the measure of.

JOSEF SUDEK

He was enterprising. In 1924, along with his friend Jaromir Funke, he was a founding member of the Czech Photographic Society, dedicated to photography as a documentary medium. He turned his back on the 'artistic processes' which he had learned as a student. During the mid-1920s he took pictures of restoration work in the cathedral of St Vitus within the castle in Prague. When the restoration was finished, fifteen of these pictures were published in a commemorative book, which was also meant to mark the tenth anniversary of the foundation of Czechoslovakia. From 1927 he worked for the publisher Družstevní práce, a collective which published the illustrated magazine *Panorama*. He also took advertising pictures for the glass designer Sutnar. In 1927 he moved into a studio in Újezd, a street in the Malá Strana on the west side of the river Vltava. He stayed there for a long time in what was really a wooden shed. One of his assistants remembered it as very cluttered, 'like an antique shop with a feeling of home'.

FROM THE SERIES 'ST VITUS', PRAGUE. 1924–8

Only 120 copies of his book on the cathedral were published. The cathedral was being refurbished as a national shrine with new gates and stained glass. Czechoslovakia, founded in 1918, was proud of itself and in Tomáš Masaryk had an exemplary president. Sudek recorded work in progress within the cathedral, showing here a heap of gravel looking like a miniature mountain landscape. It seems to be in formation on a forking path meant to give access to the parked wheelbarrow. The sacred space above is flooded with light and quite aetherial in contrast to the landscape below.

Third courtyard, Prague Castle. 1936

On the south side of the cathedral Jošef Plečnik, Masaryk's principal architect at Prague Castle, designed this courtyard. Stones for the pavement were taken from quarries in every region of the newly established country. A statue of Saint George slaying the dragon was installed on a pedestal and an obelisk was erected in honour of the Czech Legion, an army of freed prisoners from the Austro-Hungarian forces who had occupied large areas of Bolshevik Russia in 1918. Plečnik's idea was that the courtyard with its installations would help to educate the citizens of the new state.

Plečnik's courtyard is sparsely and clearly laid out; each item makes a point. Sudek, it seems, was interested in what other artists did: how they designed things and managed their affairs. In the cathedral itself he compared the superstructure of the building with the heaped material below, which it must have been difficult to assemble along those improvised planks, especially if you had to turn sideways to unload the barrow. He perceived a contrast between work well done with lucid results and a world of actualities not nearly so well organized. At the time that Plečnik was devising his courtyard, Sudek was setting up shop in a wooden shack at the bottom of the hill, improvising an existence and a poetic universe with the bits and pieces which came his way.

In 1928 Sudek bought a phonograph, and he always liked to listen to records. Friends came to his studio to listen, too. Thus he built up a world for himself. In 1933 he participated in an exhibition of 'Social Photography' in Prague, organized by the Left Front. In 1936 he participated in an International Exhibition in Prague in the company of Moholy-Nagy, Man Ray and Aleksandr Rodchenko. Even so he was never a whole-hearted modernist or exponent of the 'new vision'. He made able friends, with the photographer Jaromir Funke, for example, and in 1930 with the painter Emil Filla – an outstanding Cubist painter who was arrested on the German occupation of Prague in 1938 and who spent six years in prison. Sudek also made a living taking pictures of items in the National Gallery, from the 1920s right through into the 1950s. During the war of 1939–45 he worked mainly for the National Gallery, and with any spare time and materials took pictures in his studio and of Prague – its parks especially.

On Tuesday, from the studio window, Prague. 1940–54
Tuesday was the day for washing sheets and towels. It looks like a sunny day in summer, although there is also some condensation on the window glass. Sometimes he took pictures of snow on the trees, usually obscured by frost on the glass. There was nothing very picturesque about any of the views from his studio windows.

WINDOW OF MY STUDIO
WITH BLOSSOM, PRAGUE. 1950
The twisted apple tree features in a lot of the pictures taken from his studio windows. In this case the sprig of blossom in the drinking glass signifies that it is springtime. Pigment prints such as this were made by sensitizing a layer of gauze and applying it to a silver print. The gauze took up the image and was then removed and applied to a paper base. Sudek turned to this process in 1950, sometimes using pictures taken years before.

These pictures from the studio windows made his reputation in later years. They look rudimentary and guileless, and recall the jugs and bowls which stand on the tables in the invalids' hospital which he took twenty years before, They might even be the work of someone confined. However, it is worth remembering what his assistant, Sonja Bullaty, said about the cluttered studio looking like an antique shop. In a letter to a collector in the 1970s he described his studio as 'a bordello [i.e. a mess], where you can't lose anything but neither will you find it'. Sudek was untidy, and pictures of the studio support that impression. The other side of the coin would be orderliness, which Sudek would recognize in the progression of the seasons, represented here by these apple blossoms, and in routine household work, such as the regular washing of sheets and towels on Tuesdays. Many of the later pictures invoke the seasons and necessary routines about which there can be no doubt: eating and drinking, for example, in addition to the washing of clothes.

JOSEF SUDEK

In 1940, whilst working in a state collection, Sudek saw a nineteenth-century contact print of Chartres Cathedral, and he determined henceforth only to make such prints. Immediately after the war he began to make photographs of private gardens in Prague: first, that of the sculptress Hana Wichterlová and then that of the architect Otto Rothmayer, who had been Josef Plečnik's assistant at Prague Castle and then his successor after 1934. Rothmayer asked him along to take pictures of his garden chairs, and they became firm friends. Rothmayer (1892–1966) wasn't much older than Sudek, who reckoned that he 'was isolated, the last of his generation'. The same must have been true of himself. In 1949 he went with a newly acquired panoramic camera to take pictures in the Beskid Mountains, in the east of Slovakia. At the same time he continued to take pictures of Prague and of its parks.

PRAGUE GARDENS. 1950–54
He made several prints of this quite plain scene, which might be situated in parkland to the north of the castle. The roof of the pavilion to the lower right would make the site recognizable to Prague's residents. The city was richer in parks and gardens than it is now, for they were much used for recreational walking before automobile ownership became the norm.

Palm in Prague Castle gardens.
Negative 1942, print 1952
In this summer scene, potted palms have been taken out to experience the milder air of the new season. Sudek took a number of pictures through palm fronds, and he liked to show vistas impeded by such screens.

Why take pictures like this? One is of winter and the other is of a summer scene, but even so they don't give much away. Sudek had a wide choice of public parks within easy walking distance of his studio. Much of the high ground on the Malá Strana, from Letná to the Petřín Hill is parkland, with many gravel tracks and roads for walkers. Anyone walking these routes over the years and decades would grow used to them, and they would become as much a part of experience as the changing of the seasons. They can be thought of as a controlled environment within which walkers can mix together routines and contingencies. For instance, on the parallel tracks seen from above, a pedestrian might think twice before taking the rougher ways and might sometimes be tempted to look into the alcove to the upper left. And the palm trees, seen at ground level, look as if they have been brought out specially and are too much of a temptation to miss. Sudek on foot on these tracks negotiated exchanges between routines and special events, such as the first blossoms of the springtime. This equable state of affairs should be contrasted with the cluttered actualities of the studio at no. 432 Újezd and the wilder landscapes to which he began to turn his attention in the late 1940s: the Beskid Mountains and the primeval Mionší Forest, on the edge of the Czech lands.

JOSEF SUDEK

Sudek's major achievement was *Praha Panoramatická*, a book of 284 panoramic pictures of Prague and its environs, published in 1959 by the State Publishing House of Literature, Music and Art in Prague. He had bought an old panoramic camera in a small town in Moravia during the war. He called it a Kodak 1894, and it seems to have been a No. 4 Panoram Kodak camera, introduced in 1899, which took 3½ x 12 inch negatives over an angle of 142 degrees. These are the measurements of the pictures in the book. The camera had two traversing speeds, guided by a spring, and it could be hand-held. Sudek began the project in 1950 and his assistant, Jiří Toman, described the work as 'an incredible sports activity', starting at 9.30 a.m. and lasting until sunset. They carried three or more cameras, various materials, tripods and a darkroom for the panoramic camera – for loading and unloading film. The rather unwieldy book was designed by Otto Rothmayer, the architect who had been in charge of building at Prague Castle and whose garden Sudek liked to photograph for his 'Magic Garden' series.

The book of panoramas is thorough and requires a detailed map of the city for reference. Yet the pictures may only have Prague as a vehicle. Those curving lines which define the bank of the river recur in a lot of the panoramas. Sudek selected such concave arcs in order to suggest a rounded topography of discs, each one centring on a feature: a hill or a gap between hills, a tower, a spire, a dome, a statue, a tree or a house. On the fairground at Liben he had a veritable landscape of arcs and circles.

Rothmayer designed the book and decorated the covers with two six-pointed stars and the end papers with four ten-pointed stars. Around each star a contour line appears to be pushing in towards the centre – or to have been pulled in. Their idea may have been that the city functioned as a series of points, each one attracting the attention of a citizen positioned on the edge. In the fairground the principle is displayed in laboratory conditions as the citizens survey the choices on offer. Between them Sudek and Rothmayer had ideas about the city, probably discussed in the architect's garden and then embodied in the book.

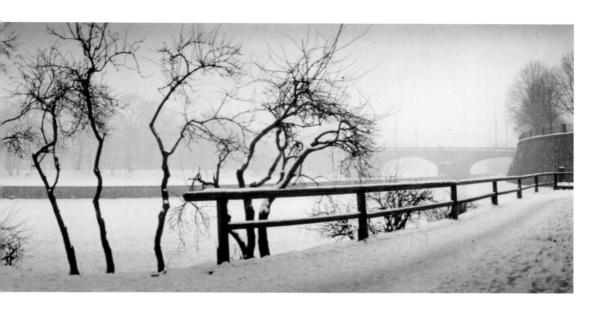

VIEW FROM KAMPA TO STRELECKY ISLAND, PRAGUE. c.1950
This site, on the western bank of the Vltava, was close to Sudek's studio in Újezd. The bridge beyond leads to the National Theatre on the far bank of the river. In the mist, though, not much can be seen other than those railings and that intermittent hedge growing up from the river bank.

Fairground at Liben, Prague. c.1950
Liben is in the north of the city, across the river from Holešovice. The fair is in operation, perhaps in the afternoon at a weekend, but is not yet doing very much business. Sudek took pictures of a number of fairgrounds in the city's outskirts showing a variety of roundabouts, sometimes in operation.

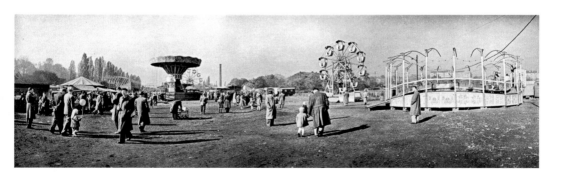

BILL BRANDT

1904–1983 Born in Hamburg, he was brought up in Germany. His father, however, was a British citizen and as a result Bill Brandt had to reflect on his origins. In later life he envisaged Britain in storybook terms, as a myth. He was bookish and had a retentive memory. Aged sixteen he developed TB and was sent to Davos to recuperate. In 1927 he moved to Vienna to undergo psychoanalysis, and it was there that he met the poet Ezra Pound and the architect Adolf Loos. He was advised to consider photography and to go to Paris to see what could be learnt in the studio of Man Ray. In Paris he came into contact with the Surrealists, whose influence remained with him. He visited London in 1929 and settled there in 1931. He spent the spring of 1932 in Spain, and the summer in Hungary.

Death and the Industrialist, Barcelona. 1932
Death takes a companionable interest in the industrialist, who rests his elbow on a ledger. His name has been obscured or wrenched from the plinth. Brandt had just emerged from a long period of convalescence and he would have been moved by the plight of the factory-owner. Sometimes pictures like this were published in picture magazines along with facetious titles.

BEGGAR, BARCELONA. April 1932
This was one of his first pictures to make an impression in the wider world, for it was published in the prestigious *Photographie* annual of 1934. The beggar holds a dish in his right hand and its shadow makes a birthmark on the side of his face. To kneel like that on a stony road would have been uncomfortable, especially with one arm held aloft.

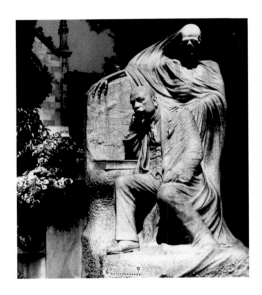

Spain in 1932 had an ineffectual Liberal government and was not yet the cockpit of Europe. Brandt, although never a political photographer, did sympathize with the afflicted. He was in a position to do so, for he was one himself. His long years in the sanatorium meant that there were certain basics that he never quite took for granted – stance was one of these. The beggar on the path, for example, has a difficult job for he has to keep the plate level and within easy reach of the donor's hand. The industrialist, for his part, sinks thoughtfully into inertia. In Brandt's scheme of things humanity aspired to verticality, which meant watchfulness and command. Policemen and soldiers, and almost anyone in a uniform, stood tall, for they were in charge. Nurses and uniformed servants also stood to attention, for they kept an eye on things. Idle onlookers, on the other hand, sit around – as if, with nothing much to do, they have succumbed. His tendency was to show crowds from above, pouring over bridges and through the streets – and he liked to look down on their rooftops. London's beggars crouch over rubbish bins; drunks and the despairing sprawl on the grass – at the sporting events he liked to attend. Fog, alcohol and heavy traffic threaten many of the participants in Brandt's London. He knew, from sometimes bitter experience, that life was an uphill struggle, but that experience gave him his most dependable format: a basic evaluative geometry around which he could organize his pictures.

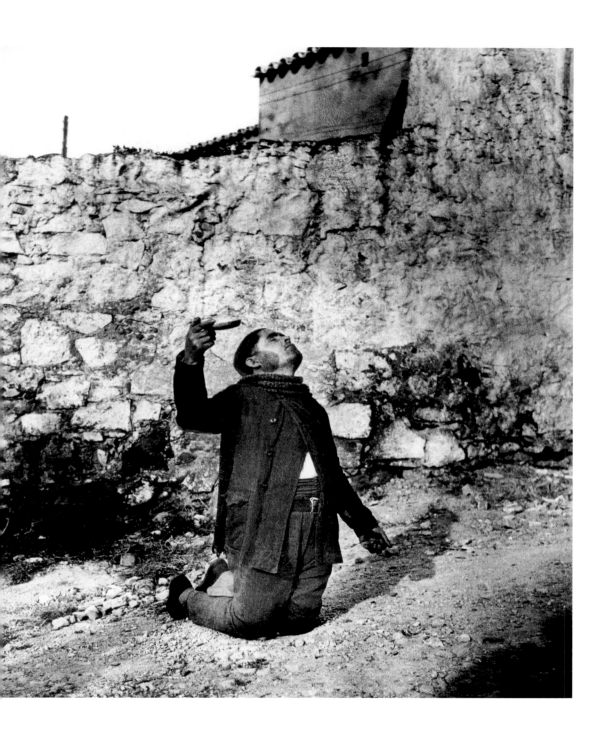

BILL BRANDT

Living in London from 1932 he worked as a photojournalist, mainly for *Weekly Illustrated*, which didn't often credit its photographers. By 1936 he had collected enough material to approach Brian Batsford, an enterprising publisher of picture books, with an idea for a national survey, *The English at Home*. Even though the book had an Edwardian air it didn't do well, but it did demonstrate Brandt's approach to photography: traditional subject-matter arranged around themes which were all his own.

THE WORK. No. 56 in *The English at Home*. 1936
In January 1936 he probably went to Wales for *Weekly Illustrated* to take pictures of coal miners. They had been on photography's agenda for some time because they were poorly paid and prone to industrial unrest. This particular miner, wearing a cloth cap, looks like a relic from a bygone, pre-industrial, age. No self-respecting industrial economy would have owned up to such a grandfatherly figure in 1936.

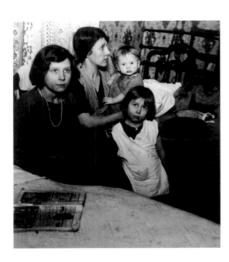

The Home. No. 55 in *The English at Home*. 1936
They confront the miner at work, and are worth examining. The mother looks off to one side, quite anxiously. The smaller children, not complicit with Brandt's scheme, stare at the photographer, who would have seemed exotic in that context in their bedroom, by the look of it. The elder girl, following directions, also tries to look off to our right. She wears a pearl necklace and has notably dirty hands, as if she has just been laying a coal fire. Brandt liked grimy details: overnight chamber pots and bad teeth, for instance. To the right, on one of the beds, is a piece of oval material which rhymes with the shape of the miner's cap, and which might even represent him as a threatening figure off-stage.

Brandt thought in terms of paired pictures, for that is how they were presented in *Der Querschnitt* [Cross-section], the German magazine to which he contributed. Pairing, a form of montage, enriched the photographer's range. Brandt used one image to complement the other. The woman here, for example, is responding apprehensively to the returning husband. All the interest lies in the group of the woman and children, with the man himself little more than a cipher. The pretty girl with her beads and dirty fingers is Cinderella. They form part of a sequence of erotic pairings in *The English at Home* in one of which a demure lady, who might have stepped out of a knitting-pattern book, pours out tea in the presence of a house clad in ivy with upper windows standing open – her boudoir.

At heart Brandt was a dramatist. In his drama assertive males act their parts in front of refined womenfolk. Male desire can't easily be spoken, but Brandt hints at it often enough. The photographer himself is a troubled factor in the scene – an onlooker, ignored by the principals who have more important things in mind, but remarked on by the children, who know no better. The Cinderella figure in this montage exists halfway between the adult world, with all its serious concerns, and childish distraction. Dirt, dust, smog (from smoke and fog) and various stinking residues constituted the background against which these romantic melodramas were played out.

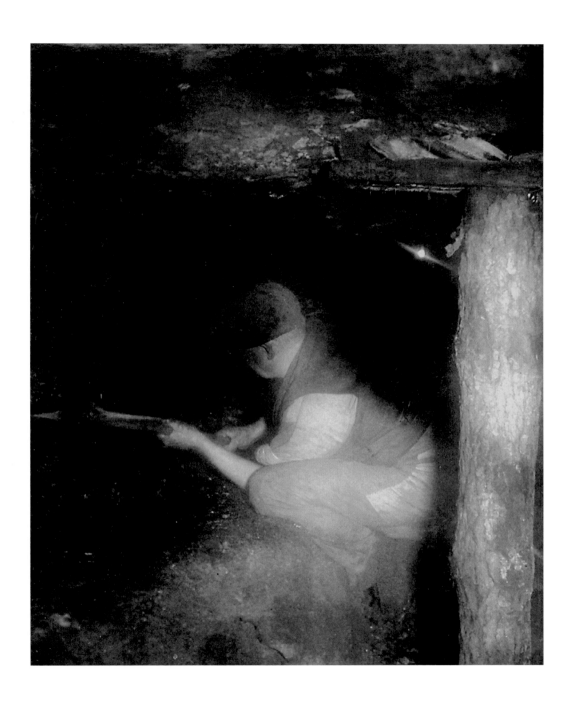

BILL BRANDT

Between 1934 and 1938, whilst working low-key for *Weekly Illustrated*, he learned about Britain. By 1938 he had collected enough pictures for a second picture-book, *A Night in London*, published by Country Life and inspired by Brassaï's *Paris de Nuit* of 1933. In the summer of 1937 Stefan Lorant, who had been a picture editor at the *Münchner Illustrierte Presse* and then at *Weekly Illustrated*, set up the monthly magazine *Lilliput*, a small-format mixture of writing, illustration and photography modelled on *Der Querschnitt*. Brandt contributed to *Lilliput* until December 1950, and it is where he is to be seen to best advantage. Britain's illustrated weekly, *Picture Post*, was launched in October 1938 and it, too, made use of Brandt throughout the 1940s. He began there, on December 5, with a portrait series on London's buskers: Screaming Paddy, Jock the Dancer, Charlie the Juggler and others.

EAST END FIGHT, LONDON. 1939

The outbreak of war in 1939 was a problem for Brandt because he spoke English with a pronounced German accent and could be easily mistaken for a spy. This picture must have been taken early in the year. Perhaps he had been asked to contribute something on the state of Britain's streets, although this is a tidily arranged event. His eye must have been caught by the bollard in the foreground, modelled on cannon discarded by the Royal Navy in the Victorian era. He liked such figurative imagery where the upturned gun stands in for the blow about to be landed. These big symmetrical pictures only became a possibility in 1938 due to the large scale of *Picture Post* (250 x 340 mm).

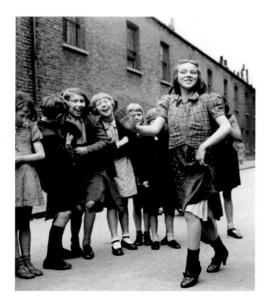

Doing the Lambeth Walk, London. 1943

She is performing a walking dance popularized in 1937 by the musical *Me and My Girl*. By 1942 Brandt had begun to get into his stride as a homeland photographer and this picture was meant to reflect on the need for somewhere other than the streets as a playground. It came out in *Picture Post* in January 1943: 'Are we planning a new deal for youth?' Written on the back of the picture, as a guide for captioning: 'Oh, mister Wu! I'm you ... Joan Whiffin is the Jessie Matthews of Wolverley Street. Grab her Mr. Cochran.' Jessie Matthews was a film star, Mr Cochran an impresario, Joan Whiffin was the girl, and Wolverley Street is in the East End of London, very close to Bethnal Green railway station. Brandt is a participant here, crouching in front of the imperious Joan Whiffin, with both of them playing to that audience of juniors, one of whom is a boy turning away – even hiding his eyes.

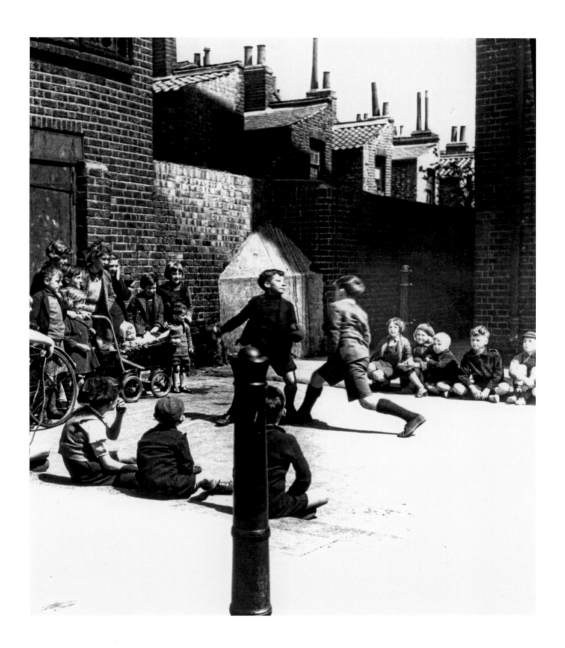

The boy with gloves will swing and miss, and be mocked for his pains by the throng. Joan Whiffin, in her borrowed finery, will grow into a temptress, and her willing audience will follow in her footsteps. Brandt's gift, once he had got the hang of British society, was to be able to deploy reserves of meaning, to read between the lines, to recall and to foretell: rites of passage, trials of strength and the crowd around – in these two instances.

During the war Brandt became a fully fledged homeland artist, but an anachronism at the same time. Styles of reportage had changed by 1945, placing more stress than ever before on action, which had never been Brandt's forte. *Picture Post* still sent him on urban missions, but accompanied by youngsters more in tune with the times. In 1943 *Picture Post* had sent him north to take pictures of the Roman Wall, endangered by quarrying and neglect. This task prompted him to think of landscape. Between 1945 and 1949 he concentrated on romantic landscape, publishing sets of pictures in *Lilliput*. The first two were on writers' landscapes: the Brontës' home on the Yorkshire Moors and Thomas Hardy's Wessex (1945 and 1946), then Connemara in Ireland and the Isle of Skye (1947), with a final series on Halifax, also in Yorkshire (1948). In these small sets of images his art was at its most expansive.

SPINNER, PORT NA LONG, ISLE OF SKYE. 1947

Brandt's set of eight pictures, *Over the sea to Skye*, came out in *Lilliput* in November 1947. This woman with her spinning wheel occupies one half of the centre spread, because Skye was relatively well known for weaving and spinning, in addition to the distilling of whisky. With her left foot she operates a treadle, to keep the wheel in motion.

Hills and Water, Isle of Skye. 1947

This very simplified landscape rests on a band of pale water. In a short text Brandt writes of 'strange, unearthly beauty' and of the clouds and darkness which characterize 'the long island winter'. The landscape faces the portrait of the woman with the spinning wheel. The Skye pictures, eight of them in all, rhyme. In one pairing a vertical tombstone in an isolated graveyard stands next to another which, having lost its foundations, has tilted towards the horizontal, towards the level ground tilled on the facing page by a farmer with a horse and harrow. In the pairing illustrated here the dark hills of Skye slope upwards to the left. They look like a geological cross-section, quite schematic. For her part the spinner rests her foot on the treadle which operates the wheel. Attached by a hinge to the crosspiece the treadle will move at the kind of angle stated by the sloping hills. Brandt was always attentive to such correlatives. Working for a magazine which featured nudes and cartoons, he had no scope for learned iconography. Nevertheless, a spinner would have reminded him of the Fates, who between them spun the yarn, measured it out and cut the thread.

Brandt's was a material vision. Humankind was born into an area of darkness which could only be negotiated with difficulty. Skye, with its leaden waters, dark mountains and lowering skies, fitted the bill perfectly. It existed out of time, or at least in an elemental time at odds with that which he came across in the city. Out of everyday time with all its distracting incidentals he was free to deploy those archetypes which so much interested him: light and darkness, the sea and the sky, life, death and regeneration – the Skye series ends with a view of a rough nest with eggs amongst rocks on the seashore.

Like many of his contemporaries Brandt drifted into fashion photography. He worked for *Harper's Bazaar* in Britain between 1943 and 1945, and then for Rima Fashion Gowns until 1948. He even took fashion pictures for *Picture Post*. His melancholia shines through, however, to the detriment of Rima's gowns. Fashion did, though, introduce him to models, some of whom he persuaded to pose nude. In 1948 his career to date was surveyed in *Camera in London*, according to which he used an Automatic Rolleiflex for most of his pictures. In 1951 many of his landscapes were printed in *Literary Britain. Perspective of Nudes* came out in 1961 and *Shadow of Light* in 1966, by which time his reputation was very well established. By the late 1960s he was classed amongst 'The World's Greatest Photographers' – quite rightly so.

WOODMAN'S DAUGHTER.
Published in *Lilliput*, July 1948
He used photoflood lights and liked to work slowly and deliberately, to the point that some of his subjects begin to feature as onlookers. In this instance he seems to have been fascinated by the shadow thrown by her right-hand side, which appears to attach itself to that horizontal strand of panelling. He has been careful to align her collar bones with the perspectival scheme against which she leans. Pictures of boats under full sail appear in several of his pictures, suggesting surging ecstasy. Her hands placed like that rob the picture of its centre of attention, showing it instead as an arrangement.

East Sussex. 1957
He took pictures for *Perspective of Nudes* on the south coast of England and on the coast of Normandy. The English coast has shingle beaches, which are difficult to walk on; and sea breezes mean that it can be cold. Nude models would have had a hard time of it. Shingle also crunches underfoot.

Brandt's models, with or without their clothes, retain their self-possession. It must have become obvious to them after a while that he was interested in cast shadows and alignments. That had always been his way when he made portraits. Perhaps, though, it was a procedure designed to elicit a certain kind of look: disinterested to indifferent. He had often presented himself as a participant in his own pictures, even if off stage. With Joan Whiffin, dancing the Lambeth Walk, he was an acolyte. With the 1940s nudes he figures as a fastidious artisan managing his photofloods and Deardorff view camera.

As a youth he had had TB, and in the 1940s he developed diabetes. He was aware that life couldn't be taken for granted, and more so as he got older. Hence those journeys to the coast during the 1950s where the stones made walking difficult and the cold wind brought goose pimples to the skin. More than likely there was also the sound of the sea in the background to add to the grating of the stones. He spent a lot of time taking stock of the material world, which he had so nearly missed and which he so greatly appreciated. Towards the end he collected and arranged desiccated flotsam and jetsam from these same beaches – an ironic farewell to everything he had held dear.

LISETTE MODEL

1906–1983

She was born Elise Félic Amelie Seybert in Vienna. Her father was a wealthy Jewish Austro-Czech physician and her mother was Italian. Her father was a keen musician and the young Elise studied music with Arnold Schoenberg. On the death of her father in 1921 she went to Paris for training with the Polish soprano Marya Freund. She became interested in painting and in 1936 married a Russian painter, Evsa Model. At some point in the early 1930s she turned to photography, for it was a promising way of making a living then. She took pictures of *clochards* in Paris; and she also made a subsequently famous series of street pictures on the Promenade des Anglais in Nice – where her mother lived. In 1938 she went to New York on a visit and decided to stay. She survived on her private income for a while but eventually looked for a job as a lab technician at *P.M.*, a New York weekly. At *P.M.*, Ralph Steiner, who had helped Walker Evans in his early days, was impressed by her pictures and recommended her to Alexey Brodovitch at *Harper's Bazaar*, who, in his turn, took them to Beaumont Newhall at the Museum of Modern Art. This was very much the American way, and remained so until the 1970s, at least.

Promenade des Anglais, Nice. 1937
Model's contemporaries in France didn't work so directly as this. The quite elaborate pattern of flowers and dots on the woman's frock charts her shape, and the hat, too, has its own system.

BLIND MAN, PARIS. 1937
The notice says that he is blind and has been since the age of seven. The small script below says that he can recognize the worth and country of origin of any coin given to him – which would have been an inducement to donors. What is remarkable about the picture is that it centres on the man and shows so little context in comparison with the photographs of Krull and Kertész earlier in the decade.

It may have crossed her mind in the 1930s that the people of the Promenade des Anglais had commercial possibilities. The magazines of the time used old hands to make in-depth reports of a dozen or more pictures. Would-be photographers starting out relied on sporadic sales to small magazines where the editors liked to juxtapose pictures for telling and sometimes humorous effect. A lot of Model's early pictures could be matched up like this. She was also lucky not to have developed an elaborate style with European nuances, because photographers who had learned their trade in Berlin before 1933 and then in Paris often didn't make the transition to the United States. Model's style, by contrast, was comparatively unencumbered and could be applied in the USA quite easily. New York in particular had many similar subjects to those she had found in Paris and Nice. Photography in New York was heading in her direction anyway, looking for a more forthright manner than that of Walker Evans, whose *American Photographs* had just been shown at the Museum of Modern Art.

LISETTE MODEL

Once she declared herself as a photographer in New York her success was immediate. Brodovitch took her on in 1941 as a photographer for *Harper's Bazaar* and her first picture, printed in July 1941, was for an article, 'How Coney Island Got That Way'. Between 1941 and 1951 her pictures appeared with twenty-two articles in *Harper's Bazaar*, although many of these were on rather workaday topics. She also worked for *Look* and *Ladies' Home Journal*. At the same time she was active in the Photo League, a socialist organization set up by Sid Grossman and Sol Libsohn in 1936. She turned towards teaching, beginning in 1947 at the San Francisco Institute of Fine Arts and continuing in New York at the New School for Social Research (1951–4 and 1958–83). Before teaching she took instruction from Sid Grossman, whose aggressive style she didn't like, but she seems to have become a successful teacher. Diane Arbus gained a lot from her advice. In 1979 Marvin Israel, who put together the commemorative book on Diane Arbus in 1972, designed *Lisette Model* for Aperture: forty-nine pictures altogether. Her motto, quoted by Berenice Abbott in an introduction to the book, was 'Don't shoot 'till the subject hits you in the pit of your stomach.'

SAILOR AND GIRL, SAMMY'S BAR, NEW YORK. c.1940

Sammy's Bar on the Bowery was an infamous saloon and cabaret, reminiscent of Berlin in the 1920s. Model took pictures there and in September 1944 *Harper's Bazaar* published ten of them in an article, 'Sammy's on the Bowery'. This is a new manner for Model: organic montage with a lot of darkness in the interstices between figures, and no spatial co-ordinates. She picked it up, in all likelihood, from the Photo League where it was used to display the people in their diversity.

Broadway Singer, Metropolitan Café, New York. n.d. Model used these diagonal formats in the 1940s to add energy to the scene. Native documentarists in the late 1930s respected the conventions, thinking it best to transcribe rather than to express. In 1936 the art historian and critic Meyer Schapiro, speaking at the American Artist's Congress, remarked on 'the passivity of the modern artist with regard to the human world'. Painters, such as Philip Evergood, took up the challenge in the late 1930s and so, too, did the photographers of the Photo League.

Model was more extravagantly expressive than any of her contemporaries in New York, many of whom were away on war service in the early 1940s. She was probably aware of German Expressionism from the 1920s – and must have been, for her husband was a painter. The photographers of the Photo League would also have alerted her to the new mood. Nor would she ever have had the time to settle down and to understand the culture to which she had been recently introduced. Expressionism, on the other hand, was open to all, a common currency – and one for which there was a demand in the USA at war.

HELEN LEVITT

b. 1913

She was inspired by the photographs
of Henri Cartier-Bresson and Walker Evans which
she saw at the Julien Levy Gallery in New York
in the 1930s. Helen Levitt also owed a lot to Ben
Shahn, but her own photography is something
else again. She made a living as a film editor and
continued to take pictures, to such good effect that
she had her first exhibition at New York's Museum
of Modern Art in 1943. A series of her photographs
was assembled in 1946 for a book called *A Way
of Seeing*, but it wasn't published until 1965. The
foreword, written by James Agee, should be read
by everyone interested in the medium. He classes
her with lyrical artists. In 1941 Levitt travelled to
Mexico City with Alma Agee, James Agee's wife.
The Mexican pictures were published in 1997, as
Mexico City. In 1959 and 1960 she was awarded
Guggenheim Fellowships to study 'the techniques
of color photography', but most of the slide material
for that project was stolen before it could be printed.

NEW YORK. Pre-1946
The children are doing nothing in particular,
although the boy to the right holds a paper mask
and his companion looks as though he has just
emerged from the cover of that white handkerchief.
Agee says that the boy in the picture epitomizes
'for all human creatures in all times that moment
when masks are laid aside'. Next to this picture
in *A Way of Seeing*, three other youngsters lie
in wait in an ambush on the steps of a house –
another stage in the process of emergence.

New York. Pre-1946
James Agee, introducing *A Way of Seeing*, calls this
a 'prodigious image of anguish and consolation',
which it is. The larger woman, consoling, looks
into the distance, for she has seen it all before
and knows how it will work out in the end. That
vignette of a child going about his own business
is another hallmark of Levitt's street scenes.

Agee was right to praise Levitt, for her pictures are without parallel. Shahn, Cartier-Bresson and Evans gave her a format which she then adapted. She had an interest in the human condition, it is true, but so finely tuned as to verge on the supernatural. It would be possible to imagine that scene of anguish and consolation, for it has a theatrical look, but surely not to this degree. A lot of her pictures are also completed by details, such as that of the preoccupied child, which go beyond making sense. She was lucky to catch 'the decisive moment' time after time, almost as if it had been waiting just for her. Agee discusses this matter of luck and decides that it would only rouse itself for the right person. The book, *A Way of Seeing*, also owes something to Agee himself for he says that the pictures run 'in an order suggested by the essay'. It was a period when writers and photographers often worked in close conjunction: Izis and Ronis in Paris, for example, and their connections with Jacques Prévert.

Why did she go to Mexico in 1941, and why did she take the kind of pictures that she did? Precursors, such as Edward Weston and Paul Strand, had photographed Old Mexico, a lot of it in the countryside. Folk art was also high on the agenda during the 1920s and '30s, for it helped to explain the Mexican painting renaissance. Photographers hadn't been attracted to Mexico City itself, even if Cartier-Bresson did take some often schematic street pictures there in 1934. Helen Levitt had gone there in 1941 expecting to travel – her companion Alma Agee had a Chevrolet, which they had taken on the ship. However, after a while she returned to Mexico City and took pictures there during the summer.

MEXICO CITY. 1941
The men may be ragpickers, in the French tradition of the early twentieth century. Whatever it is, they are concentrated on their work; and that looks like a completed sack in the foreground. But Levitt may have been attracted by the four dogs who accompany them: three of them take time off, and the fourth examines the ground – very much in the way of dogs.

Mexico City. 1941
The girl is walking lost in thought – or appears to be. She may, in fact, be picking her way over those rough paving stones which could cut or bruise her feet. The pavement beyond emerges elegantly from the rough ground to the left, and the nearly symmetrical wall beyond has been patched up in the course of its history. The picture could be read as an allegory touching on the girl's path through life: choices and some rough going. James Agee might have seen it as an embodiment of thoughtfulness and solitude.

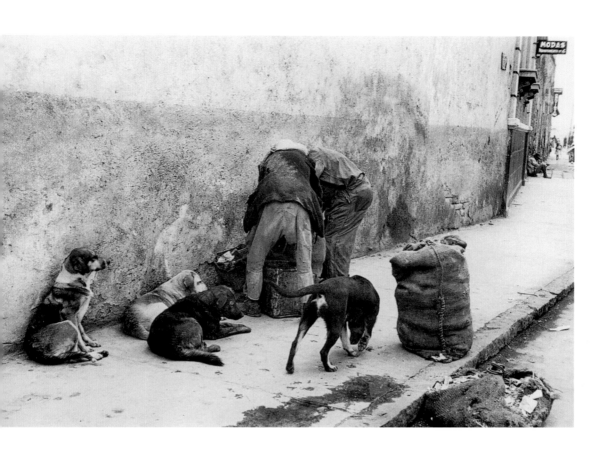

Helen Levitt's Mexican pictures, like those from New York City, are acted out in what might be called natural space: a section of street and pavement backed by walls and buildings. Modernists, such as Henri Cartier-Bresson, used steeper angles and didn't allow for these naturalistic settings. Levitt's pictures of 1941 look, to some degree, like pictures taken in Berlin a decade earlier by urban documentarists and reporters. Their idea then was to represent the average citizens of Berlin – comfortable in their own spaces: idling in parks, at café tables and talking in the street. That kind of intimate picture held that society was made up of individuals, family groups and small-scale coteries – hobbyists and model-makers, for instance. In one version of the ideal world, around 1930, citizens had a certain degree of self-control, which wouldn't be allowed in either a fascist or a communist state. Levitt's pictures in Mexico City look like a rehearsal of that position. Her personnel, including dogs, cats and children, attend to the matter in hand, whatever it is. Levitt's are the last exercises in this vein. After 1945 there was too much urgent work to be done to allow for this kind of liberal vision.

ROBERT CAPA

1913–1954
Endre Ernö Friedmann was born in Budapest, where his parents owned a fashion salon. He was introduced to photography by Eva Besnyö, whose family lived in an adjacent apartment. She later became a well-known modernist photographer in The Netherlands. In 1929 he came under the influence of Lajos Kassák, an active figure in the Hungarian avant-garde. The financial crash of 1929 affected Hungary and the Friedmann business; and that combined with anti-Semitism and political turmoil prompted Endre to continue his studies in Berlin in 1931. In Berlin he was helped by Eva Besnyö and by György Kepes, members of the Hungarian diaspora which spread far and wide during the 1930s. Endre decided on journalism, but financial hardship pushed him into photography. He undertook menial work in agencies, at first in Simon Guttmann's Dephot. Guttmann asked him to take pictures of Leon Trotsky speaking in Copenhagen late in 1932. When the Nazis came to power in 1933 he left for Paris, to become André Friedmann. In Paris he survived by courtesy of friends and by the skin of his teeth. He became an established photographer only in 1936 when he also took on the name Robert Capa: Robert from the first name of the actor Robert Taylor and Capa derived from the movie director Frank Capra. There was another and better-known Friedmann in photography. In the summer of 1936 civil war broke out in Spain where Capa photographed, with some respites, until 1939.

NEAR FRAGA (ARAGÓN). November 7, 1938
This picture was taken during a Loyalist offensive along the Río Segre. The offensive had been undertaken to divert General Franco's opposition forces from another battle at Mora de Ebro. Franco was in the process of isolating Barcelona in the north. This was one of twenty-six pictures used in an eleven-page article in *Picture Post*, 'This is War', December 3, 1938. Captions say that the man is a prisoner brought in to give information on the strength of opposition forces. Capa was introduced in *Picture Post* as 'The Greatest War-photographer in the World' and as 'a passionate democrat'.

Near Fraga (Aragón). November 7, 1938
The prisoner was no. 15 in the series, and this casualty is no. 22, entitled 'Back through the smoke come the casualties'. Each picture in the series has a title, a descriptive caption and a running commentary on warfare and politics. Spain was understood as a rehearsal for the next major war. The commentator suggested that both tanks and aircraft weren't so successful in battle.

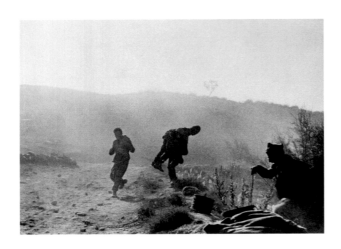

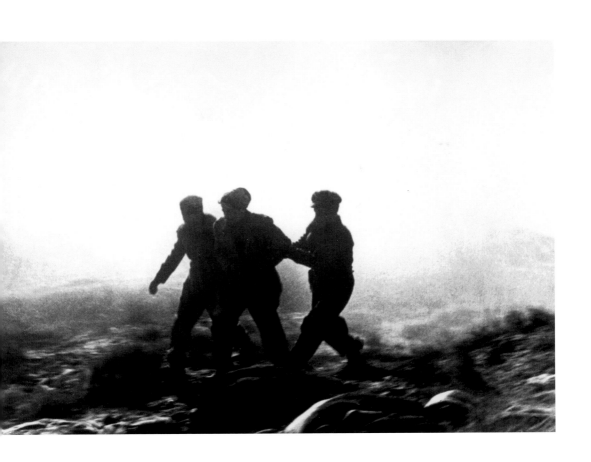

Reportage, as it evolved in the 1930s, had cinematic qualities. Photographers, and Capa in particular, knew that a printed article would include series of pictures quite closely connected. Commentaries would provide continuity, and pictures were understood as extracts from a larger event, whose dimensions could only be guessed at. The more fragmentary the images, the more urgent the event. Documentary pictures, on city nights for example, were more static. Capa's war photographs, taken in the thick of things, were a revelation in 1938.

ROBERT CAPA

Capa's biography, compellingly told by Richard Whelan in 1985, returns often to the problems in a photographic career. As an alien, as he almost always was, he had to pay special attention to visas and to identity cards. He ran a lot of risks at the front line, including that of being arrested for suspicious behaviour. A photographer in war zones, such as Spain or China, had to be able to talk himself out of any number of difficult situations. Then there was the problem of agencies. No one could work as a freelancer, but agencies liked to call the shots – and a lot of Capa's time was frittered away on dull ventures over which he had no control. Photographers working on the front line also had trouble getting their pictures back to HQ, and Capa often complicated matters by selling directly whilst under contract. The great and tragic event in his life was the death of Gerda Taro in Spain in 1937. They were lovers, and she was also a photographer and correspondent. She died in an accident whilst Capa was back in Paris. Their photographs are published in *Death in the Making*, 1939. Mindful of wrangles with agencies and with *Life* magazine over ownership of picture rights, he was one of the cofounders of the Magnum co-operative agency in 1948. In 1938 he took pictures during the Chinese-Japanese War, and in 1943 he was attached to American forces in Africa. He followed the Second War through to the end. In 1954 he was killed by a landmine in what was then called Indochina. A nomad since 1930, and an adventurer, gambler and womanizer, he was photography's romantic lead.

CHINA. April–September 1938
It may have been taken on the Yellow River in July after Chiang Kai-shek had ordered the blowing up of dykes to halt the Japanese advance on Chengchow. Capa didn't usually take such sculptural images, preferring to show continuity from side to side of the picture. The two main men are managing a heavy rudder in turbulent water.

Chartres. August 18, 1944
This is a famous picture, and quite ambivalent. Women who had taken German lovers during the war – and, worse still, had children by them – were publicly humiliated on the liberation of France. Their heads were shaved, and in this case that of the woman's mother too. The scene does no credit to the tormentors, especially considering that the site is Chartres with its famous cathedral.

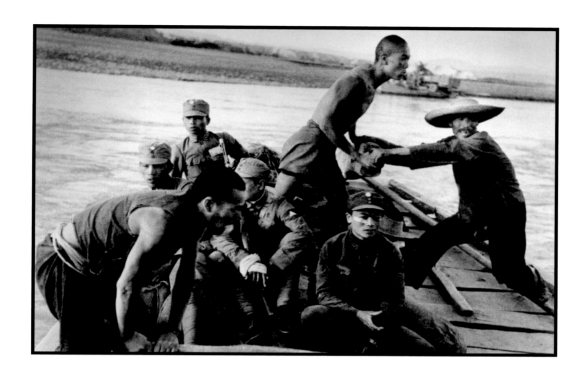

Capa did a lot to consolidate the humane tendency in post-war photography. He took a logistical view of war. Casualties had to be evacuated, and sooner or later soldiers had to take time off to rest and to smoke. Rivers had to be crossed and all sorts of arrangements had to be made, as he well knew from his own travels. With a girl in every port it would have been easy to sympathize with that woman in Chartres. When Magnum was set up its first collective venture was called 'People are People', a report on farming families throughout the world – and one of the ideas behind 'The Family of Man' in 1955.

RESETTLEMENT ADMINISTRATION
FARM SECURITY ADMINISTRATION

1935–7 & 1937–42

Photography's most celebrated archive originated in the work of a government relief agency. Rural poverty had been an issue in the USA during the 1920s and conditions became much worse after the great crash of 1929. Franklin D. Roosevelt, elected president in 1932, promised 'a new deal', part of which was the Resettlement Administration. The idea was to resettle small farmers on more viable land. Underfinanced, the RA made little headway, and in 1937 its work was taken over by the Farm Security Administration. The FSA gave loans to farmers and to tenants and it established migratory labour camps, but it, too, was underfinanced and it had enemies amongst those who valued cheap labour. Many of its clients were sharecroppers and migrants; they were often voteless and inarticulate, and thus part of no political constituency. In July 1935 Roy Stryker was appointed head of the Historical Section in the Information Division of the RA, with the job of preparing reports on the work of the organization. Photographs were needed to illustrate such reports, and Stryker began to collect pictures. Stryker didn't have much of a plan to begin with. In the summer of 1935 he spoke to the photographer Walker Evans who had been thinking about survey photography: 'Architecture, American urban taste, commerce small scale, large scale, the city street atmosphere, the street smell, the hateful stuff, women's clubs, fake culture, bad education, religion in decay' (from a letter of February 1934). Stryker recruited Evans to do some pictures on a trial basis. Carl Mydans, working in Urban Resettlement, transferred to his office, as did Theodor Jung, a graphic designer working for Emergency Relief Administration. Dorothea Lange, an experienced photographer who had already taken pictures of migrant workers in California, was also appointed in 1935.

PROSPECTIVE CLIENT WHOSE PROPERTY HAS BEEN OPTIONED BY THE GOVERNMENT.

Brown County, Indiana, October 1935 (Theo Jung) Jung made only three journeys for the RA between September 1935 and April 1936: Garrett County in Maryland, Brown County in Indiana, and Jackson County in Ohio. Jung recalled that he had been given no particular directives by management, but it would have been clear that RA clients should be portrayed. Neither Jung nor the prospective clients could have guessed that they were taking the first steps towards the establishment of a national archive.

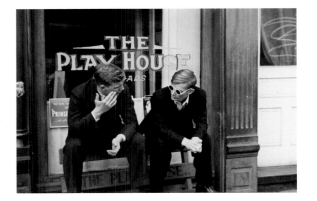

Young fellows in front of pool hall.
Jackson, Ohio, April 1936 (Theo Jung)
During the Depression people had time on their hands, and they spent it talking and waiting. Almost from the beginning RA photographers took such background pictures. Leisure, gesture or costume: how should such a scene be classified? The RA file developed organically; Stryker said that it grew 'because pictures demand more pictures'.

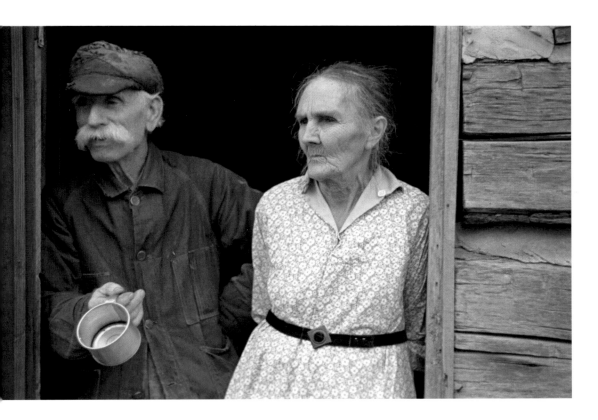

Roy Stryker thought that his photographers should inform themselves about the situation on the ground
before they took any pictures. Jung preferred to rely on intuition and to make his decisions
on site. They disagreed, and Jung was dismissed. Theodor Jung (1906–1986) was born in
Vienna and taken to the USA in 1912. He kept up his Viennese connections and spent most
of 1933 there, studying lithography and printing. His arrival in Vienna coincided with Hitler's
appointment as Chancellor in Berlin. Jung would have had the opportunity to see what was
happening in German-speaking central Europe. With such first-hand experience he would have
trusted his own judgement rather than that of Roy Stryker.
The elderly couple in Brown County have a Germanic look. Otto Dix's father, for instance,
had just such a moustache. Dix, one of Germany's major painters in the 1920s, was a New
Objectivist and a believer in the pictorial impact of things – such as that scoured metal cup
which the elder holds in his right hand. The empty cup looks very much like a saint's attribute
in an altarpiece and Jung may have wanted to elicit sympathy for the weather-beaten old
couple. They represent endurance as a virtue, just as the 'young fellows' propose able-bodied
idleness. Jung's photography, or what little there is of it – only 150 pictures for the Resettlement
Administration – is continuous with the painting of the New Objectivists and with that of such
precursors as Cranach and Dürer.

Stryker's was a hand-to-mouth operation. Photographers were taken on when funds permitted. Some left for other or better jobs, and Walker Evans was loaned out to *Fortune* magazine. There was never a master plan, although the archive concentrated on farming communities and small towns. Photographers learned from each other and Ben Shahn was an important influence – even though his connection with the RA was fleeting. People liked the candid pictures he took on 35 mm, with his right-angle viewfinder. Stryker was an enthusiast. Carl Mydans remembered being sent on a tour of the South and being asked by Stryker if he knew much about cotton. Mydans, an established photojournalist, said that he didn't know very much, and Stryker kept him back for a day to talk to him about cotton and its culture. Photographers felt that their work mattered, even if only to that one man at headquarters. As propagandists, Stryker and his unit were never very successful. He persisted, however, and eventually built up a collection of over 200,000 images. He managed to keep the file active. Sooner or later most picture archives are neglected and even mistreated, but the RA/FSA pictures survived with their reputation continually enhanced. The file, although of people very much down on their luck, must have looked, in the 1960s and 1970s, like

an ancestral cross-section. Farm people often had the look of pioneers. Moreover, most of the pictures in the file are 'speaking likenesses'. People emerge or come to the door to have their likeness taken, and they have things to say too, some of which were taken down. In the Soviet model of the early 1930s the people smile a lot but don't often seem to speak, but in Stryker's USA speech is of the essence.

COTTON WORKERS, CRITTENDEN COUNTY, ARKANSAS. May 1936 (Carl Mydans) 'Damned if we'll work for what they pay folks hereabouts', was Mydans' phrase for this image. Man and woman, black and white: a heraldic picture with propaganda value. Mydans probably talked to them and picked up the phrase in conversation. He used a 35 mm camera for reference, which was rare at the time. In 1936 he left the RA to join the illustrated news periodical *Life*.

Typical farmer group of Prairie City, Missouri in Mississippi County. March 1936 (Carl Mydans) The man with one eye reads a newspaper. The only paper available? Maybe the others don't read very well. In other photographs one sees that hunkering-down position, and there is also a lot of shop window evidence on file.

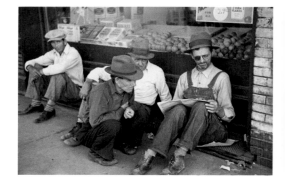

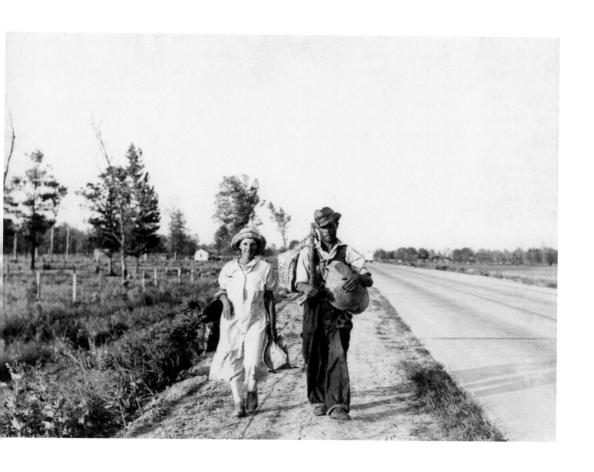

In 1936 there was no theory of the word in photography, but one is implicit in such a picture as this. What exactly is being said? The man with one eye looks as if he is figuring out the text and will shortly deliver the gist. A native speaker could well imagine the discourse, its tone and terms. The poignancy of such candid pictures is that they centre on an absence: talk and response, the essence of the moment, of which the image is a shell and residue only. Carl Mydans (1907–2004) worked for the Resettlement Administration for a year before leaving late in 1936 to join the newly established *Life* magazine. He had studied journalism and worked as a reporter beforehand for *American Banker*. Either by training or by temperament he developed a dynamized approach to documentary, even in apparently stable topics. The cotton workers proceed towards us down a long road. Even the 'farmer group' at their ease in Prairie City are receiving the word from their one-eyed source. Whenever Mydans took a group it looks barely held together for the moment before the children scatter and the adults turn away.

DOROTHEA LANGE

1895–1965

Born in Hoboken, New Jersey, Lange trained as a teacher in New York. She studied photography with Clarence White, one of Stieglitz's contemporaries, and eventually set up as a portrait photographer in California. She remained a portraitist until 1932, when she took up street photography. 1n 1934 she met the economist Paul Taylor who was studying the plight of Dust Bowl refugees in California. In early 1935 she and Taylor documented the life of migrant workers in Nipomo, which is on the coast and halfway between San Francisco and Los Angeles, and in the Imperial Valley, inland from San Diego. Roy Stryker saw the results and in August 1935 hired her to work for the newly established Resettlement Administration. In May of that year she had also taken pictures of colonists from Minnesota leaving San Francisco to settle in Alaska. She was experienced in the kind of work which the RA was about to undertake. In 1936 she went on a long trip through southern California, New Mexico and Arizona on behalf of Stryker's agency.

MIGRANT MOTHER, NIPOMO, CALIFORNIA. March 1936

This is a famous picture – as a representation of migrant labour, motherhood and humanity in general. The woman, Florence Thompson, was a pea-picker working at Nipomo. The weather had been poor, and there was little work. Lange spotted the woman with her daughters sheltering in a lean-to tent, and she took six pictures of the group, getting closer and closer until she finally took this portrait. Impoverished, the woman had been forced to sell the tyres from her car and even the tent itself – according to another caption. She had seven children, it seems, four of whom appear in the set of photographs. Lange may originally have been attracted by the apparatus of migrancy: suitcases, chairs, plates and a hurricane lamp. She soon realized that the woman was her subject. The original scene in the mouth of the tent was quite complicated, and it featured a moping adolescent in a cane rocking-chair. Lange must have done some arranging: getting the youngsters to turn their heads away, and moving the woman's hand and arm to support the head and even to draw it forward.

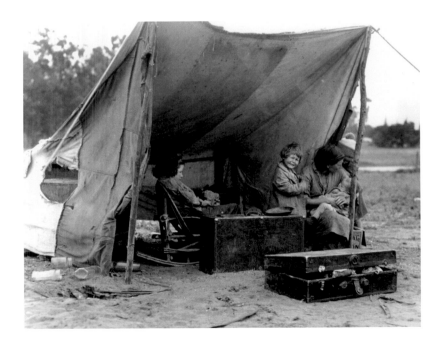

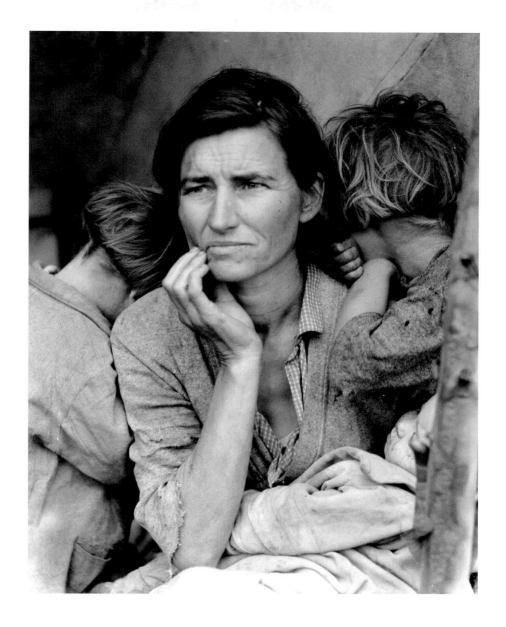

Roy Stryker thought of this picture as 'the ultimate', and it appears on the cover of *In This Proud Land*, his selection of 1973 (prepared with Nancy Wood). He was at pains to deny that the migrant mother was posed, for his organization prided itself on the naturalness of its photography. Anything contrived would have been propaganda and therefore untrustworthy – and there was trouble in May 1936 when Arthur Rothstein moved a steer's bleached skull in drought-stricken South Dakota, for the sake of a better picture. Lange, though, must have been quick enough to see that she was onto something substantial – a modern Madonna at least. In Soviet icons of the early 1930s the distant look meant utopia achieved. In the Christian tradition it meant that the Mother foresaw, in terrible detail, the destiny of her Child. Stereotypes extended the meaning of a picture, and opened it up for consideration. Lange was the only one of Stryker's photographers ever to make use of such resources.

DOROTHEA LANGE

Lange's accounts of the Resettlement Administration are believable. She seems to have gone to Washington in the late summer of 1935: 'I didn't find any organization. I didn't find any work plan. I didn't find any economics professor. I found a little office, tucked away in a hot, muggy summer, where nobody especially knew what he was going to do or how he was going to do it. And this is no criticism, because you worked in an atmosphere of a very special kind of freedom.' In 1935 she married her own economics professor, Paul Taylor. Together in 1938 they worked on *An American Exodus*, on migrant labour in the USA. Lange had begun to work for him in 1935, employed originally as a typist, for the authorities were sceptical about the value of photographs. A trained photographer, she liked to develop and print her own pictures, and to retain the negatives. Sometimes she rowed with management on these issues. During the winters she photographed in California and the North-West and during the summers in the South – usually on missions which lasted for two to three months. She stayed with the RA/FSA until it was wound up in 1942.

COUPLE, BORN IN SLAVERY, ON AN ABANDONED TWENTY-EIGHT FAMILY PLANTATION, GREENE COUNTY, GEORGIA. July 1937

They appeared in *An American Exodus* with this caption, originally noted down in conversation by Paul Taylor: 'I remember when the Yankees come through, a whole passel of 'em hollerin', and told the Negroes you're free. But they didn't get nothin' 'cause we had carried the best horses and mules over to the gulley.' In Herman Clarence Nixon's *Forty Acres and Steel Mules*, an agrarian study of 1938 illustrated with a lot of FSA pictures, they are described as 'an ex-slave and his wife'.

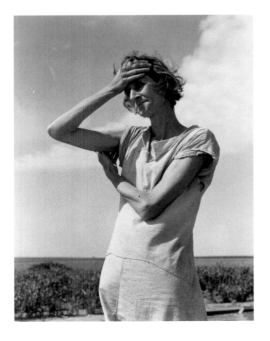

Woman of the High Plains, Texas Panhandle. 1938
This woman also appeared in *An American Exodus*, along with the caption 'If you die, you're dead – that's all.' Like the *Migrant Mother* she too holds her arms and hands expressively. The same tall, spare woman features as a migratory labourer's wife near Childress, Texas, dated June 1938 – also by Lange. There were others like her in the photography of the era: gaunt women dressed in plain shifts like this. Even though anxious and emaciated, they still have something of the quality of athletes hardened by adversity. The smiling tractor girls of the USSR are less credible by comparison.

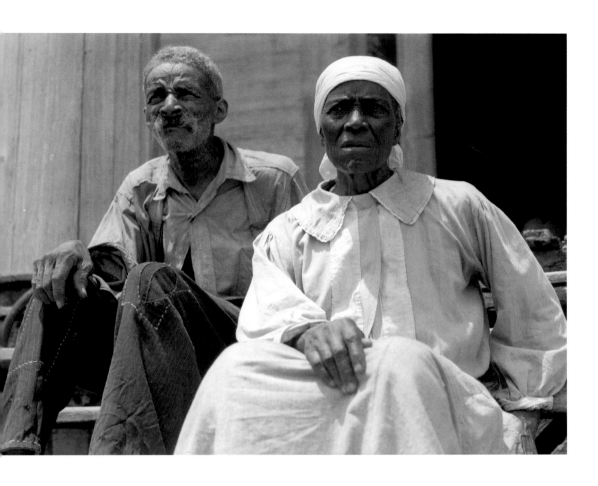

In Ben Shahn's pictures of 1935–6 people speak to each other. In Lange's pictures the speaking has already
taken place and often in the form of an adage memorably phrased because reflected upon and
repeated. The ex-slave, for instance, must often have heard the story of the Yankee liberators;
and the woman from Childress (in the north-west of Texas) must have thought a lot about
her despair. Lange's was an eloquent photography, to the point of calling for a completion
in language. In an urgent ethical context photography by itself was insufficient – good enough
to remark on practicalities, but no more. Words, conclusively phrased, might just make the
difference when imperatives were at issue. One of the problems with telling phrases, however,
was that they couldn't always be vouched for. They could be made up by the author, or
remembered from another occasion. The best words of all, in a Depression context, were
those of Erskine Caldwell, the writer who accompanied Margaret Bourke-White – and knew
the language by heart.

ARTHUR ROTHSTEIN

1915–1985

Rothstein was taken on by Roy Stryker at the Resettlement Administration in Washington as a research assistant and technician – this was at the very beginning of the operation in 1935. Rothstein, recently graduated from Columbia in New York City, intended to become a chemist or a medic but drifted into photography. In March 1936 Stryker sent him to 'explore dust storms and drought in the west and the agency's attempts at relief'. By August 1936 he had taken pictures in Kansas, Nebraska, Washington, Oregon and the Dakotas. With Russell Lee he became the most dependable of all Stryker's photographers at the RA (later to become the Farm Security Administration). Even during periods of cut-back Stryker retained him. He was the most prolific of all Stryker's photographers. In 1940 he moved to *Look* magazine. As an apprentice at headquarters in Washington DC, Rothstein admired both the candid, time-based art of Ben Shahn and the more studied tableaux of Walker Evans.

INTERIOR OF POSTMASTER BROWN'S HOME AT OLD RAG, SHENANDOAH NATIONAL PARK, VIRGINIA. October 1935
In this very compendious picture Postmaster Brown has a choice of five books. Two lamps stand ready for use. Christ and the Colosseum represent the western tradition. On the wall beyond the mirror a temptress lurks, as if the Postmaster were a religious man who had faced and overcome temptation. This must be one of Rothstein's earliest pictures, and it reveals a materialist turn of mind which would be evident in most of his work for the RA/FSA. Rothstein believed, on the evidence, that understanding was a practical matter. Pictures displayed evidence of what might be handled and used – such as the hat and the brush on top of the chest of drawers.

Farmer's wife; near Kearney, Nebraska. 1936
She is operating a National Vacuum Washer, a complicated piece of apparatus powered by electricity. Rothstein liked to show his subjects in relation to whatever it was that they used or sold. Failing that he would show them next to a fence or a heap of lumber. He didn't expect them to act, simply to appear.

If you take candid pictures, as Ben Shahn did in 1935, you raise the insoluble problem of what exactly is going on in the scene. Why are they looking over there, and just what are they saying? With Rothstein's more static pictures there are no such mysteries, and the scene can be read through. You do the talking, to yourself, as you note the books and the lamps, Christ and the temptress. Nor did Rothstein believe very much in the affective power of physiognomy – as Dorothea Lange certainly did. In Rothstein's quite practical and even melancholic understanding of the world, men and women are operatives, more or less successful at their tasks. Rothstein liked integrated images in which basics are made clear. In his skies, for instance, windmills and fluttering flags indicate movements in the air. Our own physical natures are indicated by tools, eyeglasses, things we can hold and touch; and the life within is best shown by a book. Shahn looked to words for a completion of meaning; Rothstein looked to things.

RUSSELL LEE

1903–1986 Born in Illinois, Lee graduated as
a chemical engineer. He became the manager of a
roofing plant in Kansas City, Missouri, but he tired
of management and turned to art in 1929. He studied
at the Art Students League in New York and began
to use a camera to supplement sketching. By 1935–6
he had become a photographer. Ben Shahn, who
was a friend, put him in touch with Roy Stryker
at the Resettlement Administration in Washington.
Stryker, who had no vacancies, advised him to work
for the Forest Service but then gave him a job when
Carl Mydans left the RA for *Life* magazine. Lee, who
was systematic and dependable, worked for the
RA, and then for its successor, the Farm Security
Administration, until closure in 1942. He survived the
cut-backs of 1937, when he and Arthur Rothstein were
loaned to the Public Health Service. Lee spent most
of his time on the road and from 1938 most of it
west of the Mississippi. Although an all-rounder, well
able to cope with details, portraits and the broader
picture, Lee had a predisposition to character studies.

**FARMER'S WIFE; BLACK RIVER FALLS,
WISCONSIN.** 1937
She has pinned her apron to her blouse, and
rolled up her sleeves. She looks into the distance
and narrows her eyes against the light. Stryker's
photographers rarely went to Wisconsin, but
in 1937 Lee went north to report on deforested
land which had been sold to farmers. Some
of the land was inundated and some eroded.

**Three members of ladies' quintette at a community
sing, Pie Town, New Mexico**. June 1940
'Sow Good Deeds' is the title of the last song in the
book, barely readable. Attracted by the unusual
name, Lee decided to investigate the town which
was on US 60. He found a remarkable community
spirit. In October 1941 a portfolio of the Pie Town
pictures appeared in *U.S. Camera*. Some of the
people of Pie Town (named after a pie shop long
ago) were displaced farmers from Oklahoma and
Texas, so there was some justification for taking their
pictures. By 1940, however, Stryker's photographers
had begun to interpret their mission quite broadly.

Older faces develop character; and the term has its origins in stamping and engraving. The singers
are characters, and the face of the farmer's wife has been marked by exposure to the
weather of Wisconsin. Character connotes experience, and we speak of people having depth
of character. The knack was to make portraits in which the subject was just sufficiently active.
Lee was a good judge of these expressive moments: singing, playing instruments, attending
to auctions and events. Thus he was able to give an extra dimension to documentary.
No one matched him at this.

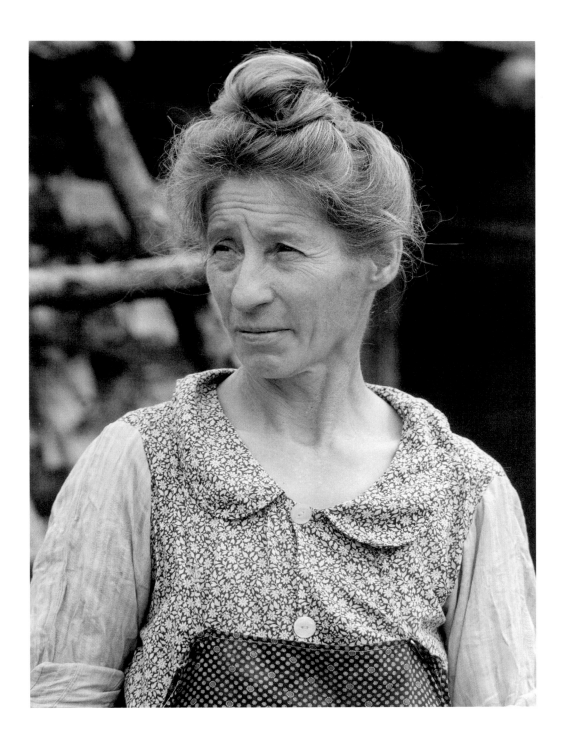

JOHN VACHON

1914–1975

Born in St. Paul, Minnesota, John Vachon went to Washington DC to study English literature at the Catholic University. In 1936 he went to work for Roy Stryker at the Resettlement Administration as an assistant messenger. It was a low-level government job. In the photograph collection he copied captions onto the back of prints and applied a name stamp. He filed pictures and became interested in photography. Ben Shahn, who was no great technician, showed him how to use a Leica – having himself been taught hurriedly by Walker Evans. At Evans's prompting Vachon learnt how to use an 8 x 10 inch view camera and in October 1938 he was experienced enough to be sent to take pictures in Kansas and Nebraska for the organization. Because of budgetary problems Vachon returned to filing and only became an official photographer in September 1940. He took pictures for the Farm Security Administration until it was incorporated in the Office of War Information in 1942. Even though he entered photography by chance, Vachon was an innovator from the outset. With Dorothea Lange, Ben Shahn, Arthur Rothstein and Walker Evans offering advice, he might easily have been confused and overwhelmed.

GIRL AND MOVIE POSTER, CINCINNATI, OHIO. October 1938
It is hard to make out where she is, or if she is standing or sitting. It may be the evening, for there is not much light, and we have to take it on trust that it is in Cincinnati. In October 1938 Vachon may have gone to Nebraska via Cincinnati. He had been sent to Nebraska to take pictures of agricultural programmes and to make a report on the city of Omaha.

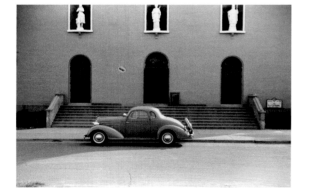

Old cathedral, Vincennes, Indiana. July 1941
This was also taken on 35 mm, and it has nothing to do with rural poverty. The old cathedral is no more than a backdrop for the handsome automobile parked in front of its steps. The saints have been sidelined – so taken has Vachon been by the gleaming vehicle. This kind of placing and spacing, fastidious and irregular on a symmetrical basis, would interest Lewis Baltz, for example, forty years later.

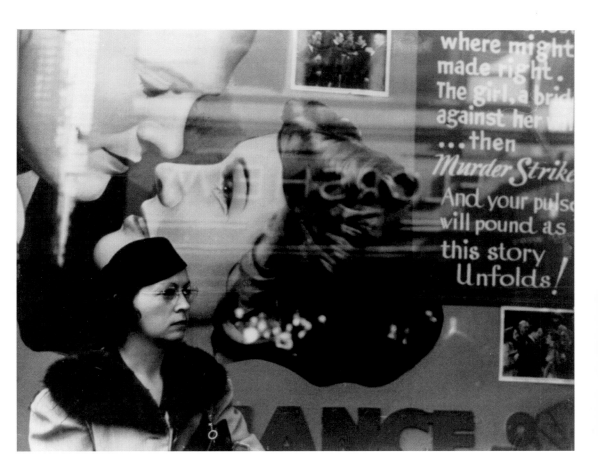

Vachon's vision, remarkable at that time and even unprecedented, was of a phantasmagoric culture. He did take pictures of rural life of the kind he had seen in the file in Washington, but as he also saw it, Americans carried an alternative world in their heads. The girl in Cincinnati might have that scene in mind, even if she does look remarkably level-headed. The automobile in Vincennes is a truly desirable item, especially compared with all those migrant jalopies of 1935. His precursors and mentors liked to imagine a world filled with things: little wooden houses, tables, chairs and enamelled panels advertising remedies and tonics. It was by and large a practical environment rich in evidence of handwork. Vachon was sceptical – or so it appears. He often photographed in wide open spaces, in Montana for example, where there was not much that was near to hand. Faced by such intangible spaces it would be easy to dream. Vachon's pictures seem to mark some new turn in the spiritual life of America.

JACK DELANO

1914–1997

Jacob Ovcharov was born in the town of Voroshilovka in the Ukraine. In 1923 his parents thought it prudent to leave the USSR for the USA. In 1936, during his final year at the Pennsylvania Academy of Fine Arts, he became Jack Delano. As an unemployed artist in 1938 he was given a grant by the Federal Arts Project to take pictures of unemployed miners in Pottsville in Schuylkill County. He showed the resultant pictures in a gallery in Philadelphia where they were seen by Paul Strand, who recommended him to Roy Stryker at the Farm Security Administration in Washington. There were no jobs available until Arthur Rothstein resigned in 1940. Soon after joining the FSA Delano married Irene Esser, who accompanied him on his photographic journeys. By 1940 Stryker wanted more positive pictures than before, and Delano delivered them. At the same time Stryker left Delano to make his own decisions under global headings: 'Photograph everything on Route No. 1 from Maine to Florida.' In 1941 he went to Puerto Rico for the FSA, the first mission overseas.

CONNECTICUT TOBACCO FARMER AND WIFE. Connecticut, September 1940
Tobacco farmers in the Connecticut River Valley were racially diverse, including Native Americans, Jews, Irish and Armenians. Mr and Mrs Andrew Lyman, seen here, were of Polish origin, and at first Delano had trouble getting them to act spontaneously until he told Mr Lyman that his trousers were falling down. Mrs Lyman was greatly amused and the picture was taken. Delano felt that ruses and interventions were called for, and the presence of his wife also helped to make these encounters into social events.

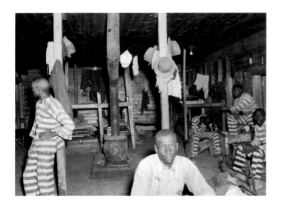

In the convict camp in Greene County, Georgia. May 1941
The convicts wear institutional outfits, apart from the man in the foreground. They have hung up their hats, and are all in after a strenuous day. Delano was in Greene County to take pictures for the sociologist Arthur Raper, who was preparing a book, *Tenants of the Almighty*. Raper's influence got him an invitation to the county jail. It was too good an opportunity to miss, and the FSA had no coverage of county jails. Delano was troubled when the guards ordered the convicts to sing and dance for the camera. To Delano and other FSA photographers from the north-eastern USA the southern states were alien territory and Delano was lucky to have a local guide, albeit one held in some suspicion by the locals.

Delano, a latecomer to the FSA, had new ideas about documentary. He thought of it as a collaboration between himself and the subject. His wife also participated in what was really a kind of theatre. Mr and Mrs Lyman share a joke with him, and so the picture is a record of that moment of interaction. The convicts in their turn inhabit a space with a range of props from convict life: worn hats, tin drinking cans, a stove, bunks and a feeble bulb giving light in the distance. Delano often took pictures in such interior spaces to which he applied light to bring details out of the darkness. He liked theatrical effects and a level of artifice which wouldn't have been countenanced in the early days of the organization.

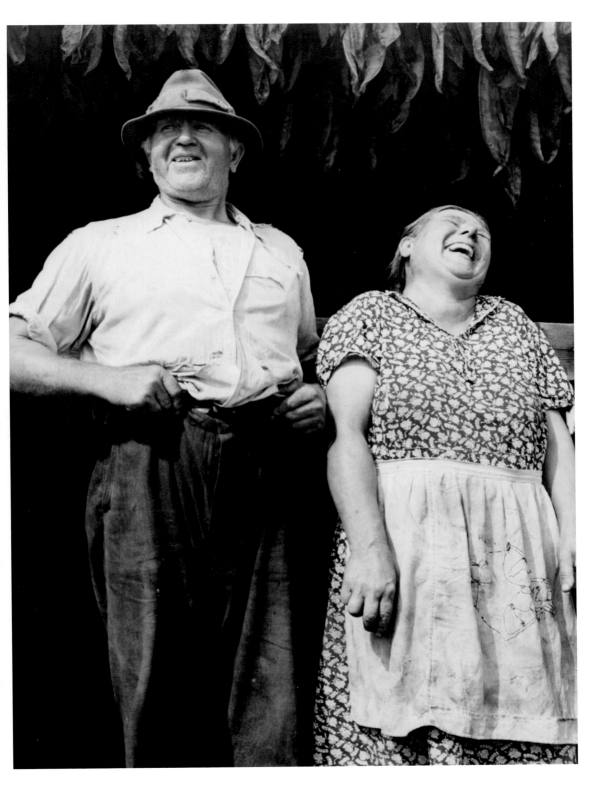

WALKER EVANS

1903–1975

Evans was born in St. Louis, Missouri. Brought up in Kenilworth, Illinois, he graduated from the Phillips Academy in Andover, Massachusetts, in 1922. He took a while to orientate himself and worked in the Map Room in the New York Public Library before moving to Paris in 1926. He meant to become a writer but made little progress in that direction. On returning to New York in 1927, he took up photography and made urban pictures typical of the era: street scenes (often from above), patterns of light and shadow, plus luminous signs and crowds at Coney Island. He lived in Brooklyn Heights, where he got to know the poet Hart Crane. Three of his photographs of Brooklyn Bridge were published in Crane's *The Bridge* (1930). By 1929 he had begun to find himself as a photographer and during the 1930s he went from strength to strength. His emergence in 1929 was sudden, and it is worth looking into.

6TH AVENUE/42ND STREET. 1929

This image appeared in Evans's *American Photographs* in 1938 (part 1, no. 19). It was taken at the intersection of 42nd Street and 6th Avenue. In 1930 it was published in *Der Querschnitt*, the famous German periodical, in an issue devoted to the USA – Evans's first appearance in a magazine. Good judges reckon that this was his breakthrough, which may be true. Before this he had reported on street life in New York City, but the pictures – taken at long range or through the safety of lunch-counter windows – weren't so remarkable. He admired Paul Strand's picture of a *Blind woman* taken in 1915 and printed in Stieglitz's *Camerawork*, but its brutality would have been beyond him in 1929.

Royal Baking Powder, New York. 1929
Evans was in the area (6th Avenue/42nd Street) looking for examples of urban patterning: windows in echelon and fruit in boxes. Royal Baking Powder, written onto the risers and interrupted by shadows, makes for an intriguing text centred on KING POWDER. The woman, opulently dressed up in a bell hat and fur stole, must have wondered what exactly he was up to: a fine-looking young man photographing a set of steps at a busy intersection. She wears a string of pearls, brightened up in the printed version of 1938, and represents materialism to perfection. The details are apposite too: that finely polished piece of radiator to the left and the cigar store sign in the background. He has also been lucky with those two rear windows to left and right above the spare wheels for they rhyme with her eyes and give a pattern and structure to the picture.

'Anti-graphic' was a term coined in 1933 by the gallerist Julien Levy to describe a new tendency
in photography. In 1935 he put on an exhibition under that title at his gallery in New York,
showing pictures by Henri Cartier-Bresson, Manuel Álvarez Bravo and Walker Evans. Anti-
graphic photographs, Levy thought, were amoral and even 'septic', and close to the fabric
of real life. In this picture of the woman in the fur stole Evans discovers the anti-graphic
tendency for himself.

In 1929 Evans briefly imagined himself as an urban reporter. He tried to see New York
as a city in the style of Berlin, alive with traffic and with nightlife. Berlin was above all noisy,
and the new German photographers of the late 1920s specialized in declamation, the roar
of motors and the din of the crowd. This vision of the city, which émigré Berliners eventually
took to London in the 1930s, was probably not much to Evans's taste. Chaos, noise and
incident belong on the expressive spectrum and can be taken in at a glance. Evans's
preference would increasingly be for visual inspection spun out for the sheer pleasure
of discernment.

Evans's early influences included Paul Grotz, a young German writer and photographer who introduced him to the Leica camera. He knew Berenice Abbott, the sculptor turned photographer who had brought Eugène Atget's pictures to New York, where they were exhibited at Julien Levy's gallery in 1931 and 1932. Lincoln Kirstein, the writer and patron of the arts, was a close friend. In February 1931 Kirstein described Evans as living in 'a particularly depressing penurious hole in the wall' – at 14th Street and 5th Avenue. Evans shared his hole in the wall with Hans Skolle, a German painter and photographer. Kirstein added that their poverty was 'really so sad', and he wondered how they kept themselves clean. Kirstein published an influential arts journal, *Hound and Horn*, to which Evans contributed.

GIRL IN FULTON STREET, NEW YORK. 1929

Fulton Street is in the Lower East Side of New York, not far from the Brooklyn Bridge. Evans, using a 35 mm camera, took three pictures of the girl. The sign to the left advertises the FULTON BILLIARD PARLOR and one above extols SPAGHETTI, but both were trimmed when the picture was printed in *American Photographs* in 1938. The picture in its definitive printing in 1938 was straightened to emphasize those three vertical sections. Evans liked systematically structured images. The girl looks resolute. Man, represented by three felt hats with bands, moves in single file to the right – a stroke of luck recognized after the event. There is always the question of what sets Evans apart as one of photography's major artists. He may have been a documentarist and an anti-graphic artist, but at the same time he looked for definitive images which might stand for a big idea. The 'girl', honoured by her placing in the central zone, represents something like militant womanhood.

Child in back yard. 1932

In *American Photographs*, where the images are presented one to a spread, she follows *Girl in Fulton Street, New York*. The child, probably another New Yorker, looks to her left across a schematic drawing of an idealized young lady. Thus the child looks forward and the girl looks back in a tableau devoted to coming of age – with some reference to its allures and dangers.

The problem in the 1930s was to make photographs count for something. The most usual way of doing this was to juxtapose two images across a spread in such a way that they made a point – although often the point was coarse or whimsical. The idea in *American Photographs* was to imitate moving pictures with one image leading to and supplementing another. On the dust jacket for the original book, readers are urged to think of the book as following on – as a kind of movie.

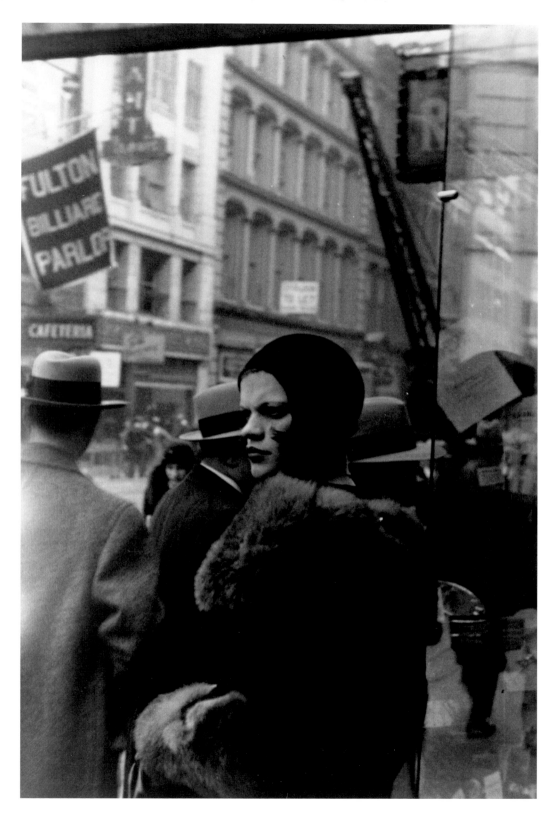

In 1931 the impoverished Evans was asked by
Lincoln Kirstein to take pictures of Victorian
architecture in the Boston area. To undertake the
work Evans had to use an 8 x 10 inch view camera,
which was new to him. He took lessons from the
photographer Ralph Steiner, who was a specialist
in American vernacular and even something of an
influence on Evans. Kirstein assisted Evans on the
architectural project and noticed how fastidious
he was: 'The sun had to be just right and more often
than not we would have to go back to the same
place two or even three times for the sun to be hard
and bright.' Evans in his turn taught photography
to Ben Shahn in 1932: 'F/9 on the sunny side
of the street, F/4.5 on the shady side of the street.
For a twentieth of a second hold your camera steady.'

POSED PORTRAITS, NEW YORK. 1931

The picture is also called 'Second Avenue Lunch'
and it was selected for *American Photographs*
(no. 40). Smoking indoors would have led to ash
on the sandwiches, and maybe they also wanted
a breath of fresh air. Evans liked a tidy picture,
and this one shows a rhomboid set on a plinth.
Or it might be seen as a triangle or even a pyramid
topped by that globe placed on the upper
edge. Look, too, at the careful profiling of the
hands down the right side of the rhomboid.
This is probably the most organized of all of Evans's
pictures, and he may have taken his cue from the
portraits of August Sander, whose work he reviewed
in 1931. Sander often made double portraits,
of twins, sisters, brothers and companions. With
repetitions within a figure there is scope to compare
and contrast, and such analysis can bring insight.
Evans might have had something like that in mind,
for both men hold their cigarettes differently – at
a time when smoking was a social accomplishment
and stylish. They wear their hats quite differently
too – at a time when a figure was completed by
a hat. In the 1930s hats registered balance and
composure. Temperamentally they look poles
apart, but they are a complementary duo.

Main Street faces, Morgantown, West Virginia. 1935

In *American Photographs* the two men from
1931 are placed after another double portrait.
The later picture was taken in West Virginia,
when Evans was working for the United States
Resettlement Administration. These men eye
Evans with a certain amount of suspicion.
Nor is there enough detailed evidence to invite
point by point comparisons, even if their
comparable hats are differently shaped.

In 1931 Evans, under the likely influence of Sander, seems to have assumed that a photograph could
give a thorough introduction to a subject. The photographer, under these inherited terms
of reference, was an investigator who wanted to know just how you tied your shoelaces.
By 1935, by contrast, either Evans or the times were more confrontational, less willing to open
up. Documentary photography, often carried out under pressure of time, has always reflected
such changes in the social mood.

225

In January 1932 Evans set out on a four-month cruise in the South Pacific. He had been commissioned to make a film of the voyage but realized that movies weren't his forte. He couldn't compose 'any significant sequence', nor could he dramatize his subjects – in his own words. Most aspiring photographers tried their hands at movie-making in the 1930s, for that was where the future lay. The South Seas didn't inspire Evans either. He returned to New York to photograph in Greenwich Village and on the Lower East Side; and he hoped for a lucky break, which came when he was commissioned to take pictures in May and June 1933 in Cuba. It was a time, he recalled, 'when anyone would do anything for work'. The pictures were intended for a book by Carleton Beals, *The Crime of Cuba*, on the iniquities of the Machado regime. Evans said that he never read the book but did spend time drinking with Ernest Hemingway, then a correspondent in Havana.

CITIZEN IN DOWNTOWN HAVANA. 1932
This was Evans's original title for the picture as it appeared in *American Photographs* in 1938. The 'citizen' stars in almost all Evans's anthologies, and rightly so. It was taken on medium format roll film (65 x 107 mm). Evans took several pictures on this site, an arcaded street corner. A newsstand faced the street and a shoeshine boy worked behind the column, as can be seen more clearly in the picture below. That is probably the seated newsvendor reading the latest issue, with the shoeshine operator almost out of the picture to the right. He has a wooden leg, as you can see, which would have fitted him for a sedentary trade. Just behind the seated youngster is the edge of a mirror, there to allow clients to check their general appearance before taking to the road. The *Citizen in downtown Havana* might be a portrait carried out by agreement, for the vendor reads *El País* attentively, whereas you would expect him to be interested in the American with his camera. The image of the seated thinker above can only have alerted Evans to the pictorial possibilities on offer, and in the second row down there is an excellent set of smouldering eyes, just above CINELANDIA. Posed thus with that left forearm athwart his body, the citizen is a quarter way towards imitating the seated thinker. The newsstand eyes hint at other options in the journey about to unfold.

Evans, one of the most gifted of all photographers, used documentary as a medium. The street in itself is only averagely interesting, but the man in white in relation to the shoeshine operation behind him becomes an appearance – even a living artwork. In relation to the seated thinker his thoughtfulness is intensified, and those watchful and seductive eyes in the background hint at something like romance. Looking back in the 1960s, Evans said that he was really practising 'lyric documentary'. He also called it 'heightened documentary'.

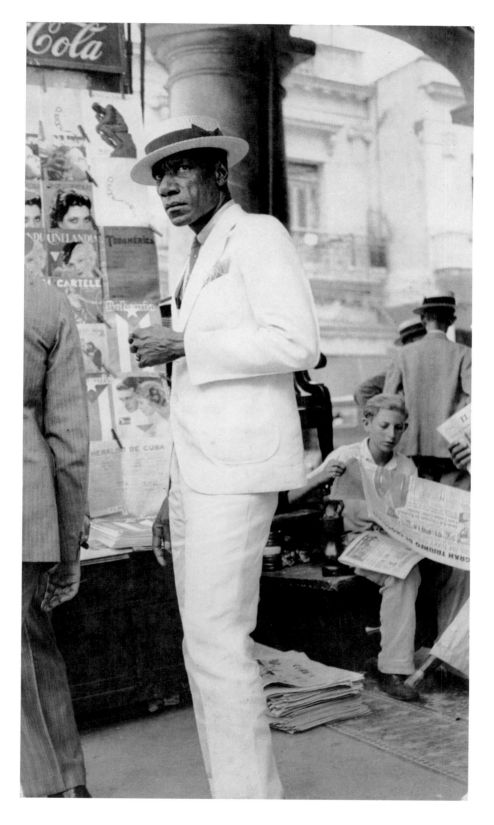

In the winter of 1934 Evans went to Florida, which he described as 'ghastly and very pleasant where I am, away from the cheap part'. In a letter he said that he had become interested in Carolina and Georgia, 'a revelation'. He was also thinking of a photo-book on the American city, on such topics as 'Automobiles and the automobile landscape' and 'People, all classes, surrounded by bunches of the new down-and-out'. In the spring of 1935 he was commissioned by a New York industrialist, Gifford Cochran, to photograph antebellum architecture in the American South. The trip was productive but came to nothing in the end. It did, however, prepare him for his next major job. In September 1935 he was hired as an Information Specialist by the Resettlement Administration in Washington. His job was 'to carry out special assignments in the field' or, in Evans's own words, 'Still photography, of general sociological nature'.

SIDEWALK AND SHOPFRONT, NEW ORLEANS. 1935

Evans seems to have taken this picture on his architectural tour. There are two versions of it, with the 'proprietress' in different positions. In the preferred image, no. 5 in *American Photographs*, she holds a pair of scissors. She must have worn that knitted top to rhyme with the striped decor on the façade. Evans was in luck as never before. The painting might have been recent, on the evidence of marks on the sidewalk. Ideally the artist ought to have made some measurements in advance, but this one didn't foresee any problems. One stripe is very like another. Working from a ladder, however, it would have been difficult to get things exactly right, and so irregularities multiplied. The inscriptions, too, are clear but erratically spaced, and likely from the same hand. It isn't difficult to put yourself in the position of the signwriter: overconfident, maybe, and pushed for time. Evans liked barber shops, and overleaf in *American Photographs* he features another one:

Negro barber shop interior, Atlanta. 1936

This was taken in March on a fruitful visit to Atlanta and is very much a documentary picture – not especially lyrical. The lamps, three on a shelf and one on the floor, suggest that a lot of the shaving and trimming must have taken place in the evening when available light was scarce. During daylight hours the clientele would be busy at their work. The newspaper coverings would also have brought some light into that shadowed space.

Documentary, as practised by Evans, was an invitation to reflect on others' work, almost from the inside: the busy signwriter who managed a bright approximation of the idea, and the barbers struggling to cope with low lighting to the best of their ability. By 1935–6 Evans had learned that improvisation was the norm. The pictures also propose that you can understand people less by how they look than through the works of their hands.

229

The United States Resettlement Administration commissioned and collected photographs. The idea was to disclose living and working conditions throughout the country. The pictures were to be used for publicity, and the management was quite specific about sites and tasks. Evans began by taking pictures in the coal-mining towns of West Virginia and the industrial towns of Pennsylvania. Thereafter he photographed mainly in the south-eastern states: Mississippi, Georgia, Louisiana, South Carolina and Alabama. More painstaking and less productive than some of his colleagues, Evans antagonized management. In the summer of 1936 he was loaned to *Fortune* magazine to report on the lives of three tenant-farming families in Alabama. He was accompanied by the writer James Agee. They spent two months with the farming families, but the results were unacceptable to *Fortune*. The eventual outcome was *Let Us Now Praise Famous Men*, published in 1941 with a text of around 300,000 words.

ALABAMA COTTON TENANT FARMER'S WIFE. 1936

Allie Mae Burroughs was her real name. In the book Agee called her Annie Mae Gudger, for all those involved had pseudonyms. Evans made several portraits of her and this one appears – clear and pale – in *American Photographs*. Evans had made close-up portraits before, but without the objectivity of this picture – probably his greatest portrait. Working with Agee in Alabama, he was on his mettle for Agee was a genius. His writing was startlingly affective. Evans wrote in a memoir of the energy of Agee's imagination and of his physical energy too. Agee described Allie Mae as a mother 'whose body already at twenty-seven is so wrung and drained and old, a scrawny, infinitely tired, delicate animal'; he felt for her, loved her even – as he loved almost everyone in the tenant families. Principally Agee wrote about his own responses: his own shame, his ardour and his feelings of helplessness. Evans must have realized that photography couldn't compete, at least not the documentary manner which he had used to date, and chose to turn to an austere style which complemented Agee's expressive extravagance.

Lucille Burroughs (Marie Louise in the book) was Allie Mae's daughter. Agee idolized her. He recalled a portrait session with Evans at the beginning of their visit to Alabama and Lucille 'looking so soberly and so straight into the plexus of the lens through those paralyzing eyes of yours, and being so careful to hold perfectly still ...' Agee loved and pitied Lucille's mother with her slender body, 'sharpened through with bone, that ten years past must have had such beauty', but was overwhelmed by the gravitas of the daughter.

Agee, perhaps more than Evans, imagined a kind of documentary which would tell all. Evans wrote of Agee: 'He could live inside the subject, with no distractions.' Others shared the vision, in particular the Mass Observers, who reported and took pictures in Britain in the late 1930s. It was, though, a tall order which made impossible demands on all concerned, audiences included.

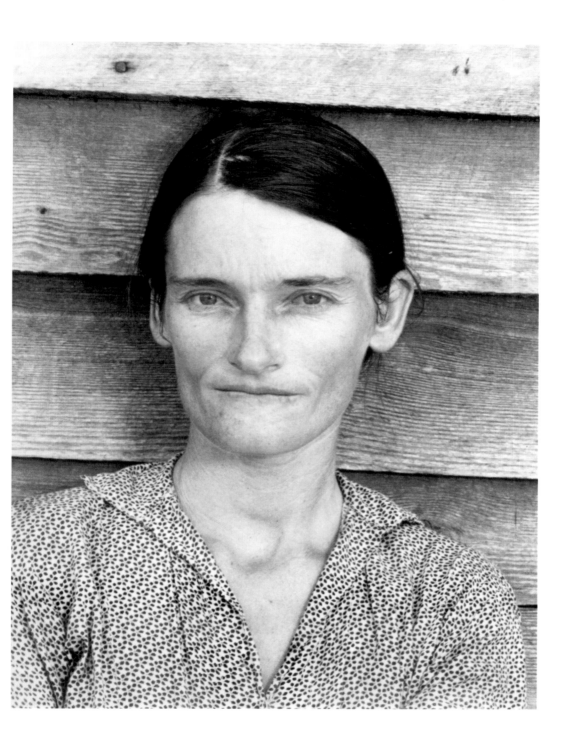

New York's Museum of Modern Art honoured
Evans with an exhibition, 'Walker Evans, American
Photographs'. It took place underground at the
Rockefeller Center and was made up of one hundred
pictures. In *American Photographs*, the book
published at the time of the exhibition, eighty-seven
pictures were printed in two sections: figurative work
and lyrical documentary in part one, followed by
thirty-seven architectural pictures. Had the pictures
been amalgamated it would have been impossible
to make the kind of semantic connections which
are so notable in the opening section. Around
1938 Evans began to take pictures in New York's
subway – portraits of the passengers taken with
a concealed camera. He worked on this scheme
until 1941, but the pictures were published only
in 1966, as *Many Are Called*. In 1941 *Let Us Now
Praise Famous Men* came out, to no great acclaim.
It was reprinted, much more successfully, in 1960.
In 1943 Evans went to work as an arts critic for
Time magazine before becoming staff photographer
at *Fortune* in 1944. James Agee did very similar
work at that time: book and movie reviews for *Time*
and *The Nation*, plus film scripts; for *The African
Queen*, for example, and *The Night of the Hunter*.

[SUBWAY PASSENGERS, NEW YORK]. 1938
A picture of this singer/accordionist concludes
Many Are Called. Orpheus went into the Underworld
to sing for Eurydice, but he looked back too soon.
Homer was a blind bard. Christ, as reported by
Matthew, spoke of the blind leading the blind –
to a bad end. Evans's title refers to Matthew 22:14
where 'many are called but few are chosen'. In the
previous verse someone (a sinner) had just been
cast into outer darkness. Agee, with whom Evans
had worked and continued to work, was certainly
learned and religious – and he liked to name
sinners. Evans, though, was not much of a moralist,
nor a very outspoken iconographer either.

[Subway passengers, New York]. 1938
Why should Evans have decided to take this series
of subway portraits, around two hundred of them?
He rejected styles in which he had become
accomplished. Originally a graphic photographer
composing with grids and geometric patterns,
he became anti-graphic around 1929. He turned,
that is, towards the real world with its imperfections.
He made complex images which could be analysed
and deciphered. Agee in Hale County, Alabama,
in the summer of 1936 taught him that there
was far more to understanding than could ever
be included in a single picture. In response Evans
developed a dispassionate, plain style, but away
from the particular circumstances of the tenant
farms there was no chance of continuing along
those lines. The subway pictures are mere pictures,
and there is no way of knowing – in the absence
of supporting material or a commentary by Agee
– what might lie behind such appearances.

We might speculate on character in front of some of these portraits, but there is really no insight
to be gained. They may be citizens, and by rights we might feel that we should be able
to understand them, but Evans allows no way in. Postmodern photographers, fifty years
beyond, would relish this kind of impasse, but in 1940 it went somewhat against the grain.
Evans had briefly toyed with the idea in 1929 that he might become an urban artist able
to represent the city in blaring action. Although he soon put that idea aside, the subway
pictures do hark back to 1929. The trains, rattling through their metal frameworks, were
oppressively noisy. To endure the journey passengers withdrew into themselves or into the
pages of a newspaper. Even the singing accordionist made no difference. Evans was dealing
with something easily recognizable as 'the noise of the world', notorious for drowning out
the heavenly voices and the kind of lucidity to which Evans the photographer had always
been attracted.

BEN SHAHN

1898–1969

Born in Kaunas, Lithuania, Shahn emigrated to the USA in 1906. He came from a family of woodcarvers and engravers, and he trained as a lithographer. A socialist by inheritance and conviction, Shahn was further radicalized by the conditions which followed the bank crash of 1929. During the 1920s he worked and spent several years travelling in Europe and North Africa. In the USA he had travelled little further than New York. The interior, which he investigated during the mid-1930s as a government photographer, came as a surprise to him. In New York he kept good company and a lot of it. Walker Evans was a close friend, and in 1932 he introduced Shahn to Leica photography. Lincoln Kirstein, the editor and curator, admired his painting. In 1933 Shahn went to work for Diego Rivera on a fresco project for the RCA Building at the Rockefeller Center: *Man at the Crossroads Looking with Uncertainty but with Hope and High Vision to the Choosing of a Course Heading to a New and Better Future* ... destroyed in 1934. Instructed somewhat by Walker Evans and using a Leica bought for him by his brother, Shahn began to take pictures in New York City – mainly as prompts for his own paintings.

SEWARD PARK, NEW YORK CITY. 1932–5
This was a small park created in 1899 in a slum area. In the Lower East Side, an area settled by Jewish immigrants. The four men pictured here look variously unemployed and destitute. The hunched figure to the left looks like a vagrant, and the old-timer to the right not too sure of himself. The man left of centre looks towards the camera but with his poor eyesight might not be sure of what is going on. Shahn would have been using a camera with a right-angle viewfinder (called a 'Winko') and thus looking down towards the right. The two men with their wits about them are probably trying to make out what he is looking at, and the other two are at a loss. The four act differently. It would be hard to find a word for how exactly each of them sits, but you might be able to enact the postures for yourself, and that might lead to insight. You could put yourself in their position, one by one, for it was an age which believed in three-dimensional reportage. To understand the predicament of others you had to act it out and a picture such as this might almost be treated as a script to be rehearsed. Shahn reproduced the group in a lithograph of 1936 but in this other medium they are no longer imitable.

Ben Shahn
Seward Park. 1936
Lithograph

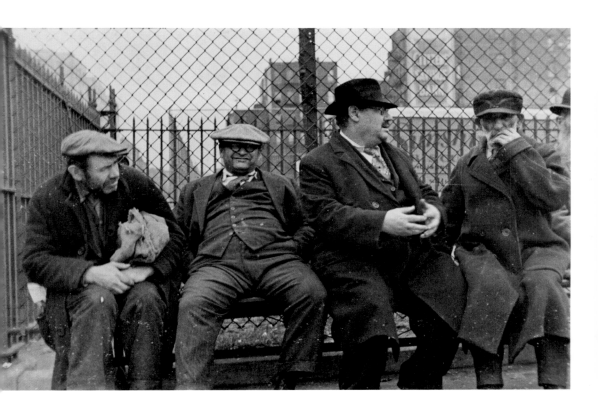

Shahn, with his deceptive camera, made more of gesture, stance and posture than any of his contemporaries. Under these terms of reference, which were strongly felt on the socialist side, common cause meant physical identification with the other. The idea kept its authority for another twenty years or so, but eventually it became difficult to identify in this intimate way with the new motorized populations of the developed world.

Sprawled and hunched, they don't make a pretty group, and are no credit either to humanity or to New York City. But if Shahn travelled in Europe during the 1920s, he must surely have been aware of the new German painting of the era, with its penchant for coarse effect. Otto Dix was its best-known representative, but there were many others, including George Grosz, who settled in New York in 1933. Grosz, in particular, had developed a kind of extreme reportage during the late 1920s to take account of Berlin during the Great Slump. Shahn's photograph is in that tradition. In 1933 unemployment in the USA stood at 27 per cent.

BEN SHAHN

Shahn began to take photographs in 1932, in Lower Manhattan. Walker Evans remembered the area, especially the Lower East Side, as 'so rich in those days in food for the eye'. Evans and Shahn spent a lot of time there, especially in the summer months. 'It was like being in Naples.' Looking back in 1969, Evans recalled Shahn's energy: 'Because he was so hopped up all the time, you got very stimulated when you were in his presence. If he came into the room, you'd start to get tired.' He was soon successful, publishing twelve pictures across two pages in *New Theatre* in November 1934. It was called *Scenes from the Living Theatre – Sidewalks of New York* and featured groups of citizens caught unawares via Shahn's right-angle viewfinder. Even so, Shahn thought of himself mainly as a mural painter with a socialist agenda. Photography would provide him with notes and raw material for these usually contested ventures. His great work was to be a mural in a corridor at the new Rikers Island Penitentiary, but class enemies ensured that it came to nothing, and the preparatory work was sold off by weight to a junk dealer (1934–5). Shahn was also signed up by the Public Works of Art Project in 1934 to do a Prohibition mural, but that Project was wound up almost as soon as it was announced.

HOUSTON STREET PLAYGROUND (NEW YORK CITY). 1932–5

The youth in the foreground wonders what the photographer is up to. So does the man with the wheelbarrow – an elegant bit of apparatus which Shahn the draughtsman would have appreciated. East Houston Street had been widened to let light into a crowded part of the city, and to allow for leisure. Shahn took several pictures of the handball courts, one of which he converted into a painting, *Handball*, 1939, now in the Museum of Modern Art in New York.

Ben Shahn
Handball. 1939

Tempera on paper on board
Museum of Modern Art, New York

Shahn's was a scientific aesthetic. He liked to take pictures within a neat restricted space backed
by a wall, by parallel boards or by the grid of a fence. Here the background is made up
of numbered panels, which reinforces the idea that he is presenting evidence. Some of the
players silhouetted against the court wear knickerbockers tucked into long stockings. Others
wear ordinary long trousers, which may signal a social difference. It is possible that Shahn
was more interested in clarity than he was in content, or that the pictures mainly concerned
themselves with simple observations clearly made. He had disagreements with Diego Rivera
on the subject of 'clutter' in the Rockefeller murals, *Man at the Crossroads*. A plain picture,
made up of an incident (provided by the two figures in the foreground) and a set of gestures
(the handball players), could be taken in at a glance and admired for its cogency. Shahn's
approach to the problem of the human condition was empirical: everyday events seen
distinctly – a pleasure in themselves.

BEN SHAHN

Shahn thought of photography because it was difficult to make sketches in the streets. Things happened too quickly. He remembered the crucial moment: trying to make sketches of three blind musicians on 14th Street and walking backward while sketching them: 'My God, I can't get all that detail, ever.' So he asked Walker Evans to show him how to use a camera. Looking back, Shahn tended to gild the lily and claimed in 1946, in an article in *U.S. Camera*, that he had only ever exposed two rolls of film in his life before being offered a job as a government photographer with the Farm Security Administration. By 1946 he was represented as a painter who rather depended on photographs, and he didn't like the idea. In 1947 the curator J.T. Soby, writing on Shahn's behalf, stressed that he used photography 'as other artists use preliminary sketches, and from its notations proceeds under the compulsion of the painter's inner vision'. On the other hand, it could be argued that his photographs had their own 'inner vision' and that they were never just 'preliminary sketches'.

BOWERY, NEW YORK CITY. 1932–4
This was one of his first pictures to be published in 1934. The two emerging customers look as though they have eaten well. Which option did they go for – tripe stew, oxtail goulash or corned beef? There is no mention of vegetables on the cheapest list and for 15¢ you get sauerkraut or turnips. For 20¢, it seems you can get all the vegetables available. This is a utilitarian take on eating. You have a choice, which is greater in the middle range, and you decide according to taste and cash in hand. By 1946 the practicalities of dining on the Bowery would have been a long way from art's register. Hunger, maybe, but certainly not just eating. In 1946 Shahn made a painting of a famished child for the US Department of State.

14th Street, New York City. 1932–4
The accordionist, taken on 14th Street in New York (1932–4), was, according to Walker Evans, 'infamous' in the area. If eating was a question of selecting dishes, music, in reality, meant pressing keys and buttons, and the keyboard here has pride of place. The man's face is also heavily pock-marked and might have been rough to the touch. Accordion playing on 14th Street was work quite as much as it was music. He reappears, this man, in 1945 in a tempera painting in front of an alleyway of severed trees, which was Shahn's way of invoking the cataclysms of the era.

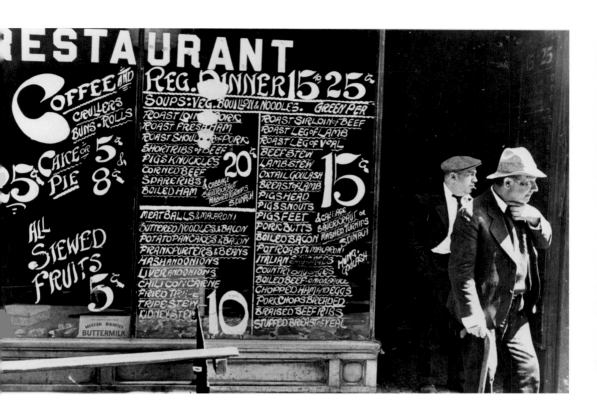

When Shahn took up photography in 1932, the progressive scene was preoccupied by process, how to do things – Diego Rivera, the great Mexican muralist, thought of little else: handwork in Mexico, machine tools in the USA. Shahn may have been one of those artists happiest with practicalities, spelling it out step by step. Photography, with its empirical outlook, would have been exactly the medium for him, as it seems to have been in the early years, but 'inner vision' wouldn't rest content with menus and keyboards. Even so, Shahn was unusually responsive to script. A lot of it was expressive, like that opulent C in 'Coffee and crullers'. Stacked up in lists and tables on the windows of shops and restaurants, it stood for the idea of plenty in times of hardship. It was also rather a neat way of remarking on the untidy business of appetites and the body.

BEN SHAHN

Shortly after the rejection of his Rikers Island mural, Shahn was employed by the Resettlement Administration (RA), which had been set up under President Roosevelt's New Deal policy to help the rural poor. In 1937 it became the Farm Security Administration (FSA). Short of funds, Shahn was delighted to receive a salary plus expenses. He was appointed to the Special Skills Division to make posters and pamphlets, but before starting in earnest was encouraged to visit relevant areas in the United States. He had travelled in Europe in the 1920s but otherwise had hardly been away from New York. It was a chance to see America and he set off in late September 1935, returning to Washington on 8 November. This first journey took him to the South. In 1938 he took pictures in Ohio during the summer. The impoverished country on which he reported in 1935 differed markedly from orderly Ohio in 1938.

COTTON PICKERS, PULASKI COUNTY, ARKANSAS. October 1935
They are among a group of around thirty cotton pickers on the Alexander plantation at 6:30 a.m., waiting to set off for the fields. In 1935 the cotton market was badly depressed and the state had tried to restrict production, forcing some small farmers and tenants out of business. The pickers on show here don't look too happy, but at 6:30 and with an arduous day ahead of them, that is understandable. The man to the left has punched holes in his hat to allow the air to circulate but otherwise there aren't many tell-tale signs. They all carry the long white bags in which the cotton was collected. James Agee in *Let Us Now Praise Famous Men*, begun in 1936, gives a very full account of the hardships of cotton-picking and describes just such scenes as this. Shahn must have used his right-angle viewfinder at the Alexander plantation, for the five aren't exactly posing for their portraits. They may be bemused by his antics, and they are still probably half-asleep anyway. It is an accurate picture, for this is how any of us might wait – still somewhat in worlds of our own. For anyone directing or acting in the theatre, Shahn's candid portraits would have been treasure trove, but their subtle disclosures weren't the stuff of documentary.

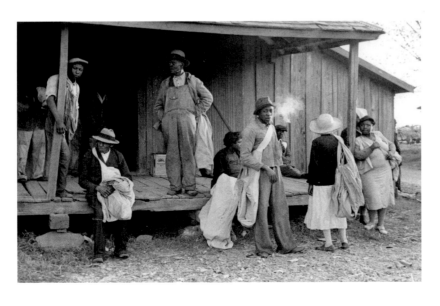

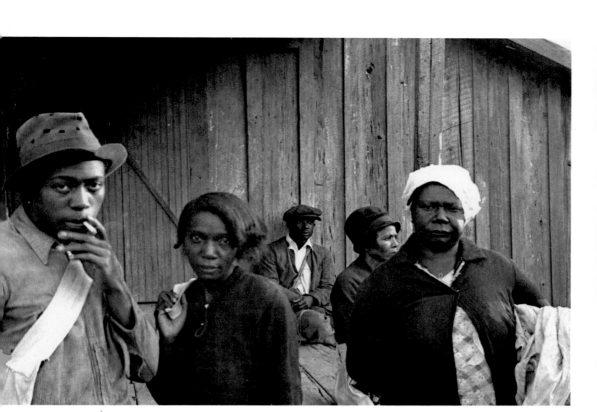

Shahn had hit on a perfect way of rendering basic ingredients: standing, leaning, crouching, talking, turning, resting, doing nothing very much. He was working, in fact, for a classification system not yet in existence. It never would be, for the conditions which made Shahn's photography possible – a piece of primitive gadgetry, an open-ended mission and unwary subject – would never be repeated. The Great War, with its hordes of prisoners, had familiarized audiences with the look of superfluous humanity – albeit in special circumstances. The Depression threw up yet more evidence of redundancy. It was shocking to think of humans as surplus to requirements or as existing just on the edge of viability – as was the case in Pulaski County. This unbearable state of being was Shahn's *forte* – life as hopeless waiting and as something of a sentence which could only be endured.

BEN SHAHN

In 1932 Shahn painted *The Passion of Sacco-Vanzetti* and it was included in an exhibition at the Museum of Modern Art in New York, 'Murals by American Painters and Photographers', curated by Lincoln Kirstein who was a close friend of Walker Evans. Attempts were made to remove Shahn's picture from the exhibition because it showed the legal authorities in a poor light. Nicola Sacco and Bartolomeo Vanzetti, who were tradesmen and labour organizers, had been convicted for murder and armed robbery. The decision was challenged unsuccessfully and they were executed in 1927. Shahn made pictures of the judge, of the investigating committee and of Sacco and Vanzetti themselves. Writing in 1947 with respect to these pictures, J.T. Soby noted 'the use of architectural setting as both psychological foil to human figures and as expressive abstract pattern'. The pictures show Sacco and Vanzetti as captives and their various judges and investigators as agents of the state, expressed in terms of elaborated, even labyrinthine, architecture. The accused in chains sit in front of a panelled background. Such tabulated backgrounds continued to interest Shahn, especially in his photography, where they represent social norms as constraints.

OZARK COUPLE, ARKANSAS. October 1935 Shahn met them in the north of the state, near to the Missouri border. He remembered that families in the Ozarks were 'on total relief – you couldn't get a work project for them because they had no vehicles and they lived twenty miles apart so you couldn't pick them up for a day's work'. Some kept their places immaculate and others didn't. These two look neat even if they are depressed. The man has combed his hair and doesn't wear a hat, so maybe he was indoors when Shahn came calling. Isolated, they may not have understood the photographer's mission, but are courteous for all that. James Agee thought that overalls were 'a garment native to this country'. The logs point to a wooded countryside and they also tabulate the relative heights of the man and of the woman. The mesh behind the man would help to keep insects out, but it makes another suggestion of measurement. Anthropologists in the nineteenth century liked to measure their subjects with calipers and gauges, and Shahn invokes such humiliating routines. Relief, given as goods and cash, was a basic measure of need and something of an affront.

Ben Shahn
**Bartolomeo Vanzetti
and Nicola Sacco**. 1931–2
Gouache. Museum of Modern Art, New York

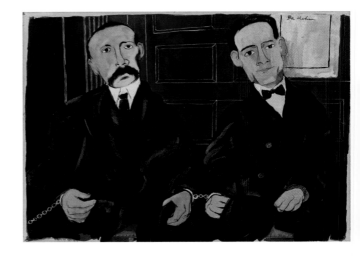

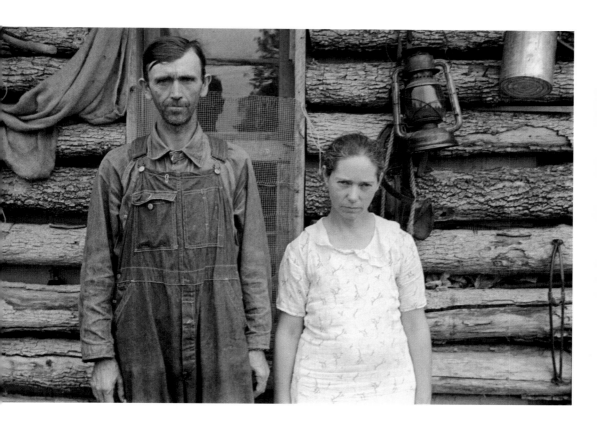

Ben Shahn, along with Walker Evans, Henri Cartier-Bresson and Manuel Álvarez Bravo, in the early 1930s, thought of **photographs as montages**: a figure or two placed against a significant background – in Shahn's case often the grid of a fence or slatted woodwork. Montages are constructed images and can be analysed in line with the artist's intentions. Shahn gave up photography quite suddenly in 1938, saying that he had too much mural work in the pipeline, but it is just as likely that he sensed that the montage style was becoming an anachronism. Its syntax was exciting but, on the other hand, it didn't bear witness sufficiently. The Ozark couple of 1935 are, despite everything, specimens. A new generation of photographers, ten years younger than Shahn, thought in terms of life stories and identity.

WORLD WAR II

1939–45

1939

Despite poison gas and unprecedented slaughter, the Great War had its constructive side. Men were reintroduced to the earth and forced to make themselves comfortable. Action took place in what the British would have called a 'theatre of operations'. The soldier of 1914–18 was a pedestrian encased in coarse cloth, leggings or puttees and boots; and such a soldier would have belonged to a unit which originated in a locality. The soldier of 1939, by contrast, was a hybrid, at home in a vehicle: in a German half-track or an American Jeep. 1939–45 was carried out between machines, and the great victories were signalled by huge amounts of metal debris – in place of the ruined fortifications which marked turning points in 1914–18. The new soldiers were travellers, and none more so than the Germans with their fine range of staff cars and motor cycles. The Germans were again the great photographers of events, at least until 1942 or so when events started to make terrible demands. None the less, German soldiers give by far the most convincing account of the war, up to and including the Russian campaign. In 1915 western soldiers entered Russian Poland and the east as curious onlookers, but in 1941 they were there to make war – to set fire to villages rather than to investigate them. There is an iconography to the Russian front: flames on the horizon, the chimneys of ruined villages, dead horses, burned-out armour and exotic captives from the far corners of the USSR. The vision of 1914 was made up of flags and ceremonies; that of 1939 had no such innocence about it. There was a plan in 1939 which took account of old resentments and looked forward to a new world order. Nor was it properly articulated, for there were unspeakable subtexts. The soldiers' photography of 1939–45 is, by comparison to that of their precursors, melancholic and savage. The photographic burden of the war passed in 1943 to the Americans fighting against the Japanese in the Pacific. Germans, in both wars, seemed to have been able to photograph at will. Perhaps they thought of themselves as recording on behalf of history – which they were. American photography was, by contrast, devised for home consumption and to show what life was like in the Pacific. It was, more than ever, a war of logistics, for there were fleets to service along with seaborne invasions and airbases. Americans lived in camps and in bases where they made portraits of each other. They had time on their hands and their communities and groups were small enough to have their own identities. The Germans travelled across the increasingly muddy roads of Russia; the Americans unloaded supplies and serviced aircraft. Some of the US portraits in the Pacific are exceptional, of a new breed of man – differently proportioned and genial.

[German soldier, member of the 3rd Panzer Division]
Three pictures taken during the invasion of Poland. 1939 (55 x 80 mm)
The soldier travelled from Szczecin through the north of Poland to Brest-Litovsk in the east. These are typical scenes along the way: a dead horse, a burning village and Polish captives.

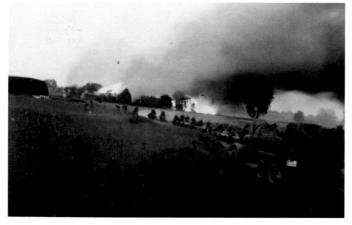

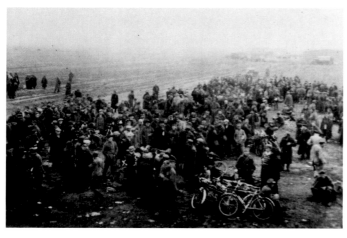

[German soldier]
Street scene, northern France.
1940 (90 x 60 mm)

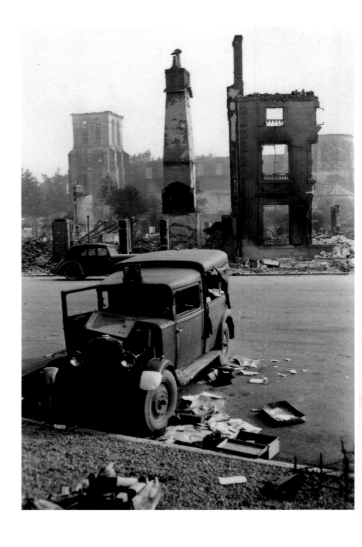

1940

It looks like a Parisian taxi which has been used in the flight from the invaders. Those are typical war ruins beyond: a roofless church, a fragment of façade and an isolated chimney stack. More eloquent still are the details in the foreground: strewn papers and opened document boxes.
The Great War, especially in the east, had affected peasant communities who didn't own documents in any quantity and who escaped on foot – if at all.

The picture signals the disruption of settled urban societies and marks a break with history in the shape of the scattered paper. Perhaps the cab broke down and it was looted. During 1914–18 there was no photographic evidence to show that culture at large changed, even if conditions at the front line did. During 1939–45, on the other hand, hostilities impacted on and changed society at large.

[German soldier]
Rhine tugboats in the harbour at Dunkirk.
1940 (70 x 100 mm)
These boats had been wrecked due to a breach in the sea defences, and were an attractive photographic topic for newly arrived German soldiers.

1940

In June British forces, driven west to the French coast, embarked for home at the port of Dunkirk. The evacuation took place in haste and the British abandoned much of their equipment. Dunkirk was a major photo-opportunity for the pursuing Germans who were able to photograph at leisure amongst the debris. Ships had been scuttled in the harbour, in order to delay its use by the occupying forces – and these vessels attracted photographers, for they made picturesque modernist tableaux. Equipment in the early years of the war was quite flimsy, using lightweight sheet metal, wire and woodwork. The Germans, who were

everywhere victorious to begin with, went to war on bicycles on the Eastern Front and used a lot of horse-drawn transport. The modernist vision, as it evolved in the 1920s and '30s, didn't take too much account of armour-plating and of the impedimenta of war. What mattered, under modernist terms of reference, was spirit which, if properly mustered, would overcome tanks and aircraft. Dunkirk, as widely represented by German photographers, looks rather like an event in nature in which insects, say, abandon their childhood casings and take wing – or flight, in the case of Dunkirk.

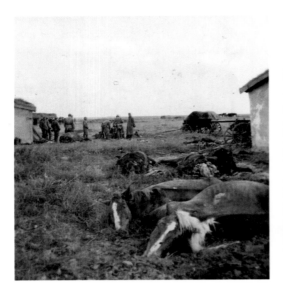

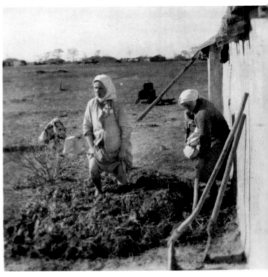

[German soldier]
Scene in a Tartar village and
Working on roof repairs, Russia. 1941 (65 x 95 mm)
The dead horses represent the aftermath of an
incident, caused by advancing Germans or retreating
Russians. Horses were important for army transport.
The two women were treading a mixture which
was applied as plaster to the roof of the house.
The documentary impulse was strong in 1941.

1941

Soldiers came across things after the event. The
Russian campaign, in particular, introduced soldiers
to another way of life. Soviet photography during
the 1930s had familiarized the west with an idealized
peasantry well equipped with new mechanical
devices. What the invaders found was much more
archaic. In one of these scenes two women prepare
daub for roof repairs: a combination of mud, dung
and straw probably. Their men were absent, dead or
in the Soviet army. In the other scene soldiers pick
over the remains of an engagement: dead horses
principally, and abandoned carts. The Russian war
turned into a series of eventualities: hard going on
muddy tracks – and all of it a long way from home.
The modernist vision of war promised engagements
carried out at a distance on terrain scanned from
fast-moving vehicles and aircraft. In 1939–45 people
saw for themselves just how intractable life in the
open could be. They were, perhaps inadvertently,
disillusioned, and this would be photography's mood
during the post-war years – less because the war
was such a terrible experience in itself than because
it laid bare the visions on which it was based.

1941–2

Germany's campaign in Russia, begun in June 1941, resulted – even if inadvertently – in one of photography's major ventures. There was no agenda and no archive, just a body of mainly amateur photographers who didn't know what to expect. The results, in so far as they survive, show a cross-section of the human condition. Nazi propaganda back in Germany didn't make much difference because events on the ground soon overrode any preconceptions. Accidents happened and were recorded; local people, or those who survived, went about their business; goods were packed and transported; food was prepared and eaten; wreckage and dead men were there to see on the edge of the roads – some horribly burned and their vehicles smashed. The soldier who took the picture at the roadside canteen was an average observer remarking on what was most important. The picture of the nine crosses on the road's edge may have had some official function: taking pictures of war graves for future reference. In this instance a single man returns to the convoy, waiting to be off now that the dead are in their place. Whoever took the picture had some sense of metaphysics and of the fragility of the past in relation to the urgency of the present – spearheaded by that gargantuan piece of equipment, maybe seized from the Russians.

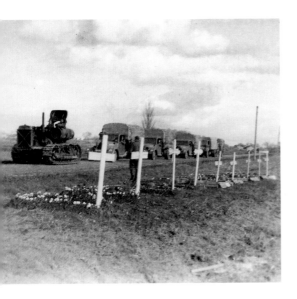

[German soldier]
Russia. 1941 (66 x 66 mm and 55 x 104 mm)
Such roadside cemeteries, often behind wooden fences, recur in the photography of 1941. Canteens also feature in the early campaign in Russia.

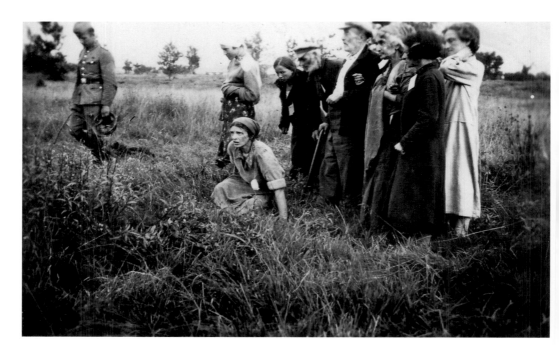

[German soldier]
Jews, just before the shooting.
Kiev area, 1941 (60 x 90 mm)
Written on the back of the picture: 'Kiev Oct
1941. Juden kurz vor der Erschiessung ...',
followed by initials. It belongs to a random
collection of soldiers' photographs.

1941
If you were about to die how would you respond?
With disbelief, more than likely. It would depend on
your age. The older people in the centre have kept
their composure, and at such an event someone
would have to occupy centre stage. The woman in
white puts her hand to her neck, to remind herself
of what it was like to be alive. The young woman in
the foreground pleads. Some of them seem to have
marks on their clothes: labels to single them out.
There are eight of them along with a shamefaced
soldier. The old man beyond and the younger
woman look as if they have been overcome by the
enormity of the event, and their response is also
believable. Photography picks up on empathy, and
nowhere more so than here. Perhaps the soldier
who hangs his head was a translator whose job
was to tell them where and how to stand, for even
at executions arrangements have to be made.
No one ever took a more poignant photograph,
even if it was meant as no more than a record.

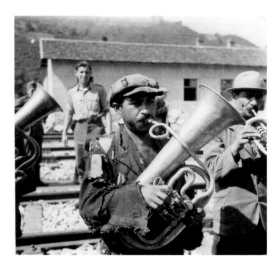

[German soldier]
Arrival at a camp and
'Freudenstadt 2625 km'. 1943–4
(64 x 64 mm and 90 x 60 mm)
There are other pictures of the site, without
the band. Such a medium-format picture
might have been taken by an authorized
photographer. The delightful 'Freudenstadt'
lies, by implication, 125 km to the east of Köln
(Cologne) – perhaps in the region of Kassel.

1943–4

They are playing in a wind band at a concentration
camp. The patched man in the foreground plays a
euphonium, and to the side you can see a flugelhorn.
Concentration camp or not, it is a typical German
band and may have been intended by the authorities
to refer to the homeland. German vernacular and
soldiers' photography, from 1914 through to 1945,
has a lot to do with the loss of a sense of place.
In 1914 whole communities had gone to war, and
had been put to the sword by 1915. The Germans,
like the others involved, were organized according
to cities and regions. Elites and specialists took the
place of the original local groupings – with pilots
as the most notable of these elites. The second war
completed the disruption which the first had begun.
Germans were scattered far and wide, campaigning
in Russia especially. Extemporized notices on forest
roads in the east often said just how far it was to
Cologne and other points of origin. 'Hier beginnt der
Arsch der Welt' [Here begins the end of the world],
another says against a background of birch trees.
A sense of loss and antipathy characterizes a lot
of the soldiers' photography of the early 1940s.

[American soldier]
American airmen. 1942–3
The portrait was probably taken in 1942–3, of
a man from Waycross, Georgia. It is from the
collection of a Lt Rupert Charles of 20B Brunell
Street. It may have been at a training camp. The
two men informally dressed in a barracks belong
to the same collection. The pictures are printed
in several different sizes from 35 mm negatives.

1943–4
American style, beautifully represented in this
picture of an airman, was developed in training
camps in the USA. The man photographed here
in a shadowy control room was, it seems, from
Georgia. Several portraits were made of him seated
in this position. In training camps military service
was still a novelty and trainees were in touch with
their families. In Europe and in the Pacific area
it was more difficult to report back, and on active
service US forces used official photographers who
kept track of divisional progress. Germans, until
things went disastrously wrong in the USSR, took
their own pictures as a rule. Germans also imagined
themselves as explorers in a strange territory.
Americans, by contrast, fought a logistical war, which
meant that a lot of time was spent in ships and at
bases. Small, temporary communities were set up,
and there was space for portraiture and character
studies. Hollywood also taught American personnel
how to present themselves to the camera. The other
two men, dressed informally for the evening, are in
improvised quarters, probably another training camp.

1944

Both pictures are numbered and dated, and belong to a series of images of promotions. They seem to be infantrymen, and G-28-D looks like a mechanic. Their promotion is taking place in a built-up area, perhaps in Italy. Master Sergeants in the US army had three stripes above and three below, as well as insignia on both arms. How exactly the promotions are made isn't clear in these portrayals but both men appreciate the gravity of the event. Photographs were a good way of keeping records, but at the same time these are also character studies. The American style was as informal as it was expressive, and in these instances both men give the impression of being citizens in uniform and of having stepped aside briefly for the event. This is a specific kind of portraiture or self-presentation: one in which the subject pauses momentarily out of courtesy, holds still or interrupts a train of conversation. In portraiture's scheme of things it stands at the liberal end of the ethical range, for the act is carried out by agreement. Both men have just taken time off from whatever it is that they normally do and quite clearly have lives to lead and responsibilities to attend to. The mode survives in US portraiture: in Joel Sternfeld's informal pictures in colour in the 1980s and '90s, for example.

[American soldier]
Promotions to Master Sergeant. 1944
(124 x 182 mm)
These portraits would have been taken by an official photographer working with a military unit – for divisional records. Signed and dated 1944.

[American soldier]
Somewhere in the Pacific. 1944–5 (92 x 113 mm)
This was probably taken by a divisional photographer
intent on an overview of the operation.

[American soldier]
Patupandan, Philippines. 1945 (92 x 113 mm)
No. 179, entitled 'Vehicles of all types are often
bogged down in sand during landings', was taken
at Patupandan in the Philippines by the official
photographer of the 40th Division early in 1945.

1944–5

American forces disembark somewhere in the Pacific.
Much war photography in the twentieth century is
about logistics, for troops spent most of their time
maintaining themselves. In this instance a Jeep
is being towed from the ramp of a landing craft
by a reversing truck. The Pacific war, which was
photographed extensively by American servicemen,
was fought from island to island, which meant
a lot of changes of location. The Americans were
part of a system, signified here by that number
886, meant to make the landing craft legible at
a distance. German photography, especially in
Russia where most of the pictures were taken,
shows manpower struggling with the elements.
What distinguishes the American version is its
evidence of organization. The malfunctioning Jeep,
for instance, belongs to the 35th Fighter Squadron.

Almost everything in the US war effort had a name
and number boldly spelled out, and personal names,
too, are a feature of the era. Somewhere – not
too far away in the American system – there is
a bookkeeper, and that might even be him in the
left foreground examining details on a clipboard.
In the second picture (no. 179), taken in the
Philippines in 1945, there are even more difficulties:
a lightweight Jeep bogged down in sand, helped out
by a gigantic crawler tractor. Another of these large
machines disembarks in the middle distance from
landing ship no. 717. Although covered by a machine-
gunner the scene looks like a public event, with
onlookers and children in the foreground. American
warfare was often informal, sometimes with the
look of a building site; and their photographers
took it for granted that this was part of the fabric.

[American soldier]
'En route to Panay aboard an L.S.T.', no. 166 and
'Artillery plotters', no. 192. 1945 (92 x 113 mm)
No. 166 was taken early in 1945 by the
photographer of the 40th Division during
the Philippines campaign. 'Artillery plotters'
is no. 192 in the same admirable series.

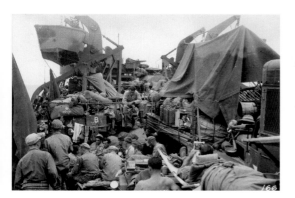

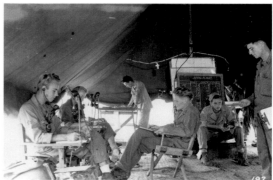

1945

In picture no. 166, crammed with detail, it seems
that the ship is laden with vehicles and men.
In the foreground someone, reading an illustrated
paper, relaxes on a stretcher, very neatly arranged.
In that space between vehicles in the foreground
a black soldier talks with white colleagues – quite
an uncommon grouping. Beyond, and right in the
centre of the picture, a seated man looks down
on the throng. He may be deep in thought, or
just waiting. He occupies the position taken by
the man in the panama hat in Alfred Stieglitz's
'The Steerage'. The interrupted journey across the
Pacific from island to island meant that American
forces became adept at packing and stowing.

Picture no. 192 from the odyssey of the 40th
Division across the Pacific is a group portrait
taken in an artillery control centre. Modernist
iconography in the 1930s often featured control
rooms with switches, dials and levers – and the
engine driver checking pressure gauges was
a favourite subject. Here telephone and radio
mean that the theatre of operations can be
managed digitally in what looks like a transit
camp: folding chairs and battered rush matting.

RENÉ-JACQUES

1908–2003

Born in Phnom Penh in Cambodia, where his father was a colonial administrator, René-Jacques was destined for a respectable career in law, which he studied, but he turned to photography in the late 1920s. His career was disrupted by military service in the cavalry and then by the war itself in 1939. Born René Giton, he took the name René-Jacques to save his family from shame when he opted for photography. He thought of becoming a writer, which didn't work out. During the 1930s he specialized in Paris. After the war he took pictures all over the country and was one of the great French landscapists. He set out with high hopes of becoming a photographer-illustrator, a peculiarly French aspiration which he shared with Willy Ronis and Robert Doisneau – it meant taking pictures with texts in mind, which the photograph somehow expressed or complemented. Economic reality meant that he had to turn his hand to anything: sport, news, portraiture. He met the writer Francis Carco, a writer of the *milieu* admired by Germaine Krull, for example, and illustrated his book of 1938, *Envoûtement de Paris* [Enchantment of Paris], with 118 photographs.

RUE DE BAGNOLET, PARIS. 1935
The street is just south of Père Lachaise, leading to the porte de Bagnolet – on the eastern edge of the city. The figure in the picture is the duc d'Aumale (1822–1897), fourth son of King Louis-Philippe. He might have become president in 1871, and was much respected. He left his considerable wealth to the nation. In 1935, however, he has been relegated to a resting place near to the lavatories in a bistro. Reputations fade – by degrees.

Rue de Bagnolet, Paris. 1935
A quiet day in the bar, perhaps in early evening – to judge from the quality of the light. René-Jacques used a Leica in the 1930s for demotic moments like this. Even before meeting Carco he was interested in the texture of ordinary life. He also had an eye for placement, even in such passing scenes. The syphon and the glass, for example, stand in relation to one another and to the beaded edge of the bar as it moves between light and shadow. Ranks of bottles and glasses are neatly contained within the frames and sub-frames of the picture.

Photography developed a fugitive poetics in the 1940s and '50s, epitomized by Robert Frank's *The Americans*. In this mode the photographer comes across scenes, instants and installations which suggest meanings which are hard to put one's finger on. If you think about it, the relegated duc d'Aumale is a poignant figure who found his way gradually to this lowly station. Going to the toilets, though, you might hardly give him a thought. The barman, too, glancing at those polished hot-water urns in the background is involved with next-to-nothing, which is a definite state of being, familiar to us all. By temperament or even by intention René-Jacques added this transient mode to photography's repertoire. He discovered it, and appreciated its suggestiveness – its tantalizing lack of specificity.

RENÉ-JACQUES

René-Jacques was a consummate professional. He worked for photographers' rights: proper contracts with publishers, for example. He belonged to syndicates and organizations, and was an important member of Groupe XV, founded in 1946 as a society of professional photographers. During the 1940s and 1950s he undertook a lot of commercial work for major manufacturers and for department stores in Paris – he prepared their catalogues, for example. At one point he owned fifteen cameras and forty-five lenses, and knew how to use them. He took landscapes throughout the country, published in books, portfolios and brochures. He soldiered on successfully into the 1970s. In 1990 he gave his collected work to the state and was named a *chevalier de la Légion d'honneur*. The only comparable career in photography is that of Ansel Adams in the USA, a near contemporary equally committed to professionalism and to the public good.

EN PROVENCE. c.1955
A citizen, lost in thought, walks through a complex scene. It is wintertime, for there are no leaves on the expressive branches of the plane tree, represented by its shadows on the far wall. The two benches were from the same batch and they throw clear shadows. The most rewarding piece of structure, though, is the staircase with its metal balustrades which invite more calculations. These contrast nicely with the two regular window grilles beyond. René-Jacques liked diverse structures, and to note flowing organic elements in abstract formats. He always made a point of working with restricted settings: a delimited number of steps as here, two benches, two windows and a tree with four main branches. Such scenes can be worked out, and they may remind some of us that we have the outlook of artisans.

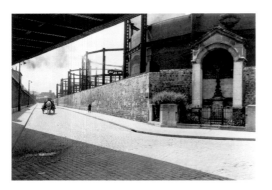

Rue de l'Evangile, Paris. 1946
He was looking west towards Montmartre in an area of railway yards, coal depots and gasworks. Paving blocks calibrate the surface of the road and streetlamps measure out its length. Coming and going, a horse and cart along with a pedestrian endure the boredom of the street.

Like maps, such lucid spaces as these can be gauged. Ancient maps show that there were, in fact, five gasholders along the edge of the rue de l'Evangile. René-Jacques had an orderly aesthetic, a certain way of putting pictures together which can be identified and appreciated. One of the virtues of this laconic, classical style was to invite interpretation. If there are only a few elements on show it is likely that they have been chosen. Christ in his niche signifies serious suffering, in relation to the mere endurance required to get along that street. At this rather discreet distance the figures have representative rather than personal status – in the manner of Giacometti, a well-known local artist of that era.

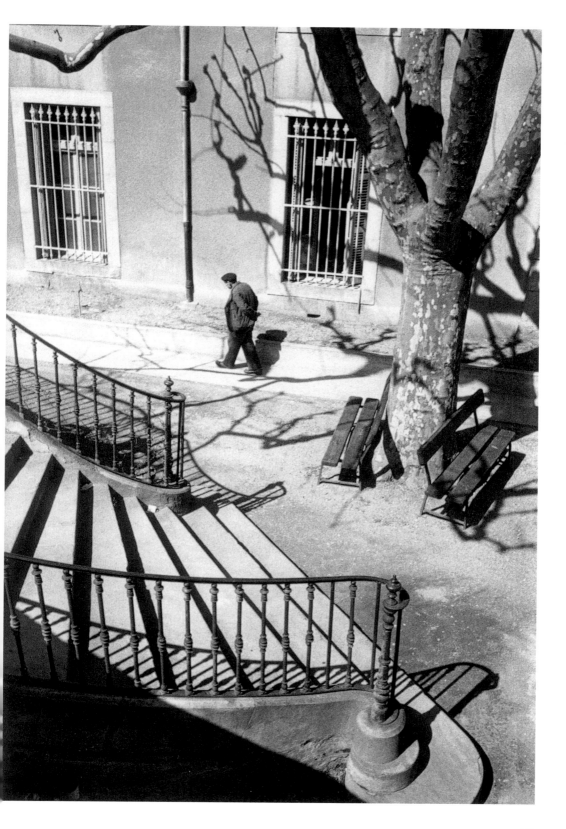

IZIS

1911–1980

Israël Biderman was born in Lithuania. In 1918 he became Izraëlis Bidermanas when the country escaped from Russian control. At the age of thirteen he was apprenticed to a photographer, and in 1930 he fled to Paris where he worked as a printer and retoucher in a studio. His contemporaries often left Lithuania for Israel, but he was attracted to Paris because he was interested in painting. Earning a living took up all his time, however, and by 1939 he was no more than an all-purpose studio photographer. On the Occupation he left Paris for the Limousin and escaped with his life. In Limoges he worked as a switchboard operator in a barracks and eventually joined the *maquis*. In 1944 he made a set of portraits of *maquisards*, which were shown and admired in Paris. In this roundabout way he began to establish himself as an artist. Quite understandably the war also affected him, and he was unwilling to return to routine work in the studio.

FAIRGROUND, PLACE D'ITALIE, PARIS. Pre-1950
It is an elaborate piece of equipment in wood and canvas, and can't have been meant to travel at speed. The young couple kiss tenderly and awkwardly. The photograph appeared in *Paris des Rêves* [Paris of dreams] in 1950, with a little text by Edith Thomas, who was reminded of Watteau's very famous *Pilgrimage to the Isle of Cythera* in the Louvre. Two helicopter rotors in the background, mounted on other pieces of apparatus, hint at more frantic alternatives.

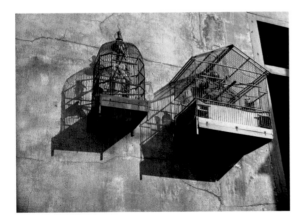

Birdcages, courtyard, rue de Paradis, Paris. 1949
There are two of them, with their shadows clearly drawn on the wall. The rue de Paradis lies just south of the Gare du Nord, and its nearest buildings of importance used to be a prison (Saint-Lazare) and a barracks. One of the cages is a pavilion and the other a house with gables. This, too, was in *Paris des Rêves*, with seven lines of poetry in a stylized hand by C. F. Landry. *Paris des Rêves*, with seventy-five pictures, each one faced by a text written by one of the many writers working in Paris at that time, was a great success. It had been turned down by any number of French publishers before La Guilde du Livre and Editions Clairefontaine in Lausanne saw its potential, which ran to sixteen editions and 170,000 copies.

Izis was sensitive to the post-war mood in Europe. For a short period, lasting into the 1950s, there were shared memories of the war and shared expectations, too. Somehow Izis managed to strike the right chord in *Paris des Rêves*. The pictures may have a gentle and personal quality, but at the same time their privateness is collective. Anyone could get the paradox of the melodious birdcages in the rue de Paradis – the poor devils singing in the sun behind their grilles. The hand-made pigeon, too, would have been a precarious vehicle for love: cumbersome and dangerous to all involved.

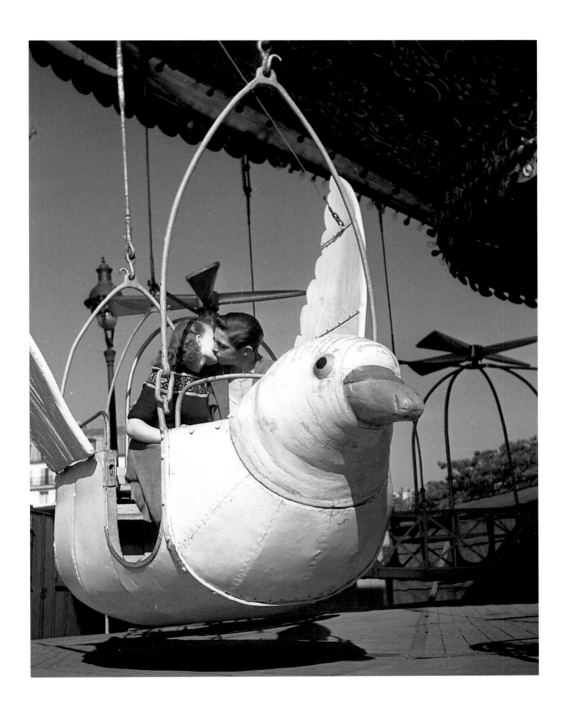

Izis seized the moment in 1950 with *Paris des Rêves*. He even persuaded forty-five writers to prepare short texts for the pictures, reproduced in their own handwriting. These included André Breton, Francis Carco, Blaise Cendrars and Francis Ponge. Jean Cocteau wrote a short introduction. At some point, certainly by 1949, he got to know the Parisian writer Jacques Prévert, who wrote extensively for his next book, *Grand Bal du Printemps*, in 1951 – a reflection on springtime in Paris, in sixty-two images. He went on with Prévert to complete a book on London, published in 1952, and another on landscape, *Paradis terrestre*, introduced by Colette in 1953. From 1949 he was a photographer for the newly established *Paris-Match*, where he specialized in writers and artists. Izis, who came by his abbreviated name in the late 1940s, perfected an iconography of Paris: fairgrounds, birdcages, children at windows, dogs, cats, pigeons and fishermen on the Seine. It was an age-old inventory but he imbued it with a melancholic atmosphere which had no precedent in French photography.

PORTE DE VANVES, PARIS. Pre-1951
Robert Doisneau lived near the Porte de Vanves in the south of the city. This picture was printed in *Grand Bal du Printemps*, even if not a typical spring scene. More than likely the standing man relishes the sun on his back, whilst she watches the shop. Izis and/or Prévert quote two sentences from Herman Melville on the facing page concerning passion, even and especially amongst such traders in rubbish as these. Maybe it involved a passion for order. The two flat-irons, for instance, have been given pride of place on the kerbstone along with a bushhammer (or boucharde) used by sculptors. If this was their regular trade, they would have been practised classifiers of such objects.

4, impasse Traînée, Montmartre, Paris. 1950
Izis included this in *Grand Bal du Printemps*. There is another version of the same scene in *Paris des Rêves*, where André Breton identifies the face to the upper right as that of Jacques Prévert – but he may have been joking. The drawings reminded Breton of both Paul Klee and Jean Arp, great artists of that era. Izis liked the site with its actors, who performed for him. The little boy running on the coping stones is Gérard, the artist, and those may be his sisters, with the eldest taking the mother's part.

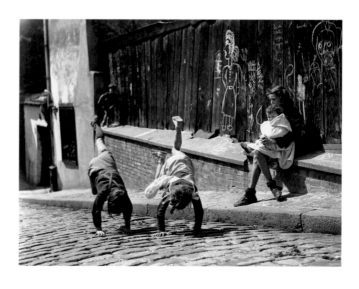

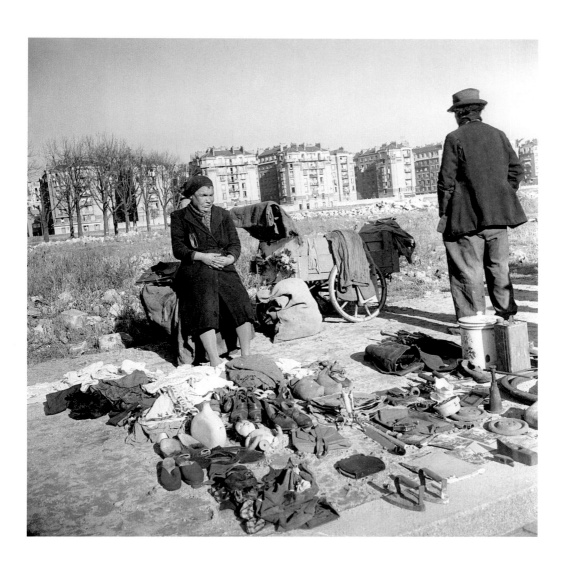

The imagination of Izis's age was furnished with great themes, more or less taken for granted at the time. One held that mankind was – if you cared to watch and wait – an artist at heart and even furnished with a divine spark. Hence that ambitious quotation from Melville at the porte de Vanves. The second understood that we were involved in a journey clearly laid out: a creative childhood, vividly realized, followed by the onset of responsibilities, represented in the impasse Traînée by the older girl with the child; after which came love, marriage and even more tasks preceding a decline into a picturesque and difficult old age. There were many stages on the way, rites of passage, some pleasures and a lot of predictable hardships. This was the model to which Izis and his contemporaries worked, but by the 1960s this, too, had become obsolescent.

MARCEL BOVIS

1904–1997

In 1981 Bovis was made a Chevalier de l'Ordre du Mérite – for services to French photography. He was interested in the history of the medium, and he was a collector. Born in Nice, Bovis studied decorative arts largely for the sake of a career. His father had been a letterer and decorative painter. In 1922 he went to Paris to work as an artist and decorator for Galeries Lafayette, and thence to the avant-garde atelier attached to Au Bon Marché – a major department store. His expertise as a designer served him well during the 1920s and '30s, and ensured that he was never altogether dependent on photography which he took up in the late 1920s – after his military service. He was influenced by the Belgian Surrealist review *Variétés* to begin with, where he saw pictures by Kertész, for example, and Germaine Krull. He seems to have started taking night pictures of Paris around 1927, which was, at that time, the very latest development in Parisian photography. He was especially attracted to fairgrounds and to their graphics.

SHOOTING GALLERY IN ARGENTEUIL. 1931
Argenteuil is just to the north of Paris, on the way to Pontoise. At that time it was admired for its asparagus. The notice says 'Pipes Œufs' [pipes eggs] within a heart. Clay pipes are brittle, just like egg-shells, and hearts may be brittle, too. The silhouettes are of birds, dogs, kangaroos, men, women and snails – all possible targets. The shooting gallery is an iconographic test. It is also seen as a complex montage overlaid by shadows and patches of light, making it hard to see exactly where things stand and how they relate to each other.

Fairground allegory. 1938
H. Pilloud, the painter, gives an address in the south of Paris. The subject is Fortune. She stands on a flying wheel, carries an hourglass and throws dice; and she is part of an elaborate painted decor. The total scene is charted by a short set of steps, an angled pole and some taut ropes. To the left a question mark and what might be an oriental bust. The whole is an intricate spatial problem.

Many of Bovis's contemporaries also took pictures of fairgrounds and of their apparatus: wooden animals on carousels especially. Carousels had allegorical possibilities: life as a merry-go-round, with better and worse mounts, and a chance to show off to onlookers. Bovis, though, was more scholarly than most and looked to fairgrounds for arrangements complex enough to be solved. Cubism, with its liking for cigarette papers, absinthe bottles, concertinas and newspaper headings, asked to be scrutinized for meanings. Bovis built on the Cubist example, accumulating identifiable motifs in sometimes quite jumbled spaces. These suggestive puzzles remind us of the delights of reading and of interpretation – at a time when ideologies were hardening.

Bovis became a professional photographer in 1930 and gradually improved his position during the decade. He was closely associated with the prestigious periodical *Arts et Métiers Graphiques* and with the humanist tendencies which had ousted the New Vision aesthetics of the late 1920s. The war brought hard times, but the occupiers of Paris had an appetite for postcards and illustrated souvenirs which made work for photographers: *Paris, 100 Photographies et un plan*, 1941, with pictures by Bovis and Emmanuel Sougez, for example. In 1942 French publishers began to interest themselves in Old France, and Bovis took pictures of Bourges and its cathedral, and of Chartres, too. This tendency continued after 1945, as if the spirit of the nation was embodied in its ancient buildings and in its classic landscapes. During the war Bovis was involved with Sougez in a group of independent photographers called Rectangle, transformed in 1946 into Groupe XV – to which Willy Ronis and Robert Doisneau also belonged. Throughout his career Bovis was a collector of miniature toys and popular graphics such as sales tickets and food wrappings. Walker Evans in the USA was also a great collector of the kind of items which he liked to photograph, and the two artists have a lot in common.

PALAIS DES DANCES ORIENTALES. 1948
Only the dances were eastern. Casablanca, dimly readable in the shadows, set the scene, and those are eastern domes visible against the painted night sky. The dancing was to be done to records, again barely visible on the table top. Announcements must have been made by the woman with the flower in her hair. That may be Muthire about to begin on stage, all for 10 francs payable across the space (*en face*). It must have been a dance of the seven veils, and she would have had to watch her step on such a rickety stage as that.

Fête du Trône. 1955
The Foire du Trône was a 'gingerbread fair' held annually in the place de la Nation and the cours de Vincennes in the springtime of each year – in the east of Paris. The throne in question had been occupied by Louis XIV to receive the homage of the Parisian people in 1660 following the Treaty of the Pyrenees in 1659 – a crucial date in the establishment of modern France. The area was famous for furniture making – witness the elaborate desk from which tickets are dispensed here. The young man is a modest client, and the sales lady is elegant.

Events like these are extemporized. If you were a show-person travelling around the country you had to use whatever stages present themselves; and if you needed the money it had to be made clear. Without musicians records would have to do – useful substitutes, even if fragile in 1948. Such makeshift worlds attracted photographers of the era who saw in them affinities with their own work in improvised darkrooms. Like the photographers, the women involved here are also selling a vision. Culture, they all know, is made up from materials ready to hand. All you need is a stage and a bit of lighting and the trick can be turned – one of the perceptions of Bovis's generation.

ROBERT DOISNEAU

1912–1994

In the 1940s and '50s Doisneau took very perceptive pictures of Parisians – character studies. Born in Gentilly, near to the Porte d'Italie on the southern edge of Paris, he trained as a lithographer, which was a trade on the wane in the 1920s. He found work as a hand-letterer and moved into photography, which he liked. For a while he worked for André Vigneau, an established photographer who had connections with writers and painters. Vigneau and Doisneau made the cover for Simenon's first Maigret book, for instance. Military service disrupted his career but he eventually got a job at the Renault factory at Boulogne-Billancourt, where he took advertising pictures and recorded life on site. This was his real training in photography. In 1939 he was dismissed by Renault and joined the Rapho Agency just before war broke out. Called to the ranks he was soon invalided out, and missed the Fall. On his return to occupied Paris he did odd jobs, such as making postcards on Napoleonic themes, and he worked for the Resistance as a counterfeiter. He was one of the few photographers on hand when the city was liberated in 1944.

Brothers. 1934

This was taken in the rue du Docteur Lecène in the 13th arrondissement in the south of Paris. Even the window in the background plays its part as a reminder of the kind of orderliness which awaits the prudent onlookers in later life. A beret, pulled well down for security's sake, was the acrobat's sign in this and other pictures of child's play from the 1930s.

CHILDREN FETCHING MILK, GENTILLY. 1932

The photographer Germaine Krull said that in the early 1930s such corner dairies as these were under threat, and that they were part of the traditional life of the city. Doisneau notes that it is 8 a.m. in a mid-rent street in Gentilly and that the parents have most likely already gone to work in the factories.

Doisneau thought of himself as a photographer and as an illustrator, at a time when illustrators were respected for their powers of observation and their cleverness. Good illustrations attracted witty captions, and the two sets of brothers on the rue du Docteur Lecène are just made for a compact remark. Likewise the two children acting the part of adults on the street in Gentilly. Photography in the early 1930s was a branch of illustration, very much along the lines of cartooning, and Doisneau, with his background in lithography, was well aware of these expectations. What set him apart was a sensitivity to the human condition, and a feeling for the stages of life and rites of passage. The girl and her little sister are rehearsing parts which they will play in later life as they become parents in their turn. The two nicely dressed boys will never break free from their parents' expectations and from the inhibition of their social class. The performers, kitted out in boots and berets, are equipped for the job.

After the war was over Doisneau took up the threads of his career. There were new illustrated magazines such as *Paris-Match* and *Réalités*. Doisneau also took pictures for *le Point*, a subscription journal with special issues on artists and writers, and *Action*, a left-wing review. He collaborated with writers such as Jacques Prévert, who was a poet and scriptwriter (Jean Renoir's *Une partie de campagne*, 1936, for instance), and the poet Blaise Cendrars, who wrote the text for his first book of pictures, *La Banlieue de Paris* (1949). Henri Cartier-Bresson asked Doisneau to join the new picture agency, Magnum, in 1947 but Doisneau preferred to remain with Rapho, which had resumed operations in 1946. He seems to have sensed that his roots were in Paris and that international missions wouldn't suit him. He was particularly interested in suburban topics and was encouraged along these lines both by Prévert and by Cendrars, connoisseurs of the commonplace.

JOSEPH MARMIN. 1952
M. Marmin features in *Instantanés de Paris* [Snapshots of Paris], introduced by Blaise Cendrars and by Albert Plécy. In 1956 the book came out in English as *Paris Parade*. M. Marmin, from Nantes, is an exception. The trees are in box, and Doisneau counted eighty different animals in the garden, plus a Roman centurion 'and a statue of General Leclerc, become equestrian owing to the rapid growth of the shrub'. M. Marmin appears under the section heading 'Love of the Arts', along with a heavily tattooed man and a cement stag in a hotel garden.

The young accordionist and her companion, café in Les Halles area, Paris 2ᵉ. 1953
In *Paris Parade* she appears in an excerpt with the seated diner to the right. She sang, 'You can't imagine how I love you. It's so sweet to be kissed...' Doisneau was intrigued by her presence and took another picture of her with a group of butchers standing by the bar, 'Music-loving butchers'. She looks cool, to say the least, and the formidable woman who holds centre stage is a mystery.

Doisneau tended to the Left and was even in the Communist Party for a few months after the Liberation of Paris in 1944. Temperamentally he was unsuited to party discipline. Right to the end of his life, though, he did carry out social reportage for *La vie ouvrière*, the magazine of the CGT, the French trade union organization. By disposition he was liberal and very sympathetic to the idea of undisturbed private life. Monsieur Marmin exemplifies the liberal mode of being to perfection, for he has constructed an engaging environment apart. Sculpting in box would have taken some time, for it is slow growing as a rule, and he has been able to suit himself. The other great liberal era was in late Weimar Germany, Berlin in particular, where such photographers as Alfred Eisenstaedt liked to remark on hobbyists and others wrapped up in local business. Berlin in the early 1930s was becoming aware of totalitarian possibilities, and Paris in the late 1940s and after was in a position to reflect on them.

In 1949 Doisneau was employed by *Vogue* as a fashion photographer. At the same time he continued to study vernacular Paris often in the company of the writer Robert Giraud, whose book on Parisian low life, *Le Vin des rues*, was published in 1955. Between 1949 and 1956 Doisneau contributed to six substantial books on Paris. In 1951 his pictures, along with those of Willy Ronis, Brassaï and Izis Bidermanas, were exhibited at the Museum of Modern Art in New York. He was very successful in the 1950s but by 1960 the illustrated press was in decline and the French themselves had probably had enough of recuperative imagery of 'la France profonde'. Doisneau turned increasingly to commercial and advertising photography, just to be able to make a living. In the 1980s he went to work again as a documentarist for the DATAR project, taking pictures of suburbs and new towns in the Paris area.

**LOCAL CHILDREN AT
THE PLACE HÉBERT, PARIS 18^e**. 1957
The place Hébert lies to the north of the Gare du Nord, surrounded, at the time, by goods depots and gasworks, and not on tourist itineraries. The young girl seems to be presenting her younger sister to the photographer, and the youth may be reflecting on a life of crime. The police post sustains that theme. He has taken his left foot out of his shoe – for comfort perhaps. They may be rehearsing future roles, but there is enough doubt to ward off easy conclusions. They may just be helpful, for it is a tender picture too – and one of Doisneau's great achievements.

Jacques Prévert, avenue d'Orléans, Paris 14^e. 1955
The avenue d'Orléans (now avenue Général Leclerc) led south to Doisneau's suburban homelands (Montrouge and Gentilly). In 1949 Librairie Gallimard published Prévert's *Paroles*, a very successful book of poetry. Prévert (1900–1979) had the common touch, for which he was both admired and criticized. Doisneau had a lot in common with him, sentiment especially, sometimes touching on sentimentality. Here, in an opportunity too good to overlook, Prévert has been placed in front of the O of MERODE, to give MERDE, the all-purpose French expletive. The poet also has a dog on a lead, and it was considered good luck to tread in dog-shit – making the best of a bad job.

Doisneau's was the last generation to involve itself much with the language of the people. From the early
1930s, photographers, with their new lightweight cameras, had been alert to what their
subjects might be thinking and saying, but speech was always too site specific to play
to international audiences. For the French, though, taking stock of the state of the nation
after 1939–45, local speech still mattered. In the 1930s the idiomatic writer to whom they
turned was Francis Carco (according to Germaine Krull), and in the 1940s and '50s it was
Jacques Prévert.

ANSEL ADAMS

1902–1981

Adams took pictures for over fifty years, mainly landscapes in the mountains of California. He was born in San Francisco and spent most of his life there. At first he seemed destined to become a concert pianist but during the 1920s turned more and more to photography, and in 1930 he took it up full time. As a child he had been taken by his parents to the spectacular Yosemite Valley to the east of San Francisco and he remained attached to Yosemite for the rest of his life. At the same time, Adams was interested in the art of photography, which wasn't always compatible with landscape. In the 1920s he was a pictorialist, tending towards soft-focus and patterned arrangements. Around 1930 he favoured a sharp-focus objective style, influenced by Edward Weston, Paul Strand and the new German photographers of the 1920s. During the late 1930s he felt the influence of the great Alfred Stieglitz, and subscribed to his idea of the equivalent – a picture which gave shape to a deeply felt intuition. He couldn't, however, commit himself totally to any style or tendency, for landscape played to very broad audiences – especially if it featured some of the world's most dazzling scenery.

MONOLITH –
THE FACE OF HALF DOME. 1927

Half Dome, in the Yosemite Valley, faces El Capitan – a concave formation. This picture was taken from the West Shoulder of Half Dome, from a granite shelf called the Diving Board. The face is darkened by lichens watered by the lip above. Adams waited for the sunlight to bisect the face giving a finely inscribed surface to the left in contrast to the Gothic shadow play which suggests itself in the right-hand panel.

Glacial Cirque, Milestone Ridge, Sequoia National Park. c. 1927

A cirque, like a circus, is an arena. The hanging valley to the left beyond the ridge is filled with sunlight. The ridge itself seems to begin as an eroded wall. As it proceeds into shadow it becomes a silhouette. The foreground feature, with granite pipes, looks like a low mountain and it complements the sunlit valley beyond. Altogether it is a landscape which looks as if it might be manipulated and reassembled. Sequoia National Park is in the Sierra Nevada, to the south of Yosemite.

Segmented scenery features in the earlier landscapes from the late 1920s into the early 1930s: blocks of rock, forested slopes, sheets of ice, towering clouds in big skies. The pictures are distinctly compartmentalized and the parts can be identified: types of rock, names of clouds. Modernist artists thought of the studio as a workshop and of the artwork as an assemblage which had to be put together by hand. Their pictures as well as their sculptures refer to the sense of touch and eve to the weight and shape of things. That rock in Yosemite, for instance, has been incised and abrad dusted with snow and neatly capped with a line of roofing – just like a manufactured structure.

ANSEL ADAMS

Adams became increasingly interested in sharp-focus objective photography, and in 1932 he was one of the founding members of Group f/64, with Edward Weston and Imogen Cunningham. This new purism was intended to be true to the nature of things, true to their essence rather than to how they might be seen in diverse conditions. As a movement f/64 only lasted until 1934. Adams feared that it might become an ideology and a constraint. He and his friends took clear, still pictures and printed them in austere black and white. They felt the need to explain themselves, both to get the better of sceptics and to get things straight in their own minds. It was an epoch when time was thought of – by thinkers, at least – as a process unfolding in no very orderly way. In this process things could be considered as events in time rather than as immutable solids. Photography, in its intensely objective form, could be seen as a way of breaking into and examining this process – a way of taking specimens and cross-sections from nature. The photographer investigated this puzzling and ever-changing condition by means of samples and soundings.

ROCK AND GRASS, MORAINE LAKE, SEQUOIA NATIONAL PARK. c.1932

A strip of trees establishes the upper edge of the picture. They run parallel to a line of pale water supported by reflections from the forest and the inverted image of a mountain. The arrangement below replicates the scene in miniature: a rock/mountain and a reed/forest. Adams plays with scale and with substitutes, which tell their own story too: evidence of lichen on the rock/mountain points to varying water levels – as you would find in a moraine lake fed by glaciers melting and freezing with the seasons. The boulder, fragile grasses and delicate surface of the lake all register some of the varieties and conditions of time as it unfolds.

High Country crags and moon, Sunrise, Kings Canyon National Park. c.1935

Sunlight has just revealed the curved line of the horizon – just enough to introduce this stony scene as a weighing scale in balance. In a moment or two it will become no more than a strip of mountain scenery and the moon will have faded into a paler sky. Time may proceed inexorably but this particular instance is a moment of equilibrium. You could think of it as a moment in which time has coalesced or come together to propose something like an essence of itself.

Both pictures contain poetic figures: a miniature landscape within wider scenery, and a balance disposed on either side of a fulcrum. Such figures ask to be noticed and the noticing takes enough time to complicate the process, to hold it up and to slow it down. Adams liked to use such poetic devices, even though he didn't remark on them in his writings. The purist doctrine of the f/64 group didn't allow for any very elaborate poetics, for it was meant as a rallying cry – to keep an aesthetic space clear for a while.

ANSEL ADAMS

During the 1930s Adams established himself, but faced difficulties all the same. He took on more responsibility than was good for him and his health suffered. In 1934 he was elected to the Board of Directors of the Sierra Club and spent a lot of time on its campaigns and projects: devising publications and making photo-murals which became popular during the mid-1930s. He resisted what he called the fungus of 'development' in the National Parks. Whereas his gifted contemporary Edward Weston lived a simple life devoted to his art, Adams lived the life of a public figure and involved himself in controversy. He met Alfred Stieglitz in 1933 and fell under his spell enough to be caught up in some of the great man's feuds – with the Museum of Modern Art, in particular, which he thought too complacent. In 1937 a fire at Adams's studio in Yosemite destroyed and damaged many of his early negatives. He saw it as an opportunity to begin again, for he was nothing if not determined.

STATUE AND OIL DERRICKS, SIGNAL HILL, LONG BEACH, CALIFORNIA. 1939
The beautiful child reflects on mortality in a darkened environment. A lot of Adams's photography is shaped by his real-world interests in ecology. He was well aware of the price paid for urbanization and there was compelling evidence in the land to the east of the Sierra Nevada, which had been drained to provide water for Los Angeles to the south. Adams travelled in such places and remarked on the dead trees which were their signature. This picture from Signal Hill is outspoken. Adams and his contemporaries had to watch their step, for they risked accusation of communist tendencies.

Glacier polish, Yosemite National Park. c.1940
Glaciers bear down on underlying rocks and rub them smooth. In this case the process has yielded what look like mortuary slabs marked by the remains of lettering. The main unit has been shattered, in the style of the fallen monuments of Ancient Egypt. Adams's imagination took such possibilities into account, for by 1940 he had experienced reversals of fortune. Geology, everywhere on show in his favourite places, also told an epic story which benefited from such ornaments as these.

Adams's was an art of great themes, geographical and geological. He was devoted to Yosemite and to the
Sierra Nevada and beyond that to an idea of the earth. His contemporaries in Berlin and then
in Paris also looked beyond local circumstances and tried to take account of society and even
of humanity. Large ideas didn't translate easily into photography because of its naturalistic
bias and fidelity to facts. To enlarge the scope of their art photographers of Adams's generation
elaborated and liked to rely on imaginary figures such as these fallen 'Egyptian' monoliths
in Yosemite – they spoke of legendary ages past, even if in geological terms they scarcely
counted. Adams spoke out against 'propaganda' but seems to have regarded the persuasive
devices in his own art as more or less natural.

Even though Adams was a latecomer, he was never discouraged by his great precursors. Alfred Stieglitz, whom he idolized, lived in New York, so that he remained, to some degree, an ideal. Paul Strand, too, lived far away, and made films during the 1930s. Edward Weston, one of photography's all-time ultras, lived in California and Adams knew him well. Weston, though, was too much of a man apart to disturb Adams. Indeed Adams wrote letters on Weston's behalf and helped him in practical ways when Weston was awarded a Guggenheim Fellowship in 1937. Adams liked to put his shoulder to the wheel. In 1940 he helped with the foundation of a department of photography at the Museum of Modern Art in New York. In 1941 he became a photo-muralist for the Department of the Interior. In 1943 along with Dorothea Lange, whom he admired, he undertook a photo-essay on the plight of Japanese-Americans interned during the war. In 1946 he received his own Guggenheim Fellowship, to take pictures of National Parks and Monuments.

SAND FENCE NEAR KEELER, CALIFORNIA. 1948
To judge from the angle of the fence the prevailing wind comes from the right. The blown sand is impeded enough to form a bank in the lee of the fence. The sun, low in the sky off to the left, casts long shadows and picks out the perforations in that metal upright in the foreground. The picture makes practical points about life in dry places, and its various calibrations are a reminder of all the calculations needed at that time to make the kind of pictures taken by Adams.

Tree shadow on rock, Yosemite Valley, California. c. 1950
The curved rock looks like a giant human body emerging from the earth. The shadow of the tree trunk with its branches might refer to an X-ray showing internal organs – veins especially. During the 1930s Adams and Weston imagined a kinship between rocks and roots and the human body, but here Adams has been more reflective than expressive. An idea like this might have occurred to anyone walking in the woods, and especially to someone in middle age and conscious of mortality.

Adams, like many artists, envisaged a world. His was richly furnished with mountains, rivers and impressive forests. He was quite clearly a romantic, yet at the same time quite ingenious and practical. The *Sand Fence* notes how commonplace things might be carried out, and as an aside there are those technical looking bars and dots of light. For its part, the *Tree Shadow* suggests itself as a useful metaphor touching on life in general. Adams moved easily between the here-and-now – embodied in rocks, roots, reeds, ice and water – and epic vistas. Landscape provided the basic materials and much of the script to which he made his own amendments as he read and reread the original. Landscape's constancy suited him and allowed him to elaborate his art over the decades. Urban artists, on the other hand, found that culture moved on, leaving them often at a loss.

MINOR WHITE

1908–1976

Like Alfred Stieglitz and Ansel Adams, who were inspirations to him, Minor White was an educator and an admirable photographer in his own right. In the 1960s and '70s his influence was pervasive in the USA. In the late 1950s he began to run short courses and workshops which were attended by aspiring photographers. His own story is exemplary: difficult years at the University of Minnesota, where he studied botany, followed by an apprenticeship as a writer whilst working as a night clerk in a hotel. His grandfather had interested him in photography during his childhood and in 1937 he turned to photography to make a living. In 1938–9 he was appointed as a 'creative photographer' by the Works Progress Administration (the WPA, whose offshoot was the famous FSA, or Farm Security Administration) to take pictures in Portland, Oregon. In 1940–41 he turned to teaching and began to exhibit, but in 1942 he was drafted into the army, where he was in the Army Intelligence Corps. Army life didn't give him much opportunity to take pictures but he maintained his interest and set out refreshed on his discharge in 1945.

DEER SKELETON, STEAMBOAT LAKE, OREGON. 1941

He has noticed a congruence between the backbone of the deer and the twisted trunk of the tree beyond. There are other rhymes, and an unusually large area of darkness in the foreground. It is a more dispersed arrangement than you would find in pictures by Edward Weston and Ansel Adams, of whose work White was aware.

Sandblaster, San Francisco. 1949

This picture is hard to make out, although that looks like a man peering into the darkness inside the frame which in its turn looks like a cutting into a road surface. The operative may have been guided by the chalked instructions in the foreground.

White was more interested in the meanings of photography than anyone before or since. He wrote and spoke extensively, although his sayings are sometimes cryptic. The image of the man working in darkness, for example, appears in a large retrospective of 1969, 'mirrors, messages, manifestations', under this phrase: 'Ever since the beginning, camera has pointed at myself'. Thus the man in the dark may be himself subject to some kind of external directive – which in the dark he can know about but not see. White had an inclination towards Zen and the *koan*, a type of puzzling phrase used by the master to prompt thought in students. A *koan*, phrased as a question, might not be readily answerable but the student would persevere none the less. The earlier picture from 1941 makes a point which can be readily understood. The later picture discourses on the nature of understanding itself – or so one might imagine. White's interest in Zen developed in the 1950s, but he was always in the habit of reconsidering his pictures and re-arranging them in new sequences in the light of new wisdom.

MINOR WHITE

After the war was over Minor White headed for New York to find out what was happening in the photography world, in particular at the Museum of Modern Art where Beaumont and Nancy Newhall were in charge of photography. He undertook courses at Columbia University and got to know Meyer Schapiro, an important art historian. In January 1946 he met the legendary Alfred Stieglitz. He also met Edward Weston, Paul Strand and Edward Steichen in New York. He intended to return to Portland to work in the museum there but in 1946 accepted a job offer at the California School of Fine Arts in San Francisco where he came to know Ansel Adams very well. Within little more than a year he had established himself, and in 1947 began to experiment with the sequences for which he became known. He quickly went from strength to strength. In 1952 he was one of the founding members of a new periodical, *Aperture*, which, eventually under White's direction, would have an important role to play in photography. In 1953 he devised an exhibition called 'How to Read a Photograph' for the San Francisco Museum of Art Extension Division. He used his own photographs mainly and relied on the theorist Heinrich Wölfflin – in particular *The Sense of Form in Art* (1931) – for his aesthetic criteria.

DRIFTWOOD AND EYE, POINT LOBOS STATE PARK, CALIFORNIA. August 1951
Point Lobos had been one of Edward Weston's favourite sites and White liked it too. He devised a sequence of pictures from the place, most of them taken in July 1949. He had been attracted by sexual motifs in the rocks but waited until the time was right to take pictures. This arrangement has an Aztec look and might be a coiled serpent or just the mouth of a beast.

Birdlime and surf, Point Lobos State Park, California. 1951
It is a natural enough scene except that the smears of birdlime look in many cases like embryos or micro-monsters. White liked subjects in which light seemed to emanate from things in the picture, for they weren't meant to be natural scenes. The photograph, as he came to see it, delivered up materials which were in the mind's eye, although based on nature.

The unconscious mind had its own agenda and any number of sublimated memories from very long ago. That stained rock, for example, could be seen as a re-enactment of the emergence of life from the darkness, for the motifs gradually take shape as they reach the top of the hill. And the savage rocks and eye might recall fearsome apparitions implanted in the psyche. These pictures can almost be explained away, although that wasn't White's intention. From Stieglitz he had taken the idea of equivalence, which meant an image which bore some relation to a remembered state of mind. Stieglitz used clouds as his vehicles, but White's rocks are more outspoken and at Point Lobos wanted to tell a melodramatic story.

In the 1950s and '60s art's reputation was high in the USA. Painting, as practised by the Abstract Expressionists, had a metaphysical dimension. Painters depended on intuition, as did the kind of photography carried out by Stieglitz and Weston. White promoted this position constantly in his writing and exhibition work, and in educational ventures to which he was irresistibly drawn. From 1953 until 1956 he was on the staff of George Eastman House in Rochester, NY. Until 1959 he was closely involved with *Aperture* magazine. Gradually he made more time for himself but all the same was constantly associated with workshops and short-term teaching commitments. He continued to teach into the 1970s. Like Stieglitz he had a vision, even the same vision at times, and like Ansel Adams he had a strong sense of responsibility towards the medium and towards its institutions. In the 1970s his aesthetic was rejected by the majority of new colourists in the USA, but they can have been in no doubt as to what they were turning away from.

METAL ORNAMENT: PULTNEYVILLE, NEW YORK. October 1957
This picture belongs to a sequence put together in 1959, *Sound of one hand clapping*, eleven pictures with this as the first. In 1957 he had been thinking for some time about the Zen *koan*, 'You know the sound of two hands clapping, what is the sound of one hand clapping?' A *koan* could be answered by an action or by the use of something handy, amongst many other kinds of responses, and White recognized his answer in the metal ornament, for he had reached a point where he could see sound.

Barn, Lincoln, Vermont. August 1968
This is a metaphysical barn rather than a piece of agricultural property. Above it there is a lantern with windows – a lookout post. The white door stands partly open, as either an exit or an entry. It was part of *Sequence 1968* which featured other openings into the beyond, sometimes into the open sea. Life, White suggests, is a journey and he prints a short piece by Saint Catherine of Siena on a preceding page: 'All the way to Heaven/ Is Heaven/ For He said/ I AM the Way.'

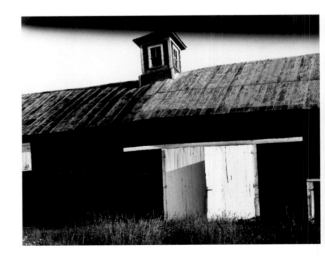

White, to his credit, was hospitable to all cultures and religions. In 1943, at the age of thirty-five,
he was baptized into the Catholic Church, whilst in the army. From the 1950s onwards
he was an enthusiast for Zen, whose three requirements were great faith, great doubt and
great perseverance. The camera was an ideal instrument, for it had an innate indifference:
'The dung heap the Grail the Star the Lotus/ Are all the same to it.' To the camera's indifference
or its disinterested take on the world, the photographer could bring what White called in a
long poem 'Holy indifference', which is where Zen, with its determination to take things as they
were, was such a help.

DAVID SEYMOUR

1911–1956 He was born in Warsaw, which at the time was in Russia. His father, Benjamin Szymin, was an established publisher of Hebrew and Yiddish books. At first he trained to be a concert pianist, but didn't make the grade. In Leipzig he studied printing, art and photography, probably meaning to go into his father's business. In 1932 he went to Paris to study chemistry, in order to carry out research into printing inks and lithography. An economic downturn pushed him into photography in an agency run by Paul Rapoport, a family friend. Henri Cartier-Bresson became a close friend, as did Robert Capa. He worked for the left-wing magazine *Regards* and covered political turbulence in Paris in 1935–6 before setting off for Spain and the Civil War. In the 1930s he was 'Chim', and then in the USA he became David Seymour, and worked in the army in photo intelligence. He had unusually poor sight for a photographer, but it didn't deter him. His parents died in the Otwock ghetto, just south of Warsaw, in 1942. He was a founding member of the Magnum agency in 1947, and in 1948 travelled widely in Europe on a UNESCO assignment to photograph children. He embodied compassion and came into his own in the years of reconstruction. He was killed at Suez in 1956, four days after the cease-fire.

Begging child and American sailors, Naples. 1948
The child has been successful, showing the American sailors in a good light. This is a genial event, in contrast to the plight of the orphans he came across in Italy, Greece and Poland.

DISTURBED ORPHAN DRAWING HER HOME, POLAND. 1948
The literacy project for UNESCO involved orphaned and afflicted children – as well as children he just saw on the street. Terezka, who had survived a concentration camp, would have had little idea of home. The drawing itself is a test of our understanding, for she has tried to fill the space available and to negotiate those three marks on the left. Perhaps Seymour, a Polish speaker, has just spoken to her in her own language.

Children had appeared in photography before. They had a place in the Ages of Man as envisaged by the Parisians in the 1930s and '40s, and they appeared in FSA photographs, often in family groups, during the 1930s. Seymour's innovation was to show them as isolated victims. The war had taken a terrible toll in civilian populations, leaving many children to fend for themselves. Under the old terms of reference they belonged to societies and to family groups, but Seymour presented them in the eye of the camera and unsupported. Thus the American sailors, who respond so willingly, are exemplary benefactors. FSA photography, with all its disclosures of hardship, justified state intervention or made it explicable. Seymour's UNESCO images, by contrast, propose a more direct personal responsibility for shortcomings in the ethical order. It was somewhat more than a photography of witness and eventually, as the century wore on, confronted us with intolerable situations in which we were powerless to intervene.

LOUIS FAURER

1916–2001

His career was over almost before anyone had noticed. Most of it took place in New York City during the late 1940s, and is of some significance. He made his own way. Good at drawing, he sketched caricatures at Atlantic City during the summer months in the late 1930s. From Philadelphia, he had friends who had studied graphic design at the Museum and who had been introduced to photography by Alexey Brodovitch – the influential teacher of the period. He learned from the photography of the Farm Security Administration, and took his own FSA-style pictures in Market Street in Philadelphia. He studied art and lettering and made a living painting advertising signs and lettering film posters. As a photographic technician he served in the US army until 1945, moving to New York City in 1946, where in 1947 he found work with the short-lived magazine *Junior Bazaar*, which hired the Swiss photographer Robert Frank at around the same time. Faurer worked in borrowed darkrooms, including that of Frank, took pictures daily and was attracted by 'the hypnotic dusk light' of Times Square. Walker Evans saw his photographs and recommended him to the art director at *Vogue*. Personal work, however, didn't make money and although he established himself it was as a fashion photographer.

TIMES SQUARE, NEW YORK. 1947–50
She exhales on a cold night and her breath blends with that blurred background. She has shaped eyebrows and wears a beret-style hat, but otherwise it is hard to make anything out. We can see about as much as she can, and the spectacles make a point about seeing. Times Square was a glamorous site in the 1940s, noted for its movie premières. Its lights at the time were incandescent bulbs, replaced later by fluorescent tubes – less helpful to night-time photographers.

New York City. 1950
They look like hoodlums were supposed to look in the post-war era, although they may have been respectable. Would important hoodlums have travelled by cab in 1950? Perhaps they owned the company. The subaltern who holds the door wears a carnation, which may be a sign of servitude. Mr Big has placed his hat foursquare, whereas the man with the cigarette has a raffish look. Nicely selected and placed, they could just have stepped out of a movie.

New York City was a theatre of dreams, especially if you came from a more prosaic elsewhere, such as Faurer's Philadelphia. There was no point in describing New York, for it was the idea which counted. One way to get at the idea was to take pictures at night when the details were obscured, for a lot of legible details made their own kind of demands. Darkness, though, wasn't sufficient by itself, which is why Faurer invokes the movies. To get at the largely imaginary reality of New York you had to tap into the legends on which the perceptions were based. To find such images you had always to be in the right frame of mind and in top form. Understanding wasn't enough; you had to be at one with the culture, to the degree that if you looked away you lost the thread.

ROBERT FRANK

b. 1924

Frank was born and brought up in Zurich, where his father ran an import company. Because his father was from Frankfurt-am-Main, Frank was technically German until 1945, when he was granted Swiss citizenship. As a foreigner of sorts, and a Jewish one at that, Frank was up against it. He couldn't take work or become an official student, so in 1941 he became an apprentice to a photographer who lived upstairs in his parents' building. In 1942 he went for further training to another studio in Basel. Early in 1947 he set sail for New York and the wider world – on the *S.S. James Bennett Moore*. He noted, in a letter to his parents, that the USA was 'really a free country. A person can do what he wants. Nobody asks to see your identification papers.' He was attracted and excited by America but at the same time perturbed by the speed of things in New York and by the focus on money. Alexey Brodovitch gave him a job as a photographer at *Harper's Bazaar* and at *Junior Bazaar* where he remained until later in the year. At *Harper's* he worked in the studio taking pictures of fashion accessories, and it was there that he met Louis Faurer, a kindred spirit with whom he rented a darkroom/studio. In this early period in New York he got to know the pictures of André Kertész as well as those of Bill Brandt, but it would be hard to ascribe influences. Tiring of commercial photography and of the commercial atmosphere he set off in June 1948 to travel in South America, mainly in Peru and in Bolivia. He travelled for six months before returning to New York.

14TH STREET WHITE TOWER.

New York City, 1948

They are drinking coffee and smoking cigarettes, maybe after work – for the clock stands at 5:30 in the original long-shot of the group. There are printed offers applied to the plate glass and to the counter beyond: items with their prices. The USA was a land of plenty, and in New York its women were well dressed. Frank took at least two pictures of the scene, one of which appeared in *The Family of Man*. In the larger picture six women sitting at the window laugh at the antics of the photographer. In this second version they are more composed, even apprehensive, as he approaches. It is a group portrait and a genre scene and might have been intriguing to European audiences unused to the idea of clients in-line looking out at the street. At the same time it is also a composition which stages the photographer himself as an object of curiosity, as a performer acting beyond the screen or in the wild. The pictures suggest that he might even be an embarrassment. At long range the idea was titillating but close to there were other questions: How do I look? How should I look? What right does he have to take my picture? In other pictures taken in the 1950s several of his subjects look less than happy to part with their likenesses. Normally it was assumed that the photographer was a discreet witness, but Frank's experience told him otherwise.

In 1947, when Robert Frank arrived in New York, there were plenty of local photographers, many of whom worked within the Photo League. That year, the league was listed by the US government as a subversive organization and in 1955 it closed down. Its members took documentary pictures in the city's meaner streets, both to promote social reform and to express the energy of the people down below. Theirs was a city of ragged children, run-down buildings and immigrant communities, and they were devoted to the place. Robert Frank, by contrast, was an outsider, and in 1947 he wasn't even sure that he wanted to stay. There were choices open to him. He could stay on in association with the fashion world, which he didn't greatly like, or opt for the open road. Photographers had always travelled, mainly to bring back imagery from China, India and the Holy Land, but in the 1920s and '30s they began to think of travel as formative experience which would bring them to a new understanding. For an urban European, from Paris or Berlin, it was important not to go too far afield for the cultural gap would be unbridgeable. Spain was a good starting point, to be followed by Mexico where indigenous cultures kept company with European introductions. Frank, with a good intuitive judgement of what was required, chose Peru and Bolivia instead. They were bleaker sites, and sparsely populated. Mexico, in the 1930s, was admired for its culture and folklore but in the late '40s, with the war still a recent memory, culture wasn't enough. In the uplands of South America the photographer was able to see and to imagine humanity isolated and endangered.

ROBERT FRANK

He spent six months in South America in 1948 and used a 35 mm Leica for the first time. He recalled, 'I went to Peru to satisfy my own nature, to be free to work for myself.' In the same interview in 1983 he added that 'I did what I felt good doing. I was like an action painter … I was making a kind of diary.' He put together two books based on his South American journey, one of which he gave to Alexey Brodovitch and one to his mother. In these books, of thirty-nine pictures each, the images are the same, but not in the same order. He was careful to pair pictures so that one responded to and supported its counterpart, which was Bill Brandt's tactic in his photo-essays for the magazine *Lilliput* between 1945 and 1948, as well as in his books of the 1930s, *The English at Home* and *A Night in London*. In 1962 in a special issue of *DU* magazine he paired a number of American pictures, taken in 1955–7 and published in *The Americans* in 1958. The pairing technique was an editorial process which spoke volumes and has been surprisingly little used. In Frank's book on the USA his pictures appear one to an opening.

A HALF-CASTE. Peru or Bolivia, 1948
Introducing this picture in 1956–7, the writer Manuel Tuñon de Lara remarked on 'a mask of immobility'. Such felt hats as this were worn by 'cholos' or city-dwellers. Country-people wore different kinds of round hats attributable to specific tribes and regions. This picture was printed in *Neuf* magazine in December 1952 in an issue given over to Frank's South American journey. It reappeared as one of fourteen pictures by Frank in a book of 1956, *Indiens pas morts* (published in English as *Incas to Indians* in 1957).

The text for *Neuf* in 1952 was written by Georges Arnaud, and at times it reads like a lurid cowboy romance. The text of 1956 was romantic too, but also full of detail. In *Incas to Indians* he was also keeping company with Werner Bischof (13 images) and Pierre Verger (50 images). Verger was a productive ethnographic photographer (b. 1902) and a model for the rising generation. It must have been vexing for Frank to see his pictures incorporated into these contexts not of his own devising. The pictures themselves seem to show a diaspora or exodus, a term used by Manuel Tuñon de Lara. He was possibly thinking of recent history and of the Europe he had left behind. The half-caste, or 'cholo', is, for example, a marginal man and he is feeling the hand of authority on his shoulder – or that is how it might be read. In *Incas to Indians* he is preceded by another 'cholo', a nomad with a guitar – and understandable as a travelling artist, in the style of the photographer himself. Frank's tendency from very early on was to deliver such suggestive fragments which might be widely interpreted.

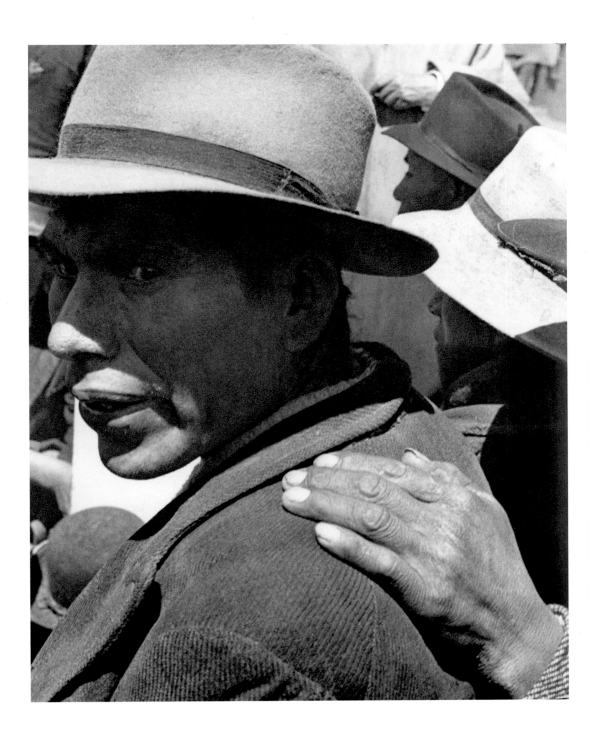

After South America he returned to New York before going back to Switzerland in March 1949. In December 1949 the Swiss magazine *Camera* published a survey of his pictures, which were valued in Switzerland because of their attachment to real life. He had the common touch at a time when a lot of New Photography was well groomed and undemonstrative. On the boat to Europe he met the photographer Elliott Erwitt, with whom he travelled to Italy. In Paris he came to know the publisher and editor Robert Delpire in whose magazine *Neuf* twenty-eight of his Peruvian pictures were published. Delpire also published *Indiens pas morts* in 1956 with fourteen of Frank's pictures. In 1958 Delpire would publish *Les Americains*, the book on which a large part of Frank's reputation rests. In 1951 and in the winter of 1952–3 Frank went to London, where he met Bill Brandt and paid his respects. He travelled to Spain in the summer of 1952 and made a photographic study of bullfighters in Valencia. In 1953 he took pictures of coal miners in Wales before returning to New York. During most of this European period he lived in Paris with Mary, his first wife.

PARIS. 1951–2

Frank returned to Europe in the winter of 1951, and this scene looks bleak enough for December. Perhaps operatives from the 'Wall of Death' lived in this transportable cabin. It has an extension and a chimney, and someone has taken some trouble with the lettering. The daredevils, who ran such risks on the Wall of Death, would have had to have somewhere to live. The wall itself was usually a large drum mounted horizontally on an axle. Within the drum, and visible through the spokes, a speeding motorcyclist depended on the centrifugal force generated by the apparatus to ride at precarious angles. Circus performers, such as Diane Arbus's albino sword swallower, were exemplary figures, for they had to hold their nerve in public. This bleak van, though, has more than an element of bathos about it, and Frank appreciated such signs of abandonment. The picture was taken at the Porte de Clignancourt in the north of the city in just the sort of area frequented by the great Parisian photographers of the era, although they probably wouldn't have taken pictures in such low light – and they might have looked for more incident, too. It features in the completely revised edition of *The Lines of My Hand*, 1989, as the introductory picture to Paris 1949–51. Parisians, if they could remember what photography was like in the 1930s, when Krull and Kertész were in their prime, would have wanted to see the wall of death itself, its fearless riders and its credulous audiences. This wheeled cabin would have been no substitute, but at the same time it is evocative. Ben Shahn, a great innovator with a literary bent, would have liked the idea of words standing in for the thing. Frank practises what might be called an art of displacement: the phrase for the event, and the tawdry ground for the show itself. Many of his pictures point beyond themselves, often into the future. In an earlier Parisian tableau (1949) a palmist's chart points to the way ahead with all its possibilities and ramifications, a hanging lantern indicates the night and a closed suitcase promises revelations.

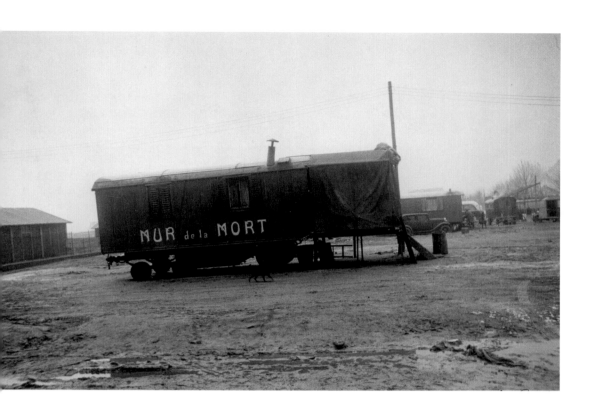

A picture like this one of the showmen's cabin wouldn't have enthused the picture business, but Frank might
have had an emerging agenda of his own. In 1952, for example, he put together three books of
original pictures which he called *B/W/T: Black, White and Things*, in three sections with twelve,
eight and fourteen photographs respectively. The black section was given over to 'sombre people
and black events', including funerals, beggars and bankers whom he had photographed on
London's foggy streets. Families, children and parks belong in white. 'Things' included portable
objects: pieces of sculpture, coins and even flowers. 1952 was notable, on the cultural front
at least, for the issue of Harry Smith's *American Folk Music* on a set of six LPs produced by
Folkways Records. The album covers for Smith's selections of ballads, social music and songs
were in blue, red and green, standing for air, fire and water. Taxonomy was in the air because
the recent war had globalized experience, casting doubt on the old compartments. To cope with
this sudden opening out schemes were necessary but they had to be thought out afresh – hence
Black, White and Things which took account of ethics and the material background or the life of
the spirit in relation to the fetishistic certainties of the senses.

DIANE ARBUS

1923–1971

Photographers are observers, and they can be quite secretive. Diane Arbus, on the other hand, told all – or most of it – in her letters and notebooks. She had a liking for aphorisms, and in a letter to Marvin Israel on January 12, 1961, she noted that 'the world is full of fictional characters looking for their stories' – apropos a series of eccentrics she was photographing at the time. Paradox pleased her: a scene from the Garden of Eden, for example, where it was the snake which succumbed to temptation, with respect to a scene in Hubert's Museum in NYC in 1960. She chose words carefully and extravagantly, to keep cliché at bay. She wrote to Allan Arbus, her husband, and to Marvin Israel, and she wrote to engage and entertain. Her public was made up of intimates who knew what to expect of her and were attuned to her inventiveness. It was a quick, spoken prose – not always dashed off – and it was the constant accompaniment to her photographs. Her other mode was the list: her notebooks are filled with lists of people to be seen and projects to be undertaken.

**SIAMESE TWINS IN
A CARNIVAL TENT, NEW JERSEY**. 1961
In August 1961 she wrote to her daughter, Doon Arbus, to say that she was busy with a project on horror 'in films, theater, TV, waxworks, spookhouses, any kind of entertainment …'
She took a picture of a human pincushion and a headless man but the 'horror show' was never realized. The idea of being conceived and then spending the rest of one's days as a curiosity in a bottle in a fairground would have intrigued her.

Couple on a pier, New York City. 1963
In 1963 she took pictures of nudists and of children from rich families, and may simply have come across this couple at the water's edge. It is the sort of picture that Garry Winogrand might have taken: a situation bearing on relations between the sexes. Hers is a poignant image, however, in that the setting is somewhat romantic. But the relationship may not last, for the youth is just a little too interested in the photographer – and the radio is something of an alien element in an intimate moment.

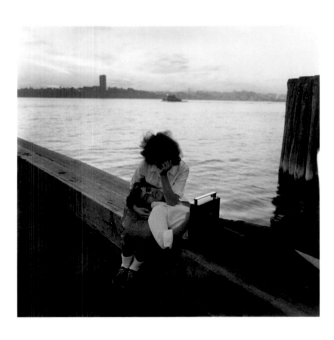

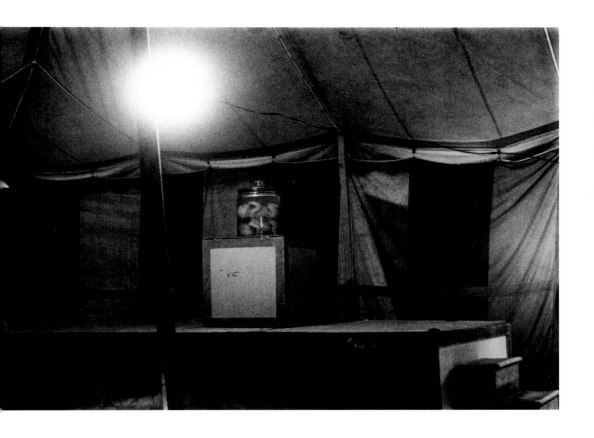

She made lists and thought readily in terms of sets and series. No one can survey whole cultures but cross-sections are possible, and in the 1940s the French had often been guided by what you might expect to find in a travelling fairground: a dozen or so attractions. This was also her take on the world, for without a manageable list you would be at a loss to know what to take and why. Mostly she made plans for the sake of magazine assignments and grant applications, but somewhere in the background there may have been a master plan: the course of human life into a frequently unforeseeable future. In French photography children rehearsed for adulthood and young people acted their parts on the Left Bank. Diane Arbus's projections were less formulaic, more open to accidents and to weird outcomes: that afterlife lived out in a bottle, for example. The young couple, too, are experiencing love but the signs aren't promising. Her collection is filled with examples of destinies you wouldn't have chosen.

Her first steps in photography were taken with Berenice Abbott in New York in 1941. Abbott had done a lot to save Eugène Atget from oblivion. In the same year she went to see Alfred Stieglitz at An American Place, his gallery in New York. While continuing to pursue various personal photographic projects, she studied with Alexey Brodovitch, art director of *Harper's Bazaar* – and a very influential teacher. She didn't learn much, however, until 1956 when she went to a course run by Lisette Model, the great Viennese photographer, who had been in New York since 1938. Model taught her to forswear graininess and to go for clarity. Model was her great influence and someone to whom she could always turn for advice. Model told her that 'the more specific you are, the more general it'll be ...' and in 1962 gave her advice on how to adapt to the medium-format Rolleiflex that she was beginning to use. In 1963 she put in for and was awarded a Guggenheim grant for 'photographic studies of American rites, manners and customs'. A second award followed in 1965 for a project on 'The Interior Landscape'. In 1964 the Museum of Modern Art began to acquire her pictures, but even so she was never a commercial success in her lifetime.

TOPLESS DANCER IN HER DRESSING ROOM, SAN FRANCISCO, CALIFORNIA. 1968

She supports her left breast with her index finger, perhaps for the sake of the asymmetry. In the left background a book on the paintings of Leonardo da Vinci makes a curious reference, for that is Saint Thomas who raises his index finger – Doubting Thomas, who explored Christ's wound with that same finger after the Resurrection. Her response to the camera is rather downcast, for she and Arbus know that her breasts, whilst a selling point, are her predicament.

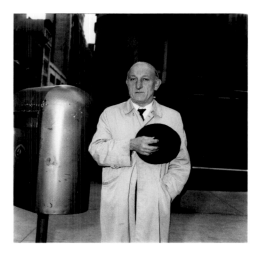

Man at a parade on Fifth Avenue, New York City. 1969

He appeared on the front cover of John Szarkowski's *Mirrors and Windows*, the catalogue of an important touring exhibition assembled by the Museum of Modern Art, New York, in 1978. It must have been a memorial parade in cool weather, for his hand is in his pocket. Staring into the camera's eye he looks sad, which is typical of many of the street portraits. But the point of the picture is probably that rhyme between the curved metal end of the postbox and his bald head. Observant and patriotic though he may be, it is that absurd rhyme which caught her eye.

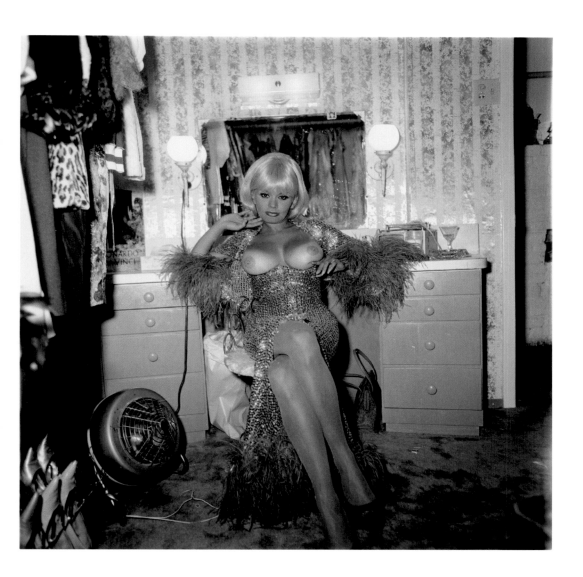

The pictures complement her writing and the speech which it reflects. She wrote pell-mell, going to extremes. Unrestrained she would eventually hit on something – a simile, metaphor or figure of speech which capped the occasion. Her accounts are usually dramatic: herself bemused as a naïve traveller in bizarre contexts – most of them in New York City. She loves to elaborate in the letters until fact becomes stranger than fiction, but the pictures are often monumental – like that of the man at the parade. To the one side stands the imagination – quicksilver in Arbus's case – and to the other the body offering nothing but constraints.

DIANE ARBUS

Early in 1971 she gave a master class in photography in a public room in Westbeth, the artists' house in New York City in which she lived. The classes were taped by Ikko Narahara, a student, for future reference and subsequently transcribed as a foreword to .diane arbus., the picture book published by Aperture in conjunction with the posthumous retrospective at the Museum of Modern Art, New York, in 1972. The transcripts, along with other excerpts, printed in the front of that book give some impression of what photography meant to her. Somehow it got at the truth for all concerned. It had more access to the truth than film, for that depended on cameramen and recordists. Nor did you have to be technically adept to take great pictures: just the right feeling at the right time – an almost impossible prerequisite. There was something accidental about great photographs, something which didn't answer to preconceptions – especially her own. There were people, she sensed, who had been to the outer limits and who had survived, and their portraits might tell you something of what they had been through. As a frequent traveller to similar but not identical outer limits she was fascinated by what the pictures might reveal.

A YOUNG BROOKLYN FAMILY GOING FOR A SUNDAY OUTING, NEW YORK CITY. 1966 This portrait appears in the posthumous book of 1972, the first sentence in which reads, 'Nothing is ever the same as they said it was.' The young Brooklyn couple have had plenty of expectations, based on promotions of the period: glamour, Hollywood and even 'The Family of Man', included. What they didn't say is that coping would be a problem: the little boy with a cast in his eye, and that tangle of straps and coats which she has to manage. She even holds a camera and Diane Arbus, mother of two, would have known the feeling. Both adults have that dispassionate look, often seen in her pictures, of people who are just about managing in circumstances of which they weren't properly forewarned.

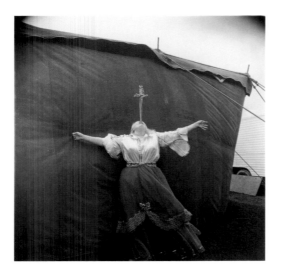

Albino sword swallower at a carnival, Maryland. 1970 On July 31st Arbus was at a carnival at Hagerstown in Maryland where she met the albino sword swallower, as well as her sister, also an albino. Here she seems to be swallowing two swords. Her right hand touches the canvas of the tent and the wind plays with the canvas flap above and with her skirt. This must be a tricky skill to learn, and one which demands that you remain absolutely steady on your feet. Bill Brandt once took a picture of a circus boy sitting drinking from a cup next to the bulging wall of a tent: another moment of equilibrium in the face of forces not quite under control.

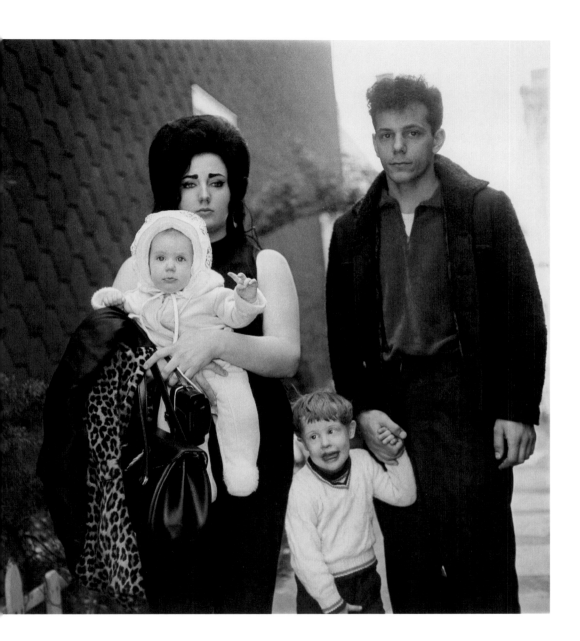

er portraits are of people she recognizes from her own experience. The sword swallower just has to hold her nerve and to keep her concentration if the act is to be completed. The young parents from Brooklyn have to grit their teeth and to keep going in the face of real life. She recognized something of herself in them and we can't help but do that too, and so we have no choice but to be at one with her, on a wavelength expressed in the prose and symbolized in the pictures.

DOROTHY BOHM

b. 1924

Dorothy Bohm was born in Königsberg, East Prussia, of a Jewish Lithuanian family, and sent to England in the 1930s to complete her education. She studied photography in Manchester, where she opened a portrait studio in 1946. In 1953 she moved to Paris with her husband Louis, at a time when Paris still hosted a community of creative photographers. Returning to London in 1956 she continued to photograph, and in 1971 she was instrumental in setting up The Photographers' Gallery – which continued to be Britain's premier photography gallery over the decades. In 1980 she began to use colour film, continuing to take the same kind of reflective street pictures to which she had been introduced in Paris in the 1950s. In 2004 a large exhibition of her Parisian pictures, 'Un Amour de Paris', was staged by the Musée Carnavalet in Paris.

SÈTE, FRANCE. June 1986

She is in her early adolescence, and here she waits for the machinery to get going. She looks slightly apprehensive – daydreaming perhaps. Everywhere around her there are signs of what lies ahead: a spray of flowers above, flanked by satyr masks, muscular caryatids showing their prowess on the drum beyond a screaming horse to the left, and – vignetted in the distance – a conversational scene from normal life. In this context the steering wheel, to which she is not really paying attention, has some significance as an emblem of the path which will have to be negotiated.

Paris. 1990

Those romantically named *pommes d'amour* are prosaic toffee-apples in English. They glisten in the reflected lights of the fairground. Above her, decorative swirls remembered from the era of Art Nouveau make organic suggestions. She is older than the girl at Sète, and must have seen more of the world. The glass screen in the foreground dulls whatever lies beyond, enhancing the lustre of what is on offer on the counter.

Modernists had life stories, whether they liked it or not. If they originated in eastern Europe, they faced disruption and made their way by perseverance, good management and good luck. Dorothy Bohm's is such a story: thrown on her own resources at an early stage – in a strange land. She had her own experiences to go on, added to which her Parisian exemplars (Izis, for example, and Doisneau and Willy Ronis) thought readily in terms of life stories. But it was rarely a format considered from a woman's point of view. These two pictures are stages along the way to maturity, each one supported by wide reference to the pitfalls ahead – and to ways around. Photography, as it evolved in Paris from the 1930s onwards, was an annalists' medium. Sooner or later most of the annalists were waylaid by the demands of the 'real world'. Bohm's luck was that she was able to continue to take reflective pictures; and hers is one of the most complete life stories in the history of the medium.

ED VAN DER ELSKEN

1925–1990

Van der Elsken was born in Amsterdam and he took up photography in 1947. Immediately after the liberation of The Netherlands he had seen copies of *Picture Post*, the British illustrated weekly, and in 1945 Weegee's *Naked City*. After working in studios in Amsterdam, he was able to equip himself and to participate in the Dutch photoworld, which was just beginning to organize itself after the war. In the summer of 1950 he set off for Paris with a letter of introduction to Pierre Gassmann, director of Pictorial Service – which did printing for the Magnum agency. After a while he was sacked by Pictorial Service, and he gravitated to the Saint-Germain-des-Prés area on the Left Bank. Café life attracted him: Chez Moineau in the rue du Four, Le Mabillon in the carrefour du Mabillon and The Old Navy on the boulevard Saint-Germain. In 1953 he met Edward Steichen in Paris, who advised him to publish his café pictures in book form. Steichen was scouting for 'The Family of Man' (1955) and for a forthcoming exhibition of 'Post-war European Photography' to be shown at New York's Museum of Modern Art in 1953. Van der Elsken participated in both exhibitions. In 1956 his book, *Love on the Left Bank*, was published in Dutch, German and English. Although denounced in the press it made his reputation.

VALI MYERS IN FRONT OF HER MIRROR, PARIS. 1954

Vali Myers was an Australian woman training to be a dancer in Paris. She had red hair and large melancholic eyes and for Ed van der Elsken she epitomized life on the Left Bank. In the book she worked as his leading lady, Ann, a siren loved unavailingly by Manuel, a young Mexican lately arrived from Stockholm. After a spell in the Santé prison, Manuel thought that Ann would be his but instead he took up with her friend Geri. In the end it turned out that Geri and Ann were secretly in love with each other. The photographer took the pictures and wrote the story. He represents Ann as self-obsessed and promiscuous.

The girl with the orange hair who danced like a negress, Paris. 1954

Ann made money as a dancer in night spots – voluntary contributions from clients. Van der Elsken's text was compact and provocative: 'Ann woke me. "Got a light?" she asked. It started to rain. "You dance like an African negress," I said. "Thank you," she replied. "I'd like to have a child by a negro. They are so elegant. Gentle and restful, too. Not such nervous idiots as the whites. I'm fed up."' They had been sleeping outside before going 'to a little place called the Mau Mau' where she slept in her chair.

Love on the Left Bank offers itself as an alternative guide to Paris in the 1950s: the price of food, wine and accommodation. In Brassaï's day a book on Paris would have taken some account of the place itself, but for Van der Elsken it is no more than a background. The residents, with their complex interrelationships, take up all the space: boozing, smoking, flirting, thieving and just about getting by.

ED VAN DER ELSKEN

In 1955 he returned to Amsterdam from Paris. Youth culture was then in transition. The impact of James Dean was clear amongst the young men of Amsterdam, and, in conjunction with the journalist Jan Vrijman, Van der Elsken reported on developments in style and manners – in the Nieuwmarkt area of the city. His subjects were *nozems* in local speech and *halbstarken* in German – *Teddy Boys* in English. He liked to be where the action was and regularly took pictures at jazz concerts in Amsterdam in the late 1950s: Chet Baker, Lester Young and Miles Davis, among others. Then in December 1957 he undertook a three-month tour in French Equatorial Africa, in the Oubangui Chari area near to the Congo frontier. This resulted in *Bagara*, a book of pictures first published by De Bezige Bij in Amsterdam in 1958. In 1959–60 he undertook a world tour with his wife Gerda, during which time they made fourteen travelogue films – and he took pictures for the book *Sweet Life*, published in Amsterdam in 1966. His career flourished and is surveyed in *Once Upon a Time*, a book put out in 1991 for a retrospective at the Stedelijk Museum in Amsterdam.

DANCING, OUBANGUI CHARI. 1957–8
The photographer set out with a French local government official on an annual tour of inspection. They travelled for seventy-five miles on foot with a group of local guides and bearers. In the villages they came across various ceremonies and examples of dancing – in connection with circumcision and mourning, for example. The old man shown here danced at the beginning of a feast, which ended with mass dancing and a special display by experts. Van der Elsken's is something like a participatory photography, close to the event and disorderly.

Dancing, Oubangui Chari. 1957–8
They danced into the night, and eventually the photographer danced with them. In his notes he writes that as the night went on 'the whole village reached a state of supreme rapture which never became hysterical, but attained incredible heights of elation and joy of living'.

Both of these pictures appear in *Bagara*, where they are printed right to the edge. *Bagara* was the local term for a buffalo – and Van der Elsken had participated in a hunt, which he didn't much like. He bears witness, though, throughout, describing events and encounters. More than that, he devises a kind of photography which goes to the heart of events – in the second of these pictures that is a fire right in the foreground. Photographers, and Van der Elsken in particular, hoped during the 1950s that their medium would allow them to break down barriers between people, so that in the end understanding would become almost physical. His account of the Banda tribe is inspiring and also informed, for he travelled with an ethnologist. This participatory manner remained a possibility in photography, but *Bagara* is its high-water mark.

GARRY WINOGRAND

1928–1984 Winogrand's achievement
is comparable to that of the great jazz players
of his era. A New Yorker, he began modestly enough
as a weather forecaster in the Army Air Force.
His father was a leather worker and his mother
made neckties. He studied painting somewhat
at Columbia University in New York and in 1948
found out about photography which caught his
imagination. In 1949 he learned photography for
a while with the legendary Alexey Brodovitch, art
director of *Harper's Bazaar*. Brodovitch taught
self-confidence. His students were asked to rely
on their intuitions and on available light. In 1951
Winogrand became a stringer at Pix. The agency
gave him access to some facilities and helped
to distribute his pictures. He persevered and learned
the business of photojournalism, only to discover
that it wasn't greatly to his taste. In 1955 he set
off to cross the USA on a photo-mission. Dan
Weiner, who had the same agent as Winogrand,
showed him Walker Evans's *American Photographs*,
which was new to him – and a revelation.

NEW MEXICO. 1957

The child heads downhill towards an accident
which has already taken place – if the tricycle
is evidence. The times were out of synch in New
Mexico. There is a contrast, too, between the little
incident on stage and the sombre landscape to the
right. There is another child dimly visible behind
the toddler. A picture without a point would have
been difficult to sell through an agency. In time,
though, this became one of Winogrand's better-
known images. By 1958 he had a daughter and
a son, and in 1957 might have had children in mind.

Utah. 1964

Crossing the road, the steer has stumbled in the
path of Winogrand's car. The glass is spattered
with dead insects, and the time of day is as
difficult to make out as the landscape. Perhaps
the vehicles have already stopped, but all the same
he must have been prepared to take pictures even
here. This incident of travel epitomizes accident
and reflex but at the same time has the makings
of a parable: a darkish road through a terminal
landscape staging the kind of small catastrophe
which barely registers in the memory. With some
reflection it can easily apply to our situation
in general on an imagined road through life.

Winogrand's was a special kind of indeterminacy: often on the edge of clarification. The child at risk and the interrupted highway give pause for thought. Too much clarity, though, would result in a picture which was no more than an illustration to an aphorism; too little and the result would be no more than an enigma. The challenge was to make a correct judgement – but regarding what? The conduct of life, or just the process? Conduct implies some degree of self-control which is difficult to maintain in the face of the unforeseen. Accidents might, of course, be inconsequential, but they might also be calamitous and Winogrand's gift was to reflect always on these possibilities.

Winogrand kept his own counsel. He was an inventive speaker but not much given to writing. He reckoned that the pictures spoke for themselves. They did, but the words are difficult to make out. Destiny brought him to photojournalism at the time of its collapse. Its great age, when it had large spontaneous publics, was from the mid-1920s through until around 1960. The disappearance of a great public allowed Winogrand to take pictures as he wanted to. What, though, could be done with them? Magazine culture was replaced, in small part, by the museums, in particular by the Museum of Modern Art in New York, where Winogrand's gifts were recognized by its photography curator, John Szarkowski. Winogrand was sustained by Guggenheim awards in 1964, 1969 and 1978, as well as by exhibitions. With magazine culture pictures were taken, published and responded to within a matter of weeks; museum culture, though, worked on longer time spans, which meant that photographers like Winogrand were thrown back on their own critical resources and forced, in fact, to work in near isolation.

FOREST LAWN CEMETERY, LOS ANGELES. 1964

The Mystery of Life is a complex presentation, and it appears to be hard to follow: people of all races and denominations in an extended Nativity. The male guide might be pointing to a slender girl who holds a posy centre stage. Winogrand liked to take pictures of eye-catching women in the street – see his *Women Are Beautiful* of 1975, selected by himself. It could, then, be a make-believe self-portrait with the man standing in for him; or he might be the boy receiving instruction in front of an incomprehensible set of options.

New York. Before 1976

He took a lot of pictures and didn't keep strict details. The extended process of selection and editing was important. Pictures emerged over the years. In this street scene a woman with two children look at a fire in a drum. Perhaps they can feel the heat on a cold day. The youngsters look a little apprehensive, for from their viewpoint it may look dangerous. By 1976 Winogrand had three children and three marriages, and it would be just possible to see this as another self-portrait – in relation to the family.

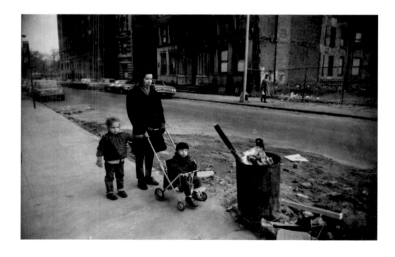

Why should John Szarkowski admire Winogrand, for after all he had nothing much to offer on the great social themes which had preoccupied photographers? Perhaps he saw that Winogrand was prompted throughout by his conscience, by anxieties and longings which could only be expressed in photographs, and in a manner born of the photojournalism which he had mastered in the 1950s. He used pictures, that is to say, in order to help him to identify his own difficulties – whatever they were. If he had known what his problem was, he might have been able to master it, but it was a condition to which he was born. Pictures could put it on show, like soundings from a domain whose scope could only be guessed at. The power of his anxieties made him a compelling artist, and without parallel in the history of the medium.

In 1969 the Museum of Modern Art in New York
published Winogrand's first book, *The Animals*, taken
at the Bronx Zoo and the Coney Island Aquarium.
In 1975 *Women Are Beautiful* was published by
Light Gallery Books, New York. In 1977 the Museum
of Modern Art, again, published *Public Relations*,
a book on events staged for media coverage:
political rallies and the like. In 1980 the University
of Texas Press published *Stock Photographs*,
of pictures taken at the Fort Worth Fat Stock
Show and Rodeo. *The Animals* was remaindered
and the others came out to mixed reviews,
especially the book on women. In 1973 he moved
to Texas, to teach, and then in 1978 moved to Los
Angeles. In California he took prodigious numbers
of pictures, and John Szarkowski estimates that
at the time of his death there were a third of a
million exposures that he had never looked at,
including 2500 rolls of exposed film never developed.
Szarkowski's essay in *Winogrand: Figments from
the Real World* (Museum of Modern Art, 1988)
is one of the medium's most interesting texts.

NEW YORK. Before 1976
Almost all of Winogrand's pictures are untitled and
undated. This picture was shown in an exhibition
of 1976 at Grossmont College. It is most likely
a New York street scene taken with a wide-angle
lens, which is very inclusive. The person must
have fallen or fainted, and it is possible that
the kneeling man has given his coat as a cover.
The woman in the leopard-skin coat, however, seems
to know that despite all that compassion on show
the cameraman really has her in his sights.

Fort Worth Exposition and Fat Stock Show. 1974–7
He often tilted his scenes, perhaps in anticipation
here of the arrival of the heavyweight bull, no. 66,
at the right-hand edge of the picture. Over the years
he took more than 1000 shots of the show, and 118
of them are printed in *Stock Photographs*. Here
the guide answers someone off to the left as the
figures beyond the fence talk amongst themselves.

It might almost be the kind of photojournalistic
picture he made in the 1950s, but more informal
and with that strange tilt. The Fort Worth pictures
show people in regional costume and in conversation.
In general these pictures note that older men
manage cattle; and the younger sheep and pigs.
They are all pictures of community, of people
with shared interests getting on well together.

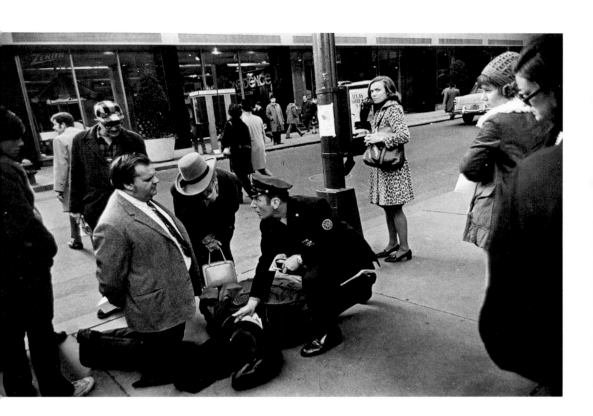

Winogrand may not have dreamed of community, but he could recognize it. Community was on his register and most often took the shape of people in conversation, sometimes oblivious to a minor catastrophe on the pavement at their feet. Community to him also meant exclusion, and there are many casualties and solitaries in his work. In Fort Worth, without a stetson, he was the alien. He may have been at home in New York City, but not being at home was a condition which seems to have troubled him. Street incidents provided an answer of sorts to the problem of priorities. They called for attention, albeit short-lived. If the incident was startling enough, it organized the whole scene in a utopian moment of care and common concern.

LEE FRIEDLANDER

b. 1934

Friedlander came from Aberdeen, a town on the Pacific coast in Washington State. Eventually he enrolled as an art student in Los Angeles but couldn't endure it and left. He kept in touch with Edward Kaminski, an artist at the Art Center School, who eventually advised him to go to New York City, which he did in 1956. In New York he met Robert Frank, Garry Winogrand, Walker Evans, Diane Arbus and Helen Levitt and he took street photographs whilst he made a living as a magazine photographer. He took portraits of jazz musicians which were used on record sleeves and in this way met Marvin Israel, who worked for the record company Atlantic. He was promoted by a dealer, Lee Witkin, and in 1960 and 1962 received Guggenheim Fellowships. His pictures were exhibited at George Eastman House in Rochester, NY, in 1960 and again in an important group show of 1966, 'Contemporary Photographers: Toward a Social Landscape'. His contemporaries were Duane Michals, Bruce Davidson, Danny Lyon and Garry Winogrand, and the curator was Nathan Lyons. Friedlander used a 35 mm camera, and continued to do so.

CINCINNATI, OHIO. 1963

There is a lot on offer here, in what looks like the window of a furniture store: cupboards, chests of drawers and a bed centre stage. A street scene is reflected in the window and that is traversed by ceiling lights and punctuated by CASHIER, printed in the depths of the shop. Various pieces of gadgetry stand on the sill of the window including a 'Motor Driven Sander', which would have been a stimulating idea to a photographer aware of the central position of August Sander in the history of the medium.

Tampa, Florida. 1970

Lyndon Baines Johnson and Hubert Humphrey, Democratic nominees, take their place with ten strippers in the window of an establishment. The promotional pictures were all of the same size, and they were all advertising matter anyway, so it would have been natural to place them thus. LBJ and Humphrey may not have relished the placing, but you can sympathize with the owner who had to continue to do business even in an election year.

Friedlander's earlier pictures are done to a montage principle: passers-by reflected and fragmented in relation to pieces of text and to such commercial items as were available. In the 1950s photography in New York City had been naturalistic as a rule – and compassionate and insightful. There is plenty of insight in Friedlander's Tampa picture even if it works at a distance. But no one before him had been so conscious of the street as a kaleidoscope ready to deliver not only beautiful forms but entertaining ones, too. Friedlander broke with the idea of the photographer as a Man or Woman of Sorrows or even as a saturnine creature of the night. This new mercurial tendency lasted, in New York, right into the 1990s and was easily adaptable to colour.

LEE FRIEDLANDER

He has kept most of his life story under wraps.
A lot of the time he took pictures, and that was
that. All the same he wasn't shy, and his first book,
published by Haywire Press in New City, NY, in 1970,
is called *Self Portrait*. Its forty-two pictures show him
at work on the streets and roads of the USA, and
sometimes in its motels: just glimpsed occasionally,
and often as no more than a shadow. In 1969 he
and Jim Dine had been the authors of *Work from
the same house*, put out by the Trigram Press in
London. The title meant that they were like-minded.
In the late 1950s, on a visit to New Orleans where
he photographed jazz musicians, he discovered
the negatives of E. J. Bellocq who had made
portraits of prostitutes in Storyville, the red-light
area in that city. He got hold of these negatives,
preserved them and published them in a book of
1970, *E. J. Bellocq: Storyville Portraits, Photographs
from the New Orleans Red-Light District, c. 1912*.

ROUTE 9W, NEW YORK. 1969
This picture was published in *Self Portrait*.
He may have had time to draw up and take
the picture, for there are parking bays across
the road. Baulks of timber would have stopped
people driving onto the grass; and coloured
light bulbs are a sign of a special place.

Kentucky. 1977
In the mid-1970s Friedlander advised his friend
William Christenberry to use an 8 x 10 inch Deardorff
plate camera. Maybe he took this picture in Kentucky
at around the same time. Christenberry lived in the
area, as did William Eggleston, and they were both
interested in such signs as this. An ENTRANCE to
what? Here and there look much the same in an
arrangement which would have suited a Zen master.

Once upon a time photographers were interested in the commonwealth with all its citizens – and some still are. Friedlander's generation, however, began to view existence as a conundrum. From what he could see nothing could be relied on or known with any great certainty. The self-portrait on Route 9W shows him in hasty action, catching that site before it passes. A lot of what we know is only picked up in transit, in moments such as this. Whoever built the shrine was also taking a chance for on a modest piece of ground like that neither God nor America are much flattered. The entrance in Kentucky makes an equally bleak prognosis ... if that landscape beyond the arch is what the desired place looks like. Another of his self-portraits in the book, taken in the 'Industrial Northern United States' in 1968, shows him reflected in a dark window which reads 'AMERICAN TEMPORARIES MALE DIVISION'. Elsewhere, in New York City in 1965, another sign beckons: 'GIRLS WANTED' it says, and adds 'NO EXPERIENCE' for good measure. 'Whatever will become of me?' was a theme of the age, and one explored in detail by Friedlander.

LEE FRIEDLANDER

He appears screened by a prize-winner's trophy
on the front cover of *Self Portrait*, and he did go
on to receive several Guggenheim Fellowships
and many other awards. In 1976 he was the
author of *The American Monument*, and in 1981
of *Flowers and Trees*. His book of 1982, *Factory
Valleys*, looks at Ohio and Pennsylvania, and it
was based on an idea by John Coplans, Director
of the Akron Art Museum. *Factory Valleys*, with
its extensive landscapes and portraits of workers
at work looks like survey photography, like a
regional study. In 1989 the Seattle Art Museum,
as his point of origin, organized a retrospective
called 'Like a One-Eyed Cat'. In 1967 he was
included, along with Garry Winogrand and Diane
Arbus, in an exhibition called 'New Documents'
at the Museum of Modern Art in New York.

JOHNSTOWN, PA. 1979–80

This picture of a monument appears in
Factory Valleys. Johnstown is in the Allegheny
Mountains, towards Pittsburgh. The monument
notes American participation in the Great
War, when puttees were worn and those
broad-rimmed steel helmets. The soldier
carries a rifle and holds a scabbard in his left
hand – and perhaps the bayonet in his right.
It is not possible to make everything out on
what seems like a damp, overcast day.

Egypt. 1983

Duane Michals, who was featured with Friedlander
in *Contemporary Photographers*: *Toward a
Social Landscape* in 1966, went to Egypt in the
late 1970s and photographed himself building a
pyramid, as a small heap of stones in the desert.
In this version of Egypt feral dogs relax along the
horizon keeping an eye on the alien Friedlander
with his camera. In Ancient Egypt, jackals were
sacred to Anubis, the dog-headed Guardian of
the Dead, and they fed on corpses. There are
many remains in the foreground here among
the stones, and the photographer would have had
to watch his step if he meant to go any further.

If we see something, we see it from a certain point of view, from a window or a vantage point. The chances are, however, that something might be in the way: a murky window pane or a parked vehicle. Always we see through something else: a clear atmosphere ideally but, failing that, perhaps a chain-link fence – and these often crop up in Friedlander's pictures. Convention proposes that we can really see things, but that is not the photographer's experience. And even when we can, as in the case in Johnstown, point of view ensures that we only see part of the story. In Egypt, for its part, the Pyramids and Sphinx are guarded by creatures who might turn nasty and who constitute yet another obstacle to seeing clearly. These pictures, too, touch on the future. We may have imagined Ancient Egypt all our lives, seeing the Pyramids in our mind's eye, but we never thought that we would have to traverse debris and chicken bones to get there. The soldiers of Johnstown may also have had a certain view of their destination in 1917 but hardly of this damp and prosaic site.

ROBERT ADAMS

b. 1937

In a talk he recalled accompanying his father in 1953 in a campaign to save the canyons in Dinosaur National Monument from the Bureau of Reclamation. In his youth Robert Adams developed an interest in landscape and in conservation, and this has continued to inform his photography. He was born in Orange, New Jersey, although he has lived mostly in the West, in Colorado and beyond. During the 1960s he lectured in English at a college in Colorado Springs, only leaving in 1970. He began to exhibit pictures in 1971 and to receive awards in 1972, leading to a Guggenheim Fellowship in 1973. He is closely associated with the 'New Topographics', which was the title of a famous touring exhibition devised by George Eastman House, Rochester, NY, in 1975. In 1974 his first book, *The New West*, was published by the Colorado Associated University Press, and it became one of photography's landmarks.

NEWLY COMPLETED TRACT HOUSE, COLORADO SPRINGS, COLORADO, USA. c. 1974

On the cover of *The New West*, this picture also appears with eighteen others in a section given over to 'Tracts and Mobile Homes'. The series shows the building of a tract house, its foundations, framework and setting, with the mountains in the background. Adams, in a commentary, describes such houses as part of a strip city developing along 'the Front Range from Wyoming to New Mexico'. He suggests that these are cheap houses with a limited life expectancy.

Alameda Avenue, Denver, USA. c. 1974

Avenues are straight approach roads, which is what this is, leading into or out of Denver, a city on a plain. The signs read SITE, MUSIC, BANK, CONOCO, TEXACO and in unsteady calligraphy TOMATOE PLANTS. SITE is a stimulating term for it asks questions about the nature of the place. This picture is placed with eleven others in a set entitled 'The City'. Adams gives a despairing account of the city as a place where 'no expediency is forbidden'.

Adams's bleak survey of 1974 caught on. He intended it as a critique, yet it is imbued with pathos. How could people set up shop with such flimsy materials? The mountains along the horizon are a reminder of geological time in which tract houses would scarcely register. Large skies and far horizons in many of the images supplement this impression. Colour photography, to which Americans were increasingly turning their attention in the 1970s, also showed sites like Alameda Avenue in Pop guise, entertainingly tinted. Adams's pale tonalities, by contrast, suggest a domain of light in which everything, no matter how mediocre, is dematerialized or has become one insubstantial substance. Adams makes this point in his introduction where he writes of a 'light of such richness that banality is impossible'. The impersonality of these landscapes in the 1970s must also have been surprising to a generation still very familiar with the sonorous rocks of Ansel Adams, Edward Weston and Minor White.

ROBERT ADAMS

In 1977 the Colorado Associated University Press published *denver: a photographic survey of the metropolitan area*, another book rather in the style of *The New West*. In 1975 Adams had also begun to take a series of photographs of landscapes from the Missouri River westward to the Pacific. Early explorers had accessed the Far West via the Missouri River, and Adams's grandparents had settled in towns along the river. He wondered what they had seen in times gone by in those impressive places, and besides that he recalled that he had been photographing suburbia for so long that he was overlooking the rest. In 1980 Aperture published these outlying landscapes in *From the Missouri West*. During the early 1980s he took pictures of Southern California, published by Aperture as *Los Angeles Spring*.

DENVER, USA. c.1977
This appears in *denver* in a section of thirty-four pictures, 'Our Homes'. The homes in this instance are trailers and campers served by a small pylon and a few poles to carry telephone wires. The name to the left says BRAVE, in memory of the Native Americans of the West; and the young girl in the foreground is delicately dressed. The picture suggests a system of walking, cycling and motoring. The settlement, which may be on the edge of the city, is temporary or provisional, and it implies that the tract houses of *The New West* are just a step up and that they, too, have something of the provisional about them.

**On top of Flagstaff Mountain,
Boulder County, Colorado, USA**. c.1980
We have to take his word for it, although there are hints in the picture that this is a special place. The drum with a plastic liner points to visitors with waste to dispose of. Nor is the view very clear, and it may be windy – to judge from the blurred shadows in the foreground.

Documentary remarks on changing social patterns, even if Robert Adams usually presents himself as
an artist interested in form – meaning the correct configuration in a picture. The street
scene, for instance, allows us to see that this city at least might be thought of as temporary
accommodation within service and communications networks. In the Parisian version, c.1950,
the city was made up of fixities and meeting points. That site on the top of Flagstaff Mountain
is also familiar to anyone of Adams's generation: a viewpoint accessed by car, with parking
difficulties, a litter problem and hazy prospects. Adams and the new topographers of the 1970s
took into account much that barely impinged on consciousness, even if it made up the usual
stuff of our lives. Adams remarks on interpretations of this sort in an essay where he notes
that the beauty of a work of art can be judged by its scope. His pictures, even when seemingly
laconic, have just enough in them to stir both memory and conjecture. His skill during the 1970s
was to touch on just enough so that the scene was more than mere topography. Few of us know
what the top of Flagstaff Mountain is really like, but many of us have been to typical viewpoints
on a windy day.

WILLIAM CHRISTENBERRY

b. 1936

Christenberry is closely associated with Tuscaloosa in Alabama. He was born there, studied there, and in 1958 went to work in the university there. It was in 1958–9 that he began to take pictures with a Brownie camera, as reference points for his paintings. He thought he should enlarge his horizons and went to New York in 1961 where he showed his pictures to Walker Evans, knowing of Evans's connections with Alabama in the 1930s. Christenberry had relatives who lived very close to the Tingles (the Ricketts of *Let Us Now Praise Famous Men*). New York City seems to have intensified his interest in the South and he returned there in 1962 to teach at Memphis State University, where he met William Eggleston. Fascinated by the South's melodramatic history he worked on Ku Klux Klan themes, which unnerved some of his colleagues. Although principally a painter and sculptor he continued to take photographs – from 1977 with an 8 x 10 inch Deardorff camera, acting on Lee Friedlander's advice. The Deardorff was the instrument of choice for many photographers in the '70s.

Rev. B. F. Perkins' Place, Bankston, Alabama. 1988
In 1988 the Rev. Perkins was an ingenious decorator, and even the buildings in the background have been patterned. The hanging gourds to the left above the rough pine cross are meant for birds to nest. The text, interrupted by the cross, can almost be read in full. If this is Golgotha, in patriotic colours, the cacti might be the crowds who witnessed the great event.

THE PALMIST BUILDING, HAVANA JUNCTION, ALABAMA. 1984
In 1964 he took pictures of this building when it was in quite good condition. He returned in 1973, accompanied by Walker Evans, when the building was beginning to fall to pieces. By 1984 it was in a state of collapse. The Palmist's sign, a painted red hand, was used in the 1970s and '80s to stop up a broken window. Trees grew and eventually screened the main façade of the building.

Authenticity counts for a lot, and to read the Rev. Perkins's texts is to be put in mind of how he might have uttered the words inscribed on the hill of bricks. Christenberry seems to have been interested in calling up the spirit of places, along with that of their inhabitants. His pictures of the South often refer to absence embodied in abandoned buildings where children once played and where business was transacted. The Palmist building is one such cruelly treated site. Nations build great museums in honour of their painters and architects. Photography's virtual museum, by contrast, houses another kind of monument: temporary wooden buildings and unsteadily lettered signs constitute its architecture and its painting respectively. Museums, both the real and virtual versions, bring you face to face with the original, preserved from wear and tear. In Christenberry's collection, however, time has taken its toll amongst materials which were never meant to last.

WILLIAM EGGLESTON

b. 1939

Eggleston was born in Memphis, Tennessee, near to his family's cotton farm in Tallahatchie County, Mississippi. He attended nearby schools and universities, without much impact either way, but whilst at Vanderbilt he became interested in photography. He came across Cartier-Bresson's pictures in 1962 and found them stimulating, and he saw Walker Evans's *American Photographs*. Initially he took black and white pictures, moving to colour in the mid-1960s. In 1966 he began a colour series called 'Los Alamos', of around 2200 images, brought to a close in 1974. The title came from the National Laboratory at Los Alamos in New Mexico. A selection from that venture came out as *Los Alamos* in 2003, published by Scalo. By 2003 he was one of the brightest stars in photography's firmament, in part due to the publication of *William Eggleston's Guide* in 1976.

THE LAGUZZI TOMB. USA, c. 1970

The Risen Christ is a substantial piece of iconography. He stands for the resurrection of the body, and shows the wounds on his hands. The flaming heart on his breast is a sign of spiritual love, and came on the scene late. Those red dahlias stand in for the blood which flowed at the Crucifixion, although in front of such a graceful piece of kitsch as this it is hard to recall the gory details of the original scene. *Los Alamos* gives neither date nor details, but the picture might have been taken in New Orleans, which was one of the cities Eggleston visited.

Dancing. USA, n.d.

In *Los Alamos* there are a lot of details of vernacular lettering and illustrations which was the stuff of surveys from the 1930s onwards. DANCING, stencilled onto that pink board, is accompanied by a nice pattern of shadow as rhythm. The organic motif to the left says that 'It's booze time' via a courtship scene.

Popular art, kitsch and advertising, all of which interested Eggleston as he travelled in the USA, mediate and attenuate: red flowers instead of blood, smooth marble for wasted flesh, and words instead of identities. Kitsch's tactics preserve us from too much contact with reality, which we might find hard to take, and at the same time they help us to keep going, for they suggest that life can be a game. By the time Eggleston came to undertake his survey, Pop art was well established. Its touch was light and its range encyclopaedic. *Los Alamos*, too, takes a lot into account: big issues such as sex, age, race and politics, and such smaller issues as the ubiquity of décor. If you chose to raise these topics seriously you would get nowhere, for they weigh too heavily, but in Pop's pack of cards they could be adduced and withdrawn in a flash. One aspect of Pop, which is often overlooked, is that it was tactful and unusually tender with respect to all those who had to make do with all that flawed material which came their way.

In 1967, having been a photographer for a good while, Eggleston went to New York to make contact with others in the business: Garry Winogrand, Lee Friedlander and Diane Arbus. He also took his pictures to show to John Szarkowski, the astute curator of photographs at the Museum of Modern Art. Szarkowski was impressed, but even so Eggleston was no overnight success. In 1974 he received a Guggenheim Fellowship, which allowed him to print the pictures which he had taken on his *Los Alamos* survey of the southern USA. In 1969 he began to prepare material for an exhibition at the Museum of Modern Art, *William Eggleston's Guide*, May 1976. Eggleston made a selection of 400 pictures, taken on colour transparency, and from a final selection of 100 he and Szarkowski chose seventy-five. Forty-six of these were published in a catalogue which soon took its place on photography's A-list. The *Guide* can properly be described as hermetic, and remains a real test for readers. It includes a number of portraits (23) which Eggleston didn't usually take. The pictures are from Memphis and surrounding areas, none of them very far away.

SUMNER, MISSISSIPPI, CASSIDY BAYOU IN BACKGROUND. c.1970

Sumner is a small town not far south of Memphis, and a bayou is a river spur – from the French *boyau* for the gut. Brown leaves on the ground show that it is winter, and with their hands in their pockets the pair of them look somewhat cold. They must have been asked to stand like that near to the car, whose driver you can just see through the glass. The white man wears a black suit and the black man wears a white jacket, and seems to be acting the part of a servant or employee. It could be a skit on race relations in the South, and would convert easily into a jingle or rhyme. The man waiting in his white car, given such prominence, points to the tableau as an extemporization – a matter of moments.

Huntsville, Alabama. c.1970

Huntsville lies to the east of Memphis, and Eggleston took some pictures there at the airfield. The man may have been in management and he is full-featured and well-fed: a high, domed forehead, proud nose and the beginnings of a double chin. A flailing propellor, of the kind warned against in the notice, would make short work of him. Otherwise it is a beautiful day.

Portraiture is not straightforward, for it is intrusive. Eggleston's answer to the problem was to devise a scheme within which the subject might feature as an actor for just so long as it took to get the picture. At Sumner the theme was race and at Huntsville death. Nor are these themes to be trifled with, and they have been responsible for some nerve-racking photographs over the years. But Eggleston's aesthetic tactics, honed throughout the era of Pop, meant that he had the resources to deal with them by sleight-of-hand. The Sumner trio have been asked just for a moment of their time, and know something of what is afoot. The Huntsville subject probably didn't even know what it was all about. Many of the *Guide*'s portrayals touch on the journey through life, including the Last Things.

WILLIAM EGGLESTON

Eggleston was interested in the techniques of colour, sometimes using negative film and sometimes transparencies. He came across dye-transfer printing in 1973, an expensive process used in advertising, which gave a lot of colour saturation. His first portfolio of dye-transfer prints, *14 Pictures*, was published by Julien Hohenberg in 1974. After the *Guide* his next book was *The Democratic Forest*, an anthology of 1989 which opens with a long suite of landscapes from Mississippi, Kentucky, Tennessee and Arkansas. Commissions took him to Georgia (USA) and to Louisiana in 1980. He took pictures overseas, in Africa and in Europe, some of which were published in *Ancient and Modern*, a survey of 1992 exhibited at the Barbican Art Gallery in London. In 1984 he photographed at Elvis Presley's mansion, Graceland, near to Memphis, a site of sumptuous colour. *Faulkner's Mississippi*, 1990, by Willie Morris, presents seventy-eight pictures by Eggleston. These keep company with their text – not intruding, for Faulkner's story was a rich mixture.

ROOMS, USA. n.d.
This picture introduces a book of 1999, *William Eggleston 2¼*, published by Twin Palms and including forty-five medium-format images taken quite early in Eggleston's career. ROOMS is a tautology, for it is a free-standing house made up of such things. Eggleston likes to remark on words and on their varying relations with their subject-matter. Words in adverts, for example, foretell the future, making pledges and promises. Digits on automobile number plates refer to geographical and bureaucratic systems. A clock face might tell the time, in relation to time's daily system. Words declaim, sometimes emptily, and defaced they tell of their ill-use in the past – in history.

Near the river at Greenville, Mississippi. n.d.
Published in *The Democratic Forest* in 1989, this shows an outdoor cooker at Greenville on the Mississippi river. The hatchet, painted red, picks up on the red cable and hammer, making the ensemble look like a version of a murder scene. Photographs, taken on the wing, deliver up metaphors answering to the unconscious. A metaphor, which carries meaning from one item to another, is a major figure on the creative list which includes a lot of other suggestive terms dealing with the substitution of one thing for another, or parts for wholes.

During the 1960s and '70s Eggleston was taking his pictures within a context well aware of sign systems and of the part that could be played by language in art. His photographs may have been taken in and around his homeland, but at the same time he was exploiting art's new turn of mind, which was engrossed by just what happened when words and terms were added and subtracted. Colour's natural look disguised this playful interest in signs.

TOMATSU SHOMEI

b. 1930 Tomatsu, one of the most poetic
of all photographers, is both a symbolist and
a materialist – and a history artist, too. Although
only a youth during the war, he served as a lathe
operator. Afterwards he entered the Law and
Economics Department of Aichi University and might
have ended up in conventional employment, but
his elder brothers were interested in photography
and he followed their lead. He entered competitions
and got to know established photographers.
On graduation in 1954 he moved to Tokyo and was
given a job at the office of *Iwanami Shashin Bunko*,
a periodical set up by Iwanami Shoten in 1950.
Shashin Bunko was a small-format block book,
and the idea was that each issue was to be devoted
to a single subject and that everything should
be expressed through images – which would replace
language. Life at *Shashin Bunko* was formative
both for Tomatsu and for Japanese photography
in general. Europeans, by contrast, liked to think
of sets of selected images supported by texts.

MEMORY OF DEFEAT 2,
RUINS OF TOYOKAWA NAVAL DOCKYARD,
AICHI PREFECTURE. 1959

Tomatsu recalled the war, its bombing extravaganzas
especially. Japan's industries had been ravaged and
in 1959 the ruins were still to be seen. This wall
of corrugated iron has been peppered by shrapnel,
and with the light behind it looks like a night
sky illuminated by stars or by distant gunfire.
Those defunct meters in the foreground stand
in contrast to the liveliness of the cosmos beyond.

Ise Bay typhoon devastation 2, Nagoya. 1959
There were floods in Ise Bay in September, and
when they receded a layer of mud covered the
debris. There is a boot in the centre, and near to it
a bottle, both of which should ideally stand upright.
Here, though, they function in profile and in low
relief, and as reminders of the normal world we
have lost. There are other items to be discovered
in what could be seen as an archaeologist's
cross-section of a vanished civilization.

Tomatsu, like most of us, is a latecomer to the scene. The war has taken place and by now (1959) exists in the imagination. An allegory will restore it to life: those twinkling lights in place of bursting shells. The flood, too, has been and gone. Tomatsu asks us to note just how the imagination works and how likely it is to be brought into play by such insignificant details as those twinkling lights and that muddied footwear. The same imagination also feeds on absence, on bygone events in these two instances. Tomatsu often proposed that he was an investigator examining scenes which were hard to understand. In this respect he is a forerunner of the postmodern aesthetic which is wary of certainties, which knows that we have arrived too late and are a prey to false impressions.

Tomatsu became an independent photographer in 1956. In 1958 he began to work on a project later called 'Chewing Gum and Chocolate', on the American presence in Japan. In 1959 he was a founding member of the agency VIVO, which kept going only until 1961. It is likely that those involved had distinct ideas about photography and weren't team players. The young photographer Moriyama Daido had been attracted to Tokyo by VIVO and recalled Tomatsu's 'overpowering presence', his well-organized contact sheets and his liking for axioms. He told Moriyama that photography was haiku, and like haiku it was an art of limitless choices. In haiku three lines of seventeen syllables make allusions which invite conjecture, and haiku does provide a key to the understanding of Tomatsu's art.

CULTIVATION 2, NAGOYA. 1959

This picture also relates to the typhoon and flood photographs taken at Nagoya in 1959 and it was published in *Nippon*, a survey of 1967. It is a work picture, and a piece of documentary. The man uses a hoe and the shadow of his right hand can be seen on the lower edge. Sunlight comes into the image from the upper left and just touches the tip of his little finger and brushes against the folds on his shirt. There is some dried mud on his thigh, which shows as broken light.

House 6, Amakusa Shimoshima Island, Kumamoto Prefecture. 1959

This was part of a series, 'House', published in 1960 in the magazine *Photo Art*. The pictures were taken in an old run-down traditional house on an island off the coast of Kyushu in the south. Tomatsu's childhood home had been inundated in the floods of 1959. In this example the floor is wet in parts and wrinkled. That might be a table in the foreground. The main event has involved a bowl which has fallen and broken, and in a scene where little else is on display it is easy to think of that moment.

Time passes, and it has always been hard to envisage. Indeed, it has usually not been worth dealing with for its instants are inconsequential. Usually they are lodged in duration, in longer passages during which events unfold and statements are made. Tomatsu's way of coping with time has been to present its instants within larger structures. In the case of the land worker that tiny speck of light on his finger takes place within a context of traditional labour which is either timeless, repetitive or cyclical. The broken bowl on the damp floor is a diagram of an accident, for the shards have spread on impact and come to rest. The moment of impact, that is to say, is supported in various kinds of duration: that of the larger event, and beyond that of domestic life in which such a moment is no more than a typical incident. For good measure he has also put light on show dwindling into the foreground through varieties of darkness. These reflections on time set him apart in the history of the medium.

TOMATSU SHOMEI

In 1960 Tomatsu was asked by the Japan Council against Atomic and Hydrogen Bombs to take pictures of Nagasaki. In 1958 Domon Ken, a photographer admired by him, had taken pictures of the survivors of Hiroshima. Tomatsu's photographs were published in *11.02 – Nagasaki* in 1966. He was interested in relics and in cataclysm, and in 1960 had taken pictures of urban detritus embedded in the soft asphalt of Tokyo's streets – looking like the earth's waste floating into deep space. His flood photography of 1959 had also prepared him for Nagasaki and its survivors.

A WRISTWATCH DUG UP APPROXIMATELY 0.7 KM FROM THE EPICENTRE OF THE EXPLOSION, NAGASAKI. 1961
The city, on the western coast, was attacked on August 9, 1945, at 11.02 a.m. This wristwatch, stopped at the exact moment, is a relic. Tomatsu has seen it as a symbol, for it looks somewhat like an orb in the sky; and it might be the sun or even a reference to the Japanese flag. The object has been placed on a textile ground, just sufficiently distorted to make shadows and to suggest atmosphere. After his visit of 1961 Tomatsu returned to Nagasaki to take pictures of disfigured survivors.

Statues of angels at Urakami Tenshudo Catholic Cathedral that was destroyed by the blast 0.6 km from the epicentre of the explosion, Nagasaki. 1961
Nagasaki has a large Catholic population living in the area close to where the bomb was dropped. Tomatsu wondered at the choice of target and took several pictures in the ruined cathedral. These angel heads may have been intended originally as corbels to hold the roof in place. Salvaged, they look heavenwards into the light, as if in a re-enactment of the radiant bomb. The figure in the immediate foreground seems already blinded.

Photographers, too, have to deal with myths and legends. By 1961 the bombing of Nagasaki and Hiroshima was history and a story to be told. Tomatsu used the sources at his disposal, including the Christian iconography of the bombed church. He took a picture of a bottle melted by the heat and hung up to look like a flayed carcass or even like the tortured body of Christ hung on the cross. Memories of great events reverberate in photography. The war of 1914–18, undertaken in trenches and tunnels, led to a reaction in favour of bright lights and artifice – the modernism of the 1920s. Memories of the Holocaust continue to crop up in western photography into the 1960s – in Robert Frank's alienated subject-matter, for example. The Japanese for their part had Nagasaki and Hiroshima, along with constant reminders in the shape of the US Air Force stationed in Okinawa. Until the 1960s the fear was of repeat performances of recent catastrophe. Eventually, as memory faded new worries emerged, very often of the kind of social breakdown which Tomatsu identified in occupied Japan.

TOMATSU SHOMEI

In 1964 he travelled to Afghanistan and took pictures for several weeks. In 1968 these were published as *Salaam Aleikoum*: 101 images with neither titles nor numbers. In the 1950s, working for the periodical *Iwanami Shashin Bunko*, he had been in the presence of editors who wanted to express everything through images, omitting language. The book on Afghanistan is an exercise in this direction. Neither Tomatsu nor the Afghans knew much about each other, and he only knew what he could see and sense. Japanese photographers in the 1990s and after would extend this principle to the world at large.

SHRINE, AFGHANISTAN. 1964

The alcoves are arranged in five vertical lines and in seven of them candles are burning. Smoke marks show that some are more used than others. A robed figure crouches in the foreground, giving nothing away. Tomatsu was amongst people whom he didn't know, some of whom, like the figure here, were unapproachable. Even so, they were human beings with a full range of faculties, which the photographer alludes to in that set of niches which might be read as a figure for consciousness. Elsewhere in the series other robed figures rest under inscribed tablets which also stand in for the mind.

Child's game, Afghanistan. 1964

The boy plays with two discs which are attached by string to his thumbs. Maybe he was trying to bring them into alignment or to make a correlation between their shadows. A girl of about his age watches the performance and a child looks out from a doorway. Children's games feature in post-war and humanist photography; and the human interest here involves male/female relationships and the passage into adulthood. The best humanist games, though, were collective, whereas this one is an introverted game of skill. Tomatsu has also taken a picture of a dark figure in bright light, leading to sharp tonal contrasts.

Documentary presupposed knowledge on the photographer's part, for how otherwise could anything be made clear. Tomatsu's journey to Afghanistan challenged this idea. He could bear witness to the place and to its people, but not entirely in their terms. He is somewhat like the boy playing his solitary game in the sunlight. The child may know what he is doing, but we can only surmise and recognize his intentness. *Salaam Aleikoum* is an experiment whose outcome Tomatsu could not predict. He even goes to some lengths to make sure that the pictures are hard to read, sometimes by shooting into the light to show silhouetted figures against the glare, and sometimes by taking pictures at unusual angles to rob the scene of its foundations. He also likes to remark on materials, because they catch the eye and resist interpretation. The Japanese manner, exemplified by Tomatsu, was sceptical of overviews and of common knowledge.

Tomatsu's study of the American impact on Japan resulted in *OKINAWA Okinawa OKINAWA*, published in 1969. Okinawa, in the Ryukyu islands, was in American hands. Tomatsu was surprised to find that traditional culture had survived despite the occupation, and he returned there frequently. In 1965 he was contracted to organize an exhibition on the history of Japanese photography, and by then he himself had the standing of an old master. He was also living in turbulent times. In Japan student protests were on the rise from 1965: prompted by the war in Vietnam, the continued American presence in Japan and local developments – such as the building of Narita airport. Tomatsu's successors, notably Moriyama Daido and Nakahira Takuma, thought that they would go it alone, and in November 1968 set up a new periodical, *Provoke*. In June 1970 Tomatsu set up his own periodical, *Ken*. He remained in touch with the avant-garde, to whom he had been an inspiration.

PROTEST 1, TOKYO. 1969
Students protested because they found the old order irksome. Nor did they like the new economic order. They were also aware of China's Cultural Revolution, announced in 1965. 1968 opened with the 'Prague Spring', suppressed by the USSR, and moved on to the 'May Events' in Paris. At the time it seemed as if a new spirit was abroad, and that it was rebellious, idealistic and violent. History, which had once seemed explicable in terms of policy decisions and economic pressures, began to look as if it had a telepathic dimension linking diverse cultures. Tomatsu's student is caught up in the onrush envisaged here as a torrent abraded by radio waves.

Kadena-cho, Okinawa. 1969
In February 1969 Tomatsu visited Okinawa to take pictures for *Asahi Camera*, an important periodical. He spent two months on Okinawa and on the adjoining islands. The picture of the bomber may have been taken under cover, for airforces are secretive. The picture, with that Futurist shudder, expresses the intimidating power of the machine. The impression is that Tomatsu and his camera have been shaken by the event.

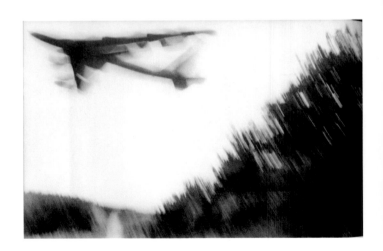

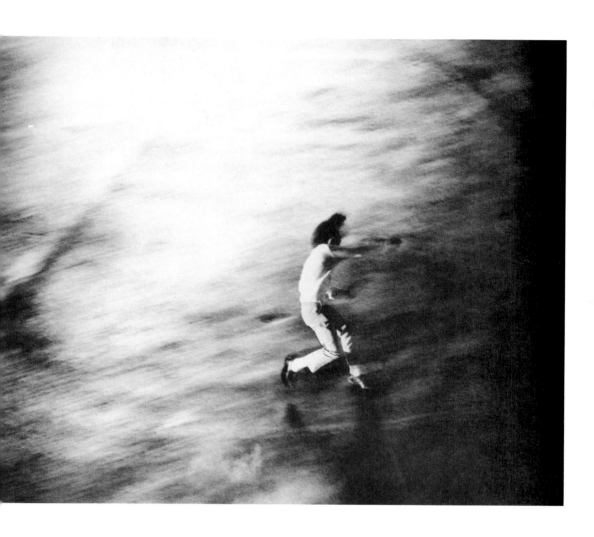

The postmodern outlook developed from the 1960s onwards. Photographers had believed, in the 1930s, that they were participants in history and that their testimonies made a difference. Increasingly they came to realize that they were witnesses to events which could scarcely be understood. The upheavals of the late 1960s exemplified this new spirit, which seemed to have affected a generation everywhere. The roaring bombers of Okinawa were also part of a global scheme almost beyond the comprehension of this cameraman hiding in the bushes. The new generation in Japan, Tomatsu's own rebellious students (Moriyama and Nakahira, for example), were, if anything, even more interested in this unequal relationship between History and the individual.

NAKAHIRA TAKUMA

b. 1938

A shooting star, Nakahira Takuma co-founded the magazine *Provoke* in 1968. This only came out thrice but achieved legendary standing. Taki Koji was the other founder. They were impatient with contemporary documentary, as too descriptive and tautological. They looked for atmosphere instead, for it could be made up. Nakahira's atmospheres were apocalyptic. At Nihon University in 1967 he had given advice to the magazine *Foto Critica*. At the time he was editing the leftish magazine *Gendai no Me* [Contemporary eye], and he had helped the great Tomatsu Shomei to organize an exhibition on the history of Japanese photography. *Provoke* photographers were Takanashi Yutaka, Taki Koji, Moriyama Daido and Nakahira himself. He had learned from Tomatsu and like him took pictures into the light for expressive effect. No one in the history of the medium ever had such a lurid sense of the end of the world as Nakahira had in 1968–70. *Provoke*'s last issue came out in March 1970. He seems to have turned away from photography as the heat went out of the political situation in the early 1970s. Alcoholism brought memory loss in 1977.

TELEPHONE, TOKYO. 1968–70
A similar, but not identical, public telephone appears in the second issue of *Provoke*, March 1969. Bright lights, which reveal and dissolve their subjects, suggest the transience of the material world. Light eats into the fabric of things. Nakahira's iconography of darkened streets, blazing horizons, alleyways and tunnels derives from *film noir* and from the city photographs of William Klein. Maybe he meant to take revenge on material culture and on society at large, or just to assert the omnipotence of imagination in that hostile context.

From **For a Language to Come**.
Published by Fudosha, Tokyo 1970
It looks like a development on the far edge of an indecipherably dark landscape, and is one of the most dystopian pictures ever taken. The grain of the film proposes pollution rising from or settling back into the surface of the earth.

A powerful imagination may be burdensome. Nakahira Takuma could envisage another state of affairs, or a version of the last days peopled by a handful of refugees. Tomatsu was worried by cultural deterioration and Moriyama presented himself as an outsider preyed on by impressions and distractions. Nakahira's, though, was a vision of abandonment – quite impersonal. Bill Brandt, in the 1940s, had also been able to take apocalyptic landscape pictures of the end or the beginning of time. Imaginative excess of that kind doesn't allow for investigation and debate, which may be why Nakahira renounced his previous photographic work in 1972 in a book of essays, *Why an Illustrated Botanical Dictionary?* He pledged a new beginning in purely illustrative photography with no 'traces of manipulation', but with such an imagination future good conduct was no more than a pipe-dream.

MORIYAMA DAIDO

b. 1938

A rolling stone, Moriyama revealed almost all in a long memoir published in 1983 in fifteen parts in *Asahi Camera*. The title was *Memories of a Dog*, republished in 2004 by Nazraeli Press. In addition to his achievements as a photographer, Moriyama is a compelling writer. His childhood memories are strong and coloured by the Occupation, which was the background to his formative years. A romantic, he tried to get into a merchant marine high school but failed and didn't do well in education at all. Eventually he got a job in a film studio. In Osaka, more or less his home town, he designed matchbook covers for bars before getting work in a photo studio. In Kobe he took souvenir portraits of sailors and passengers on the pier. In 1961, lured by the idea of the VIVO agency, he moved to Tokyo only to find that VIVO, which included Tomatsu Shomei in its ranks, was on the point of closure. He went to assist Hosoe Eikoh, ex-VIVO, and then set up as a freelancer in Zushi, just to the south of Tokyo.

STRAY DOG, AOMORI, JAPAN. 1971

Aomori is at the very north of Japan's main island, Honshu. Sometimes the dog is attributed to Misawa, a nearby town. The picture was published in a book of road pictures of 1972, *Karyûdo* [Hunter]. It was taken near to a US air base and Moriyama describes the dog as showing the whites of its eyes and snarling. In fact it looks aged and disabled, but eventually the picture became Moriyama's motif. In Misawa there were 'dogs everywhere' along with 'barbers, cabarets, boutiques, beauticians and oculists'. Moriyama liked the temporary qualities of bases and their seediness, and he liked dogs, too. Japanese strays patrolled their areas and kept an eye on things, and in this respect they had a lot in common with photographers.

Tyres, Yokkaichi, Japan. 1968

Yokkaichi is on the coast, on a main road between Osaka and Nagoya. The truck's tyres have been decoratively chalked, perhaps in a quarry. Moriyama began to develop a snapshot aesthetic around 1965. In 1969 he started to travel widely in Japan, 'on the road' in the style of Jack Kerouac, the beat writer whose work he admired. The pictures of this era he referred to as 'abrasions', picked up in passing.

What would it be like to see the world from ground level – from a dog's point of view? Taking pictures from a car, as he often did, put him in an intermediate zone where a truck's tyres and underparts would appear at eye level. The new humanity, to which Moriyama belonged, was, for long stretches, car-borne and sedentary, and thus had a new take on things. Preceding generations had walked upright and photographers took that posture for granted. If the traditional viewpoint was privileged the new one was insecure and vulnerable.

Once in the Tokyo area Moriyama soon made contact with the avant-garde. He published in *Camera Mainichi*, an important periodical – comparable to *Asahi Camera*. For several years he had connections with an experimental theatre group managed by Terayama Shuji with whom he established a magazine, *Scandal*, in 1968. But for *Scandal* he might have been one of the first *Provoke* photographers in 1968. This exceptional magazine was co-founded by the photographer and polemicist Nakahira Takuma, another of Moriyama's friends. *Provoke* was meant as a quarterly and was advertised as providing 'Provocative Materials for Thinkers'. The founders proposed that words had 'lost the material force that once held reality'. Photographs would take their place. Japanese theorists had been toying with this idea for some time; in the 1950s the *Shashin Bunko* venture, with which Tomatsu Shomei had been involved, also believed that images should have priority and even replace language. Photographic imagery would also allow for self-expression, but only if the conventions were ignored. Pictures should be taken without using a viewfinder – anything as long as the eye didn't compose according to preconceptions. Moriyama joined *Provoke* for its second issue in March 1969 with twenty-two pictures showing an encounter in a love hotel. To the third and final issue he contributed a set of pictures of supermarket shelves, 'Yours in Aoyama Street'. The supermarket was called 'Yours' and the goods were boxes of detergent, crates of Coca-Cola and tins of creamed Green Giant corn. The shelves were illumined by the flashing lights of police cars, for it was 1968–9 and the streets were alive with protest.

ON THE BED I, TOKYO. 1969
The love hotel pictures are quite objective, with a certain amount of attention to detail: the lampshade, light switch and that rudimentary kitchen equipment in the corner. She draws deeply on a cigarette, which glows in the half-light. A generation of smokers would easily identify with that gesture, with the posture and the pleasure.

After school, Ishikawa, Japan. 1971
Ishikawa is an area on the north coast of Honshu, quite far from the major cities. The child, lost in thought, may have been photographed from Moriyama's car, for this was a time when he was still travelling constantly in Japan. She looks slight and alone in that gloomy landscape. Moriyama was never a daredevil and he kept his distance. As a child he had been a solitary with a taste for reading and he had a wealth of memory, to judge from his reminiscences of 1983. His pictures often suggest that the other, like himself, is a daydreamer.

Photographers sometimes have theories, which can be helpful. The *Provoke* agenda helped a new generation break free of convention. Moriyama, like many others, also had a vision founded on his own childhood. In *Memories of a Dog* he looks back to some of the promises made to him in his early days by the coloured illustrations in books and by the texts themselves. Taking photographs later on he looked for realizations of these early proposals. In adolescence the books were replaced by popular and sentimental songs whose words and sentiments crop up in the later writings.

Having worked for *Camera Mainichi* in the mid-1960s, he switched to *Asahi Camera* in 1968. He took pictures of traffic accidents rephotographed from road safety posters, and he exhibited billboards covered in enlarged copies of magazine adverts. A series of pictures called 'Journey to Something' was published in *Asahi Camera*, for this was a period of constant travelling. In 1972 his books *Hunter* and *Farewell to Photography* were published, and he set up the magazine *Records*. He had taken a lot of urban pictures and in the early 1970s the pace began to tell. He tried to reconstitute himself by going to the countryside, especially in the north of Japan, which had always attracted him.

HAKODATE, JAPAN. 1975

Hakodate is the main town on the southern peninsula of Hokkaido, Japan's large island to the north. Ferries sailed to it from Aomori. Moriyama went to Hokkaido to recuperate in the 1970s, and he had childhood memories of it, too, from an illustrated encyclopaedia *Shakai no zenka* [The complete course in society]: a ferry, a lighthouse, ice floes and 'Ainu with blue-tattooed lips, standing in front of the skull of a bear.' Childhood impressions, as recounted in *Memories of a Dog*, were highly coloured and insistent, and those of Hokkaido were compelling. He admired its 'harsh, deeply carved seasons and landscapes', in contrast to 'the humid mainland with its extremely delicate seasons'. But why a picture of a tramcar? It is turning, no. 514, through a skein of wires, and it may have looked like an allegory. 'Streetcar' motifs appear in his memoirs: a 'streetcar named Memory' and another 'named Truth', in the context of Tennessee Williams's *A Streetcar Named Desire*. Moriyama reflects on Williams's remark that worthwhile memories lie somewhere between fact and non-fact.

Kushiro, Japan. 1971

Kushiro, a port, lies towards the eastern end of Hokkaido, and it is remote. Moriyama recalled that 'around the train stations in small towns, there were still many houses with board walls and wooden electric poles, and dusty dirt roads ...' – just like this. It stands as a figure for a distant childhood, and it looks like an early photograph in which light struggles to register. Reflecting on Nicéphore Nièpce, who took the first photograph, Moriyama proposes that photographs are memories of light – and deposits and traces making up a kind of archaeology.

Moriyama and his contemporaries foresaw a time when photographs would communicate all by themselves. Ironically their pictures elicit words more urgently than ever before. In the 1960s Tomatsu Shomei insisted to Moriyama that photography was haiku – laconic in the first instance, but wordy when you begin to reflect on its possibilities. Moriyama's own cryptic imagery leans even more heavily on the artist's commentaries. It was an editor at *Asahi Camera*, Tanno Kiyokazu, who first saw the connection and made the invitation to write.

In *A Dialogue with Photography*, published
in the early 1980s, Moriyama explained himself:
'... most of my snapshots I take from a moving
car, or while running, without a finder, and in those
instances one might say that I am taking the
pictures more with my body than with my eyes.'
He remained intent on freshness of vision. *Light
and Shadow*, a book of recent pictures, came out
in 1982. Throughout the 1980s he worked for the
monthly *Shashin Jidai* – for nine years, until it closed
in 1989. The clothing company Hysteric Glamour
commissioned him in the 1990s to make books
on Tokyo and on Osaka: *Daido Hysteric*. In 1974
he had been included in the exhibition 'New Japanese
Photography' at the Museum of Modern Art
in New York. By the late 1990s he was amongst
the most famous of all photographers.

PEONY, KANAGAWA, JAPAN. 1980
Peonies are Japanese natives, preferring slopes
swept clean by avalanches, but Moriyama may not
have had botany in mind. In *Memories of a Dog*
he quotes a haiku by Buson: 'cutting a peony/my
spirit flags/is it evening?' Yosa Buson (1716–1783)
was a great poet of the late eighteenth century,
and he was noted for his realism. Moriyama
thought that he had 'a surpassing sense of reality'
and that he even outshone Bashō from the
previous generation. Bashō was a great traveller,
and so was Moriyama, and as haiku has a lot
in common with photography, he must have
seen parallels between his life and theirs.

Felt hat, Tokyo. 1980
It was published in *Light and Shadow* in 1982,
and towards the beginning of *Memories of a Dog* –
and may have been a signature picture. To put it on
he would have held it by the front of the crown.
As defined here it isn't shaped to his head, but
felt is malleable. It looks like part of a disguise.

Disguise helps with privacy and anonymity. If your task is a delicate one it is necessary to concentrate – without distractions. The land of Japan provided Moriyama with his raw materials: elemental Hokkaido in the north, genial Honshu with its temperate valleys, and the tropical south. Culture was, as ever, everywhere but increasingly infiltrated by the occident, inadvertently imported from the USA in 1945 and after. Moriyama presents himself as a connoisseur of US base style and of popular culture from home and abroad. Creative momentum came from early imagery, from all those motifs of childhood to which he returns in *Memories of a Dog*. Just as important was the aesthetic tradition to which he belonged: the culture of poetry represented by Bashō and Buson. Throughout the memoirs of 1983 he makes fine distinctions about states of mind – distinctions befitting a poet. If, as a successor to Buson, your attention wandered, you would fail to make the grade. That picture of the woman smoking a cigarette in the love hotel is haiku – accurate. Tomatsu had noted early on that photography was haiku. Theirs was the last major photography with such a close attachment to classical aesthetics.

LEWIS BALTZ

b. 1945

Born in Newport Beach in California, he studied at the San Francisco Art Institute and then at the Claremont Graduate School. He began to exhibit in 1971, and in 1975 was included in the landmark 'New Topographics' exhibition at George Eastman House in Rochester, NY. Baltz, like others in his generation, turned away from primal America – the rocks and stones and trees of the National Parks – to look at suburbia, which had been on and off America's agenda since the 1950s. William H. Whyte had written *The Organization Man* (1956) which was about life in the new 'package suburbs': the Park Forests and the Levittowns as Whyte called them. Once photographers started to look in that direction, there was no holding them. In 1975 Baltz's *The New Industrial Parks Near Irvine, California* was published by Castelli Graphics, who also put out his *Nevada* in 1978. *Park City* followed in 1981, an extensive study of 'a rapidly growing ski resort and second-home development east of Salt Lake City in Utah's Wasatch Mountains' on land which had formerly been used by mining companies.

SAN FRANCISCO. 1972

The SAND DUNES in question were probably nearby, and the name had been taken quite naturally – for whatever kind of establishment this was. In the conceptual era name transfers such as this were often remarked on. Somewhere in the mental distance an idea of the coast might survive – but greatly weakened. The scene itself looks like an inventory of what might happen to any cemented wall daubed, smeared, streaked and cracked – and the pavement spotted.

North Wall Automated Marine International. c. 1975

This is element no. 16 in *The New Industrial Parks Near Irvine, California*. The fifty-one pictures in this series were arranged for exhibition in three rows, one over the other – as a set of modules. Mostly these photographs from the early 1970s deploy a few rectangles on a flat ground. These rectangles, as here, suggest a ratio.

Ratios and proportional systems, when they occur in architecture, hint at a transcendental order. If you can deploy the correct mathematics, and use your intuition, you will be able to identify and replicate the golden section. But all rectangles within rectangles look promising in this respect, even if they are no more than doors and windows on the façades of industrial buildings. Baltz's investigations, which are really a form of Minimalism, result in what might be understood as a critique. They imply that ratios are easily come by and that they are part of the stock in trade of the new order. To be active and beneficial a ratio needs to be experienced in three dimensions, in doorways, vestibules and room interiors, but those on show in California are in fact no better than diagrams. So, if the ideal system exists it does so as a notion, of the same remote order as that seashore evoked by the proprietors of SAND DUNES.

These are some of his projects: *The Highway Series*, 1967–9; *The Tract Houses*, 1969–71; *The New Industrial Parks Near Irvine, California*, 1974–5: *Maryland*, 1976; *Nevada*, 1977, 1978–80; *San Quentin Point*, 1981–3; *The Canadian Series*, 1984; *Continuous Fire Polar Circle*, 1985; *Near Reno*, 1986; *Fos Secteur 80*, 1987; *Candlestick Point*, 1984–8. The projects, when exhibited, look like objective scientific studies in which all the evidence is given equal emphasis. Because they are often of neglected land or of areas under development, the series have an ecological aspect, but they have other qualities, too, which are worth considering.

PARK CITY. 1978–80

No. 1 in *Park City*, this image has an extended caption giving details. The picture was taken on Masonic Hill looking towards Quarry Mountain, for example. Those are new parking lots in the foreground – the dark spaces covered with tar macadam. Other names are given, such as Holiday Ranchette Estates and Racquet Club Estates. The names ask for our attention but give little away; they hover over the terrain but don't come to rest. The parking lots, which are the main feature of the area, soak up that diffused light – like storage pools.

Park City. 1978–80

No. 42 in *Park City*, this is a view of Prospector Village, Lot 102, looking west. In this case that same undifferentiated white sky is reflected on a number of boards and palettes arranged on a heap of earth excavated from a foundation just to the right.

Unless they were commissioned by construction companies, photographers hadn't ever been in the habit of taking pictures of disturbed ground. All the same, such sites are interesting because they are typical of the era: machine-moved earth, debris scattered awaiting removal. But in 1980 both of these pictures would have been looked at as found examples of Robert Smithson's displacement images. The idea was – re: no. 42 with its slabs of reflected light – that a set of mirrors would serve as a distraction, breaking up the scene. Perspective had accustomed us to an imagery of orderly progression leading into the far distance. Binocular vision, or the normal operation of our eyes, brought objects into alignment in a way which suited our urge to control, to see things on a stage of our own devising. This habit of seeing also staged the self as the centre of the world, and in the 1960s and after that supposition caused disquiet. All of Baltz's pictures challenge the authority of the self. There are those names in the panorama, which are really someone else's business: the developers', future residents'. Then the scattered boards in no. 42 reflect the sky at random; and perspective, which we find so consoling, is stopped short by that mound. In its turn the arrangement of wood and metal may be man-made but it is also accidental, and so it is pointless to make anything more than desultory enquiries. Baltz's is a disinterested aesthetic sceptical of our urge to understand and to put everything in its correct place.

JOEL MEYEROWITZ

b. 1938

Meyerowitz became famous for his colour pictures during the 1980s after a spell as a street photographer in black and white. He had turned to photography in 1962, having seen Robert Frank at work. Frank's example encouraged him to explore 'the gestural potential of 35 mm photography'. He took pictures in colour from the outset but found them expensive to print. From 1973, however, he was able to make his own prints and so reverted to colour. In 1976 he started to use an 8 x 10 inch Deardorff view camera, manufactured in 1938, and it was this which he used to take the landscapes which made his name. Born in New York City, he attended Ohio State University, Columbus, on a swimming scholarship. He studied painting and medical drawing, and thereafter worked as a designer and art director until claimed by photography.

ELEPHANT AND AIRCRAFT. c. 1968

This was printed in a special issue of the periodical *Aperture* in 1974 on 'the Snapshot'. In 1968 he exhibited pictures at New York's Museum of Modern Art in 'My European Trip: Photographs from a Moving Car'. This picture, to judge from its details, was taken in Great Britain. With respect to this and other 'snapshots' he quotes Proust writing on behalf of the motor car as 'helping us to feel with a more fondly exploring hand, with a finer precision, the true geometry, the fair measure of the earth'.

5th Avenue, New York City. 1968

This, with its array of brisk pedestrians, is a classic street picture: agitated and quite hard to make out. Its fulcrum is a beggar's dog to the right. The beggar's notice reads: 'God Bless The/ Cheerful Giver/ I Have No Other home/ I Wish You Good Luck.' The dog wears a blanket and what look like leather boots, which draw attention to all the other footwear on show on that sector of 5th Avenue. Meanwhile the tiger rages unremarked in its window.

Introducing the aircraft image Meyerowitz notes that snapshots 'accept the accidental conjunctions
and chance incidents occurring in the frame'. If too many of these crop up, pictures will
be unjustified, for there will be neither starting point nor findings of any significance. In a
further statement Meyerowitz adduces the idea of 'insistent vision', which saves the image as
photograph. His tactic in both of these quite early pictures is to cite resting points or termini:
the airport road leads into the distance and is crossed by that flight path; the gasholder in its
turn is a distribution point, and the pipe yard also tells of networks and destinations. In New
York City, 5th Avenue leads onwards to a vanishing point, but it is the shod dog which organizes
the street, raising the issue of all that different footwear on show. Photography, under these
terms of reference, is a game of chance, for the picture may have a key if you can spot it in
time. If you are cued into the scene your unconscious will do the work for you – Meyerowitz's
'insistent vision'.

JOEL MEYEROWITZ

In 1976, with the aid of a Creative Artists' Public Service Program grant, he bought an 8 x 10 inch camera and set to work taking pictures on Cape Cod. These were published in 1978 in *Cape Light*, beautifully realized by the Acme Printing Company of Medford, Massachusetts. The same printers produced *St. Louis & The Arch* in 1980. He had gone to St. Louis in 1977 with the writer, Colin Westerbeck Jr., and had conceived of the idea of taking pictures of that city remarkable for its arch, designed by Eero Saarinen and completed in 1965. In 1978 he took a series of pictures in New York City, of the streets in relation to the Empire State Building. Meyerowitz received a Guggenheim Fellowship in 1970 to travel in the USA and to take pictures of 'leisure time', and he received a number of awards and grants thereafter.

PROVINCETOWN, USA. 1976
Provincetown lies towards the northerly tip of Cape Cod (between Boston and New York). Dairy Land is a café and there are some indications that it is a coastal site: seafood on the menu, for example, and those bollards bound with rope in the foreground. The lights have just gone on, however, on DAIRY LAND and on the sandwich sign on the gable of the building. The setting sun has reddened the clouds. Sally Eauclaire, a connoisseur of colour in the 1980s, noted Meyerowitz's liking for the dusk, 'the time the French call *entre chien et loup* (between dog and wolf)'. At sundown time articulates itself by stages: the lamps go on whilst there is still light in the sky, and at a certain point moonlight begins to cast a shadow.

Busch Memorial Stadium, St. Louis, USA. c. 1978
The Giants are playing the Cardinals in front of a reduced audience. These pictures from the late 1970s are meticulously realized. The baseball field is seen as a sundial whose shadows deepen to the right. Exactitude attracted him in these relatively early pictures: comparable but not identical pillars and walls, near symmetries where differences are refined and in some cases hard to discern.

Topography has its phases. French photographers were keen topographers during the 1940s and 1950s, and
a new generation of Americans went in that direction during the 1970s. You might expect survey
projects to be quite strictly carried out, as they were for the FSA during the 1930s, but in the
1970s that wasn't the case. Meyerowitz, the most senior of the new colourists, had an exacting
aesthetic but beyond that he was attentive to nature's light effects and to décor: design details
and street furniture. One new factor in the USA during the 1970s was photographers' awareness
of such a capable judge as John Szarkowski at New York's Museum of Modern Art. They were
playing as never before to an audience that had expectations and also took idiosyncracy
for granted.

STEPHEN SHORE

b. 1947

A prodigy, Shore took up photography at the age of eight, inspired by a TV programme, *Love that Bob*, which featured a successful commercial photographer. Aged fifteen, he worked with Andy Warhol at The Factory and in 1968 published black-and-white pictures in *Andy Warhol* (Moderna Museet, Stockholm). In 1970 he attended a ten-day workshop run by Minor White, poles apart from the world of Warhol, and Shore's only formal training in the medium. In 1973, at the age of twenty-six, he showed his black-and-white pictures in the Metropolitan Museum in New York, 'Landscape/Cityscape'. In 1975 he participated in the important 'New Topographics' exhibition at George Eastman House in Rochester, NY.

U.S. 10, POST FALLS,
IDAHO, USA. August 25, 1974
Idaho, in the far northwest of the USA, is mountainous with rivers and waterfalls. The artist who decorated THE FALLS got straight to the point in that painting of the operative bit of a waterfall. SELECT FRUIT, the boxes say, and those are onions in the foreground, along with corn cobs.

Bellevue, Alberta. August 21, 1974
There are substantial mountains in the distance, and a heroic sky. The picture was shown in an exhibition of 1976 at the Smithsonian Institution in Washington, DC, 'Signs of Life: Symbols in the American City', devised by the architects and planners Venturi and Rauch. The chapel is part advert and part functioning building, for the sign says 'Walk In'. In the exhibition the picture was intended to show that 'the symbol is more important than the building'.

Survey pictures are innately mysterious. They invite naming and reading: this is a miniature chapel, for instance, and those are mountains far off, and a fine display of clouds. Naming and reading are tautological and redundant exercises, for we know that those are stones and fences and onions anyway. Documentary returns us to early childhood in the first instance, before raising supplementary questions. The chapel would have been just large enough to be delivered to its site by truck. The sign to the right advises us to 'Drive Safely, Drive with God' – who may be mindful of motorists' transgressions. Then at Post Falls the vehicle drivers have left their doors open – for ventilation or in haste? There is no knowing where documentary analyses will end. The Chapel image, for instance, may have caught Shore's eye because it juxtaposed the organic white and blue of the sky with the geometries of the building, also in white and blue. Documentary in the 1970s and '80s, which was a great era in the history of survey pictures, was unruly and promiscuous, likely to spring any number of surprises. Authorities and pundits such as Venturi and Rauch might point out a preferred meaning but the photographers of the period, and Shore in particular, had plenty of options in reserve – many of them temptations to reflect across a broad spectrum.

STEPHEN SHORE

In the 1970s he photographed far and wide: Monet's gardens at Giverny in 1977 for the Metropolitan Museum of Art, and the Yankees at Spring Training for the *New York Times Magazine*, in 1978. In 1982 Aperture, an American publisher, surveyed his work to date in *Uncommon Places*. Shore was born in Manhattan and lived there until 1978. He had, however, a liking for Montana where he spent his summers from 1979 and lived during 1980–82. He took a series of pictures which he called *The Montana Suite* in Gallatin County: green hills, flowered meadows and wheatfields. He made these pictures with an 8 x 10 inch Deardorff view camera, of the kind used by his near contemporary, Joel Meyerowitz. In 1984–5 he began to take another landscape series on *The Hudson Valley*.

**ULSTER COUNTY,
HUDSON VALLEY, USA**. 1984
The Hudson Valley, running due north from New York City, has a reputation for natural beauty and it attracted landscape painters in the nineteenth century. This scene in Ulster County wouldn't have been on their itinerary, apart from passing through. Somewhere down there is what could be a jetty and some mooring facilities. That looks like a raised ship's anchor to the right, and those are electricity and telephone wires to the half-hidden structure on the left. A parked car and a trailer complete the scene.

**Coverage of Monica Lewinsky's
testimony, Washington, DC**. 1998
The sign in the background says UNITED STATES COURT HOUSE under the names BARRETT and PRETTYMAN. The plinth on which the event takes place looks as if it might have been meant for a statue, but the operatives with their equipment fill it intricately, like an installation.

Photographers, perhaps out of perversity, began to take pictures of transit landscapes in the 1970s and '80s. The Germans, too, were interested in such spaces in-between. Landscape has always raised cognitive problems because places are hard to define. A river, for instance, may have a name and a presence but no site in particular; and a regional title, like Ulster County, might only have a bureaucratic identity. This scene might even qualify as a place if it could be seen, and, for good measure, the anchor makes allusions towards fixity. Our usual experience of scenes is of the kind we encounter here: spaces to be reconnoitred with care – here there is no parapet to the turning space. Photographers remark, sometimes *sotto voce*, on social change. Robert Frank in the 1950s noted that we were becoming sedentary in automobiles, and living in an asymmetrical and disadvantaged relationship with, say, recorded music and the powers that be. Shore's perception here, at this media event, concerns artifice. A youthful subgroup of technical experts stages an older spokesman. Contemporary culture, as it enacts itself in the law, finance and broadcasting, is sustained by millions of such invisible servitors and technicians. Photographers, often rather apart from the culture at large, are in a position to remark on such tendencies.

ANDERS PETERSEN

b. 1944

Between 1966 and 1968 he studied at Christer Stromholm's influential photo school in Stockholm. Stromholm advised him to find a subject that meant something to him and Petersen decided to take pictures in Hamburg, which Petersen had visited in 1962. Returning to Hamburg he found the Café Lehmitz, near to Hamburg's notorious Reeperbahn in the St Pauli area of the city. He lived in Hamburg between 1967 and 1970 and the pictures he took of the Café Lehmitz were published by Schirmer/Mosel in Germany in 1978, and then by Contrejour in France in 1979. A Swedish edition of the book came out in 1982. During the 1970s he took pictures for various Swedish magazines. He maintained his interest in marginal communities: prisoners, the elderly and people in psychiatric care.

SCAR AND ROSE FIGHTING, CAFÉ LEHMITZ. c. 1968

This was his scene of operations, where the preferred drink was 'Baren Pils', sold in squat bottles. The fighters look ill-matched, and none of the clientele takes the dispute seriously. Cigarette smoke would have hung in the air, and Jägermeister, advertised above the bar, is a sweetish liqueur with a reputation. Scar, the smaller man of the pair, was a retired sword swallower. Petersen's first exhibition, of 350 pictures, was in the Café Lehmitz, and patrons were invited to help themselves to their own likenesses.

Open-air dance floor at the Grona Lund amusement park, Stockholm. 1970

This may have been taken simply for a magazine article at a time when open-air dance floors were a feature of some European cities. They survived in ex-communist states into the 1990s. Dancing cheek to cheek in the old style means that you look into the distance and are alone with your thoughts. The new dancing of the 1960s entailed some degree of eye contact.

Petersen is a compassionate photographer. Of the Café Lehmitz he said that its people 'had a presence and a sincerity that I myself lacked. It was okay to be desperate, to be tender, to sit all alone or share the company of others. There was a great warmth and tolerance in this destitute setting.' From the 1930s onwards European observers (e.g. Germaine Krull in Paris) looked for signs of authenticity, which were beginning to disappear from the scene. By the late 1960s these had become hard to find. The new transformed humanity travelled by car, encased in metal and glass, and enjoyed mediated experience on TV – it was also, for the most part, sedentary. Advertising's idealized icons abounded and gave rise to anti-fashion, of the sort Petersen found in the Café Lehmitz. At the time these pictures were taken Josef Koudelka was completing a study of Gypsy settlements in East Slovakia, which became *Gypsies* (1975), an even better-known instance of anti-fashion. Koudelka's gypsies re-enacted an outcast version of 'The Family of Man', with all its festivals and ceremonials; Petersen's café-goers make up a microculture of celebrities.

JOEL STERNFELD

b. 1944

Born in New York City, Sternfeld studied at Dartmouth College, Hanover, New Hampshire. He received two Guggenheim Awards, in 1978 and 1982, and has made colour pictures since 1970. He is best known for *American Prospects*, a book of 1987 published in conjunction with an exhibition at the Museum of Fine Arts, Houston. The pictures in that show had been previewed in an exhibition of 1984, 'Three Americans', at the Museum of Modern Art, New York. During the late 1970s he travelled through the USA in a Volkswagen camper-bus and took pictures of the natural and social landscape with an 8 x 10 inch view camera – a wooden Wista. *American Prospects* is one of photography's outstanding collections, printed by Amilcare Pizzi, an Italian company noted for its quality. Prior to 1978 Sternfeld took street photographs with a 35 mm camera and a 4 x 5 inch press view camera.

MCLEAN, VIRGINIA. December 1978
Providence would have to be on your side to find a picture like this. Using a 35 mm camera there would have been a choice of the house or the sales point, but both together might have been difficult. The house is alight, and that fireman is busy in the foreground. Perhaps the incident is not so serious? His coat matches the orange flames in the roof as well as the colour of the pumpkins strewn in the foreground.

Exhausted renegade elephant, Woodland, Washington. June 1979
Another lucky break, for escaped elephants are rare on country roads outside of Africa. Perhaps it had heat exhaustion, which would account for their hosing it down and that water on the road. The sheriff must have been there to oversee events.

It wasn't usual to take pictures of incidents with an 8 x 10 inch view camera, because events didn't wait to be photographed so deliberately. But in both instances Sternfeld has come across sustained events which look as if they might have been staged. A collapsed elephant, a sheriff and a good number of onlookers couldn't have been rounded up by a man in a camper-bus. None the less, both incidents look as if they have been intended as tableaux, and both look like forerunners of the docu-dramas which preoccupied some art photographers during the 1980s and '90s. The virtue of such pictures, in relation to reportage proper, is that they allow a lot of room for idle speculation on anything and everything represented. They are, it is true, of real-life events, but so slowed down as to belong to another time zone, leavened by paradox: a non-urgent house fire, for example. Sternfeld's aesthetic, somewhat prompted by his apparatus, suggested a world running down and subject to a certain amount of official indifference: exemplified by the spare-time fireman and that laid-back policing in distant Washington.

JOEL STERNFELD

Sternfeld's travels in the USA from 1978 onwards took him almost everywhere, including Alaska in 1984. As a New Yorker he may have believed in an America of myth and legend but was quickly disillusioned. He put stereotypes aside and accepted people for what they were. By 1983 he was beginning to take more and more portraits. Very early in 1983 he came across a settlement of unemployed and dispossessed people living on the outskirts of Houston, Texas. At the time there were around eleven million unemployed people in the USA and reminders of the Depression during the 1930s. Portraiture was appropriate in such conditions. He continued to make portraits, of a broad cross-section of American society: see *Stranger Passing*, a collection of sixty colour photographs which accompanied a large exhibition at the San Francisco Museum of Modern Art in 2001. In 1998, along with Melinda Hunt, he completed a book on *Hart Island*, a cemetery island and former prison in Long Island Sound. He also took the pictures for *Walking the High Line*, a book of 2001 on a derelict railroad track on the west side of New York City.

A BLIND MAN IN HIS GARDEN, HOMER, ALASKA. July 1984
He had lived in Homer since the 1940s, carrying out biological research, and had become very familiar with the area. By the time Sternfeld came to take this picture, he had begun to go blind. His garden is a riot of colour, and the delphiniums encouraged to prodigious heights by the long days of summer. Otherwise there are marguerites, aquilegias and foxgloves in his garden, and much else. The Alaskan pictures appear as a group in Sally Eauclaire's *American Independents* (1987).

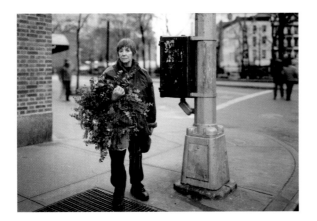

A woman with a wreath, New York. December 1998
She may have collected the wreath locally on a cold winter's day. Placed like this she rhymes with that metal pillar substantially anchored on the pavement. She has turned to the camera obligingly and made some effort to pose, but not much for she knows that what attracted his attention was the wreath on her arm. Confronted by a camera on a tripod we will always strike a pose, for by now it is a second nature. At the same time, though, we will weigh the situation up and gauge an appropriate response. More than likely, in an informal situation, we won't be quite sure of our ground, and *Stranger Passing* is a record of these personalized uncertainties.

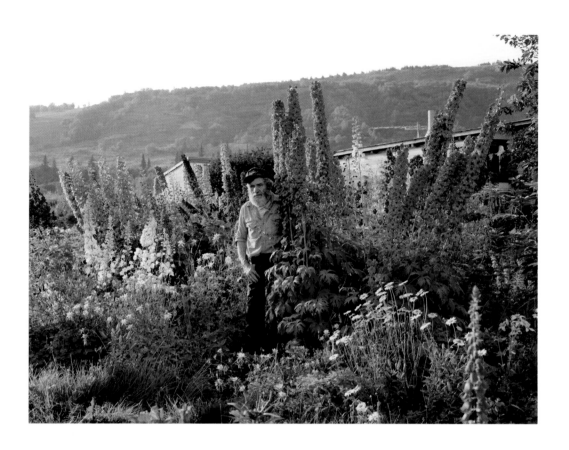

Neither of these figures represents anything. The blind man is a specialist and a good gardener who has been asked to stand amongst his prize plants; and the winter woman simply lives nearby. Sternfeld's portraits are of people he met, who might have something to say about Homer or the festive season … if they had the time. Sternfeld's knack has been to get people to pause for just long enough. Any less and he'd be back taking street photographs, and any more and the picture would become a monument. Thus he acknowledges the continuity of others' lives. In this respect he is a successor to those liberal photographers of the Weimar era in the late 1920s and early 1930s – Alfred Eisenstaedt and his companions in Berlin – who were devoted to the idea of private life and free association.

BIBLIOGRAPHY

SERIES

Photo Poche
Actes Sud, France, 1982–.
Its many titles – around 150 – feature
individuals as well as historical and social
themes. It was originally directed by the
famous editor Robert Delpire. Examples
from the series are published by Thames
& Hudson under the heading *Photofiles*.

55
Phaidon Press Ltd, London and New York, 2001.
This set of compact books, each with
55 images, an essay and analyses, introduces
many of photography's major figures: Gustave
Le Gray and Mrs Cameron, for example, through
to Moriyama Daido and Tomatsu Shomei.

In Focus
The J. Paul Getty Museum, Los Angeles.
In these small monographs the
museum introduces photographs
from its own collections. The series
came out in the late 1990s.

CATALOGUES

The liking for exhaustive shows with substantial
catalogues was at its peak around 1990, prompted
by the 150th anniversary of the announcement
of photography in 1839 by W. H. Fox Talbot and
L.-J.-M. Daguerre. Joseph Nicéphore Nièpce was,
of course, the original inventor in the 1820s.

The Art of Photography. Royal Academy of Arts,
London, 1989, 476 pp. Edited by Mike Weaver.
*On the Art of Fixing a Shadow: One Hundred and Fifty
Years of Photography*. National Gallery of Art,
Washington, and The Art Institute of Chicago,
1989, 510 pp. Edited by Frances P. Smyth.
*The Waking Dream: Photography's First
Century*. The Metropolitan Museum of Art,
New York, 1993, 384 pp. Edited by John
P. O'Neill and introduced by Maria Morris
Hambourg, this is a book of pictures
from the collection of the Gilman Paper
Company – very beautifully printed.

*An American Century of Photography: from
Dry-Plate to Digital*. Nelson-Atkins Museum
of Art, Kansas City, 1995, 423 pp. This book,
by Keith F. Davis, presents pictures from
the Hallmark Photographic Collection.

HISTORIES

A New History of Photography. Edited by Michel
Frizot for Éditions Adam Biro, Paris, 1994.
The English version was published by
Könemann, Cologne, 1998. The book has 41
sections and 29 principal contributors and is
in every respect an editorial *tour de force*.
The Photograph. Graham Clarke, Oxford University
Press, 1997. Clarke's first chapter is entitled
'What is a Photograph?' and the second
'How Do We Read a Photograph?'
The Photographic Art. Mike Weaver, The Scottish
Arts Council, Edinburgh, 1986.
In this catalogue, subtitled 'Pictorial Traditions
in Britain and America', Mike Weaver tries
to save the idea of art in photography.
His proposition, expounded in 21 short
chapters, is that photography, until 1986 at
least, was determined by an aesthetic agenda
of long standing. He both elaborates and tests
this conviction – sometimes to breaking point.

THE FARM SECURITY ADMINISTRATION

The photographs of the FSA, readily and even freely
available, have been a godsend to enthusiasts.
The FSA deployed many photographers over
a long period and kept its files in good order.

*Portrait of a Decade: Roy Stryker and the
Development of Documentary Photography
in the Thirties*. F. Jack Hurley, Louisiana
State University Press, 1972.
*In This Proud Land: America, 1935–1943, as Seen in
the FSA Photographs*. Roy E. Stryker and Nancy
C. Wood, Galahad Books, New York, 1973.
Documentary Expression in Thirties America. William
Stott, Oxford University Press, New York, 1973.

*A Vision Shared: A Classic Portrait of America
And Its People, 1935–1943.* Hank O'Neal,
St. Martin's Press, New York, 1976.
Documenting America, 1935–43. Carl Fleischauer
and Beverley W. Brannan, eds., University
Press of California, Berkeley, 1988.
FSA: The American Vision. Beverley W. Brannan
and Gilles Mora, Abrams, New York, 2006.

COLOUR

Sally Eauclaire, a critic and curator, was the author
of three important books on US photography
in the 1980s. Together they give an impression
of a significant tendency as it unfolded.

the new color photography. Abbeville
Press Inc., New York, 1981.
new color/new work: eighteen photographic essays.
Abbeville Press Inc., New York, 1984.
*American Independents: Eighteen
Color Photographers*. Abbeville
Press Inc., New York, 1987.

A CURATOR

John Szarkowski, Director of the Department of
Photography in the Museum of Modern Art in New
York, was the author of three noteworthy books,
all published by the Museum of Modern Art.

The Photographer's Eye, 1966.
Looking at Photographs, 1973.
*Mirrors and Windows: American
Photography since 1960*, 1978.

Szarkowski believed in 'serious' photography,
which could be identified irrespective of
its genre. As photography diversified this
category became increasingly difficult to
secure – as was becoming evident by 1978.

A CRITIC

Max Kozloff, in his incomparable essays,
considers many outstanding careers.
The essays in these collections include examinations
of portraiture and street photography.

Photography & Fascination. Addison House,
Danbury, New Hampshire, 1979.
In 13 texts he discusses *inter alia* the
photographs of Diane Arbus, Henri Cartier-
Bresson, Jacques-Henri Lartigue, László
Moholy-Nagy and August Sander.
The Privileged Eye. University of New Mexico Press,
Albuquerque, 1987.
This group of 19 essays concludes with
an outstanding piece on Eugène Atget.
There are appraisals, too, of the art
of Robert Doisneau and of Helen Levitt.
Lone Visions, Crowded Frames. University of New
Mexico Press, Albuquerque, 1994. In one of the
21 essays collected here, he considers Walker
Evans's *American Photographs*. A review of
1991, *Bad News from Epic Landscape*, touches
on the art of Robert Adams and of Lewis Baltz.

SOME MONOGRAPHS

Ansel Adams
Ansel Adams: Divine Performance.
Anne Hammond, Yale University Press,
New Haven and London, 2002. This
exemplary biography places Adams
in relation to the thinking of his era.
Diane Arbus
*The Estate of Diane Arbus. Diane Arbus:
Revelations.* Jonathan Cape, London,
2003. This exhibition book, with many
texts and illustrations, is revealing.
Eugène Atget
Atget's Seven Albums. Molly Nesbit, Yale
University Press, New Haven and London,
1992. The author gives a wonderfully
elaborate account of Atget's intricate and
evolving classifications of his pictures.

Marcel Bovis

Marcel Bovis. Pierre Borhan, with Alain Fleig, Arlette Grimot and Claude Vittiglio, Collection Donations, Éditions la Manufacture, Besançon, 1991. René-Jacques features in the same series with texts by Pierre Borhan and Patrick Roegiers, 1991. The French have been attentive to their photographic inheritance.

Bill Brandt

Bill Brandt: Photographs 1928–1983. Ian Jeffrey, Barbican Art Gallery in association with Thames & Hudson, London, 1993. Appendices give details of Brandt's extensive work for the illustrated press.

Manuel Álvarez Bravo

Dreams – Visions – Metaphors: The Photographs of Manuel Álvarez Bravo. Nissan Perez, The Israel Museum, Jerusalem, 1983. See also the catalogue *Documentary and Anti-Graphic Photographs*, on the early pictures of Bravo, Cartier-Bresson and Walker Evans, prepared by Agnès Sire for the Fondation Henri Cartier-Bresson, Paris, 2004.

Julia Margaret Cameron

Julia Margaret Cameron 1815–1879. Mike Weaver, The Herbert Press, London, 1984. Weaver, an assiduous researcher, is at his best in this account of the mysterious Mrs Cameron.

Henri Cartier-Bresson

Scrapbook. Thames & Hudson, London, 2002. Michel Frizot introduces this survey of the early pictures. Jean Clair's short text for *Europeans*, Thames & Hudson, London, 1998, offers insights into the master's work.

Frederick H. Evans

Frederick H. Evans: Selected texts and bibliography. Anne Hammond, ed., Clio Press, Oxford, 1992. No. 1 in the World Photographers Reference Series.

Walker Evans

Walker Evans: The Hungry Eye. Gilles Mora and John T. Hill, Thames & Hudson, London, 1993. A picture series showing the original layout of *American Photographs* as it appeared in the Museum of Modern Art, New York, in 1938 sets this book apart from the many others on Walker Evans.

Louis Faurer

Louis Faurer. Anne Wilkes Tucker, Merrell, in association with the Museum of Fine Arts, Houston, Texas, 2002.

Robert Frank

Robert Frank: New York to Nova Scotia. Anne Wilkes Tucker, ed., The Museum of Fine Arts, Houston, 1986. Tucker's essay, 'It's the Misinformation that Counts', is informative on Robert Frank's career, despite larger and later surveys.

Lee Friedlander

Like a one-eyed cat: photographs by Lee Friedlander, 1956–1987. Rod Slemmons, Seattle Art Museum, in association with Harry N. Abrams, Inc., New York, 1989.

Lewis Hine

America and Lewis Hine: Photographs 1904–1940. Alan Trachtenberg, Aperture, Millerton, NY, 1977. A thorough account of Hine, distinguished by Trachtenberg's essay, 'Ever – the Human Document'.

André Kertész

André Kertész. Sarah Greenough, with Robert Gurbo and Sarah Kennel, National Gallery of Art, Washington, in association with Princeton University Press, 2005.

François Kollar

La France Travaille: François Kollar. Anne-Claude Lelieur and Raymond Bachollet, Chêne, Paris, 1986. Supplemented in 1989 by a very slightly smaller book by Patrick Roegiers and Dominique Baque, *François Kollar*, Philipe Sers, Paris.

Dorothea Lange

Dorothea Lange: Photographs of a Lifetime. Robert Coles, Aperture, Millerton, NY, 1982. Aperture's writers were often distinguished outsiders such as Robert Coles, a psychiatrist connected with the Harvard Medical School.

Jacques Henri Lartigue

Jacques Henri Lartigue: The Invention of an Artist. Kevin Moore, Princeton University Press, Princeton and Oxford, 2004. This researched book deals with Lartigue's formative years and with his relaunch by the Museum of Modern Art, New York, in 1963.

Helen Levitt

Helen Levitt. A Way of Seeing, with an essay by James Agee, Horizon Press, New York, 1965–81. The book was prepared in 1965 and published in 1981. The essay by Agee is remarkable. Levitt's pictures of Mexico City were published by Duke University, North Carolina, in 1997, with an essay by James Oles.

Moriyama Daido

Daido Moriyama. Memories of a Dog, Nazraeli Press, Tucson, Arizona, 2004. The book's fifteen instalments were first published in 1982 in *Asahi Camera*. They bring Moriyama to life like no one else in the history of the medium.

Albert Renger-Patzsch

Albert Renger-Patzsch: Photographer of Objectivity. Thomas Janzen, Thames & Hudson, London, 1997.

Aleksandr Rodchenko

Rodchenko: Photography 1924–1954. Alexander Lavrentiev, Könemann, Cologne, 1995.

August Sander

August Sander: Photographer Extraordinary. Sander Gunther, Thames & Hudson, London, 1973. Originally published in German in 1971 by Verlag C. J. Bucher, Lucerne and Frankfurt/M., this book reintroduced Sander to the wider public. *Antlitz der Zeit* [Face of Our Time], the portrait book on which so much of his reputation depends, was republished in 1978 by Schirmer/Mosel, Munich.

Ben Shahn

Ben Shahn's New York: The Photography of Modern Times. Deborah M. Kao, Laura Katzmann and Jenna Webster, Fogg Art Museum, Harvard, in association with Yale University Press, New Haven and London, 2000.

Alfred Stieglitz

Alfred Stieglitz. Graham Clarke, Phaidon Press Ltd, London, 2006. Clarke's book is an introduction to a complex career which can also be approached via *America & Alfred Stieglitz: A Collective Portrait*, edited by Waldo Frank, Lewis Mumford, Dorothy Norman, Paul Rosenfeld & Harold Rugg, published by The Literary Guild, New York, 1934.

Paul Strand

Paul Strand: Essays on his Life and Work. Maren Stange, ed., Aperture, Millerton, NY, 1990.

Josef Sudek

Josef Sudek, Sonja Bullaty and Anna Farova, Clarkson N. Potter, New York, 1978.

William Henry Fox Talbot

British Photography in the Nineteenth Century: The Fine Art Tradition. Mike Weaver, ed., Cambridge University Press, Cambridge, 1989. See especially Weaver's essay 'Henry Fox Talbot: Conversation Pieces'. What exactly Talbot meant by his pictures has never been clear.

Tomatsu Shomei

Islands of Time. Ryuta Imafuku, ed., Iwanami Shoten, Publishers, Tokyo, 1998.

Doris Ulmann

The Appalachian Photographs of Doris Ulmann. The Jargon Society, Penland, North Carolina, 1971. A 'Remembrance' by John Jacob Niles and a 'Preface' by Jonathan Williams are both worth attention.

Edward Weston

Edward Weston: Forms of Passion, Passion of Forms. Gilles Mora, ed., Thames & Hudson, London, 1995. The original, by Éditions du Seuil, came out in Paris in 1995.

Gary Winogrand

Winogrand: Figments from the Real World. John Szarkowski, The Museum of Modern Art, New York, 1988. *Public Relations*, Winogrand's exhibition of 1977, also at the MoMA, is much admired. The original catalogue, introduced by the photographer Tod Papageorge, was republished in 2004.

INDEX

PICTURE ACKNOWLEDGEMENTS

Every effort has been made to contact copyright-holders of photographs. Any copyright-holders we have been unable to reach or to whom inaccurate acknowledgement has been made are invited to contact the publisher.

Ansel Adams
The Museum of Modern Art, New York / Scala, Florence 276; Collection Center for Creative Photography, University of Arizona / The Ansel Adams Publishing Rights Trust 274–5, 277, 279–80; © Corbis / Ansel Adams Trust 278, 281

Robert Adams
© the artist 322–5

Diane Arbus
© the Estate of Diane Arbus L.L.C., New York 298–303

Eugène Atget
© the artist / Musée Carnavalet / Roger-Viollet 30–37

Lewis Baltz
© the artist 354–7

Max Beckmann
Harvard Art Museum, Cambridge, Massachusetts, © Katya Kallsen, President and Fellows of Harvard College 80

Dorothy Bohm
© the artist 304–5

Margaret Bourke-White
© Margaret Bourke-White Papers, Special Collections Research Center, Syracuse University Library, Syracuse, New York 100–103

Marcel Bovis
© Ministère de la Culture, France / La Manufacture

Bill Brandt
© Bill Brandt Archive Ltd. 182–91

Brassaï
© Estate Brassaï / RMN / Jacques Faujour 149, 151; © Estate Brassaï / RMN / Michèle Bellot 150

Manuel Álvarez Bravo
© Colette Urbajtel, Mexico City 162–71

Julia Margaret Cameron
George Eastman House, Rochester, New York 22–3; National Media Museum / Science and Society Picture Library, Bradford, West Yorkshire 24–5

Robert Capa
© the artist / Magnum Photos 200–203

Henri Cartier-Bresson
© the artist / Magnum Photos 52–61

William Christenberry
© the artist 326–7

Moriyama Daido
© the artist 346–53

Jack Delano
Library of Congress, Washington, DC 218–19

Robert Doisneau
© the artist / Rapho 268–73

William Eggleston
© 2008 Eggleston Artistic Trust / Cheim & Read, New York 328–33

Ed van der Elsken
© the artist / Nederlands Fotomuseum, Rotterdam 306–9

Peter Henry Emerson
The Royal Photographic Society Collection, Bath 26–7

Frederick H. Evans
George Eastman House, Rochester, New York 28–9

Walker Evans
© Walker Evans Archive, The Metropolitan Museum of Art, New York, 220–33

Louis Faurer
© Mark Faurer 290–91

Roger Fenton
National Media Museum, Bradford / coll. Royal Photographic Society 18–21

Robert Frank
© the artist / The Museum of Fine Arts, Houston 295; © the artist / National Gallery of Art, Washington, DC 293, 297

Lee Friedlander
© the artist, courtesy Fraenkel Gallery, San Francisco / © 2008, The Museum of Modern Art, New York / SCALA, Florence 316, 318, 320–21; © the artist, courtesy Fraenkel Gallery, San Francisco 317, 319

Paul Géniaux
© the artist / Musée Carnavalet / Roger Viollet 40–41

The Great War
The Art Gallery of Ontario, Toronto 44–6, 50–51, 56, 61–3; Archive of Modern Conflict, London 47–9, 52–5, 57–60

David Octavius Hill & Robert Adamson
© the artists, National Portrait Gallery, London 12–13

Lewis Hine
George Eastman House,
Rochester, New York 70–73
Boris Ignatovich
© Claudia Ignatovich 94–5
Izis
© Manuel Izis Bidermanas,
Paris 260–63
Theodor Jung
Library of Congress,
Washington, DC 204–5
André Kertész
© RMN / Adam Rzepka 134, 138;
© RMN / Jacques Faujour 136;
© RMN / André Kertész 137, 140;
© RMN / Georges Meguerditchian
139; © RMN / Bertrand Prévost 141
François Kollar
© the artist / Bibliothèque
Forney / Roger Viollet 96–9
Germaine Krull
Museum Folkwang, Essen 142–7
Dorothea Lange
© The Dorothea Lange Collection,
Oakland Museum of California, City
of Oakland 209; Library of Congress,
Washington, DC 208, 210–11
Jacques-Henri Lartigue
© Ministère de la Culture –
France / AAJHL 42–3
Russell Lee
Library of Congress,
Washington, DC 214–15
Gustave Le Gray
Bibliothèque Nationale, France 14–17
Helen Levitt
© the artist / Courtesy Laurence
Miller Gallery, New York 196–9
Joel Meyerowitz
© the artist / Courtesy Edwynn
Houk Gallery, New York 358–61
Lisette Model
The Lisette Model Foundation,
Inc. / National Gallery of
Canada, Ottawa 192–5
László Moholy-Nagy
Courtesy Hattula Moholy-Nagy 126–9
Carl Mydans
Library of Congress,
Washington, DC 206–7
Anders Petersen
© the artist / Galerie VU, Paris 366–7
René-Jacques
© Ministère de la Culture,
France / La Manufacture 256–9

Albert Renger-Patzsch
© Albert Renger-Patzsch
Archiv – Ann and Jürgen Wilde,
Zülpich, 2008 122–5
Aleksandr Rodchenko
© SABAM Belgium 2008 84–91
Arthur Rothstein
Library of Congress,
Washington, DC 212–13
Erich Salomon
BPK / Berlinische Galerie,
Berlin 130–33
August Sander
Die Photographische Sammlung /
SK Stiftung Kultur – August
Sander Archiv, Cologne; SABAM,
Brussels, 2008 74–81
David Seymour
© the artist / Magnum Photos 288–9
Ben Shahn
© President and Fellows of Harvard
College 234–5, 237, 239; © 2008
The Museum of Modern Art,
New York / Scala, Florence 236,
242; Archives of American Art,
Smithsonian Institution 238
Arkady Shaikhet
© Maria Anatol'evna Zhotikova 92–3
Tomatsu Shomei
© the artist / The San Francisco
Museum of Modern Art,
San Francisco 334–5, 336, 339,
342–3; © the artist 337–8, 340–41
Stephen Shore
© the artist 362–5
Joel Sternfeld
Courtesy of the artist and Luhring
Augustine, New York 368–71
Alfred Stieglitz
The Metropolitan Museum
of Art, New York 64–9
Paul Strand
© Aperture Foundation,
Inc., Paul Strand Archive,
Millerton, New York 114–21
Josef Sudek
© 2008 the artist, c/o Anna
Farova, Prague 172–81
Nakahira Takuma
© Nakahira Takuma / Courtesy
of Osiris 344–5
William Henry Fox Talbot
British Library / National Media
Museum, Bradford 8–11

Wilhelm Ritter von Thoma
Archive of Modern Conflict, London
47–9, 52–5, 57–60; The Art
Gallery of Ontario, Toronto 61
Doris Ulmann
used with special permission
from the Berea College Art
Department, Berea, KY, 82–3
John Vachon
Library of Congress,
Washington, DC 216–17
Louis Vert
© the artist / Musée Carnavalet /
Roger Viollet 38–9
Edward Weston
Collection Center for Creative
Photography © 1981 Arizona
Board of Regents 104–13
Minor White
© Minor White Archive,
Princeton University. Bequest
of Minor White 282–7
Garry Winogrand
© The Estate of Garry Winogrand,
courtesy Fraenkel Gallery,
San Francisco 310–15
World War II
Archive of Modern Conflict,
London 244–55